Making Histories in Museums

Making Histories in Museums
Series Editor: Gaynor Kavanagh

Also in the series:
Making City Histories in Museums, edited by Elizabeth Frostick
Making Early Histories in Museums, edited by Nick Merriman

Forthcoming:
Making Histories of Sexuality and Gender, by Mark Liddiard

Making Histories in Museums

Edited by Gaynor Kavanagh

Leicester University Press
London and New York

Leicester University Press
A Cassell Imprint
Wellington House, 125 Strand, London WC2R 0BB
370 Lexington Avenue, New York, NY 10017-6550

First published 1996
Reprinted in paperback in 1999

British Library Cataloguing-in-Publication Data

A catalogue record for this book is available from the British Library.

ISBN 0 7185 0007 5 (hardback)
 0 7185 0008 3 (paperback)

Library of Congress Cataloging-in-Publication Data

Making histories in museums/edited by Gaynor Kavanagh.
 p. cm. – (Making histories in museums)
 Includes bibliographical references and index.
 ISBN 0–7185–0007–5 (hardcover)
 ISBN 0–7185–0008–3 (paperback)
 1. Museums–History. 2. Historical museums–History. 3. Museum
techniques–History. 4. Historiography–History. 5. History–
Methodology. I. Kavanagh, Gaynor. II. Series.
AM7.M35 1996
069´.09–dc20 96–33747
 CIP

Typeset by BookEns Ltd, Royston, Herts.
Printed and bound in Great Britain by Biddles Ltd,
www.Biddles.co.uk

Contents

Contents

Illustrations

Contributors

Ken Arnold is Exhibitions Officer at the Wellcome Institute for the History of Medicine, London.

Jonathan Bell is Head of the Curatorial Division at the Ulster Folk and Transport Museum.

Anthony D. Buckley is the curator responsible for the presentation of community life at the Ulster Folk and Transport Museum. He is also Chairman of the Anthropological Association of Ireland.

Elizabeth Carnegie is Curator, History, with Glasgow Museums.

Julia Clark was Curatorial Manager at the National Portrait Gallery in Canberra and is currently a freelance museum consultant.

Spencer R. Crew is the Director of the National Museum of American History.

Reg Crowshoe ('Awakasina') is a Governor of Heritage Canada and is currently the Director of Development for Keep Our Circle Strong, a proposed museum, research facility and community cultural centre on the Piikani (Peigan) Nation. He is a respected ceremonialist and elder.

Alissandra Cummins, the Director of the Barbados Museum and Historical Society since 1985, is a Fellow of the Museums Association of the Caribbean and was recently appointed to the board of the Peter Moores Barbados Trust.

Kath Davies has worked as Development Officer with the Council of Museums in Wales since 1994.

Lawrence Fitzgerald is Curator (Science), specializing in industrial and engineering design, at Glasgow Museums.

David Fleming is Director of Museums and Galleries in Tyne and Wear, and is a visiting lecturer at the University of Newcastle upon Tyne.

Amy de la Haye is Assistant Curator at the Victoria and Albert Museum in the 20th Century Dress Collection.

Simon Jones is Curator of the King's Regiment Collection, National Museums and Galleries on Merseyside.

Gaynor Kavanagh is a lecturer in Museum Studies at the University of Leicester.

Mark Liddiard is a lecturer in Social Policy at the University of Kent at Canterbury.

Nick Merriman is Head of the Department of Early London History and Collections, Museum of London.

Mark O'Neill is Senior Curator of History in Glasgow Museums.

Janet Owen is currently teaching archaeological curatorship and collection management at the Department of Museum Studies, University of Leicester.

James Rattue is Assistant Curator at the Royal Engineers Museum in Chatham.

John Reeve is Head of Education at the British Museum.

Michael Ross is a museum consultant based in Calgary, Alberta, Canada.

Nima Poovaya-Smith is Keeper of Arts at Bradford Art Galleries and Museums.

Brian W. Shepherd is Director of the Museum of Childhood at Edith Cown University, Perth, Western Australia.

Preface

Historians working in museums have an extraordinary and compelling task. They have not only to create the record, through fieldwork and the acquisition and care of objects, but also to make meanings from this material through exhibitions and other public services. The work varies from that which is intensely personal to something which can have an extraordinarily high public profile. The intimacy of recording and study, especially where relationships with individuals have been built, say in oral history work, is in direct contrast to the levels of social and intellectual engagement with large and varied audiences which result from making exhibitions. It takes a real commitment to succeed in these areas, and such commitment often stems from a love of a subject and satisfaction in sharing understanding with others.

It also takes a range of very special and complex skills and there are three areas which are now essential to modern-day history museum practices. Each interlocks with the other and they are therefore hard to separate and impossible to prioritize. Historians working in museums need to be fully conversant with the dynamics of museum provision, as a well-defined and distinctive site for history making. Making histories in museums is simply not the same as writing a monograph, delivering a lecture or making a documentary. It has possibilities all of its own, arising from the deliberately placed centrality of material (as opposed to documentary) evidence as the direct record of human experiences. Of equal importance is an awareness of audiences, whether as individuals or distinctive social groups, and the readiness to work with them. People encounter and use museums on many different levels and access the meanings that best fit their own agendas. It is now recognized that the museum visitor is capable of being gloriously subversive in the messages taken from exhibitions or thoroughly disempowered by omissions, oversights and generalities. Finally, historians need to be aware of the energy within their own subject and the interweave of ideas and possibilities that emerge from it within the museum context; this is where the emphasis of this volume lies.

In these circumstances, a fabulous piece of research is as nothing if visitor needs are ignored or if basic collection management procedures are overlooked. By the same token, no communication strategy under the sun will make up for curatorial ignorance or a flaccid grip on a subject. It is a difficult balance and it is easy for the best intentions and the sharpest minds to drown under a tidal wave of apprehension and criticism. Historians working in museums know only too well that they can be tarred with the brush of false consciousness, bias and triviality that cultural critics in particular like to wield. They also recognize those museums where such criticisms might be totally just. Similarly, as there is no such thing as neutral history, all acts of history making in museums are by their nature political, at the very least in what they include and exclude. History curators are no strangers to controversy and, of late especially in the USA, to sometimes hostile reaction to carefully critical histories. This is the kind of public reaction that university-based historians rarely encounter and it takes an exceptional strength of purpose to remain clear in the goals for history in the museum.

That strength of purpose derives from a commitment to present histories which are compelling and accurate, relevant and insightful, plural and object rich. Museums are capable of being at the cutting edge of history discourse if their very special nature is realistically grasped. Indeed the diligent, inventive and visually astute work to be found in museums around the world, from the Tower Museum in Derry, Northern Ireland, to the Hyde Park Barracks in Sydney, New South Wales, to the newer exhibits in the National Museum of American History, Washington DC, provide ample evidence of the tremendous potential of museum-based histories. It was once believed that the juxtaposition of a few objects to make a 'Victorian bedroom', 'craft shop' or 'Edwardian kitchen' would be sufficient. It plainly is not and this abdication of intellectual and social commitment has done much to damage history museum practice in the long term. In contrast and at their best, the histories now being produced are often people-centred, full of feeling, dazzling in the range of material and oral evidence presented and, more than anything else, original.

There has never been a time when an articulate case for history in museums has been more necessary, not only to maintain a positive disposition towards museums among opinion formers and the public in general, but also to instil a sense of direction within the profession itself. The dogmas of history-is-good-for-you and people-will-pay-for-nostalgia are singularly inadequate. Instead, a case for history in museums has to be developed from an awareness that history museums are one of the means through which people can engage with issues and ideas about themselves and their past. If they visit museums at all, they

do so by choice within their leisure time as part of their personal and social experiences. Engagement with histories in museums can be on levels which stimulate the imagination, provoke discussion and increase the ability to question how and what we know. In other words, history in museums can help develop skills as well as knowledge. From this, it has to be acknowledged that history in museums is at least as much about the present as it is about the past, as much about how people feel as it is about what they know, as much about responses as it is about facts.

The constructed nature of all histories, not least histories in museums, is well understood, although sometimes difficult to recognize at close quarters. Museums hold the stories we tell ourselves about ourselves. These are the comfortable narratives with preferred storylines, occasionally jolted and revitalized by new meanings and emphases. The histories we make are ourselves, here and now, struggling as much to understand our own predicaments and sense of self as with the ultimately impossible task of 'recovering' the past. In the absence of certainty, we ask questions, move around to get a better or at least alternative perspective, look for new evidence in the effort to understand something of past experiences. And indeed the more we know, the more we recognize that there is never one simple story, nor one solid narrative, but many. The histories thus shift to plural voices, contradictory accounts and discordance and in this is enrichment and possibly enlightenment.

In the acceptance of alternative narratives is the recognition that if history in the museum is to be valid intellectually and worth while socially, it has to find ways of admitting to and dealing with the darker side of ourselves and our pasts. Fear of censorship and more pertinently the curtailment of funds has kept many museums away from more honest appraisals of life experiences. Thus, science museums rarely deal with the social costs of technological and scientific development. Farm museums rarely explain that their cute animals eventually are slaughtered, processed and eaten. Costume museums rarely collect or display the clothes of the elderly, infirmed, overweight or dispossessed. A mainstream of conservatism in museum practice has been created which justifies the lack of intellectual activity and engagement of issues on the grounds (usually assumed) of what the public wants. However, as work in a number of museums, in particular Croydon Museum, tells us, when the public are asked what they want and are given a chance to respond to novel and imaginative proposals, there is considerable tolerance of and interest in a whole new range of possibilities.

The need to step out from the fear of censorship, to open museums to braver and better researched histories presented with greater imagination and real regard for visitors was in part the underlying

motive for bringing this book together. But I also felt it was time that historians working in museums revealed their ideas and concerns to a readership beyond the museums profession. The authors are mainly, but not exclusively, historians and anthropologists working in museums who in both academic and professional terms have 'made history' in the public domain. They speak with voices of experience. Their chapters collectively confirm the richness of possibilities for making histories in museums and also many of the responsibilities, not least to ensure an inclusive and visually articulate approach to the past. The tone is deliberately upbeat and positive. One of the underlying points throughout is how powerful history in the museum can be. It is a medium (theoretically at least) open to everyone, a very distinct component of the opportunities for lifelong learning. Whether the messages are constructed in the mind of the curator and articulated through the design strategy of an exhibit, or in the imagination of the visitor and explored through memory and conversation, the impressions made can be long lasting and deeply affecting. We can take Tony Buckley's view that as history is a construct, we might as well accept it and make it up anyway, but perhaps this means continuing what we already do, yet with a lot more honesty, humour and creativity.

This book is dedicated to those, inside and outside, museums who care about history as a site for discovery and further questions about ourselves, and especially those people working in museums who have the courage to grasp the opportunities to make histories in museums both extraordinary and empowering.

GAYNOR KAVANAGH
May 1996

Acknowledgements

An editor has many tasks and responsibilities. Everything involved with the editing of this book has been a sheer delight, essentially because it has enabled me to work with people whose ideas and perspectives stand to make a real difference to history museum provision. I thank them for their enthusiasm, good humour and co-operation, but most of all for their production of stimulating and original essays.

The following museums, libraries and archives kindly gave permission for their photographs to be published: Wellcome Institute Library, London; Ulster Folk and Transport Museum; Radnorshire Museums; National Museums and Galleries of Wales; Landsmuseum für Technik und Arbeit in Mannheim; National Library of Australia; Tasmania Museum and Art Gallery; Glenbow Archives, Calgary; Provincial Archives of Alberta; and the Museums and Collections Services, University of Alberta.

Thanks are also due to Janet Joyce and her colleagues at Leicester University Press for their enthusiam for this book and the *Making Histories* series of which this is the first volume.

I acknowledge that there are some obvious gaps in the range of papers in this volume. Making histories of men, sports, buildings, gays and lesbians have not been dealt with, even though these are legitimate areas for modern history museum provision. Further volumes in the series will, I hope, give these areas the full coverage they deserve.

1

Making Histories, Making Memories

Gaynor Kavanagh

Histories meeting memories

Museums are challenged to produce histories that are more compelling, more accurate and more sophisticated (Ames, 1992). Undoubtedly, much responsibility for this lies with the curator and the range of abilities and ideas that person brings with them. But to centre the discussion solely on curatorial aptitude and output is to acknowledge only half of the process of constructing history in museums. There is another equally important element: the visitor and the nature of his/her engagement with the museum. In many ways, museums are a meeting ground for official and formal versions of the past called *histories*, offered through exhibitions, and the individual or collective accounts of reflective personal experience called *memories*, encountered during the visit or prompted because of it. History and memory meet in the collections, within the research process and within the museum visit.

Memories are the substance of the oral histories museums gather and should be, in theory at least, a good part of the records behind the objects collected. The collections and archives created in museums are research resources of tremendous potential. From them professionals construct and subsequently present histories within exhibits. In particular, extracts of oral testimony are increasingly used in galleries as 'sound bite' quotes on text panels and constructive parts of computer interactives.

Working with memories holds many possibilities for history exhibits. Museums such as the 'People's Story' in Edinburgh (Clark and Marwick, 1992; Marwick, 1995) and 'Lifetimes' in Croydon (MacDonald, 1992, 1995) were developed out of extensive fieldwork and recording, and much careful consultation. Their inclusiveness and depth owes much to determined efforts to honour memories and life experiences in all their

1

diversities and contradictions. In these museums, the interplay of images and words, memories and things, builds rich and moving accounts that acknowledge pluralities and change, continuities and dislocations. In Britain, they have opened up new ways of working, hitherto confined to wishful thinking and conference rhetoric.

Nevertheless, for many museums, there is still a preferred way of working which prioritizes the fabric and form of the object over the individual memories behind it, the formal outsider's history over the insider's account, the history over the memory. Regardless of how thought-provoking the history might be, the individual memories behind an object in this approach are at best subsumed and, at worst, lost. So, it does not matter too much if this was the plough Elijah Thomas, farmer, rarely used because he preferred another, or if this was the plough the Rees family took two years to save for; or if this was the plough made solely to be used as decoration in a pub garden. It will be exhibited as *the* plough, the type used, the symbol of local agriculture – no questions asked please. In such circumstances, memory is lost and history ill-served.

When people visit museums, they can do no other but bring their life histories and memories with them, maybe not ostentatiously nor even consciously, yet within reach. Personal memories may be stirred by the images, objects or words made visible and may dominate over any 'formal' history offered. Such memories may then be compared and discussed, often on a cross-generational basis within a family group: 'Your Grandad used to have one like that, I remember when ...' Memories might also be stirred by exclusions and absences: 'Your Gran could never afford one of those, so she had to make do with ...' or 'where we come from, it's not called that ...' or 'how can they say that ... for us it was so different' or 'I never wore anything like that in the 40s!'

Moreover, memories of the visit will add to the store of memory for most if not all visitors. The content of such memories can sometimes have as much to do with social aspects of the visit, for example whether the coffee in the museum cafe was cold, the car broke down on the way back or a child was misplaced, as with the brilliant innovation (or dullness) of the exhibitions (McManus, 1993; Radley, 1990).

In thinking about memory and history in museums, the multi-layered nature of the provision has to be recognized. What happens in museums is far more than the cold meeting of the minds of the visitors with the curator's carefully constructed displays (see, for example, McManus, 1987, 1991). This encounter has to be viewed in a totally different way. Both curators and the visitors make meanings; neither can put to one side who, when and why they are and neither can be or become a neutral, pure or homogenous unit. As a result, in the meeting of the

visitor with the museum, there is a potentially powerful, rich, dynamic opportunity to bring together individual experiences with a (sometimes) unpredictable assemblage of material and ideas.

Perhaps the promise of this serendipitous moment explains, at least in part, the continuing appeal of museums and the fascination they hold for visitors and many history curators alike. In this view, the museum becomes a site for explorations and discoveries, whether it be about oneself or some aspect of the past to which a personal connection might be made. Each visitor according to their own lives and priorities will select or reject, engage and disconnect from the histories on offer. What is 'true' for one, cannot and will not be 'true' for all. The museum curator goes through similar processes in making the exhibit in the first place. Picking and choosing, comparing and contrasting, judging and concluding are acts which constitute curatorial practice. The self, as much as, the 'professional' is brought to this and cannot be set aside. We are what we create and what we create, in good part, constitutes ourselves, and sometimes our souls.

Sheldon Annis has argued that museums essentially embody three forms of symbolic space (Annis, 1987). First, museums provide something formal in an intellectual sense, that is their history exhibitions developed to be explored and enjoyed. Thus, museums provide a 'cognitive space' aimed to be rich in evidence and insightful interpretation: the sum total of many levels of understanding and the product of many unseen hands. The cognitive space is the dominant and most visual part of history-making in museums and the subject of this book. It is the part which is most obvious, although in truth only one element.

Museums also provide what Annis referred to as 'social spaces' which people engage with, regardless of the *exact* nature of the exhibits. The sheer act of visiting enhances – in however significant or minor way – the social bonds that see us through life, whether they be with friends, family or on our own. Part of that bonding is promoted through the sharing of the experience of the visit and in particular through the exchange of personal and collective memories. Such exchanges may contradict or agree with the histories offered, or indeed may be only tangentially associated with the topic on view. So for partners, a museum visit may offer a change to discuss the new car, a family might find itself in intermittent conversation about their dog, and a 'singleton' might be clearing her head of much accumulated work-related rubbish (see Falk and Dierking, 1992).

But, the reason why museums can be so powerful for our memories is that they are also what Annis called 'dream spaces', where we as visitors respond to images, colours and textures in rather random yet highly personal ways. Odd memories, bits of conversations, scraps of

3

songs, images of things we once owned or used, or fragments of information long forgotten may slip into our minds. The dream space allows for lateral and creative thinking, for problem-solving and leaps of fantasy. It can open up feelings and thoughts long buried. It can lift the lid on our memories.

When we walk through or around a museum we weave both our bodies and our minds through these spaces. Slipping in and out of the museum's structures, we access a whole range of thoughts and feelings. Sometimes, this is a deep and moving experience, often it is at surface level only. But the fact that this experience can be so profound, makes the role of the museum in opening up histories and prompting memories all the more significant. It is therefore important to explore both in greater depth.

Making histories

The word 'history' has two meanings. It is used to refer to what happened in the past. It is also used to refer to the representation of that past in the work of historians. In general terms, historians operate as agents of society and produce histories to service that society. They have the task of sifting through the infinite debris of human experience (usually selecting documents above all else) to find answers to questions, most of which tend to begin with the words 'why' or 'how'. They interrogate and cross-question their sources like bad-tempered prosecution lawyers, looking for inference and evidence that 'rings true' to them. Locked into professional polemics over contested readings, historians have become introspective, self-critical and, at times, downright uncertain. They operate in the knowledge that one year's seminal breakthrough is another year's ill-judged consideration. Very different ideas about social order, produce rival even contradictory theories ensuring constant revision and in turn new questions (Tosh, 1984). The history of history is largely about the historian and the uncertainty associated with the process of making 'sense' of the evidence of the past. Yet, just how well their job is done has consequences for all of us.

Histories are being made and contributed to by a vast number of people inside and outside academe (Samuel, 1995). Such work as they produce can be manipulated to help form a national consensus, or be confined just to the *cognoscenti*. Equally, it can become the basis of informed discussion and debate, even to the point of creating or precipitating change. History is too powerful and important a discipline to be dismissed as an intellectual pastime, a specialized province where only the elect are accepted, or a quite life for someone – least of all museums.

The formal study of history allows for the perspective and objectivity that is often denied in personal memory. As Halbwachs (1950) has pointed out, history is the product of a self-conscious act, memory in contrast is instinctual. Because history usually deals with contexts and thus the broader picture, it asks questions and makes comparisons far outside the scope of recollection. It can also reach back to times not encompassed in our current stock of active memory and draw parallels with more recent experiences. History can employ a whole range of analytical approaches, such as the use of statistics or the models supplied in cultural theory or social psychology, to gain deeper understanding of the complex web of human activity and the processes of change.

Historians working in museums have possibly the most creative and complex roles of all history-makers. They have a wide range of evidence on which to draw, including objects, oral tradition and observed social practice; forms of evidence often ignored by academic historians. They can work with and learn from people who lived and experienced the past in particular ways. They can literally make histories with those who made history.

Furthermore, the task is not just confined to producing histories in exhibition and educational or outreach programmes – the archive or collection has to be created too. Most other forms of history, including academic work and that of documentary film-makers, rely upon others to create the larger part of the archive. Because of this dual role, museums can be places where history is both remembered and forgotten, as curators have to decide what to collect and what to let go, what to record and what to ignore.

Making histories through things

Because curators construct histories in museums using objects as a primary source, they cannot be reliant on the traditional document-based skills of the historians. They have to adapt their way of working and borrow methodologies from other disciplines. Objects can be tremendous bearers of information, but not in the same way as documents and therefore the 'reading' of material evidence has to take other forms. This is by no means easy. Spencer Crew and James Sims (1990: 159) have expressed this dilemma wonderfully well: 'The problem with things is that they are dumb. They are not eloquent, as some thinkers in art museums claim. They are dumb. And if by some ventriloquism they seem to speak, they lie.'

The situation is complicated and made more challenging because each object in the collection has numerous and often extremely different meanings. The meanings achieved may be as varied and useful

as the questions asked. For example, just because a flat iron (the most standard of history objects, present in most collections) can be identified as such, this should not suggest that this is all it was. It could also have been a doorstop, an ornament in a modern home, a defensive or offensive weapon in domestic disputes, a piece of scrap iron sacrificed in a wartime metal (Build a Spitfire) campaign or a book end. Of course, it could also have been a much despised, uncomfortable to use, ineffective domestic tool used in the laundry, or a commodity sold in an ironmongers. One, all or none of these meanings might apply.

For a history curator, objects not only have to be identified and set within categories of meaning, they have also to be positioned and understood within their social, political and temporal contexts. In this, one has to understand that human life is operated not just through objects but through the interplay and manipulation of space, material things and language within given moments in time. History in museums therefore has to be approached through questioning this complex interplay. As a result, unlike most other museum disciplines, such as art or archaeology, although objects are a central concern, indeed the distinguishing characteristic of museums and this particular form of history-making, they are certainly not the sole source nor the only point of interest. Oral history, the encodement of space, movement, physical action and emotional reaction are as important. How else could a museum, with any degree of accuracy, show how a woollen mill was operated by the millhands and managers, or how a religious service was conducted?

The power of museum histories should not be underestimated. As Canizzo (1987) has pointed out, museums embody the stories we tell ourselves about ourselves. They are a form of negotiated reality. Because of this, it is necessary to be more conscious of the formal processes in which museums are engaged. Curators remove objects from their contexts, and record what can only be part of the memories associated with them. The museum allows objects to survive in ways unintended by their makers, and their value increases, both financially and symbolically, by being placed in a museum collection. Sometimes such increases may be beyond the scale of an object's social or historical importance. Curators say of the object they collect 'this is historical evidence' and of the one they refuse (or do not see) 'this is not relevant'.

Such acts, however carefully considered, inevitably influence the kinds of histories successor curators can make from the collections and records that are amassed. To correct the past and present imbalances and omissions, new forms of collections and exhibitions are produced. In a small but growing number of museum exhibitions, it is possible now to find the admission that women, children, workers, minorities had and

have histories of their own. The histories of the elderly, sub-cultures, the disabled, gays and lesbians are still largely neglected. This fails the needs of significant sectors of the population. The gaps and silences can sometimes be filled by the visitors themselves. Andreas Huyseen (1995: 15) has pointed out 'no matter how much the museum, consciously or unconsciously, produces and affirms the symbolic order, there is always a surplus of meaning that exceeds ideological boundaries and opens spaces for reflection and counter-hegemonic memory'. Yet, this is of limited value if one's own histories are somehow omitted. There is only so much one can do as a visitor to 'fill in the blanks'. Power in terms of 'counter-hegemonic memory' is to some degree dependent upon a knowledge base. If this is not nurtured in some way, one can be literally *dis*empowered (Bourn, 1994).

Because such possibilities can be acknowledged, curators are, in theory at least, much freer to work in a more honest and experimental way. Instead of looking for 'truth' or a continuous uninterrupted narrative (in themselves two of the biggest intellectual cul-de-sacs in the history museum field), encouragement can be given to the study of the past through an open-ended exploration which is comfortable with plural, even contradictory, histories. This is a healthy process which can raise as many questions as it answers and, because of this, can potentially be both interesting and stimulating.

Indeed, consciousness that histories are not delivered in a blinding moment of God-given intellectual or professional purity is never more real than when a carefully nurtured and constructed history is confronted by a visitor remembering and declaring with *total* authority 'it wasn't like that' or 'we never did it that way in my time', or 'where did they get that from ... That's not right'.

Making memories

Memory is the ability to recall and represent information from the past. It is what enables us to pour the hot water into the teapot and not the milk jug, pick up a pen and sign our name, recite a poem and recognize our grannies. Neurobiologists believe that when we learn something there must be chemical and electrical changes in the brain, although no one really agrees on what those changes are. But, whether we are 4, 40 or 94 years old, we have both short- and long-term memories, adapted and responding to our needs and situations (Rose, 1992).

Obviously, long-term memories, especially episodic and procedural memories, are of particular interest to history curators. Long-term memories are notoriously difficult to erase, indeed like scar tissue, they are perhaps the most durable features acquired in a person's lifetime. They are thought to be physically embodied and therefore can endure

for at least three score years and ten. Not even electric shocks, anaesthetics or freezing can take them from us. Death is the only end to our memories – unless of course they are passed on through oral tradition, biography, the memories of our children or the records in museums and libraries.

Memories are context dependent. We do not perceive or remember things in a vacuum. Feelings, smells, objects, places, spaces, colours can prompt them and they tumble, however welcome, into our minds. That is why the 'dream space' in museums, mentioned above, is so affecting and effective. For example, in Britain some of the industrial and maritime museums are the sole places where grandparents can really recall and share with their families the details of their working lives, as much of the evidence of their work and workplaces has long since been disposed of or built over. Once that generation is lost to us, the records kept by museums and by their families will be all that we have of their feelings and experiences.

It is however important not to get too carried away with this. Memories, like histories, are constructions and therefore can be both faulty and flawed. They exist in many different forms from the personal, individual and private to the collective, cultural, and public. These memories are threaded through with issues of motivation and personal psychology and exist within shifting anthropological and political contexts; as a result, memories change over time.

People construct memories to respond to changing circumstances and alter the detail according to the setting in which it is recounted. When we reveal our memories we narrate them to an audience, if only of one, and become story-tellers with our memories organized and presented accordingly. Such memories get added to the 'repertoire' and are brought out for 'performance'. Other memories are held much deeper and are only encountered in the privacy of the mind. The construction and organization of our memories, the decision to disclose or keep secret, are a significant part of our coping strategies in life. Sometimes, if we do not want to remember something in a particular way, we will find some other way of remembering it, another story to tell, or keep silent. Children are particularly adept at this – 'his head hit my fist', 'the greenhouse got in the way', 'it wasn't me Mum'. Thus in childhood we learn the strategies of memory management.

This process is especially promoted where community, politics and social contexts reinforce how we prefer to remember things. These preferences allow us, even license us, to omit, reshape and reorganize memories, perhaps without even giving them a second thought. If we, or our world changes, our memories are revised to suit (Connerton, 1989). One vivid incident or episode will drive another from our minds, giving us fresh interests or worries, and new memories can be recalled one

day, as needed. Whether we present consistency or change in our lives, our memories will be used as validation. This is a very human way of dealing with life. It can be a warm and sometimes startlingly honest process, yet it can also be subversive, deeply disruptive and damaging.

Working with memories

Historians working in museums are concerned first to recognize and record memories through objects and oral history and, secondly, to provide a place where individuals and groups cannot only share, compare and even confront memories, but also relate these to broader histories. In this, two issues should be kept in mind: the social dynamic of the memory and the bridge between history and memory.

For the purposes of historians, the social dynamics of memory, *why* and *how* people remember some things rather than others, and the form the memory takes, is as important as the accuracy of its content. If this means dealing with contradictory memories, the contradiction itself becomes the point of interest. The memory is always important for the person at the moment of construction, and is not necessarily an accurate depiction of a past moment. David Thelen (1989: 1123) has this to say about historians studying memory in itself:

> The historical study of memory would be the study of how families, larger gatherings of people, and formal organizations selected and interpreted identifying memories to serve changing needs. It would explore how people together searched for common memories to meet present needs, how they first recognize such a memory and then agreed disagreed or negotiated over its meaning, and finally how they preserved and absorbed that meaning into ongoing concerns.

Awareness of how memories are constructed is as important to historians in museums as an awareness of how history is constructed. It should at the very least help us to understand a little more about how people connect to their pasts (or not) when visiting museums. It should also prompt us to consider carefully the memory content employed in history exhibitions, and how people can relate to exhibits that encompass periods beyond active memory. In turn, this could help museums provide facilities and services which not only release memories, but also help people gain access to other forms of understanding.

This is a hugely important, though daunting, task. A lot can go wrong here. To misread memories or to make false assumptions about them, to unintentionally trivialize memory or gratuitously employ it is to place museums in a situation where they could be open to scorn or, at the

very least, loss of credibility. Moreover, real harm might be done to someone. However, the affectation of memory is quickly spotted, especially by those who know. David Thelen (1989: 1125) gives us this example:

> During the vice-presidential debate of 1988 ... Dan Quayle sought votes from people with positive memories of John F Kennedy by suggesting that he and Kennedy had shared experiences (and generations). Lloyd Benson answered Quayle's familiar kind of rehearsed appeal by a vivid and authentic memory rooted in first-hand experience: 'I served with Jack Kennedy. I knew Jack Kennedy. Jack Kennedy was a friend of mine. Senator, you're no Jack Kennedy.' Watchers (and pundits) gasped. They knew the difference between a memory that a person constructed on the spot out of a vivid experience and in response to a present need, and a rehearsed appeal that floated lazily out in hopes that listeners might somehow connect it with their own personal memories.

Settlement into collective memory can be rather difficult to confront when contradictory evidence becomes available, especially when that collective memory has been set by a variety of different media forms including popular films. The film *The Great Escape* (1963) is shown at least once a year on British television. Recently a documentary programme brought together three men who had been imprisoned in the camp on which the film was based. Their memories were prompted by the experience of being together again and visiting the site of the camp. The memories of two of the former POWs were radically different. For one, the single-minded heroics as portrayed in the film and familiar to all who have seen it were resonant of much that he remembered. For the other, a different form of memory came to the fore. He recalled the men in the camp who despised those with a fanatical drive to escape and refused to have anything to do with their plans. Some were not prepared to give up their bed-boards for the construction of the tunnel and wanted no more than quiet time to read, tend their gardens and wait for the war to end. This was a side of the camp not shown in the film. The clash of memories made at least one of the parties unhappy and they chose to differ on their accuracy.

In some situations, people's memories can be a powerful corrective. In 1994, the government decided that part of the commemoration of the fiftieth anniversary of D-Day should be a big family day out in Hyde Park in London. Former servicemen and women with firsthand experience of D-Day itself were flabbergasted at this. They did not remember the Allied invasion of Northern Europe as a jamboree and recalled all too vividly the cost in human life of this one operation (37,000 British servicemen alone in the two and a half months onslaught). Their

protests persuaded the government to drop this plan in preference for more dignified and appropriate means of commemoration. Someone in Whitehall perhaps had got their history wrong. Had they confused the spirit of VE Day with D-Day? Could they tell the difference? Had they done their homework? In any event, collective and individual memory was there to put them right.

In a hard-hitting article on the relationship between memory and history in the USA, Michael Frisch argues that the justification for much public history in the USA (of which history museums are a significant part) is expressed in formulaic self-congratulatory prose, rich in good intentions. Frisch argues that these generalized and untested responses to the purpose of public history beg questions about the very nature of historical sensitivity and consciousness in America and whether this can or needs to be altered and if so to what specific ends. He writes: 'What matters is not so much the history that is placed before us, but rather what we are able to remember, and what role that knowledge places in our lives' (1986: 6). He argues that in the USA the relationship between history and memory is peculiarly fractured and that repairing it needs to be a major goal of public history. This problem is by no means just an American problem – all countries and most social groups have it in one form or another.

Bridging the gap

But what can museums do to help bridge the gaps between memory and history, between popular and professional approaches to making history? A number of proposals might be made.

From the study of memory it is evident that people do not remember things sequentially, but rather episodically. Indeed the form of memory which gives rise to life narratives is called 'episodic'. Often our bearings in episodic memory are taken from our life stages, thus 'when I was a boy ...' 'when your dad and I were first married ...' 'after the war ...' and 'just before Billy died ...'. In contrast, asking people to position say the 1870s (as opposed to the 1770s or 1970s) is at first very difficult. Historians take their deftness with sequence and chronology for granted. But for the many people who are not historians (in the formal sense) the dates of, say, the Boer War, the span of time in which English churches were built or extended using the style we call perpendicular, when the trams stopped running, are at best only hazily held in mind and at worst held to be not relevant. What makes them relevant and therefore knowable is when connection is made between current life experiences and past ones: 'Grandad's Grandad was alive during the Boer War'; 'we got married in a church that looks like that, was it that old, hasn't it survived well'; 'we used one of the new trams to get here

today, when did they take the old lot away'. Once such connections are made, positioning information within a chronological span becomes much easier and further connections and comparisons can be made.

The Old Grammar School in Hull which houses the history exhibits for the city, was redisplayed in 1990. The new exhibits were oriented around the stages of the life cycle from birth to death and within each of the stages the curatorial team brought together evidence of personal experience of people who lived in Hull during the last 500 years. Using documentary evidence, oral history and objects, the exhibition emphasizes both similarity and difference across several centuries, for example the exuberant playfulness of childhood and life expectancy.

The exhibition creates a kind of intimacy through communicating the experiences of recorded Hull residents, which in turn helps forge senses of empathy and identification. In this instance, once the imagination is captured, the ability to think further, to be conscious of period is in fact enhanced. If the chronological story-line is like a rope, then this cross-chronological approach is like a web, open yet stronger, more textured and much wider in its scope. The key here is to allow and indeed encourage lateral thinking and logical connections, as another museum, Croydon, has ably demonstrated in their interactive displays and computer stations where one can move, for example, from a globe with the British Empire red staining itself across several continents, to an image of an African man marrying a British woman in the 1950s, to discussion of marriage and parenting, to issues of racism. Placed within chronological frameworks, such explorations begin to 'make sense'.

Histories and memories give rise to very different ways of telling. There is always more than one version of anything, and perhaps this ought to be allowed more willingly in history exhibitions. In the recently opened Museum of the Famine in County Roscommon, Ireland, not one version of the famine is offered but eight different accounts, from rabid Nationalist to rabid Tory. In the temporary exhibition, at Birmingham City Museum and Art Gallery, on the area of Birmingham called Heartlands, a variety of people, from council officials to single mothers, gave their candid views of what it is really like to live there; one was left in little doubt of the rawness of the experience. This exhibition and many of its type make space for visitor comments and recollections, usually through a comments board. Often these read like a flowing debate as over several days visitors agree and disagree with remarks and observations made earlier.

Another bridge between history and memories lies in the records made of the lives which lie behind the objects a museum chooses to collect and exhibit. University-based historians comment on the lack of evidence in the public (documentary) records of the lives of ordinary people, especially on the development of values and attitudes (Harris,

1995). Ironically, museum collections are substantially rich in the physical evidence of ordinary people, through the very things they once made and used. The people behind the flat irons, ploughs, buses, guns and wedding dresses had lives, priorities, abilities, personalities, connections and memories. Where full note has been made, very rich archives are to be found and insightful exhibits can result.

Finally, perhaps it should be more readily accepted that museums are places where memories and histories meet, even collide, and that this can be an emotional experience. Indeed, if it is not, then something is going seriously wrong; *feeling* something leads to the motivation to learn something. This is by no means to advocate gratuitous promotion of a predetermined range of reactions. But histories which prompt people to think and use their memories are ones which are capable of moving us, whether this be to laughter or sadness. If the thoughts and feelings in the histories museums make are not recognized, if they fail to have any impact beyond relentless tedium, then somewhere along the line a point has been lost.

In sum, the role of history museums has huge potential to encourage thoughts about the past and to promote the exploration of the relationship between history and memory, but current museum practice is just stroking the surface of this. Better understanding and, as a result, better provision will only come about if there is a deeper awareness of the present as well as the past, of memories as well as histories.

References

Ames, K., Franco, B. and Frye, L.T. (eds) (1992) *Ideas and Images: Developing History Exhibits*. AASLH, Nashville.

Annis, S. (1987) 'The museum as a staging ground for symbolic action' *Museum* 151, 168–71.

Bourn, G. (1994) 'Invisibility: a study of the representation of gay and lesbian history and culture in social history museums', unpublished MA dissertation, University of Leicester.

Canizzo, J. (1987) 'How sweet it is: cultural politics in Barbados' *Muse*, Winter, 22–7.

Clark, H. and Marwick, S. (1992) 'The People's Story – moving on' *Social History Curators Group Journal* 19, 54–5.

Connerton, P. (1989) *How Societies Remember*. Cambridge University Press, Cambridge.

Crew, S.R. and Sims, J.E. (1990) 'Locating authenticity: fragments of a dialogue' in Karp, I. and Levine, S.D. (eds) *Exhibition Cultures*, 159–75. Smithsonian Institution Press, Washington DC.

Falk, J.H. and Dierking, L.D. (1992) *The Museum Experience*, Whalesback Books, Washington DC.

Frisch, M.H. (1986) 'The memory of history' in Benson, S., Briers, S. and Rosenzweig, R. (eds), *Presenting the Past: Essays on History and the Public*, 5–17. Temple Press, Philadelphia.

Halbwachs, M. (1950) *The Collective Memory*. Harper and Row, New York.

Harris, T. (ed.) (1995) *Popular Culture in England c1500–1850*. Macmillan, London.

Huyseen, A. (1995) *Twilight Memories, Marking Time in a Culture of Amnesia*. Routledge, London.

MacDonald, S. (1992) 'Your place or mine?' *Social History Curators Group Journal* 19, 14–20.

MacDonald, S. (1995) 'Changing our minds: planning a responsive museums service' in Hooper-Greenhill, E. (ed.) *Museum, Media, Message*, 165–74. Routledge, London.

Marwick, S. (1995) 'Learning from each other: museums and older members of the community' in Hooper-Greenhill, E. (ed.) *Museum, Media, Message*, 140–50. Routledge, London.

McManus, P. (1987) 'It's the company you keep ... The social determinants of learning-related behaviour in a science museum' *International Journal of Museum Management and Curatorship* 6, 263–70.

McManus, P. (1991) 'Making sense of exhibits' in Kavanagh, G. (ed.) *Museums Languages and Texts*, 33–45. Leicester University Press, Leicester.

McManus, P. (1993) 'Memories as indicators of the impact of museum visits' *Museum Management and Curatorship* 12, 367–89.

Radley, A. (1990) 'Artefacts, memory and a sense of the past' in Middleton, D. and Edwards D. (eds) *Collective Remembering*. Sage, London.

Rose, S. (1992) *The Making of Memory: From Molecule to Mind*. Bantam Books, London.

Samuel, R. (1995) *Theatres of Memory*. Verso, London.

Thelen, D. (1989) 'Memory and American history' *Journal of American History* 75, 1117–29.

Tosh, J. (1984) *The Pursuit of History. Aims Methods and New Directions in the Study of Modern History*. Longman, London.

2
Time Heals: Making History in Medical Museums

Ken Arnold

Introduction

Throughout the summer, gaggles of American tourists climb a spiral staircase and crowd into 'the little room with (a) gory past tucked into a church attic in the heart of London'. What draws them there, reported Wendy Moore recently, is 'the lure of leeches, body snatchers and pickled organs' (Moore, 1995). Ask just about anyone what they think is displayed in medical museums and the chances are they will mention blood, guts and jars of preserved body parts. It is tempting to argue that serious museological approaches to the history of medicine should strive to move as far as possible from these clichés. But that would be a mistake, for such popular notions provide a key to understanding the strength of feeling to which medical museums can have a privileged access.

Even the display of a simple piece of medical technology, a pair of eighteenth-century obstetrical forceps say, can produce responses drawing on profound emotions (see Figure 2.1). For some, just putting a name to this piece of bent steel, conjures up notions of horrific pain and possibly even disturbing personal memories. The reactions of others come more from the reason that the gut, embodying perhaps a grateful sense that recent medical progress has made life less arduous. While for others, this piece of technology is a frightening symbol of the frequency with which formalized medicine has enabled male practitioners to exercise power over female patients. Others still might well marvel at their simplicity of form, at how closely the forceps reflect the nature of their function (Tröhler, 1993: 345–7).

The range of reactions to this single object is both wide and deep, touching on instinctual fears that many people feel are somehow part of their primal being. Perhaps this is why medicine has been a topic of

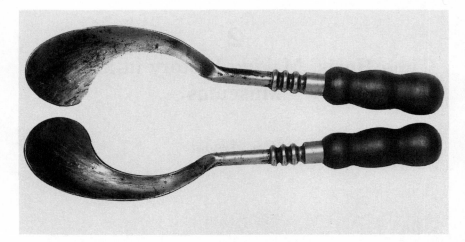

Figure 2.1 Obstetrical forceps, Palfyn's 'Tire Tête', commonly known as 'les mains de Palfyn' (Wellcome Institute Library, London)

such enduring scientific, intellectual, cultural, social and moral contention. Just think of the ferocious debates that today surround issues such as AIDS, abortion, animal testing, national health care, smoking and euthanasia. While it would be foolhardy consequently to presume that everyone instinctually has a deep *interest* in medicine, it is none the less hard to imagine many who have absolutely no *concern* for it. Bridging this divide – that is, creating an interest out of an inherent concern – is the fundamental challenge faced by those who present medical history in museums.

The history of medicine, in theory at least, has a considerable potential to make a profound impact on museum visitors. Like anything that runs deep, the subject of medicine also covers a wide terrain. Just a little lateral thinking quickly makes apparent the extraordinarily inclusive and invasive nature of the subject. Anatomy leads to art, health policy to politics, pills to commerce and economics, hospitals to architecture, medical research to science and belief, and medical practice to employment, anthropology and ethnography. The connections are myriad, and for any but the most determined internalist, medicine is more likely to yield a thematic slice of human history than a mere topic constrained by disciplinary boundaries.

Medicine also has considerable visual strength - much of medical science has sought to 'picture' different parts and functions of the body, a good proportion of its associated material culture is visually striking, and medical subjects have always been a dominant concern for artists in all media. The fact that medicine has a strong visual culture has also

played no small part in ensuring that the histories of museums and medicine have for hundreds of years been so thoroughly intertwined.

The choice of the museum as a specific context in which to present the history of medicine has the added strength of drawing on an intimate relationship between medicine and museums that stretches throughout the entire history of the latter. Many of Europe's first museums were founded by medical men, and any number since then have, both socially and scientifically, served medical ends: for a period some became absolutely core institutions in the provision of medical education; later they were used as convenient centres from which the State could propagate public health policies; and later still, in an age of wealthy industrialists seeking worthy diversions, pharmaceutical men not infrequently tried to further their public prestige through eponymous exercises in museum formation. This long entwined history has provided both the broad platform on which to stand, but also the shadow out of which to emerge, for the most recent efforts at presenting medical history in museums.

Medicine in the history of museums

The cradle for the first European museums was provided by the apartments and workplaces of medical men; many of their curators came from the healing professions; and much of the *raison d'être* for their formation was medical. The very earliest examples of cabinets in Renaissance Italy, were, as the historian Paula Findlen (1994: 3) explains, formed in an attempt to manage the empirical explosion of materials uncovered in travel to unfamiliar countries, voyages to completely unknown lands, the excavation of ancient buildings and in general a new scientific interest in the material world. Many of the objects they found and collected were understood in terms of medical 'principles' that were held to correspond to a particular function and part of the body.

As Findlen has shown, these early curators did not just idly admire their collections, they also engaged with their objects through all their senses. The museums they founded were turned into studies in which nature was not just gathered but also experienced and experimented upon; and just as with the scientific laboratories that were simulta-neously being created, museums became privileged sites of knowledge. Particularly significant activities were the anatomical dissections practised in museums – and not just for medical students. These spaces provided the model for 'theatres of experiments' more generally – places in which, for example, to test theories about fossils, to explore the magic of lodestones, and above all to forge a reform of *materia medica*. In all these projects, experiments allowed early curators to

marshal their objects into facts that served a particular purpose. Many apothecaries and doctors also used their collections as a badge of respectability in an age when the medical market-place demanded that practitioners distinguish themselves from one another (1994: 245).

This link between medicine and museums was still very evident in the evolution of institutional scientific museums in seventeenth- and eighteenth-century England. Many of the leading figures in the foundation of the Ashmolean Museum in Oxford and the Royal Society's Repository in London had medical training and interests. Once again, their backgrounds encouraged them to use cabinets of rarities for medical ends. Changes in the use of *materia medica* (the introduction of new herbs from the Americas, and an increasing use of minerals) were reflected and, indeed, informed by museum-based studies. While in the opposite direction, many early museological practices relating to the arrangement and care of collections (placing dry things high up, for example) were borrowed directly from the professional practices of the apothecary. Three particular exhibits cum cures – unicorn's horns, mummies and human skulls – stand as emblems for this overlap between the worlds of medicine and museums. No cabinet worthy of a virtuoso's attention did not contain at least one sample of each; while in medicine the powers of these rarities were widely held to be virtually panacean (Arnold, 1992: 181–231).

This natural alliance between curiosities and cures also surfaced in the life and work of Hans Sloane, whose collections formed a cornerstone of the foundation of the British Museum in 1759. Trained as a doctor, Sloan's collecting instincts sprang from a curiosity with the material world instilled in medical practitioners eager to balance the natural harm of some substances with the curative properties of others (Macgregor, 1994). Later in the eighteenth century, the dominant medical figures of the Hunter brothers further exercised the by now well-established medical passion for collecting and curating. Both John and William formed museums, the former creating what he saw as an unwritten 'book' embodying his new approach to 'the Animal Oeconomy' and the latter concerned more to establish a teaching museum of anatomy. The collection of John Hunter (1728–93) comprised an enormous array of alcohol-filled jars of dissected and prepared specimens that he used in his research. A particularly spectacular experiment and thus exhibit in his museum, which can still be seen at the Royal College of Surgeons in London, involved grafting a living human tooth on to a cock's comb, where for a while it continued to grow. Another testament both to John Hunter's surgical skills and his instinct for a good show is the 144 ounce tumour that he removed from a man's neck in 1785, without anaesthetic it should be remembered (Rolfe, 1985).

The cement that has held together the two worlds of museums and medicine has throughout its history had a strong didactic component. During the eighteenth century, any number of cabinets comprising entirely of samples of *materia medica* were formed and used as the core teaching material for courses of medical instruction, often given publicly for a small fee. Though a continual presence in the teaching of medicine, during the nineteenth century the role of museums became more and more exclusively focused on this educational function, with a simultaneous reduction in the use of medical museums for research purposes (Pickstone, 1994: 118–21). Thus their place at the cutting edge of certain scientific disciplines gradually gave way to a secondary one of educating 'tomorrow's scientists'.

By the end of the nineteenth century, most of the Royal and learned medical societies in Europe and America had gathered collections expressly for the purpose of teaching, more than a few surviving surprisingly intact to this day (Skinner, 1986: 413–14). The Mütter Museum in Philadelphia, USA with its traditional glass and dark wood cases filled with medical preparations, is just one example of such a collection. What makes it less usual is that since 1986 it has been deliberately redisplayed in a fashion redolent of the context in which it was first established, in part turning it into a museum of a medical museum (O'Donnell, 1995: 38). In nineteenth-century America, this type of museum, particularly those based on pathological and anatomical collections, grew to sufficient numbers to warrant the establishment of an Association of Medical Museums in 1907 (Edmonson 1990: 10).

One man with a monomaniacal collector's passion managed single-handedly to usher in a new era in the history of medical museums. Henry Wellcome was an American-born pharmaceutical industrialist who, after moving to England in 1880, made a fortune selling drugs, specifically those he patented under his own term 'Tabloid' (James, 1994; Symons 1986, 1993; Turner 1980). The size of his collection was extraordinary; 'by the early 1930s, (Ghislain Lawrence has calculated) it was five times larger than that of the Louvre'. Wellcome's 'Historical Medical' collections essentially began with prehistory and ran to his own day. As to types of artefact collected, Wellcome saw such disparate material as weapons, fabric, furniture and potsherds to be as much part of the history of medicine as scalpels and syringes (Russell, 1986; Skinner, 1986: 10–11).

Henry Wellcome's Historical Medical Museum was in fact meant to be nothing short of a 'Museum of Man', covering all periods and all parts of the world. The intellectual context for his collection is provided not by history as it was practised in the late nineteenth century, nor indeed by the museum world, with which he had very little contact, but

rather by the disciplines of archaeology and anthropology (Skinner, 1986: 383, 388). Philosophically founded upon a Spencerian 'science of society', Wellcome meant his museum to chart the history of humankind on a Darwinian trajectory of evolving civilizations. For Wellcome, it was just as natural to locate this research project in a museum as it was to place his other natural science research projects in the physiological and chemical laboratories that he also founded (Skinner, 1986: 398).

The full potential of Wellcome's museological vision was blunted by a drastic under-use of his massive collections. By the 1930s the discipline of anthropology was shifting its emphasis away from museums towards universities; and from 1932 to 1947 the collections went into store, only then re-emerging minus some 60 per cent that had been disposed of in the meantime. Further de-accessioning of material thought not strictly to be of medical interest occurred in 1977, when the remaining objects in the collection were given on the basis of a 'long-term' loan to the Science Museum (Russell, 1986: 13–14).

Wellcome's project none the less had its lasting impact, not least through imitators like Howard Dittrick in Cleveland, Ohio who founded a medical museum that drew on the Wellcome example for inspiration (Edmonson, 1990: 11-12). The entirety of Wellcome's vision for a museum of medical history was no doubt impossibly broad and some scaling down of the enterprise was inevitable. It is hard, however, to resist the sense that much of what followed his efforts in the next half century lacked the grandeur, and no doubt the arrogance, embodied in Wellcome's personal vision and efforts.

The next period of medical museums from the Second World War on was in part characterized by a task of consolidation, reflecting in a more general way the specific exercise of whittling down Wellcome's collection so as to make it more manageable. The other great medical collections, like that of the Hunters, were at best kept intact if largely out of view of the general public. Any number of regional museums also established recreated period streets in which at least one building was not infrequently a pharmacist's shop, dental surgery, doctor's office or dispensary (Edmonson, 1990: 13).

From the nineteenth century on, an alternative type of display that used medicine and very occasionally its history, was exploited by national states or by local governments, as a tool in educating the public on matters of health, sanitation and hygiene. The part of the Smithsonian Institution in Washington DC dealing with medicine, for example, adopted the name Division of Medicine and Public Health in 1939 (Davis, 1988: 60-1). The best known example in Britain was the Parkes Museum of Hygiene, founded in 1879, designed, as the 1953 *Guide to London Museums and Galleries* described it, 'for instruction in all matters connected with public health' (121). Typically, these

museums contained little historical matter, though when they did, they were most likely to be presented, as at the Smithsonian's medical exhibition, 'to warn the public against the perils of quackery and the faults of folk medicine' (Skinner, 1986: 414).

Medical history in museums: a new age

By virtue of this enduring interconnection, many of today's museums have locked up, both in their collections and in their histories, an extraordinarily rich medical legacy – one which by now stands atop a succession of medical-museological enterprises: early efforts at fundamental research; a continuing tradition of professional education; a variety of projects to educate the public in matters of health; and any number of attempts to found museums by medical practitioners, the most grandiose resulting in a collection that meant to capture nothing less than the full gamut of human history. Each motivation has had its lasting effect on the shape of the history of medicine within museums.

From medicinal glass bottles kept in the American Museum in Bath to the apothecary's shop in the Woolstaplers Hall Museum, and from the Water Sampling Pavilion in Strathpeffer Spa in the Scottish Highlands to the nursing items in the Scolton Manor Museum near Haverfordwest, Britain boasts some 200 or more museums with medical collections, and having come through a period when every effort was made to refine and reduce what was deemed to be medically relevant, discarding the rest, medicine and its history is once again being treated to a refreshing range of interpretations. Filtered through the effect of time's erosion, the legacy of all sorts of 'medical collections' is now having both a material and inspirational effect on what is emerging as a new era of medical history in museums, one characterized by a mixture of reflection and analysis (Weir, 1993).

Two particular changes have shaped the emergence of a new era in medical museums, shifts in emphasis which they clearly share with many other types of museum. First, in the area of collecting policy, efforts have been made to cover a far broader social terrain. As the history of medicine has increasingly been studied from the patient's as well as the practitioner's perspective, so the material culture collected by museums has come to reflect this trend. As a consequence, the thrust of recent acquisition policies has expanded from a traditional concentration on scientists, doctors and hospitals to the much more diffuse matter of health in general. Second, museums that deal with medicine, which for much of their history have been largely of interest to those already involved in the subject, have increasingly focused their energies on engaging audiences drawn more from the general public. Fed by the broadening range of material collected, more and more

21

museum time has recently been devoted to questions of interpretation and display. Thus, museums that were initially hosts to medicine in the making, and that then turned to serve the objectives of medical instruction and health propaganda, are now more and more devoted to presenting the general public with the spectrum of social and cultural issues wrapped up in health and healing.

For many history of medicine exhibitions, the place to start is still, naturally enough, the history of medical science. The Thackray Medical Museum, for example, which opens in 1996, aims to present the history of medicine paying particular attention to the 'commercial pressures which spurred technical developments'. The story it will tell charts the developments of medicine from its origins in 'religious influences, myths, legends and misconceptions'; a second section is entitled 'The Light Begins to Dawn' focusing on a medical inquiry of 1842; a third traces 'improvements in surgery and dentistry, advances in methods of diagnosis ... the conquest of epidemic diseases'; with the final section bringing the story up to date (Thackray, n.d.).

The narrative is perhaps a rather unsurprising tale of medical progress that highlights landmarks on a journey of successive improvements. But the context in which it will be presented would have been unimaginable a couple of decades ago. For the 'Museum Interpretative Plan' (an unpublished proposal written in 1994) speaks of a 'particular emphasis on the social and political influences', while one of the museum's primary aims is to illustrate the relevance of the history of medicine and medical care to present day issues.

The 'Health Matters' gallery recently opened at the Science Museum, which explores the making of modern British medicine, provides another example of a project that attempts both to tackle the issue of contemporary relevance and to tell a story reflecting social and political, as well as technological and scientific elements. The gallery also provides visible evidence of the new broader collecting strategies outlined above.

At first glance, the exhibition seems to start off fairly conventionally with a display of diagnostic and therapeutic machines that have played a crucial role in twentieth-century medical practice. The point of displaying them, as the exhibition's chief curator Ghislain Lawrence explains, is not to imply that machines made modern medicine, but rather that these lumps of technology provide 'nodes' about which the wider influence of social, political and technological developments have clustered – thus, for example, the development of radiotherapy is linked to the nuclear weapons industry in the 1940s. Not then presented as determining factors in the story, these artefacts are instead presented as the occasions for specific junctures in the evolution of modern medicine (Lawrence, 1993; Lawrence and Boon, 1994). The accom-

panying information panels reveal as much about price, reliability and other everyday concerns as technical specifications and medical effectiveness. Even the identifying labels incorporate an effective use of graffiti-style explanations of technical terms that attempt to undercut the impersonal and didactic tone of all too much museum text.

One of the other concerns of the 'Health Matters' gallery is to attempt to relate the relatively mundane aspects of science, to humanize its process as distinct from its product. This is particularly effectively achieved through the display of a series of desktops and lab benches of working scientists as recreated by the sculptors Louise Scullion and Matthew Dalziel (Boon, 1993: 20). Elsewhere, the exhibition makes clear the ubiquity of laboratories and surveys in modern medicine. The same general theme of uncovering not what scientists know, but rather how they set about finding it out, and then what makes them believe in what they claim to know, is also effectively explored at the 'Science for Life' exhibition at the Wellcome Centre for Medical Science. Here a computer interactive based on the idea of finding the causes of a mysterious disease makes much play of the role of luck and accident in medical research, as well as the commonness of frustration and failure. With more than a little inspiration from the philosophical principles of science centre, both these displays reflect an increasing concern with matching the presentation of 'the known' with that of 'the knowing', that is, placing the practice of science alongside its product.

As well as paying more attention to how things were done, medical museums have also increasingly dwelled upon the significance of where medical work took place. A prime example of a museum making justifiable capital of its location and building fabric is The Old Operating Theatre, Museum and Herb Garret in Southwark, London. Billing itself as 'London's most intriguing historic interior', the museum manages very successfully simply to present itself and its story. The operating theatre was converted from a herb store in the garret of the eighteenth-century church of St Thomas in 1822. It is a remarkably atmospheric space with an eventful past, which, with just a few words of explanation far more powerfully conjures up the sense of medicine practised in an entirely different social, technical and cultural context than any number of pictures or pages of description. It is rare to find an interior that is quite so densely evocative of past medical practice, which actually makes the less imaginative display of the museum's collections seem far less uninteresting, doing little more than paying lip-service to the standard tale of 'the horrors of medicine before the age of science'.

One other medical museum based on the historical importance of its site is the Alexander Fleming Museum in St Mary's Hospital, Paddington, London. The museum tells the story of Fleming's discovery

and the subsequent development of penicillin. The core of the museum is the room where Fleming did his research. Treated almost in hushed reverence, visitors are encouraged to reflect on the fact that this fascinating episode in scientific history took place *here*, in this precise location – though in truth the laboratory has had to be put back into a room that had, since Fleming's departure, been more than once converted for other uses. Photographic evidence and a mixture of objects either actually used by Fleming, or from that period, has enabled the curator and designers realistically to reconstruct Fleming's cluttered small laboratory. The effect here lies not in what visitors see, but rather in the absolutely crucial fact that they know that this really is the place where he did his work. This is the palpable magic that the museum unapologetically exploits, a strategy further enhanced through the use of volunteer guides who lead visitors in Fleming's footsteps. These amateur interpreters are from mixed backgrounds: some are retired nurses, others are housewives, while another is a JP; one or two even have direct links with Fleming and his discovery. What they do is manage to bring to life a display that is conventional and necessarily static. In a very simple way, both by telling the rudiments of a standard story and by sharing their own personal experiences of Fleming and the impact of penicillin, the combination of a charged space and this human intervention sets free the visitor's imagination.

The value of these site-specific museums lies in their ability to focus the attention of visitors on the actual experience of medicine, either in the making (at the research stage), or in the doing (on the operating table). More effective than any dark ride could be, these two examples come close to giving a real sense of stepping back in time. They represent the most successful ventures in communicative strategy that attempts directly to place visitors in the past. A more oblique approach to the question of how to convey the meaning of medical history turns away from the immediate experiences of health and healing towards instead their reflections in art and politics.

Medical history in art and politics

Medicine has always had close ties with the muses, particularly in the area of fine arts. As subjects, bodies, in health and in sickness, have provided one of the most enduring topics of artistic enquiry. While, as the historian Barbara Stafford (1993) has pointed out, there has long been a creative link between the surgeon's knife and the artist's pen, pencil and brush, each profession having lent to the other an enriched sense of its quest for a 'body' of knowledge. The history of these ties has left an enormously rich legacy, which any number of recent exhibitions have sought to uncover. In 1993 the Wellcome Institute for

the History of Medicine put on a show entitled 'Picturing the Body: Five Centuries of Medical Images', which surveyed some dominant visions of the body produced during periods of prominence for a series of medical ideas (Arnold, 1993). The exhibition basically set about exploring the idea that an intimate connection has existed between understanding and picturing. With a slightly different emphasis, leaning more towards a concern for the aesthetic pre-eminence of the exhibited images, the Philadelphia Museum of Art has produced no less than three exhibitions under the title of 'Ars Medica' in which images from the museum's collection sponsored by the SmithKline Beecham Corporation have been displayed (Karp, 1985).

The L'Âme au Corps' show at the Grand Palais in 1994 was a major exhibition that tackled head on the intricate relationship between scientific and artistic perceptions of the human body and soul. Looking back at the founding of the Louvre, the Jardins des Plantes and the Conservatoire des Arts et Mètier in Paris some two centuries earlier, the exhibition sought to put back together again the unity of human self-inquiry, before it was separated discipline from discipline. The display was dazzling, drawing on collections which since the end of the eighteenth century have been housed in institutions spread far and wide across the city, increasingly excluded from the gaze of everyone except ever more myopic experts, but there presented in such a way as to make the beauty of science and the logic of art appear incontestable (Clair, 1993; Davies, 1994).

Art also has its place in the Science Museum exhibition 'Health Matters', though here it is employed more as an interpretative tool than as a series of exhibits. Thus, in a section which looks at the study of the health of the population in modern Britain, facts and figures have been introduced by means of brightly coloured interactive exhibits, which blessedly look nothing like touch screen computer terminals, which are in danger of becoming the most common exhibit seen in today's museums. In another part of the gallery, as already mentioned, sculptors worked on turning desktops and lab benches of four working scientists into works of art, which manage to make real, in a bricks and mortar fashion the abstract work of medical science (Boon, 1994: 20).

This use of artistic insight and intuition as a means of interpretation is also at the heart of the Wellcome Institute's exhibition *Materia Medica*: A New Cabinet of Medicine and Art'. For it, seven artists were invited to present a mixed 'cabinet' of their own work and historical material from the Wellcome Collections. This newly exhibited 'cabinet' shares with those for sixteenth- and seventeenth-century Europe, which scholars and gentlemen stuffed with curiosities, a strong sense of visual wonder and unexpected resonance – qualities which were largely surrendered to the systematic classifications that shaped more modern

museums and collections. The exhibition's aim is to explore some of the major themes in the interfaces between medicine and art, now and in the past, through the eyes of artists who have already been involved in such areas in their own work.

All of these shows start with a medicalized view of the human body, but by their nature inevitably accompany this physical concern with more abstract reflections on the human condition. Each employs a very different interpretative strategy, but all of them provide an essay on the theme of the mind and body as inseparably coextensive. Just as mainstream medical thought has in the last 20 years relented on the rational project of separating physical and mental ailments – in other words what happens to our bodies from what goes on in our heads – so too these exemplars of a new type of museum-based medical history reflect an increasing willingness to see health and the healing arts as fully comprehensible only within the context of a larger more diffuse culture.

The same lesson has been learned with respect to the political dimensions of health. Though it has been a slow and painful path to travel, many curators and exhibition-makers have come to realize just how unrealistic it is to present the story of change without the details of conflict and controversy. Even a gallery focusing on as potentially a neutral topic as food, and displayed in a national institution fearful of stoking up heated debates, has attempted to make it clear that facts in science are sometimes contested rather than just accepted, and that scientific research is a political as well as an intellectual process. Thus a section on food poisoning in the 'Food for Thought' gallery at the Science Museum, while not dwelling on the matter, did state bluntly that scientists argue about the reasons for the recent increase in food poisoning (Macdonald and Silverstone, 1992: 76). The Science Museum tackled an area of controversy with even more directness in a recent 'Science Box' display on passive smoking. Despite some notable gaps in the treatment – no mention of the role of advertising for example – here was an exhibition that took an episode of conflict as its central theme. Other recent medical exhibitions, that have dealt with what have been termed 'difficult' subjects, have been put on by Glasgow Museums – 'From Here to Maternity' on pregnancy and childbirth and 'Out of Mind: Out of Sight' on mental health, and by the Franklin Institute Science Museum in Philadelphia 'What About AIDS' (*Museums Journal* September 1994). Exhibitions at the Wellcome Institute have also sought to explore matters of scientific controversy: 'Fatal Attractions' looks at the range of medical, public and personal perspectives on AIDS and syphilis, many of them marked by heated argument, while 'Birth and Breeding: the Politics of Reproduction in Modern Britain' sought to present some of the propaganda campaigns that shaped the evolution of

debates about such matters as who should control the place and process of birth, what the role of contraception, abortion and sterilization should be, and the extent to which it is right to interfere with 'natural' processes (Arnold, 1994, 1995).

Conclusion

Drawing on a long tradition of putting medicine on display then, the present work on medical history in museums represents the opening of a new chapter. What this brief survey of recent exhibitions indicates is how today's curators and exhibition organizers are seeking more and more vigorous ways of exploring how medicine and the whole issue of health has both touched people in their diurnal experiences and, moving on from this, has influenced broader aesthetic, political, ethical and spiritual aspects of their lives too.

Curators of medical collections are beginning to realize just how powerful, provocative and broad their collecting area is. Objects, images, ephemera, documents, literature and spaces connected with health and healing have in large measures both 'resonance' and 'wonder', to borrow Greenblatt's terms (1991: 42) – the power that is both 'to reach out beyond (an exhibit's) formal boundaries to a larger world' and 'to stop the viewer in his or her tracks'. Lending itself equally to the lateral digressions of politics and poetics, the history of medicine also naturally bleeds into many other areas of human endeavour and reflection. The result has been a thoroughly invigorating breadth of possibilities, just beginning to be explored, in which medical stories are offering up for inspection something of a cipher for an entire aspect of human experience; from the core themes of investigation (medical research shown in motion) and practice (medical intervention shown in action), to the wider realms of magic and art, ethnography and politics, commerce and spirituality.

Extrapolating from present trends, the future for medical history made in museums promises other examples of focused thematic exhibitions which seek to uncover more and more areas of unexplored terrain, filling gaps in the coverage of such areas as alternative medicine and the experience of patients, and further exploring the relation between health, sexuality and politics. For much of their more recent history medical museums have sailed close to an array of subjects and themes that have been titillating and alluring, without ever daring to address them. All that is changing; what once appeared to be a morbid curiosity with the darker side of life is more and more often being used as a tool with which to explore and present issues in a direct and honest way. Thus medical history museums stand on the threshold of an opportunity to confront human frailty and mortality in increasingly

creative ways, a trend which may yet prove that time heals not by allowing us to forget, but rather by forcing us to recognize the value of remembering.

References

Arnold, K. (1992) 'Cabinets for the curious: practicing science in early modern English museums'. Unpublished PhD thesis, Princeton University.

Arnold, K. (1993) *Picturing the Body: Five Centuries of Medical Images*. Wellcome Trust, London.

Arnold, K. (ed.) (1994) *Birth and Breeding: the Politics of Reproduction in Modern Britain*. Wellcome Trust, London.

Arnold, K. (ed.) (1995) *Fatal Attractions: AIDS and Syphilis from Medical, Public and Personal Perspectives*. Wellcome Trust, London.

Boon, T. (1994) 'Health matters at the Science Museum' *Museum Development*, July/August, 17–20.

Clair, J. (1993) *L'Âme au Corps: Arts et Sciences 1793–1993*. Gallimard-Electra, Paris.

Davies, E. (1994) 'Body and soul' *Museums Journal*, 23 March.

Davis, A. (1988) 'The history of the health sciences at the National Museum of American History' *Caduceus* 4(2), 59–71.

Edmonson, J. (1990) 'Dr Dittrick's Museum' *Caduceus* 6(3), 1–25.

Findlen, P. (1994) *Possessing Nature: Museums, Collecting, and Scientific Culture in Early Modern Italy*. University of California Press, Berkeley.

Greenblatt, S. (1991) 'Resonance and wonder' in Karp, I. and Lavine, S. (eds) *Exhibiting Culture: the Poetics and Politics of Museum Display*. Smithsonian Institution Press, Washington, 42–56.

Guide to London Museums and Galleries (1953) HMSO, London.

James, R. Rhodes (1994) *Henry Wellcome*. Wellcome Trust, London.

Karp, D. (1985) *Ars Medica, Art, Medicine and the Human Condition: Prints, Drawings, and Photographs from the Collection of the Philadelphia Museum of Art*. Philadelphia Museum of Art, Philadelphia.

Lawrence, G. (1993) 'Introduction' in Lawrence, G. (ed.) *Technologies of Modern Medicine*. Science Museum, London, 7–10.

Lawrence, G. and Boon, T. *Health Matters: Modern Medicine and the Search for Better Health: Souvenir Guide*. Science Museum, London.

Macdonald, S. and Silverstone, R. (1992) 'Science on display: the representation of scientific controversy in museum exhibitions' *Public Understanding of Science* 1, 69–87.

Macgregor, A. (ed.) (1994) *Sir Hans Sloane, Collector, Scientist, Antiquary, Founding Father of the British Museum*. British Museum Press in Association with Alistair McAlpine, London.

Moore, W. (1995) 'Blood and gore tour' *Independent on Sunday*, 15 January.

Museums Journal (1994) Whole issue, vol. 94 no.9, devoted to 'difficult issues'.

O'Donnell, S.C. (1995) 'I'd rather be in Philadelphia' *Museum News* 74, 36–63.

Pickstone, J. (1994) 'Museological science? The place of the analytical, comparative in nineteenth-century science, technology and medicine' *History of Science* 32, 113–32.

Rolfe, W.D.I. (1985) 'William and John Hunter: breaking the Great Chain of Being' in Bynum, W.F. and Porter, R. *William Hunter and the Eighteenth Century Medical World*. Cambridge University Press, Cambridge.

Russell, G. (1986) 'The Wellcome Historical Medical Museum's dispersal of non-medical material, 1936–1983' *Museums Journal*, Supplement: S1–S36.

Skinner, G.M. (1986) 'Sir Henry Wellcome's museum for the science of history' *Medical History* 30, 383–418.

Stafford, B.M. (1993) *Body Criticism: Imaging the Unseen in Enlightenment Art and Medicine*. MIT Press, Cambridge, MA.

Symons, J. (1986) 'The development of the Wellcome collections' *Museum Ethnographers' Group Newsletter*, 20.

Symons, J. (1993) *Wellcome Institute for the History of Medicine: A Short History*. Wellcome Trust, London.

Thackray Medical Museum (1994) Unpublished proposal. The Museum, Leeds.

Tröhler, U. (1993) 'Tracing emotions, concepts and realities in history: the Göttingen collection of perinatal medicine' in Mazzolini, R.G. (ed.) *Nonverbal Communication in Science Prior to 1990*. Olshki, Florence.

Turner, H. (1980) *Henry Wellcome: the Man, his Collection and his Legacy*. Heinemann Educational, London.

Weir, S. (1993) *Weir's Guide to Medical Museums in Britain*. Royal Society of Medicine Services, London.

3

Making Rural Histories

Jonathan Bell

At present, around 11 per cent of the collections in British museums relate directly to rural social history, and a further 14 per cent include relevant material (Kavanagh, 1991: 189). The range of social needs fulfilled by rural history museums is very wide. People's need for a history which allows them to make sense of the present has produced views of the rural past which range from seeing it as a primitive state from which we are escaping, to a golden age which we have lost. It is vital that curators working in rural history museums are aware of these conflicting views and how they can shape their own, and other people's, interpretations.

Views of the rural past

The proliferation of rural festivals which include representations of country life in the past is evidence that country people wish to have a useful model of their own history, which is also one which they can present to tourists and other outsiders. John Berger argues that, in general, European peasants tend to idealize an imaginary past as a time when each peasant family was free to struggle against scarcity without interference (Berger, 1979: 201). The picture is, of course, more complex than this. In Ireland, for example, popular rural history emphasizes poverty and landlord oppression, but even in this case Berger's generalization does have value, since an underlying assumption of the Irish model is that if the people had been left alone, they would have created a golden age.

The peasant view of the past fits well with the interpretations of rural life put forward by national élites, especially from the late nineteenth century. The model of rural life which emphasizes harmony between people, and between people and nature, has undergone many

30

transformations, to suit the needs of groups as diverse as leaders of the co-operative movement, members of various politically green parties and many middle-aged suburban residents, for whom 'Greensleeves' and Constable's *Haywain* represent a time when England was England.

Central to this view of the rural past is the concept of 'community'. In Britain, E.P. Thompson (1963: 254-5) dates the use of the concept to the development of Owenism 'To the political myth of English freedom ... there was added the social myth of the ... village community ... The savage penal code, the privations, the brideswells of old England were forgotten – but the myth of the lost paternal community became a force in its own right.' Rural communities were seen as close-knit groups tied together by bonds of kinship and neighbourliness; a stable world where conflict was uncommon and short term.

Closely related to the concept of the smoothly functioning community is the notion that the rural past in general is somehow unchanging. This timeless quality is often related to the cyclical change of the seasons. In *Between the Acts*, Virginia Woolf (1941: 76) describes a pageant where the villagers present an unchanging backdrop to the story of English history: 'Digging and delving ... for the earth is always the same, summer and winter and spring; and spring and winter again; ploughing and sowing, eating and growing; time passes ...'

The notion that rural life is somehow unchanging has been used in many ways, one of the most significant of these being the claim that it is possible to identify changeless, essential elements within regions which can be used to delineate distinct 'culture areas'. Until very recently this was a central preoccupation for folklife scholars. Politically, the identification of unique culture areas has been used by nationalist leaders, and the notion of cultural essences was also used by Nazis who attempted to connect culture to race.

All of these ways of seeing the rural past have been criticized. Marx, for example, was unwilling to admit that there was anything positive in rural life which he saw as idiotic, conservative and doomed to extinction by capitalism (Marx and Engels, 1848: 44). His description of nineteenth-century French peasants is very different from the 'Golden Age' view of country life:

> Smallholding peasants form a vast mass, the members of which live in similar conditions, without entering into manifold relations with one another. Their mode of production isolates them from one another instead of bringing them into mutual intercourse. The isolation is increased by ... poverty ... Their field of production the smallholding, admits of no division of labour ... no variety of talent, no wealth of social relationships ... A smallholding, a peasant and his family; alongside them another peasant and another family ... In this way the great mass ... is

formed by simple addition of homologous magnitudes, much as potatoes in a sack form a sack of potatoes. (Marx, 1852: 170–1)

The notion of a smoothly functioning, independent peasant community has been heavily criticized by many scholars. Popkin (1980: 415), for example, accuses academics who argue for the existence of such communities of indulging in 'romantic scholarship' which ignores the conflicts and calculations of rural life. The most cursory review of changes in landholding, technology and the division of labour shows that a view of country life as somehow unchanging, can only have meaning at the level of mysticism. The search for cultural essences proves to be an endless hall of mirrors, since no culture is fixed.

However, if we dismiss everything based on the notion of an unchanging community, we are left with the problem of explaining a sense of loss, reported not only by co-operators and nationalists, but by many older country people themselves, who lament the skills which have vanished, the disappearance of local music and story-telling, and the feeling that people have become more isolated. It seems that the most convincing view is a complex one. As Thompson (1963: 255), discussing the 'myths' of Owenism, points out, 'To say that it was "myth" is not to say that it was all false; rather it is a montage of memories, an average'.

Museum curators must be aware that in fulfilling their central aim of conveying something about past human experience, they, as well as their visitors, will bring to the display models of rural society which in many instances are difficult to distinguish from mythology. Curators have a duty to deal with these preconceptions. At the same time, however, curators should avoid neurotic self-scrutiny. We are telling a story which we know can be no more than a partial story, but it can also be a true story and interesting as well. What is now known as 'the past' is not what anyone ever experienced as 'the present'. History is always an account, a narrative. Not only is the experience of past reality not possible, our constructions of it must be partial if they are to make sense. To think is to generalize, to abstract, otherwise there is only a mass of detail (Lowenthal, 1985). History can provide real knowledge of the past, but it is always subjectively biased. Sartre has convincingly argued that all knowledge, including historical knowledge, is constantly changing and progressing. He denies the possibility of any systematic, analytic, unchanging history (Sartre, 1976). Our responsibility is to produce a history which has a truth for us which, from our own position, we cannot go beyond.

The development of rural history museums

The changing role of agricultural museums clearly illustrates changes in the concerns of the people who set them up and visited them. The earliest museums were explicitly directed at the present and the future, rather than the past. Agricultural societies in Britain and Ireland began to display artefacts in order to educate farmers about new developments in technology. In 1841, for example, the Royal Agricultural Society of Ireland established an Agricultural Improvement Society. The society attempted to promote the improvement of farming through various projects; by holding an annual show, helping local societies, opening a college and library, and setting up an agricultural museum (Berry, 1915: 297). The Great Exhibition in London in 1851 included a display of agricultural implements, again emphasizing new breakthroughs, such as horse-drawn reaping machines. The first national collection in Britain was begun in the 1860s. This has remained in the Science Museum, where it has changed from a contemporary display of new, improved technology to a record of past achievements.

A concern with the rural past, and specifically the past of the ordinary people, developed in the later nineteenth century. The main centres for this work were in Scandinavia. Artur Hazelius founded Skansen Museum in 1891, and this and other early Scandinavian institutions remain a model for outdoor folk museums in Europe (Hudson, 1987: 121–2). In Britain also, a concern for a 'folk' heritage developed during the late nineteenth century. This did not lead to the development of specialized museums, however, but to rather fantastic representations of 'Merrie England', or occasionally to 'merrie' versions of the other countries in the UK. By 1900, international exhibitions in Britain were built on romantic urban views about the countryside; 'Tudor bliss, the maypole, the village green, and exaggerated vernacular buildings' (Kavanagh, 1991: 190).

The 1920s and 1930s saw the beginning of systematic collection of rural material, particularly in Scotland, Ireland and Wales. The Manx Folk Museum and the Highland Folk Museum were both established during this period. Post-war developments have included the Welsh Folk Museum, the Ulster Folk and Transport Museum and the Museum of English Rural Life at Reading. The latter institution is highly regarded for its major archive collections, which contain records of many important British agricultural implement manufacturers. This concern with the technological mainstream sets Reading apart from the other museums mentioned. These, as their names make clear, are much more directed towards folklife, with its emphasis on recording distinctive aspects of local cultures.

The folk project represents an inversion of the nineteenth-century impulse to establish museums. 'Folk' objects were collected because they seemed to connect directly to an ancient past – a mythical dreamtime. Irish folklife collectors saw Ireland as a particularly rich area for this kind of material. Estyn Evans, for example, saw modern Irish rural life as profoundly influenced by a 'prehistoric sub-stratum' which still shapes cultural practice, attitudes, and beliefs. The source of these influences goes back even beyond the 'intervening' Bronze Age, to the 'primary' Neolithic culture (Evans, 1992: 66). It is not surprising that these high-flown claims for ancient pedigrees should have found popularity in the 'Celtic Fringe' of Britain and Ireland, where they can be understood partly as a response to a sense of inferiority to the dominant culture of England. In Europe, in general, such claims can be seen sometimes to have had a positive role historically, in encouraging confident resistance to imperialism, and a negative role in inflaming the fantasies of racism. Whatever their social significance for modern societies, however, they are at best speculation.

In museum terms, the folk project has also negative and positive aspects. The most unfortunate result of the search for folk essences is that they tend to create a functionalist view of the past related to the myth of the unchanging community discussed earlier. Folk museums like Skansen have been seen to

> tidy up images of the rural poor ... editing information about ways of life
> so that it might be of use to a rising industrial middle class ... Arguably
> ... [these museums] came to serve dominant needs for access to a placid,
> rural, essentially non-industrial past; a secure harmonious history,
> officially constructed. (Kavanagh, 1991: 191)

The positive achievement of the folk movement is the focus it has given to the lives of ordinary people. The inadequacy of documentary sources in providing detailed accounts of these lives has led to the development of fieldwork, and particularly to the collection of oral evidence as a research tool. The simple construction of many 'folk' artefacts and often their sparsity, has heightened awareness of the central importance of recording the contexts in which objects were made or used. 'Folk' museums tend to escape the pitfall of becoming impersonal displays of technological or stylistic change.

Modern rural history museums

The growing interest in rural history throughout Britain has produced a range of museums. Gaynor Kavanagh (1991: 195) suggests that these can be divided into four main types: small local museums serving local

rural areas; county museums which aim to exhibit county-wide collections; working farm museums; and national museums.

Each of these museums has its own set of problems, but they also share some basic ones, which have to be faced by any curator attempting to make social history intelligible in a museum context. The biggest problems centre around the gap between people and objects, particularly utilitarian objects which form a major part of social history collections. How can we use artefacts such as churns, ploughs, or hedging tools to deepen understanding of, for example, the role of women, hired labour or systems of landholding (see Figure 3.1)?

Some anthropologists, such as Marvin Harris (1969: 654–89) or Lévi-Strauss (1962), have been very optimistic about the possibility of discovering or explaining social relationships by examining material

Figure 3.1 The division of labour. Cassie and Paddy McCaughey in County Tyrone, 1906. Cassie is shovelling soil on to ridges turned by Paddy (Ulster Folk and Transport Museum collection)

objects, both functional and symbolic. However, when we examine available historical evidence, it is clear that postulating any causal link between technological and social change in agriculture would at best be highly speculative. This becomes clear if we examine changes in the division of labour. In Europe during recent centuries, farmers could recruit workers from kin, neighbours, or from different sorts of hired labour. All three sources might be called on, especially for tasks such as haymaking, where there was a need for a large labour input, but any of the three might also be used for tasks such as spadework, where two men (usually) worked alongside one another in building up a ridge. The most striking feature of recruitment processes, especially in small-scale farming, is the flexibility of possible arrangements, rather than any close articulation with particular technologies.

This is not to say that an examination of technological processes can tell us nothing about the division of labour. Reaper-binder machines probably reduced the need for co-operation between neighbours at harvest, while steam threshers probably led to more co-operation. Skills such as horse ploughing were highly prized, and we could expect ploughmen to have a high status relative to other farmworkers. A detailed knowledge of production processes can also deepen understanding of changing status relationships in rural society. The changing position of women on many European farms during the last century is a good example of this. A series of studies suggest that women have been de-skilled, in that a major aspect of their work, the processing of farm produce, has been taken out of the farm context, and centralized in creameries, bakeries and meat curing plants (Hannan, 1970: 11). Historical studies of the de-skilling process can help us to understand why, in some European countries at least, women have left the land in much greater numbers than men.

An understanding of the details of technology can also sometimes help us to understand cases where social relationships were being directly expressed using technology. For example, one blacksmith recorded in Northern Ireland, said that he had been accused of displaying his sectarian preferences by the different ways he set plough irons for Protestants and Roman Catholics before a horse-ploughing match. It obviously increases our understanding of this incident if we understand the technology, but it is also obvious that similar conflicts could be expressed in very different ways.

When, as in the instances given above, we have historical evidence for a direct relationship between technology and social relationships, we can begin to bridge the people-technology gap a little more confidently. However, it is clear that speculation about the social relationships is always risky, even when we are dealing with utilitarian objects, and as archaeologists know only too well, we are liable to be

even wider of the mark when we attempt to deduce the significance of non-utilitarian objects.

History curators are of course fortunate that for the modern period, many sources of evidence are available which can be used to discover the social significance of objects; documents, oral evidence, photographs and film can all be used to give context to artefacts. Without such context, many objects in history museum collections would have little meaning. Gaynor Kavanagh (1990: 111) has given a striking example of the importance of context to understanding in her analysis of several blankets, one of which was used by a mother to carry her baby, and another by a hunger striker in a Northern Ireland prison. Here the objects become icons, participating in the reality which they represent (that blanket actually held a baby, this was actually worn by a prison protester).

Discoveries can also be made by using past technologies in an experimental museum context. The development of living farm museums means that, for example, the operation of horse-drawn or manual implements can be recorded in detail (see Figure 3.2). Danish open-air museums have led the way in this work, which has shown, for example, how medieval cultivation ridges were constructed by several kinds of ploughs (Lerche, 1970). Some museums in Britain and Ireland have followed this example, and interesting discoveries have resulted. Agricultural curators at the Ulster Folk and Transport Museum, for example, have reconstructed an eighteenth-century Irish plough, using documentary sources. When used at the museum's annual ploughing match, it was found to confirm contemporary accounts of the way it turned furrows, and the number of ploughmen (three) required to operate it. This may seem rather obscure when compared to research into social relations, but even here it can make a modest input. Scholars trained in the social sciences are often taken aback by the unexamined assumptions historians make about particular categories of people in the past. One of the most persistent of these is that peasant society is in some way innately, and by implication, irrationally, conservative. This assertion has been made especially frequently when peasant caution in adopting new technology is discussed. Research into actual practice and the constraints in which particular farming systems were used has shown that the charge of unthinking conservatism is not only unhelpful, but at variance with the results derived from historical case studies and experiments. These have shown that the emphasis should rather be on peasant ingenuity and adaptability (Bell and Watson, 1986).

Curators have to discover ways in which to move from objects to people, avoiding both the traps of presenting the objects as an obscure story of technological development, or making facile connections between technology and the people who used it. In meeting this

Figure 3.2 Making cultivation ridges in County Fermanagh. A
fieldwork photograph from 1984 (Ulster Folk and
Transport Museum collection)

challenge they have many tools to assist them. Research into recent
history can make use of the variety of sources listed earlier, and
particularly of the problematic, but overwhelmingly rich material made
accessible by oral history. Displays can also make use of a wide variety
of sources to interest and educate visitors.

No display method should be ruled out. Models, for example, can
convey a large amount of information in a small space. Massive artefacts
such as steam threshing complexes can be represented, vanished
technologies such as medieval plough teams can be shown three
dimensionally, and the importance of tasks such as flax pulling, which

were done without the use of tools, can be emphasized. Full size 'heritage dummies' are more problematic.

Mixing figures with original artefacts creates an illusion. When the illusion breaks down, the presence of figures can interfere with the appreciation of original artefacts as direct links with the past. However, they can perform useful functions in situating artefacts or buildings in a particular period, and showing the kind of people who would have used them. Audio-visual presentations can bring movement to gallery displays, showing technology in action, and the associated division of labour. They also provide a way to show social relationships without the necessity to refer to artefacts, by using old film, dramatic reconstructions or interviews with older people.

The use of interactive displays and hands-on activities in museums is strongly advocated by educationalists, and this is an area where rural history museums which include working farms can delight and inform visitors in ways not accessible to displays confined to galleries. People for whom horse ploughs, grubbers, or seed drills are undifferentiated pieces of metal will stand enchanted when they see the same implements pulled by horses in a field. Inner-city children can be thrilled by the chance to touch animals, collect eggs, or even to plant a potato (see Figure 3.3). All of this excitement can be channelled by educationalists to teach subjects as wide-ranging as biology, ecology, economics and of course social history. The buildings and fields in outdoor museums also provide sets where historical presentations can show the inter-connectedness of rural life, or specific events such as hiring fairs. These presentations can be very labour intensive and therefore costly, but less ambitious activities can also be organized, where teachers can make use of the museum using guidelines and props provided.

There is no rule for the right balance between these display methods. To this extent the construction of an exhibition is a creative act, like a work of art. Whatever the balance selected, however, it is important that curators do not lose sight of the central importance of original historic artefacts. The collection of artefacts is the museum's most important resource. These can provide a direct link with the past in a tangible way which can be both very informative and profoundly moving. It has been pointed out that the authority of objects can be distorted, by using them to give the appearance of hard reality to what in fact is an ideological construct (Meltzer, 1981: 120). In the end, however, their authority is inalienable. They carry messages beyond the restricted meanings taken from them in any interpretation. The poet Seamus Heaney (1993: 33) has expressed this ongoing significance very impressively:

Figure 3.3 Learning skills. Two County Leitrim boys with a miniature one-sided spade, 1994 (Ulster Folk and Transport Museum collection)

To an imaginative person, an inherited object like a garden seat is not just an object, an antique, an item on an inventory; rather it becomes a point of entry into a common emotional ground of memory and belonging. It can transmit the climate of a lost world and keep alive in us a domestic intimacy with realities that otherwise might have vanished. The more we are surrounded by such objects and are attentive to them, the more richly and connectedly we dwell in our own lives.

It is our duty to present objects, whether in static displays or in demonstrations, in ways which lets them, and the messages they carry, have their full impact.

References

Bell, J. and Watson, M. (1986) *Irish Farming*. Donald, Edinburgh.

Berry, H.F. (1915) *A History of The Royal Dublin Society*. Longmans, London.

Berger, J. (1979) *Pig Earth*. Writers and Readers Publishing Co-operative, London.

Evans, E.E. (1992) *The Personality of Ireland*. Lilliput, Dublin.

Hannan, D. (1970) *Rural Exodus*. Chapman, London.

Harris, M. (1969) (1972 edn) *The Rise of Anthropological Theory*. Routledge and Kegan Paul, London.

Heaney, S. (1993) 'The sense of the past' *History Ireland*, 1(4), 33–7.

Hudson, K. (1987) *Museums of Influence*. Cambridge University Press, Cambridge.

Kavanagh, G. (1990) *History Curatorship*. Leicester University Press, Leicester.

Kavanagh, G. (1991) 'Mangles, muck and myths: rural history museums in Britain' *Rural History* 2(2), 187–204.

Lerche, G. (1970) 'The ploughs of medieval Denmark' *Tools and Tillage* 1(3), 131–49.

Lévi-Strauss, C. (1962) (1972 edn) *The Savage Mind*. Weidenfeld and Nicolson, London.

Lowenthal, D. (1985) *The Past is a Foreign Country*. Cambridge University Press, Cambridge.

Marx, K. (1852) (1980 edn) 'The Eighteenth Brumaire of Louis Bonaparte' in *Selected Works*, Lawrence and Wishart, London, 96–179.

Marx, K. and Engels, F. (1848) (1980 edn) 'The Communist Manifesto' in *Selected Works*, Lawrence and Wishart, London, 35–63.

Meltzer, D.J. (1981) 'Ideology and material culture' in Gould, R.A. and Schiffer, M.B. (eds) *Modern Material Culture: The Archaeology of Us*, Academic Press, New York, 113–26.

Popkin, S.L. (1980) 'The rational peasant' *Theory and Society* 9(3), 411–20.

Sartre, J-Paul (1976) (1978 edn) *Critique of Dialectial Reason*. New Left Books, London.

Thompson, E.P. (1963) (1980 edn) *The Making of the English Working Class*. Penguin, Harmondsworth.

Woolf, V. (1941) (1992 edn) *Between the Acts*. Penguin, Harmondsworth.

4

Why Not Invent the Past We Display in Museums?

Anthony D. Buckley

Past events ... have no objective existence, but survive only in written records and in human memories. The past is whatever the records and the memories agree upon ... (It is) whatever the Party chooses to make it ... Recreated in whatever shape is needed at the moment ... this new version *is* the past, and no different past can ever have existed. (George Orwell, *Nineteen Eighty Four*).

Once upon a time, four blind men encountered an object in a jungle. One man said he had found a rope; another a tree trunk; another an overhanging wall; the fourth a python. Not until they discussed the matter did they come to a proper conclusion. They had, of course, found an elephant. (Popular tale)

Compared with the opinions about the elephant, the stories which are told of the past are legion. There are countless periods of time, countless locations, countless topics. One historian writes about war; another about religion; another about the economy. History itself is political. Its narratives reflect the class, the ethnicity, the personality, the hobby-horses, the economic interests of the person who tells the story. History can be a form of intellectual property: it can 'belong' to a social group (Harrison, 1992). Histories are a focus for the allegiance of social groups. They are used operationally as models for action (Caws, 1978), they provide historical charters for the present (Bohannan, 1952; Malinowski, 1963). They are used as rhetoric (Billig, 1985; see also Buckley, 1989; Buckley and Kenney, 1995).

From an awareness of the complexity which lies behind history, a relativist orthodoxy has entered the world of museums. Relativism states that all ideas arise out of a particular culture or sub-culture. It assumes too that all cultures and the ideas of all cultures have an equal value. According to this view, the truth of an idea is not 'absolute', it is

'relative' to the viewpoint and culture of the person who holds them.

This acceptance of cultural relativism in museums comes from both left and right. For many years, liberals and socialists saw cultural relativism as a decisive answer to racism (Stein, 1986). Racist oppression and colonial conquest had been sustained by the belief that white culture was superior to all others. By claiming that all cultures were equal, relativism could undermine this chauvinism. No culture, it asserted, was superior to another, just different.

At first, in its heyday during the 1960s and 1970s, there was a pleasing iconoclasm about the idea that the ideas of all cultures were equally true. Science, we learned, arose out of inspiration (Watson, 1970) or anarchy (Feyerabend, 1975). Ideas such as these were invigorating: they smelt of freedom and fresh air. Later, however, during the 1980s and 1990s, the fresh air acquired a different aroma. Relativism ceased to be rebellious and became an orthodoxy. The notion that governments and private corporations will manipulate information through public relations and advertising ceased to be disreputable and became commonplace. Image replaced truth. We were left with only a multiplicity of points of view. Relativism was now being used by the strong.

In the museum world, relativism justifies the bread and circuses of commerce. There has been a growth of theme parks and display centres, and the ethos of these institutions has spread into more sober mainstream museums. The prime aim of such bodies is commercial: their concern to raise revenue. And to this end, there is a new emphasis on providing not only for the comfort and entertainment of the public, but also versions of history that 'people want to see'.

Given the pressure to produce histories which serve particular causes, some hard questions arise. Should the museum curator invent soporific pasts which soothe the self-regard of powerful groups in society? Is the truth even possible? Is a curator a kind of public relations person? Can one take 'authenticity' seriously? Does truth matter at all? Is truthful history merely boring, of no interest to the paying customer?

There is a more sinister question at stake here too. The extract from Orwell (1954), given above, is also quoted by a civilized writer, David Lowenthal in his acclaimed book *The Past is a Foreign Country* (1993: 190). In the quotation, Orwell exaggerates, so as to exemplify, the dangers inherent in both Stalin's and Hitler's attitude to the truth. These dictators, whom Orwell roundly despised, saw the truth as indefinitely expendable.

What is unnerving is that Lowenthal (1993: 327) sympathizes less with the libertarian socialist George Orwell than with the authoritarian Big Brother: "'Like Orwell's Ministry of Truth," he writes, "which

continually revised the past to show that Party had always been right, we brainwash ourselves into believing that we simply reveal the true past – a past which is unavoidably, however, partly of our own manufacture.''' One must surely question this epistemology. Can we really accept that Hitler, Stalin and Orwell's Ministry of Truth were right after all? Are the only valid epistemological questions to do with power? Is truth determined only by the person who controls the medium? Must we lie down and accept that history, in and out of museums, will always bend the facts to benefit some social group? Is the truth really just what the powerful or the consumer (or anybody) chooses it to be?

The question finally for museum people is this: if the truth is just a matter of self-interested opinion, why should we not just invent the history we present in museums?

I maintain that it is not enough to say that the truth is merely the view that one's own social group happens to hold. But it is also absurd to say that the ideas generated by all cultures are equally valid or true. A better perspective is a dialectical one, in which, like the four blind men, we engage in dialogue with others. In such a view of history, we can learn what the world looks like from other people's perspectives. Thus we can hope that all our own more partial visions can be superseded. Such a view respects the truth while not claiming that any one version is complete.

My argument is that it is both theoretically and practically possible to present a history in museums which respects the truth, and moves forward in search of it. More than this, I believe a respect for the facts in historical presentations sustains some of the better elements of human society. I want also to resist that kind of commercialism which does not care what it tells its public so long as they pay their money at the gate.

Theoretical objections to relativism

The first step is to suggest that extreme forms of historical relativism, are theoretically untenable. One version of this view comes from Thomas Kuhn (1962), a seminal theorist of the history of science. Kuhn argues that scientific knowledge is organized around the paradigmatic work of a great scientist in the past. After a scientific revolution (such as that of Copernicus or Darwin) known facts from old paradigms are reassembled to fit into new paradigms. When they do not fit the new theory, they are quietly ignored.

Kuhn's hypothesis has been widely accepted and, indeed, I have myself used his approach in a study of the quasi-scientific knowledge of an African people (Buckley, 1985). Kuhn, however, is mistaken when he

claims that a scientific paradigm will alter the very language of science so that adherents of different paradigms will be unable to communicate with each other. A similar viewpoint is expressed in the more radical book by Feyerabend (1975).

There are three broad objections to this sort of argument. The first objection is that this extreme form of relativism contradicts itself. It casts a shadow of 'irony' or doubt not only on the truth of the knowledge being investigated, but on knowledge as such (Woolgar, 1983; Woolgar and Pawluch, 1985a, 1985b). Relativism denies that there is any truth which is independent of particular, culturally determined theories. Nobody judges a theory by whether it fits the facts. Rather the facts are dependent on the theory. In short, relativism implies that all theories are equally true, and equally false. If effectively all theories are untrue, then it follows that the statement 'all theories are untrue' is also untrue. This kind of paradoxical argument is, of course, unacceptable. Woolgar and Pawluch (1985a) call it 'ontological gerrymandering' (see also Dixon, 1977).

A second objection comes from linguistics. There is an older view that each language divides the world into its own peculiar semantic categories and that these determine a people's perceptions and understanding (e.g. Whorf, 1941), but this opinion has been seriously challenged. Berlin and Kay (1969) and their followers (e.g. Berlin, 1978; Brown, 1977; Collier *et al.*, 1976; Rosch, 1972, 1977a, 1977b, 1978; Rosch *et al.*, 1976) have established that individuals from different countries, speaking different languages, see the world in the same 'basic' categories. It seems there is a bedrock of common concrete experience which can be communicated between individuals of whatever culture. There is, in effect, a universal language which, at its simplest, consists of pointing at objects. This language of pointing translates easily into the more complicated human languages based on sound. And this procedure in turn enables individuals to teach each other their own languages and therefore communicate with each other. It is this facility that enables a European to walk through an African forest and understand what an indigenous healer means when he says 'these leaves cure fever' (Buckley, 1985).

The third objection to an extreme relativism is that it leaves individuals stranded inside their own heads, unable to interact with the social and physical environment that sustains them. It seems more plausible to say that the theories which people hold bear some relation to the real world. They are not mere theories. People everywhere make practical judgements based on their knowledge of the world. We depend on such judgements to allow us to cross the road. This kind of pragmatic weighing of evidence does not produce 'The Truth' in some final sense. This is because all representations of reality are partial, and will always

exclude much of the data. Nevertheless, empirical experience exists independently of the theories which elucidate it. And a critical judgement which uses available evidence to decide between different versions of the truth is a universal human faculty.

Why bother to be truthful?

Having argued that it is at least possible to be truthful, one must now ask whether the truth is worth telling. Why should historians and curators spend valuable time and money getting their facts right when the general public doesn't always seem to mind very much what it is told? I want to look at some ways in which people actually make use of history, and to suggest that truthful versions of the past are in fact a valuable resource. And then I want to consider the broad nature of curatorship in museums and elsewhere.

History as source of pragmatic models

One reason that people need to have their history cared for by curators is that the past is a source of pragmatic or operational models; models for action (Caws, 1978). It has long been known that when individuals act, they do so imitating the actions of individuals who have gone before them. Piaget (1954: 90) calls this 'deferred imitation'. One should not, however, see the imitation of past events as a confining activity. On the contrary, by imitating others, one learns a skill. And this skill can be applied for many purposes. More than this, in defining the nature of any given situation, we are not doomed to use only one limited historical metaphor. On the contrary, we may choose eclectically from among a wide range of model situations. And, indeed, the greater the number of models, the better.

It is true, of course, that an individual will sometimes model himself or herself quite slavishly on particular historical figures, or imagine present events precisely to mirror past ones. One much used source of metaphors for the present have been stories about Hitler. Since 1945, the image of Hitler and his associates has given metaphorical definition to a whole range of political situations, from Margaret Thatcher's unconcern for the poor, through Saddam Hussain's attacks on rich oil sheiks, to the killings in Rwanda. Often this talk has been mere rhetoric. Sometimes it has provided practical models. For example, when Anthony Eden invaded Suez in 1956, he undoubtedly saw President Nasser as a 'dictator' with insatiable 'territorial desires', whom it would be folly to 'appease'.

Much more important than the slavish application of a particular historical metaphor to the present is a more relaxed use of a range of

different models. When used in this way, the past can deepen one's understanding of present events. History in this way provides not naïve model answers to practical problems, but rather food for thought.

Santino (1989) for example, discusses the true stories told by conductors on Pullman trains in the USA. These stories about the past give countless different variations upon the same theme, the interrelationship between the porters and their customers. Santino does not suggest that any one narrative will ever provide a conductor with a simple blueprint for action, enabling him to deal once and for all with his problems with customers. Together, however, the narratives enrich his understanding of his working environment.

The past is not, of course, the only source of models for action. Popular songs, for example, work in an inherently similar way. Here too, the songs unusually provide variations on one theme, in this case, relationships between a man and a woman: 'Stand by your man'; 'You will see a stranger across a crowded room'; 'Zing went the strings of my heart'; 'In my solitude'. The words of any one song may be banal. Taken together, however, such songs, like the stories of history add up to a sort of wisdom. From this wisdom, one can choose for oneself a course of action, even a kind of identity. As Amanda in Noel Coward's *Private Lives* remarks, 'It's strange how potent cheap music can be'.

And, indeed, there is a well-established psychological approach which suggests that the 'scripts' which people employ in their daily lives are given shape not so much by history as by fairy stories. Bettelheim (1977) and Berne (1975) argue, each in rather different ways, that a child constructs important features of his or her identity by identifying with characters in nursery stories.

While historical stories are only one source of such metaphorical models, they are among the most important. 'Cheap music', *Hamlet*, romantic fiction, fairy stories, even soap operas like *Neighbours* may, indeed, be potent in reflecting some present reality. History, however, consists of 'true' stories.

History comes with the seal of having been based upon properly researched evidence. Scholars who have been 'backstage' (Goffman, 1959) during the process of writing know that history involves much interpretation, difference of opinion and even guesswork. Nevertheless, there is an important sense in which a scholarly history is closer to the actual events of the past in a way that *Neighbours* or even *Hamlet* is not. Whereas in fiction, the writer is confined only by imagination, in history, the writer or curator is confined also by the evidence and by the judgement of peers who are familiar with the evidence. This makes history (and other human sciences) a peculiarly valuable resource for deepening the common understanding of the human situation. And it gives to museum curators a special authority which should not be betrayed.

The past as the basis for rights

Another important use for history is as a basis for identity, and for the rights and duties which adhere to identity. These are negotiated between individuals who exercise social control upon each other (Buckley and Kenney, 1995). Here too the past is relevant, for it is in relation to past events that an individual's rights and duties are most frequently defined.

Almost all rights in law, morality and politics are established by past actions. The fact that I own a house or a car depends on the fact that I signed documents and paid sums of money in the past. My property and other rights are deeply involved in past transactions which took place in the past.

The same is true in family life. Family life is rooted in relationships and actions (often marital and sexual ones) which took place in the past. My cousin, for example, is indeed my cousin because of events in the past: my grandfather begat four children; one of whom begat my cousin; another of whom begat me. The core meanings of kinship terms such as 'father', 'mother', 'brother', etc., can only be explained in terms of past events.

Importantly, political rhetoric, demanding rights in the present, usually depends on the stated need to redress past wrongs. There is a whole array of groups whose present claims depend on their having been denied their rights in the past. The political claims, for example of people of African descent and women, arise out of narratives which speak of past discrimination. Other causes arouse less sympathy, but have a similar pattern. German claims to territory in the 1930s, for example, were in part based on their claim to have been unjustly deprived of territory in the past.

I do not suggest that this relationship of present to past is simple. In law courts, in politics and in more informal discourse, there is often dispute about the way things were in the past. And the main reason is that the past can legitimize relationships in the present.

In such disputes, the relative power of the opponents can sometimes be decisive in deciding not only the outcome, but also which version of the past is finally accepted. In her celebrated study of one legal system, that of the Tiv in Nigeria, Bohannan (1952) shows how judges in the courts break their own rules, altering history to suit powerful interests. When Bohannan tried to produce a definitive history of the Tiv which did not allow for such manoeuvring, her efforts were strenuously resisted.

And, indeed, most societies have problems reconciling the existence of powerful people with the principle that law is based on impartially weighing the evidence of what actually happened in the past. One way

out of this difficulty in our own society is for powerful groups to employ expensive procedures and skilled lawyers to ensure that (at crucial moments) a particular historical account favourable to their own cause is upheld.

However, just because the interpretation of history is subject to manipulation, one should not discount its value. On the contrary, since it is the powerful who are most likely to get away with manipulating the past for their own advantage, it is in the interests of the weak to insist that high standards of intellectual probity are maintained. Since evidence is ultimately independent of powerful interests, it provides a source of legal, moral and political legitimacy which ought to be safeguarded. Not least, this is so they may protect the weak against the strong. The past is too valuable to be allowed to become a matter of mere opinion.

Curatorship

Despite the importance of the past in our lives, I shall now suggest that a concern with history is often a minority pursuit. It is not something with which a majority of people are more than occasionally involved. I shall also ask whether this means that the activity of the curator who looks after the documents and artefacts which sustain this past is also of small importance, and whether the seeming public unconcern about the details of history should be reflected in the curator's own attitude.

This, however, misses much of the point about the role of the curator. Curators ought not to expect their public to be deeply interested in what museums preserve and display. On the contrary, the curator's main role is to look after historical and other culture on behalf of people who are not very interested in it.

It is instructive to look at the curators to be found outside of museums. Curators do not exist only in museums. On the contrary, every interest-group, from the largest ethnic and class groupings to the smallest dramatic society or pigeon-fanciers club has its own traditions and history. And these will be looked after by a 'curator' (Buckley and Kenney, 1995).

Most museum people are familiar with such 'curators'. In my own museum, in Northern Ireland, we dub them 'buffs'. There are railway buffs, Titanic buffs, family history buffs, Orange Order buffs and so on. Such people are usually a small minority in their own groupings. Nevertheless, they are crucial to the survival of the distinctive traditions of their enthusiasm and of the people who follow them.

One should not be dismissive of the antiquarianism nor of the partisan perspectives of these 'curators' of popular culture. It is indeed true that popular 'curators' are likely to produce partisan histories.

Such people are centrally interested in collecting histories which celebrate their own favoured activity. But rarely will such people try to distort the facts. As Kenney and I have shown, even the notoriously partial histories of Catholics and Protestants in Ulster usually show a meticulous respect for historical truth (Buckley and Kenney, 1995).

Not everyone, however, in any interest-group is likely to be interested in the group's culture, traditions and history. I know, for example, of a small club in Northern Ireland devoted to the Chinese system of exercise called Tai Chi. Hardly any of the participants in this activity knows much about Tai Chi's history and traditions. Despite this, the history is crucially important to the group. There is a leader who has studied in China and who passes on the historical anecdotes and fictional parables associated with the art. A few others repeat their leader's stories, reading books to learn more. Most members, however, listen contentedly to the titbits they are told, and pick up what they find of interest. One should not assume, however, that the ordinary adherents do not care about the history of Tai Chi. Rather, they are pleased that somebody else, the local curators of the tradition, are looking after it for them.

So too for the museum professional. The general public who come to a museum may not be very interested in history. They may well be looking for a children's entertainment, or for a place to go when it rains. Nevertheless, since they are visiting a museum (and not, say, a cinema) they may well also feel that they deserve to have the real thing, genuine history, well researched and presented in an accessible form. One might well be surprised at the outcry if people began to suspect that museum curators were making it all up. Museum curators look after history and culture on behalf of a population which is not very interested in it. But this, indeed, is why curators are needed.

Concluding remarks

This chapter began by noting that part of the modern enthusiasm for relativism arose out of a tolerant desire not to crush the cultures of the poor and the weak. And it is clear that any attempt to redress the balance of relativistic ideas in museums must not do so at the expense of this highly desirable goal.

In particular, in reasserting the idea that historians and others can judge documents and other evidence realistically, I have not pretended that this removes the need to present a variety of different views. Even the most sophisticated work of history, or the cleverest of exhibitions remains only a representation. It will always be only a partial vision, never the whole truth. Each representation will reveal some aspect of past events, but also hide others.

Historians and museum curators, therefore, resemble the blind men with the elephant. To gain a reasonably accurate picture of the past, they need to ask different individuals about their experience of it. Such a dialogue, however, will be both creative and destructive. For when individuals learn from each other, their old partial visions will give way to new, more complete ones.

An important reason for listening to the other people's views has to do with the fact that individuals and groups claim to 'own' particular versions of history (Harrison, 1992), the history often echoing their present needs. There is an inevitable tendency for museums to reflect the aspirations of the social class to which museum curators themselves belong. Museums also tend to defer to powerful groups in society. To counterbalance this, museums should strive to present different histories, especially those belonging to less powerful social groups (Karp and Levine, 1991).

The argument in this chapter, therefore, has had two features. The main point has been to argue that it is contrary to sound theory and good sense to assert that all versions of history (or any other domain of knowledge) should be treated as equally true. My aim here has been to reassert the idea that it is honourable to try to find the truth in history (as in other disciplines), and that this quest should be central to the activity of a museum curator.

I have also argued, however, that one should not therefore overturn an important insight which arose from the relativistic orthodoxy of the 1960s. This is the idea that one should respect the diversity of opinion that exists. An implication is that museums should continue along the now well-worn path of representing the diversity of different opinions about the past. But one should do this earnestly, not to satisfy the whims of important groups in society, such as 'consumers', but in the hope of enhancing the depth of human understanding.

References

Berlin, B. (1978) 'Ethnobiological classification' in Lloyd, B.B. and Rosch, E. (eds) *Cognition and Classification*, Erlbaum, Hillsdale, 27–48.

Berlin, B. and Kay, P. (1969) *Basic Color Terms*. University of California Press, Berkeley.

Berne, E. (1975) *What Do You Say after You Say Hello?* Corgi, London.

Bettelheim, B. (1977) *The Uses of Enchantment: The Meaning and Importance of Fairy Tales*. Vintage, Toronto.

Billig, M. (1985) 'Prejudice, categorisation and particularisation: from a perceptual to a rhetorical approach' *European Journal of Social Psychology* 15, 79–103.

Bohannan, L. (1952) 'A genealogical charter' *Africa*, 22.

Brown, C.H. (1977) 'Folk-botanical life-forms: their universality and growth' *American Anthropologist* 79, 317–42.

Buckley, A.D. (1985) *Yoruba Medicine*. Clarendon Press, Oxford.

Buckley, A.D. (1989) ' "We're trying to find our identity": uses of history among Ulster Protestants' in Tonkin, E., McDonald, M. and Chapman, M. (eds) *History and Ethnicity*. ASA Monographs 27, Routledge, London.

Buckley, A.D. and Kenney, M.C. (1995) *Negotiating Identity: Rhetoric, Metaphor and Social Drama in Northern Ireland*. Smithsonian series in ethnographic inquiry, Smithsonian Institution Press, Washington.

Caws, P. (1978) 'Operational representational and explanatory models' *American Anthropologist* 76, 1–10.

Collier, G.A., Dorflinger, G.K. Gulick, T.A., Johnson, D.L., McCorkle, C., Meyer, M.A., Wood, D.D. and Yip, L. (1976) 'Further evidence for universal color categories' *Language* 52, 884–90.

Coward, Noël (1947) *Private Lives: An Intimate Comedy*. French, London.

Dixon, K. (1977) 'Is cultural relativism self-refuting?' *British Journal of Sociology* 28, 75–87.

Feyerabend, P. (1975) *Against Method: Outline of an Anarchistic Theory of Knowledge*. New Left Books, London.

Goffman, E. (1959) *The Presentation of Self in Everyday Life*. Doubleday, Anchor, Garden City, New York.

Harrison, S. (1992) 'Ritual as intellectual property', *Man* (NS) 27, 225–44.

Karp, I. and Levine, S.D. (1991) 'Introduction: museums and multiculturalism' in Karp, I. and Levine, S.D. (eds) *The Poetics and Politics of Museum Display*, Smithsonian Institution Press, Washington, 1–9.

Kuhn, T.S. (1962) *The Structure of Scientific Revolutions*. University of Chicago Press, Chicago.

Lowenthal, D. (1993) *The Past is Another Country*. Cambridge University Press, Cambridge.

Malinowski, B. (1963) 'The foundation of faith and morals' in his *Sex Culture and Myth*. Rupert Hart Davis, London.

Orwell, G. (1954) *Nineteen Eighty-Four*. Penguin, Harmondsworth. (First published 1948).

Piaget, J. (1954) 'Language and thought from the genetic point of view' *Acta Psychologica* 10, 88–98.

Rosch, E. (1972) 'Universals in color naming and memory' *Journal of Experimental Psychology* 93, 10–20.

Rosch, E. (1977a) 'Linguistic relativity' in Johnson-Laird, P.N. and Wason, P.C. *Thinking: Readings in Cognitive Science*. Cambridge University Press, Cambridge, 501–19.

Rosch, E. (1977b) 'Classification of real world objects: origins and representations in cognition' in Johnson-Laird, P.N. and Wason, P.C. *Thinking: Readings in Cognitive Science*. Cambridge University Press, Cambridge, 212–22.

Rosch, E. (1978) 'Principles of categorisation' in Lloyd, B.B. and Rosch, E. *Cognition and Classification*, Erlbaum, Hillsdale, 27–48.

Rosch, E., Marvis, C.B., Gray, J., Johnson, D. and Boyes-Braem, P. (1976) 'Basic objects in natural categories' *Cognitive Psychology* 8, 382–439.

Santino, J. (1989) *Miles of Smiles, Years of Struggle: Stories of Black Pullman Porters*. University of Illinois Press, Chicago.

Stein, H.F. (1986) 'Cultural relativism as the central organising resistance in cultural anthropology' *Journal of Psychoanalytic Anthropology* 9, 157–75.

Watson, J.D. (1970) *The Double Helix: A Personal Account of the Discovery of the Structure of DNA*. Penguin, Harmondsworth.

Whorf, B.L. (1941) 'The relation of habitual thought and behaviour to language' in Spier, L. (ed.) *Language Culture and Personality: Essays in Memory of Edward Sapir*. University of Utah Press, Salt Lake City.

Woolgar, S. (1983) 'Irony in the social study of science' in Knorr-Cetina, K.D. and Mulkay, M. (eds) *Science Observed: Perceptions on the Social Study of Science*. Sage, London.

Woolgar, S. and Pawluch, D. (1985a) 'Ontological gerrymandering: the anatomy of social problems explanations' *Social Problems* 32, 214–27.

Woolgar, S. and Pawluch, D. (1985b) 'How shall we move beyond constructivism?' *Social Problems* 33, 159–62.

5

Trying to Be an Honest Woman: Making Women's Histories

Elizabeth Carnegie

> Those who have the power to make the symbols and their meanings are in a privileged and highly advantageous position. They have, at least, the potential to order the world to suit their own ends, the potential to construct a language in which they are the central figures. (Dale Spender, *Man Made Language*)

The realities of male power in society is so dominant that museum professionals, regardless of gender, contribute to that notion with every judgement and with every decision on how and what to display. The question therefore becomes not just 'who am I doing this exhibition for and what is it about?' but also 'who am I?' and 'what is my role in redefining and creating symbols and interpretations of objects which use that power, that potential, to promote the interests of all?'

The act of collecting and interpreting women's history is subject to an acceptance that 'history is a discourse about, but categorically different from, the past' and that 'the past has occurred. It is gone and can be only brought back again by historians in very different media, for example in books ... etc., not as actual events' (Jenkins, 1991: 6). The challenge, then, is to establish the rights of women to share in that past in such a way as to reinforce their stake in the present. Collecting, displaying and communicating women's history means creating new histories (and therefore symbols) from existing collections and working with people to collect and interpret new objects.

To understand how museums present women, it is first necessary to consider the role of women as staff. Although they make up a large part of the workforce at low and middle-management levels, usually higher management and the directorate are men (Shaw, 1989). Indeed, the influence of a male hierarchy can be cited as a reason why displays feature women in a particular way or else exclude them altogether

54

(Porter, 1988). Yet, the reality goes deeper than gender and the personal fears or prejudices of the people at the top. It also encompasses cultural expectations, the nature of the collections and long-held assumptions about the meaning of objects.

Elspeth King in collecting women's suffrage, temperance and peace movement material for the People's Palace in Glasgow highlighted how the gender of the curator can greatly influence the nature and range of collections: 'Scotland has a surfeit of military museums glorifying war and the plunder of Empire and bristling with regimental uniforms, silver and medals. My own museum, until the 1950s when the first woman curator was appointed, was of this nature' (King, 1985: 6). Viewed in this way the histories of museum buildings, staff and collections are as relevant as the histories in the displays.

Gender is more pervasive and more obviously distinctive than other defining factors, yet people rarely define or align in these terms. Indeed, it is wrong to assume that there can be an unproblematic unity between women, simply because they are women. Cultural, class and race differences can and do create divisions. Making women's history means accepting that there is more than one history and hence no single truth.

Many women visit museums and may make up the majority of the visitors. Certainly, this seems true for art galleries and National Trust type properties (Higonnet, 1994: 257). The visitor profile for Pollock House museum in Glasgow shows that over 60 per cent of visitors are women of pensionable age. Women, with or without children, will feel comfortable within museums and galleries where they see themselves reflected not just within the displays, but crucially in the faces of the security and front of house staff where more women are now employed. In Glasgow Museums under the Museum Assistants scheme 40 per cent of these posts are held by women. Prior to 1990, most of the security staff were male. In 1985 there were no women attendants in Edinburgh City Museums. In 1995 they make up one-third of the security workforce. The aim of the Equal Opportunities Working Group has been to raise the number of women in security posts to 50 per cent as part of the Target Action Plan. Helen Clark, Edinburgh City Museums' representative on the group, has pointed out that this target arose as a direct result of letters written to the council complaining that women, and Asian women in particular, did not visit museums because they were put off by the sight of a uniformed man at the door. A visitor's response at the Art Gallery of Ontario sums up this need to see ourselves reflected in displays 'I would not bring my child here because we are not represented ... I am a black woman who is Canadian (born)' (Worts, 1994: 173).

Museums risk excluding a part of the public, who would be natural

and regular users, if they do not provide a comfortable visitor experience. In particular, women with small children need to feel welcome in museums. Yet, museum buildings are not always user-friendly nor child-proof.

So, if museums cannot get the environment right, what is the point of having good women-related displays? At the most basic level, few museums ever manage to provide enough seats, toilets or places to park buggies. Improvements can be easily made, as is shown in the Scandinavian countries and the USA where, compared to the UK, women's and children's rights are more firmly established (Higonnet, 1994). Stockholm City Museum, for example, even considers the needs of mothers outside of the museum and runs guided pram-walks around the city.

Concern for personal safety determines and constricts women's lives. Interestingly, museums and particularly art galleries or National Trust properties provide a safe place for women to go alone or to meet friends. Recent informal market research work undertaken on behalf of the Gallery of Modern Art opening in Glasgow in March 1996, suggested that women would visit the gallery, even if they did not much care for the subject-matter. Men who did not like art said they could not go (Carnegie, 1995).

Giving women access to collections helps to reinforce the ideas of public ownership of museum objects and a number of projects have aimed to do just this. The Open Museum in Glasgow, set up to increase public access to the collections held in the city's museums and art galleries, regularly works with women's groups. Recent work has included the involvement of schoolgirls from the Gorbals (an area of the city) and, as with many of their projects, it has resulted in the pro-duction of an exhibition taken out into community centres in the belief that some women may be unable or unwilling to come into the museum. Another example of how museums can work positively and construc-tively with women was an exhibition entitled Women's Pictures at Paisley Museum. This was curated by Jane Kidd, who invited groups of local women into the stores to choose the works and give their own thoughts on them for the labels (Carnegie, 1992). In ways such as these, women can be active participants in museum processes and with this comes empowerment. Such projects have dealt particularly with working-class women who in many other respects have very little power. The projects of the Open Museum and others acting in this area often use oral history, which in its way quite literally gives women a voice and encourages opinion. Significantly, working with women's groups means being prepared to relinquish some curatorial control and this inevitably shapes the final project.

Almost every object can be interpreted in a way that includes women.

Even if the point is that it was something not used by women or they were forbidden access to its true meaning, as in Masonic or secret society material, there is still something to be said. In effect, sometimes women can be included by highlighting their exclusions. This approach, though not ideal, was necessary in the St Mungo Museum of Religious Life and Art in Glasgow: for example, within the Jewish faith, women do not carry the Torah. There is no law which forbids women from handling the Torah as such. Rabbi Greenburg (in interview) states that women have been relieved of the task of praying at set times as this might conflict with their domestic role within Judaism. Women do not take an active leading part in the Orthodox service, though they do attend as worshippers.

Gender roles in relationship to the objects need to be made explicit. A particular view of women's history is offered in the traditional displays of costume, tapestries and samplers which many museums hold. Although aimed at women visitors, these tell little of the lives of the women who made or used them. Other approaches are required, for example costume displays might raise issues to do with fashion, economics, gender and class (did a woman make this for another woman's use?) They can also consider the role of traditional female skills in modern society. Embroidery and women's crafts have retained their popularity despite the fact that these skills are no longer viewed as part of women's heritage handed down from mother to daughter and have proved difficult to reconcile with feminism and class attitudes.

For the exhibition 'Keeping Glasgow in Stitches' 12 banners were created during 1990 by the NeedleWorks for Glasgow Museums project. This involved over 600 people of all ages and abilities. During 1995, women grieving for loved ones lost through drug abuse, participated in a quilt-making project in Glasgow and found the act of creating the quilt brought a real release for trapped feelings, with the resulting hope that the quilt itself could be a symbol with the potential for change.

> There was one woman for whom her grief was very fresh. She had lost her brother who had had a tattoo of a little red devil on his arm. She spent the whole week looking through the shops to find a little red devil toy. She had planned her square in her mind even to the point of having brought black satin to back it. We stuck the toy on to the quilt in such a rush of activity that her whole square was finished in 40 minutes. (Interview with Janie Andrews, 1995: 12)

In the project 'The Ribbon: A Celebration of Life', co-organized by Justine Merritt and Marianne Philbin for the Peace Museum, Chicago, thousands of women from all over the USA worked to create a banner for world peace which was tied round the Pentagon on 4 August 1985.

Each banner illustrated the theme, 'what I cannot bear to think of as lost forever in nuclear war' (Philbin, 1985). This was Justine Merritt's view:

> When I was making my own Ribbon Panel, I found that as I would thread my needle, I was confronting the fear, confronting the grief and terror. As I drew the needle up through the cloth, I was praying for peace, and the prayer became an affirmation of life. The very task of creating the panel helped empower me to face the reality of living in a Nuclear Age. (Philbin, 1985: 12)

The very simple act of threading the needle took on a moving significance and the resulting banner embodies her feeling of fear, love and hope. Involvement in the Ribbon Project allowed women to use skills particular to their gender and was something in which older people could participate. Elizabeth Morgan from South Wellfleet, Massachusetts, commented

> I am 63 and am extremely emotional about the current world situation and the prospects of a future for the coming generations. I've not got the energy for marching anymore, so this was a way for me to add my voice to pleas for peace with all the peoples of the world. (Philbin, 1985: 45)

At Aston Hall in Birmingham, the Women's Textile Group, was established to 'use the craft of embroidery as a tool to integrate Asian women and at the same time preserve their art tradition within our system' (reported by Viegas in an unpublished working brief, 1992). In this way, women were able to use or learn a skill no longer necessary to their lives but which was crucial to their understanding of their own culture and, in turn, an important means of self-expression.

Such projects do more than just provide a permanent record of community involvement. They can help to create a modern artefact to interpret the past, without attempting to re-create it. Visitors to the exhibition, 'Women: Mothers, Workers, Politicians 1910–1920' at Birmingham City Museum and Art Gallery, were invited to help create a banner in the present to help fill the gaps where the original objects, especially relating to female suffrage, had failed to survive. Survival of women's material is a point made by Jette Sandahl (1992), founder of the Women's Museum, Denmark: 'apart from perpetuating our species, women have left few material traces. The labour of women most often has produced perishable goods'.

It is also true to say that many things produced by men have long since perished as well, but the intrinsically perishable nature of women's products make it doubly hard to interpret women's history.

Not only are the women themselves perceived as invisible, but there is little material evidence of their existence. Collections have been developed to perpetuate that which will last, or those things for which significance has been assumed. So in many instances, history curators have to interpret what literally is not there. In an exhibition entitled 'Mining the Museum' at Maryland History Society, the artist, Fred Wilson's provocative approach was to show empty pedestals, one labelled Harriet Tubman, as a way of reclaiming the invisible lives of Maryland African Americans (Wilson, 1995).

Most exhibitions involving women's history tend to focus on a particular aspect or activity drawn from a group of defining categories, such as work or home life. Yet there is a need not to look for women's history in the wrong place or to accept material which is out of touch with their lives and experiences. In a recent exhibition on the artist Stanley Spencer and the Clyde shipyards during the Second World War, women seemed to be under-represented in his paintings and drawings but, given the relatively small number of women who actually worked building ships at this time, the level of representation may well have been fair. From this exhibition, visitors could be left with impressions of a few remarkable women, rather than the many equally remarkable women who worked in the administration of the shipyards.

Traditional exhibitions which are making general points on, for example, work cannot always be expected to deal fully with women's history, especially if the industry has historically been male dominated. There is however a most persuasive argument for a separate approach, an alternative view. 'Not Just Tea and Sandwiches', Edinburgh City Council's exhibition on women's contribution to the 1985 miner's strike, put their role centre stage. In an exhibition just on the miners or the history of mining, the women might have been relegated as a side issue.

Often women become remarkable because they have succeeded in a man's world in a male way, yet they can rarely shed their perceived roles as women. Museums reinforce this by splitting domestic and working life categories, as if they were mutually exclusive. Links need to be made between the two. Indeed, this might ensure that unpaid housework and voluntary work gain credence *as work*. Further, there is a tendency to show only the positive aspects of women's lives and to deny the contradictory or problematic. Credit must be given to Croydon museum for both highlighting Marie Stopes's pioneering work and acknowledging that she was a proponent of eugenics. How are we to present the history of, for example, child abuse without stating that increasing numbers of women are being charged with abuse? This is especially difficult as it challenges the concept of male power which allows women to be victims. As difficult as it might seem, the conclusion

must be reached that true equality can only be arrived at when we are able to approach women's history in an honest way, warts and all.

While it is obviously desirable to include women within mainstream exhibitions, some aspects of women's history such as birth, health and sexuality remain invisible, for reasons associated with power, cultural squeamishness, privacy and shame. Artist Ghislain Howard spent four months in St Mary's Hospital Manchester recording her response to birth, motivated by an awareness that part of her own history was missing. She noted that despite having had two children she herself had not witnessed these events:

> This residency has allowed me to recapture something of my own history. It has occurred to me on more than one occasion that, above all it has been my gender that has allowed me access to the scenes interpreted here and I feel privileged that as a woman, I have been able to make visible what previously has been to some degree, invisible. (Howard, 1993)

In the Women's Museum in Arhus, Denmark, an exhibition on birth, encouraged visitors to view the process of birthing through the eyes of the woman giving birth. This meant looking down at the swollen stomach, as if it were your own. This was particularly important if it is considered that the act of birth can actually exclude the mother from the process.

Birth is the uniting factor for the majority of women, yet it has become increasingly defined in terms of male technology, rather than celebrated as an act of creation, despite the fact that most cultures have women as the centre of their creation myths. Many museums hold goddess figures from antiquity and there are many paintings of women as mothers, notably of the Virgin Mary in Western culture, although these images tend to be post-birth and are usually by men.

For the exhibition 'From Here to Maternity', Glasgow Museums funded an artist's residency in a maternity hospital and in creating the exhibition freely mixed media, discipline and period, drawing on all the Glasgow Museums collections to interpret pregnancy and birth. The scope of the exhibition embraced ideas from early goddess worship to the attitudes to and experiences of mothers, partners and professional carers. The objects were hard, masculine and brutal, like forceps, or perishable and personal, like a nut charm held for luck during the birth. Most museum exhibition designs tend to be based on masculine angles rather than feminine curves. For this exhibition, the designer Janie Andrews created shaped cores painted in flesh tones which suggested the female body. The hard objects were shown against soft-looking forms in an effort to challenge the idea that display space and materials are neutral.

Some of the objects surrounding birth have not survived because of taboos. Although Queen Margaret (c. 1045–93) is said to have kept a sark, that is a chemise, which she wore during the birth of her children and this was later worn by Mary of Guise when she gave birth to Mary Queen of Scots at the Royal Palace of Linlithgow in 1542, most women would not have kept items bloodied and therefore rendered base. In many cultures women are considered unclean and contaminating for some time after birth, as indeed they are often thought to be during menstruation, and are usually kept apart from ordinary society (men). Oral history collecting for Glasgow's People's Palace Museum display on puberty revealed that sex education and the onset of puberty invariably meant teaching girls to hide and conceal their womanhood:

> When you got your periods you thought something had happened to you and you got handed two pieces of cloth and some tape to put on. When it gets full you had to wash it out and make sure your brothers and sisters weren't about when you were doing this. (Interview with Mary, 1994)

> To Collette it was always her wee flower. Now I am trying to explain it is her private parts because I am trying to put it across that it's just hers and no one else to touch and see. I always tell her to hide her private bits and change in a private place. You have to try and say it all nice. (Interview with Marie, 1994)

These two quotes span over 70 years and show how in talking about these subjects women present a private side of themselves which they have always been taught to keep hidden, sometimes for reasons of personal safety and sexual discretion.

The People's Palace display 'Mister and Missus' looks at gender relationships and highlights domestic violence, another 'invisible' activity. Wolf (1990: 153) sums up the relationship between gender relationships and safety:

> When novelist Margaret Atwood asked women what they feared most from men, they replied 'We're afraid they will kill us.' When she asked men the same question about women they replied, 'We're afraid they'll laugh at us.' When men control women's sexuality, they are safe from sexual evaluation.

Domestic displays tend to show wedding photographs and clothes which tell the story of a day, not a marriage and can be more about power and accepted rules of behaviour. Shame and embarrassment can stop people from admitting they are victims of domestic violence and clearly museums must be sensitive to how women wish this to be depicted, if at all. Having interviewed two old women one of whom was in her nineties,

it became clear that they felt pleased that the museum was to treat this subject seriously and therefore reinforce the idea that domestic violence was a crime and they were relieved to feel free to talk about what for them had become a painful secret.

Two objects in this exhibition, a poster from the Zero Tolerance campaign against domestic violence and a cartoon from 1888 showing a husband and wife fighting, are rendered more powerful when shown alongside quotes like this:

> I had 47 years in fear. If I had a headache it didn't make any difference to him. You still had to have intercourse. The only time I had freedom from him was when he died in 1973 for I had to be in the house for him to get his dinner and he would have intercourse at odd times. (Mary, 1994)

Mary's words shows that the fear of sexual and physical abuse, and the entrapped feeling of having to be in the house, renders the environment of the home as unsafe for some women as the street. To highlight the relationship between home and street in terms of women's safety, a leaflet proclaiming a woman's march in the streets of the South side of Glasgow in protest against a recent spate of sex-linked attacks on women was collected for display.

Sensitive subjects need to have the backing and support of the women whose history and indeed present are being presented. The need to participate in the production of history was the motivation that inspired ex-prostitute Nickie Roberts to write her book *Whores in History*.

> Everything I had read about prostitution and prostitutes appeared to be written by men – the client class ... Women are the real experts about our own lives – after all, we live them. With this in mind and with the encouragement of some whore and ex-whore friends, I therefore decided to search out that most hidden history of all; the history of the Bad Girls. (1992: xi–xii)

It is interesting to note that Roberts concluded that feminism had failed the prostitute, a reminder again that gender is no guarantee of empathy. Her book traces a link between goddess worship as attributed to the 'Venus of Willendorf' to the modern street 'whore' a word which she is trying to reclaim, choosing not to be silenced by censure. Equally, Jo Spence in documenting her own breast cancer was not only breaking the taboos surrounding women's illness, but was finding a way to stay in control of her body and her life: 'documentary photographs were taken from the patient's point of view, and this in itself was therapeutic, enabling me to concentrate on what was happening to me in a different way from lying passively in bed' (Spence, 1986: 158).

When dealing with women's rights museums need to be aware of cultural position and partiality. Amnesty International (1995) points out that women are particularly vulnerable world-wide: 'Despite moves to encourage legal and political equality for women, discrimination on grounds of gender is an international reality. As a result, women are more likely to become victims of human rights violations'.

To fail to highlight past and present abuse is to appear to condone it. But trying to interpret the symbolic objects from outside one's own culture, has its difficulties, however well-meaning the approach might be. A photograph of a young girl undergoing clitoridotomy (genital mutilation) in a section called 'Coming of Age' within the St Mungo Museum of Religious Life and Art brought a strong response from visitors, to the extent that a group representing a local feminist magazine, *Harpies and Quines*, picketed the museum, in an attempt to persuade us to take the picture down. This was declined on the grounds that, as female circumcision was banned by the World Health Organization, it was necessary for the museum to highlight the fact that this practice was done in the name of religion, if not a direct tenet of a particular faith. The Islamic community were equally upset by the photograph which, as it was from Cairo, suggested that the girl was a Moslem. In the end, the label was lengthened, but the photograph remained on display.

Over 60 per cent of people interviewed as part of the community consultation for the St Mungo Museum were women. This number, though not contrived, was in fact deemed representative of women's involvement in religious activity, historically one of the few legitimate reasons for women to leave their homes. The intention was to challenge cultural, racial and sexual stereotypes by interviewing, for example, young Moslem women on their role and identity within Islam. A passport-sized photograph of each speaker was shown alongside their words. The intention was to empower women, but this backfired as early as the opening night, when elders from the central mosque requested that we take the women's pictures out of the display pertaining solely to Islam, on the grounds that as the women's faces were not fully covered, they were improperly dressed. It was also considered generally inappropriate to have women's faces (covered or not) in the case at all. The decision was therefore taken to remove all personal photographs of men and women.

The experience with the St Mungo Museum taught that the act of collecting and interpreting women's culture and belief comes best (though not exclusively) from people working within that culture and gender. Yet this is only one defining factor. Inevitably, displays will reflect not just the personalities, ambition and drive of the individuals involved and the particular remit of the organization, but also the

thinking of the times. Such displays, regardless of approach, over the longer term will become dated and, as a result, no longer accurate. They can eventually be seen as unhelpful or even offensive.

Currently, feminism borne of the trade union and radical socialist movements of the 1960s and 1970s, which inspired much collecting of politically edged material, is being replaced by the emergence of a more holistic approach in keeping with the current political climate. Curators must hope for a sympathetic environment in which to tackle issue-based work. In the case of interpreting women's history, every museum has objects which were used, made, bought by or depict women which can be interpreted in ways which allow honest and fair appraisals of women's roles in society. Museums need to create a policy to promote women's history which can be applied to all museum activities and staffing levels. Nearly every museum has its own histories of women's activity. Perhaps we should start by looking at those histories, and therefore at ourselves, and acknowledge and grasp that privileged position. This needs to be done so that museums can move forward through creating new histories and new dialogues for the twenty-first century.

Interviews

Janie Andrews, artist and designer.
Helen Clark, Keeper of Social History, Edinburgh City Museums.
Women interviewed for the People's Palace redisplay.
Rabbi Greenburg.

References

Amnesty International (1995) *Women's Rights, Human Rights: Campaign Journal for Amnesty International, British Section*, May/June. Human Rights, London.

Carnegie, E. (1992) 'Women's pictures' *Scottish Museum News*, Spring, 8–9.

Carnegie, E. (1995) Unpublished research for the Gallery of Modern Art.

Higonnet, A. (1994) 'A new center: the National Museum of Women in the Arts' in Sherman, D. and Rogoff, I. (eds) *Museum Culture: Histories, Discourses, Spectacles*. Routledge, London.

Howard (1993) *A Shared Experience: Paintings and Drawings by Ghislain Howard*. Manchester City Art Galleries, Manchester.

Jenkins, K. (1991) *Re-Thinking History*. Routledge, London.

King, E. (1985) 'The cream of the dross; collecting Glasgow's present for the future' *Social History Group Journal* 13, 4–11.

Philbin, M. (ed.) (1985) *The Ribbon: a Celebration of Life*. Lark Books, Ashville, NC.

Porter, G. (1988) 'Putting our house in order: representations of women and domestic life' in Lumley, R. (ed.) *The Museum Time Machine*, Routledge, London, 102–27.

Roberts, N. (1992) *Whores in History*. HarperCollins, London.

Sandahl, J. (1992) *Women's Museum in Denmark*, (leaflet).

Shaw, P. (1989) 'The state of pay' *Museums Journal*, July, 26–28.

Spence, J. (1986) *Putting Myself in the Picture*. Camden Press, London.

Spender, D. (1985) *Man Made Language*. Routledge and Kegan Paul, London.

Wilson, F. (1995) 'Silent Messages' *Museum Journal*, May, 27–29.

Wolf, N. (1990) *The Beauty Myth*. Vintage, London.

Worts, D. (1994) 'Extending the frame: forging a new partnership with the public' *Art in Museums: New Research in Museum Studies*. Athlone Press, London.

6

Making Family Histories in the National Portrait Gallery, Australia

Julia Clark

The National Portrait Gallery is one of Australia's newest cultural institutions. In August 1993 the National Library of Australia was asked by the Federal Government to undertake its management and development in Old Parliament House in Canberra. The library's vision for the gallery was of a place which would serve as a focus for debates about the nation's cultural identity, and which would recognize contributions to national development in the broadest and most inclusive way. The exhibition policy adopted by the library's council in 1994 acknowledges that

> portraiture is more complex and varied than simply the representation of distinguished subjects through the traditional media of oil painting or photography. A National Portrait Gallery developed in Australia might serve a broader and more democratic purpose, namely to reflect the life and work of the widest cross-section of Australians. (National Library, 1994)

While recognizing 'that the primary emphasis of the National Portrait Gallery should be on portraits of a high quality or of critical historic interest and importance and that a strong emphasis should be placed upon Australians of high standing and achievement' the council also endorsed the presentation of 'portraits of lesser known Australians whose achievements may have been overlooked or forgotten, and ... generic or representative portraits (which) can offer ... a more democratic and egalitarian orientation which will have a strong appeal in the Australian context'. The council supported a thematic approach to exhibition development, in which each exhibition is constructed around a linking narrative or common issue, rather than simply presenting 'a changing program of selected portraits of well known

Australians, [which the Library believed would lack] a critical focus and would quickly become stale and predictable'.

At the opening of the first exhibition in March 1994 the Prime Minister the Hon. Paul Keating MP endorsed that vision, commending the initiative as one that would represent the experience of all Australians, 'all the hopeful, brave, despairing, anxious, lofty and lowly males and females of any and every ethnic origin whose portraits were ever rendered by any means on this continent'. Mr Keating went on to say

> It will be better if it is not dominated by governors and eminent Victorians ... [or if it is not] a gallery with an exclusive emphasis on high achievers. It will be better, I think, if it is a much broader gallery of our national life ... intrinsically and inescapably democratic, like the country itself.

He saw it as

> exciting an interest in our history and society, [or encouraging us] to learn the story of Australia, and to better understand the stories of our fellow Australians. It might help us to understand what it is to be Australian ... [and] it might induce us to recognise the enormous contribution made to Australia by our artists.

The National Portrait Gallery occupies a series of small galleries in Old Parliament House. We have set ourselves a gruelling programme of exhibitions which will change every four months. Each exhibition will be largely composed of loans from other national collecting institutions and from private owners, as well as from the collections of the National Library.

In keeping with the thematic approach supported by the Council of the National Library and to establish ourselves as significant players in debate on issues of national importance during the International Year of the Family, for our second exhibition we chose to focus on families in Australia through portraiture. Rather than attempting an exhaustive history of the notion of family in Australia, which was not possible given a four-month development period, we set out to raise some issues which we felt were important and overdue for consideration. We also wanted to celebrate diversity of experience and achievement, forged in the crucible of the family. In our own family albums we memorialize our family history and achievements. This exhibition was in a sense a family album for the nation, in which well-known families could speak to others of the trials and joys of family life. Their successes, failures, conflicts and tragedies are familiar despite the fact that, as Dame Edna Everage

(Housewife Superstar) reminds us, they're famous and we're not. We all share some experience of family.

The exhibition used a wide range of media and covered the period 1788–1995, which a glance at traditional and post-contact family life and structures in Aboriginal culture. Some subjects were well-known, others obscure or unknown, but all seemed to speak to us in significant ways about our understanding and experience of 'family'. Through extended labels we raised questions about the nature and history of the concept of 'family', about 'traditional' family values, about gendered roles within the family, about differences and change across space, culture and time. The portraits were selected to represent aspects of those questions, and the family experience of each subject or set of subjects explicated what we saw as key moments and ideas in our historical experience of 'family'.

We sought a definition of family which would be inclusive and value-neutral, rather than prescriptive and exclusive. We wanted to avoid the narrow structural definition promoted by the political right wing, and opted instead for a functional definition, based on the question 'What is a family for'? The transmission of property and perpetuation of the male family name spring to mind, but fundamentally we felt that a broad social definition to serve our purposes was 'a group of people who live together for at least some of their lives, and who love and care for one another'. This definition seemed more in accord with the trends which we believed could be discerned within contemporary society than the current conventional (but not traditional!) definition of 'a man, his wife and their children'. This meant that many people who otherwise are generally excluded from discussions on family, such as the nun Mother Mary John Cahill (1793–1864) painted by the convict artist William Paul Dowling (c. 1824–75), can be included on the basis of the familial reality of their emotional and social lives. Like very many men and women in the nineteenth century, a religious order and the community it served filled the role of family. Mother Mary John Cahill's chosen family was her Catholic sisterhood and her orphan pupils.

We opened with photographs of desert Aboriginal families taken by the anthropologist Baldwin Spencer (1860–1929) in 1896 and 1901; a missionized group of Tasmanian Aboriginal people taken by Bishop Nixon (1803–79) in 1858; and a bark painting of ancestral Wandjina figures by Charlie Numbulmoore (c. 1907–71). According to three groups of Aboriginal people in the central Kimberly area of northern Western Australia, the Wandjina are responsible for the reproduction of life. The Wandjina are described as the 'real fathers' of their people; their human fathers found them in water but the Wandjina put the spirits into the water. The extended family structure of desert Aboriginal people, and the division of living arrangements into men's

and women's camps for much of the annual round, attest to the marked cultural differences between traditional Aboriginal culture and that of the Anglo-Celtic mainstream.

For later generations of Aboriginal people 'family' embraces a large group of both immediate and extended relations, some of whom are only tenuously related in a European sense. Family responsibilities of caring and support are owed to all those relations. The group is considered more important than any individual in it, and co-operation rather than competition sets the tone of family relationships. The portrait of 'Mum Shirl' (b. 1921), social activist and prison reformer, shows her surrounded by some of the more than 60 children she raised. Shirley Smith earned her nickname, 'Mum Shirl' from her prison visits. When quizzed as to her relationship with a young inmate she would invariably respond 'I'm his mum'. Although a convenient fib in a sense, in another sense it was an expression of Aboriginal notions of family, in which all women are 'mother' to all those in their children's generation. It was also an expression of the kind of relationship which she knew those young men needed, and which she offered to them.

In the face of this kind of broad definition of 'family', the inevitability of mutual cultural misunderstanding, and the violence done to Aboriginal society by colonialist forced adherence to the 'norms' of the Anglo mainstream are obvious. Deviance from these 'norms' does not of course belong exclusively to Aboriginal people. One of the main purposes of the exhibition was to investigate the 'tradition' behind 'traditional family values'; where do these values come from, how long and how widely shared is this tradition?

Australia's 'first family' in a sense is that of Governor Philip Gidley King (1758–1808), whose wife Anna Josepha (1765–1844) was the first Governor's wife to join her husband in the infant colony. This family displayed traits which were certainly very common in their day, but equally certainly would not be promoted by today's political right as a model of family relationships. Before his marriage, like many men of his class and time, Governor King had taken a convict mistress. He and Anne Innett had two sons. Although he abandoned her and later married his cousin, unusually King took responsibility for his illegitimate sons' education and career, publicly acknowledged them, and Anna Josepha King took some maternal interest in the boys. They do not however appear in the family portrait, painted by Robert Dighton (1752–1814) in 1799, which shows a happy nuclear family unit of Anna Josepha and Philip King with their legitimate children.

Even a family which conformed to today's model nuclear family could fail the test of respectability in colonial society. In the closets of the Wentworth and the Piper families lurked the skeletons of shameful convict ancestry which, despite both free-born families' wealth,

education and taste, inevitably blighted their social aspirations. Sarah Wentworth and Ann Piper were additionally damned since they each bore several children out of wedlock. Despite this parade of outraged morality by the guardians of social standards, one in five women in the colony was pregnant when she married, including many so-called 'respectable' women such as Elizabeth Macarthur.

The Wentworth and Piper portraits, painted by notable artists, are big and luscious, and bear eloquent witness to their wealth; attempting to establish social status, they conceal social ostracism and opprobrium. By commissioning Augustus Earle (1793–1838) to paint his family and himself Captain Piper (1773–1861) sought, unsuccessfully, to establish himself among the other 'exclusives' to whom Earle acted as court painter. Such deliberate visual deceits serve to warn us that portraits must always be read with caution, as much for what they seek to conceal as for what they reveal.

What role did women play in colonial society? Did they also conform to today's conservative model of 'angel of the hearth', and did the public sphere belong to men alone? To use their portraits alone as documentary evidence would confirm this view. Women are invariably depicted in a domestic environment, festooned with children, wearing house gowns which are often sumptuous and liberally adorned with lace and jewellery. In fact, women in this period played many different public roles which attracted no surprise or criticism. Anna Josepha King took an active role in her husband's public affairs and founded and managed a school for poor and orphan girls. Mrs Margaret Moore Smail (1826–70) was painted, with her two young children, by Joseph Backler (c. 1813–95) in 1858 as half of a pair of portraits, the other being a solo portrait of her husband. As well as her role of wife and mother however she was an active partner in the family provisioning and bakery business. Perhaps if photography had been available we might have seen her in the shop or working over the accounts.

The mother who works outside the home is thus clearly not a recent phenomenon, but was very much part of nineteenth-century society until the 1880s. Only then did the notion of 'separate spheres' for men and women become the powerful idea which is now regarded by conservatives as a key component of 'traditional family values'. Even then, it was probably only ever a middle-class ideal. Woman's place was to be in the home. There she was to exert a morally uplifting influence on her family. She was seen as a weak, dependent creature, requiring masculine protection from the rigours of public life – an arena belonging exclusively to man.

But for the poor, the labour of women and children has always been essential for family survival. Two publicity photographs of child circus stars, May Wirth (1875–1978) and Mary Sole (1892–1975), show the

girls in their working clothes. The need to advertise has overridden the imperative to pretend to notions of middle-class respectability which other studio photographs of the girls endorse. In these portraits their tough, muscular little bodies are swathed in yards of feminine fabric, their hair floating in soft wisps around face and neck.

Once the notion of separate spheres had been internalized by the middle classes, many women were denied an independent career outside the home. Catherine Mackerras (1899–1977), broadly educated, formidably intelligent, quick witted and well travelled, poured her considerable energies into raising her family. After a rigorously intellectual and musical upbringing all of the six Mackerras children excelled in the arts, humanities, education and science. The family photograph shows Catherine Mackerras sitting triumphant in the centre of her extraordinary adult brood, radiating satisfaction and pride. Her autobiography reveals the price that this intellectually precocious and ambitious young woman paid for that satisfaction, no less than the sacrifice of her own talent.

This was too high a price for Nora Heysen (b. 1911), daughter of the famous painter Hans Heysen (1877–1968). She had seen her talented mother Selma sublimate her own potential artistic career in the raising of her family and the furtherance of her husband's career. Nora's father encouraged her artistic ambition. In her self-portrait of 1932 she painted her new-found independence; she wears the brown velvet coat that she bought with the proceeds of her first sale, when she began to believe she really could be an artist. She holds the palette which as a child she had been given as encouragement by Dame Nellie Melba, a generous patron of emerging artists and frequent visitor to the Heysen home. She still paints with that palette today. In the next picture she has painted romance and family, in the pensive yet passionate face of her young husband Dr Robert Black (1917–1988). They met during the war in New Guinea, where she was Australia's first woman war artist. In marriage however she found herself unable to continue her creative life, which was her obsession. After 19 years her marriage broke down, and she resumed her life as an artist. She never remarried.

Few women in the early twentieth century are memorialized for public achievement. Most appear in family snaps or in portraits for private consumption as mothers, wives, sisters. Hugh Ramsay (1877–1906) frequently painted his sisters, mother and financée, in part because they were very important and dear to him, but also because he suffered from tuberculosis and was often not well enough to leave the house. Without government services, families in crisis were thrown back on their own resources. Hugh's sister Jessie nursed him until he died; she also contracted the disease and died four years later. Unlike public commissioned portraits, each of Ramsay's portraits seems

imbued with a sense of intimacy and deep trust between artist and sitter. Perhaps there is also the premonition of impending loss.

It is very difficult to locate formal portraits of those women who broke free of social convention. Many educated middle- and upper-class women rejected limitations upon their talent and intelligence, but in the twentieth century social conventions about the appropriate role and visual representation of women still often conceal their key role in public life. The most popular portrait in the exhibition was a 1930 photograph of husband and wife Walter Burley Griffin (1876–1937) and Marion Mahony Burley Griffin (1871–1963). (Figure 6.1) Part of its popularity lay in the rediscovery of the remarkable Marion Mahony Burley Griffin. Unbeknown to almost all our visitors, she was an equal partner in their winning bid for the design of Canberra, was the most gifted architectural draftsperson of her age according to Frank Lloyd Wright (her employer of 11 years) and she ran the family architectural practice in Melbourne and Sydney. Hers seems to have been the dominant personality in the relationship, and her strong views on marriage and family life set the tone of their life together. Yet she has effectively been written out of history, and is only now being recognized in her own right as an intriguing individual and a gifted professional. In the photograph Walter stands facing the camera, occupying the lion's share of the frame and meeting our gaze with confidence. Marion stands side on, not meeting the viewer's gaze and seeming intent on giving as little as possible of herself to our scrutiny. An uncritical reading would perpetuate his reputation as the star of the duo, and hers as a helpmate and dutiful wife.

And what of those who never married or divorced, or who were single parents in an era which treated women in these situations as reprehensible, even invisible. Outside the socially prescribed roles of dutiful daughter, wife and mother they found another kind of family to sustain themselves. Sometimes this meant embracing poverty and insecurity. The women of the Thorburn family lived for four generations, throughout the twentieth century, in a house on the New South Wales south coast. The permanent residents were single women, mothers, daughters, divorcees, cousins and aunts, around whom occasionally fluttered unmarried brothers and male cousins in need of emotional succour.

Despite their long years of residence, because of the laws of inheritance the house never belonged to any of the women, but always belonged to a male relative. In insecurity and often some financial difficulty they lived lives rich in affection, fun and interest, giving the lie to the notion which still prevails in some quarters today, that single women are useless, frustrated and pathetic. The portrait shows a tight knit group of women, relaxed and confident, physically very much at

Figure 6.1 Marion Mahony (1871–1963) and Walter Burley Griffin
(1876–1937) 1930. Photographer Dr Jorma Pohjanpalo
(b. 1905) (National Library of Australia)
Joint winners of the international architectural competition
to design Australia's new capital city, Canberra, only
Walter Burley Griffin's role is now publicly celebrated.
Marion Mahony Griffin's apparently differential and
marginal pose in this portrait echoes her historical
oblivion, yet hers was the organizational genius that ran
their joint practice. Her drawings are regarded as among
the most brilliant of her age.

ease with one another in contrast to the stiff and anxious formality of many conventional family portraits of husbands, wives and children.

For some talented individuals the family of origin did provide the opportunity for a flowering of unusual ability, and also shaped that future through providing inspirational role models. Dr L.L. Smith (1830–1910) entrepreneur, unconventional doctor, wealthy purveyor of patent medicines, parliamentarian, businessman, was famous for his ferocious energy and eccentricities, yet the portrait of 1890 by Tom Roberts (1856–1931) shows him in uncharacteristically dignified and restrained pose as the statesman. His daughter, Louise Hanson Dyer (1884–1962), born into this wealthy establishment family, late and only child of a second marriage, was as colourful as her father. She began her adult life as an elegant young matron and society hostess, and was painted in this role by the academic portrait painter W.B. McInnes (1889–1939). But she had obviously inherited something of her father's bold and restless genius. Taking up residence in Paris and mixing with the most avant-garde artists of her time, she founded the famous music publishing company L'Editions de l'Oiseau Lyre. She brought back to Melbourne the music all Paris was listening to, particularly Couperin, and staged a series of concerts to promote this work. The impact of her entrepreneurial drive and avant-gardism must have been electrifying in stodgy, provincial Melbourne. She must also have made an impact on Paris, since Max Ernst painted her in one of his rare and highly abstract portraits. The single penetrating blue eye, unmistakably recognizable as one of the pair in the portrait of her as a poised child of four by Tom Roberts, challenges the viewer to find any trace of the conventional matron.

Family support and encouragement have always been critical in the development of outstanding sportspeople. Many of our current stars also come from families with several generations of great sporting achievement. The Roycroft family of Olympic equestrians are an outstanding example; father Bill was a member of five Australian Olympic teams, on several occasions alongside his sons Barry, Wayne and Clarke and daughter-in-law Vicki. Mark, Gary and Glen Ella come from a long line of talented Aboriginal sportspeople. They all played Rugby Union football for Australia, and their sister Marcia played netball at international level. Their mother May always encouraged her children to play sport 'because then you always know where they are'. In the family photograph she sits in the centre of her brood of sons, in a living-room lined with family sporting trophies.

The story of the Heide circle's artistic family is contained within a suite of portraits. In the 1940s the wealthy art patrons John (1901–81) and Sunday (?–1981) Reed established an extraordinary community in a farmhouse outside Melbourne. There a group of some of Australia's

most gifted writers and artists, including Joy Hester (1920–60), Sidney Nolan (1917–92) and Albert Tucker (b. 1914), gathered to talk, work and live. The Reeds provided financial and emotional support, which made it possible for these people to establish and develop their careers. The juxtaposition of Albert Tucker's riveting self-portrait, his wife Joy Hester's haunting self-portrait, Tucker's posthumous and discomfiting double portrait of the Reeds, a gentle and intimate photograph by Axel Poignant of the writer Cynthia Reed (1913–76), John's sister, and her husband Sidney Nolan, offers a rich and multi-layered reading of the texture of life in the artists' 'family' at Heide.

We also looked at those who had dedicated their lives to achieving social, legal, economic and political change in the interests of Australian families. A group of activists, beginning with Vida Goldstein (1869–1949) and her mother, and continuing through Jessie Street (1889–1970), Lionel Murphy (1922–86) and Edna Ryan (b. 1904) have played significant roles in gaining a measure of economic independence for women and their dependent children which was previously denied them by patriarchal unions, laws and social conventions and traditions. In the case of at least two of these people, their early family life determined the course of their adult careers. Edna Ryan and Vida Goldstein both witnessed their grandmothers or mothers struggling to raise their families, subject to inescapable domestic violence and an economic and social system which assumed that all women and children were supported by male family heads and breadwinners. This experience of such injustice turned them into agitators who gave their lives to ensuring that the next generations of women would not suffer like their foremothers had. Edna Ryan struck a fundamental blow against the 'traditional' family value of the wife who does not work outside the home, when she demonstrated before the Arbitration Commission in 1974 that 130,000 Australian families depended solely on the earning power of a woman. As a result the minimum wage was extended to women.

The final section of the exhibition deals with family life in the late twentieth century, which is as diverse, as much prey to external circumstances, as adaptive and as little in accord with narrow, conservative ideas of 'tradition' as it was in the nineteenth century. A lesbian family, blended and step-families, extended Aboriginal and European families, families truncated by forced migration, matriarchal families, adopted families and nuclear families jostle the walls, claiming equal attention, equal respect. Resisting any attempts to categorize, to disapprove and disallow, from the walls these faces stare back, declaring that this is the reality of our time. These are the strategies we have evolved to satisfy our need to be cared for, loved and protected. This is family.

The art of portraiture undergoes significant change in its approach to family within the 200-year period spanned by this exhibition. Portraits of middle-class family groups, especially those of women with children, often matched as a pair with another showing a man alone, are very common in the first half of the nineteenth century. In these portraits we see what Daniel Thomas has called 'a frank pleasure in family' (Faigan, 1988: 11). The portraits of the middle class and obscure Smails and Sinclairs are images of loving relationships as much as they are portraits of individuals. The features are not beautified, the poses are informal; they are private tokens of affection.

Others, perhaps more ambitious, are designed for public consumption. The portraits of the Piper family are of the 'family as property' school. The sitters pose surrounded by the trappings and symbols of affluence, the scale of the work indicates a public rather than a private purpose. That this purpose is often to deceive must be recognized; these works try to entrap us into sharing the sitter's self-image and ambition, rather than depicting any reality. Their solidity, their air of permanence, of a simpler and happier time, also deceives. In reality life was fragile, and families often torn apart by illness, accident and death. Those rosy babies and complacent mothers faced devastating infant and maternal mortality rates.

With the ready access of photography by the 1860s these kinds of group portraits become much less common. The family is now generally memorialized in snapshots or studio photographic portraits, while painting is increasingly reserved for the wealthy class, and especially for individuals of significant public achievement. This trend becomes more marked in the twentieth century, where painted or sculpted portraits are more commonly commissioned by universities or other institutions than they are by families. As a result they portray the formal face of public life rather than the affectionate and proud mother or husband of earlier portraits. That secondary portrait, of the relationship as well as of the individual, is now missing. It now becomes much more difficult to reconstruct families visually, and the emotional and other ties that bind and shape can only be inferred from a reading of a group of portraits of related individuals. Does this mirror a social change, in which the family, both as a contemporary unit and as one's personal heritage, is of less interest and importance to us than is individual achievement? Do we take less 'frank pleasure in family'? Or is it simply a construct of changes in technology and changing economic priorities in more straitened times. Yet secondary portrait is strongly present in photography, the immediacy of which is so well suited to preserving happy memories and a sense of group cohesion. That is not to say that photographs tell us the 'truth'. Almost all the sitters have projected a happy, united front for the camera. They know what a family ought to look like.

An important change also occurs in the depiction of Aboriginal people. The photographs by Baldwin Spencer of desert people are typical of work which serves a scientific and documentary rather than an artistic purpose. The people are viewed principally as specimens, their way of life as a phenomenon worthy of scientific study. There is little sense of an attempt to depict individual personality or the emotional ties of family. Despite this the confidence with which some of the people face the camera conveys some of those qualities.

Those Tasmanian Aboriginal people who survived the European invasion and its aftermath are posed, placed, lined up to be 'shot' yet again by the photographer Bishop Nixon. They scowl, radiating their powerlessness, their lack of assent and choice. But in the *c.* 1885 portrait of Fanny Cochrane Smith (1834–1905), born into this sad community but liberated from it by the colonial government through her marriage to a white man, we see the Aboriginal person who now has the power to control her own representation (Figure 6.2). She has chosen the occasion, her clothes and ornaments, her pose, her expression. She, and her sisters' lawyer and magistrate Pat O'Shane (b. 1941) and prison reformer and social activist 'Mum Shirl' (b. 1921), are not specimens but powerful individuals whose portraits speak eloquently of their personality, and of their struggle and their victory over colonial and post-colonial oppression.

A small and informal survey was undertaken on visitor response to this exhibition. Many visitors enjoyed following the story which emerges from the portraits as a group. They also responded readily and critically to the questions which they raise. A few rejected what they saw as an overly didactic approach in the extended labels, labelling them 'politically correct' and 'subjective'. It must be a truism by now that all exhibitions express a particular view, some more clearly than others, and that some views are less controversial (and thus are often said to be 'more objective') than others. All our work of course strives to get the facts right, but the curator signs each exhibition, and makes it clear that while attempting fairly to explicate our subject-matter the exhibition does take a position which invites discussion. Only by making this position clear can we achieve our aim of serving as a focal point for discussions about contentious issues like national identity, and the history and nature of Australian society.

Figure 6.2 Fanny Cochrane Smith (1834–1905) *c.* 1885. Photographer unknown. (Tasmanian Museum and Art Gallery)
A Tasmanian Aboriginal woman, she was born on Flinders Island, where she had settled following the Black Wars on the Tasmanian main. After her marriage to a white ex-convict she bore and raised 11 children, to whom she taught her Aboriginal culture as well as European ways. In this portrait she expresses her confident mastery of both worlds, her European dress overlaid with an Aboriginal girdle of fur and traditional shell necklaces.

References

Faigan, J. (1988) *Uncommon Australians*. Art Exhibitions Australia, Sydney.

Keeting, Paul (1994). Speech opening the National Portrait Gallery, 30 March. Unpublished.

National Library of Australia (1994). National Portrait Gallery exhibition policy. Unpublished internal document.

7

African Americans, History and Museums: Preserving African American History in the Public Arena

Spencer R. Crew

The preservation of their history has always been a critical concern of African Americans. The question of the depth and the breadth of their accomplishments both in the USA and on the African continent has played an important role in defining their status in this country. Enslavement and second-class citizenship traditionally have been more easily rationalized for individuals who allegedly have no past or contributions worth preserving.

Because of the importance of controlling the recounting of their history, African Americans have waged a prolonged struggle over this issue. The process has been arduous and demanded constant engagement on their part. One of the most recent efforts has been to influence non-African American museums to include African American history and culture within their walls. Through the use of an assortment of tactics and alliances they have achieved some successes in this effort over the past few years. As a consequence more and more museums have slowly begun to include African American history as an integral part of their work. The more recent achievements African Americans have had in this arena are part of a larger and longer struggle they have waged. This struggle has roots stretching back to the early years of the country and focuses upon the necessity of African Americans researching and preserving their history.

In the earliest of these efforts, African Americans formed organizations which sought to give light to their full history. The Reading Room Society in Philadelphia, launched in 1828 began with the intent to demonstrate the historical and literary achievements of African Americans (Ruffins, 1992: 514). Members held lectures and hosted forums which highlighted the accomplishments of African Americans. Out of these activities more formal efforts emerged in the form of publications documenting the contributions of African Americans. *The*

Colored Patriots of the American Revolution written by William C. Nell (1854), *Text Book of the Origin and History of the Colored People* by James W.C. Pennington (1841), and *History of the Negro Race from 1619 to 1880* by George Washington Williams (1882) all documented African American achievements. These works did not halt the denigration of the historical achievements of African Americans, but they did provide vehicles for transmitting information to later generations.

Indeed, these writings encouraged others to further document the accomplishments of African Americans. Carter G. Woodson, for example, recalled reading these books as a young adult and gaining inspiration from them. Later, as a graduate student at Harvard, his knowledge caused him to question the negative assumptions about African American history held by his professors.

Spurred by what he learned while working on his PhD, Woodson dedicated more and more of his time after graduation to further research and dissemination of his findings to the general public. To this end he eventually established the Association for the Study of Negro Life and History (1915) whose mission was the promotion of African American history. The primary vehicle for dissemination of this information was the *Journal of Negro History* which published articles and tidbits of information about black history.

To attract greater interest on the part of the general public in African American history, Woodson established Negro History week. This celebration took place every year in February between the birthdays of Frederick Douglass and Abraham Lincoln. During this time churches, schools, sororities, fraternities and other organizations in the African American community sponsored activities which highlighted African American achievements. As the event grew over the years and eventually became African American History month in 1976, it came to include parades, oratorical contests, banquets, lectures, exhibitions, and a wide variety of other activities. All of these undertakings were geared to the promotion and nurture of African American history (Goggins, 1993).

Woodson's efforts encouraged a new generation of scholars to pursue research in African American history because of his own work and the venue provided by the *Journal* for the publication of their efforts. More importantly, Woodson also inspired individuals not formally trained in scholarly research to study and investigate aspects of African American history they found interesting. The pages of the *Journal* as well as the yearly meetings of the association provided outlets for the sharing of their efforts. In many ways the national body and the local chapters which sprang up across the country replicated the efforts of the literary societies created by African Americans nearly a century earlier. The

intent of these groups like those of their predecessors was the preservation and promotion of their history.

When the civil rights movement gained momentum in the 1950s and 1960s interest in African American history soared to new levels. As African Americans more aggressively and successfully asserted their rights as citizens, they increasingly looked to the history of their contributions as one means of justifying their demands. Individuals who fought in the American Revolution, the Civil War and other military efforts, who helped settle the West, and who struggled under slavery while making tremendous economic contributions, all provided examples of longstanding and exemplary contributions made on behalf of this country. Their efforts clearly paralleled the efforts put forth by other Americans.

This new surge of interest in African American history fuelled increased research in the field. A plethora of new and innovative studies emerged which dramatically increased the information available about African American history. Books by Gilbert Osofsky (*Harlem: The Making of a Ghetto*, 1966), John Blassingame (*The Slave Community*, 1972), John Hope Franklin (*From Slavery to Freedom*, 1956) and others presented new ways of understanding the history of African Americans.

Another manifestation of growing interest in African American history was the rise of African American museums during this period. The earliest of these black historical institutions emerged in Boston, the Elma Lewis School for the Arts (1950), on the West coast, the San Francisco Negro Historical and Cultural Association (1956), and in Chicago, the Ebony Museum of Negro Culture (1961). They appeared as a result of the neglect of African American history and culture in the exhibitions and programmes of the major museums across the country. Their founders felt it incumbent upon the African American community to create their own institutions which would highlight and investigate the role played by African Americans in the evolution of the USA. Their efforts simultaneously would generate greater self-confidence and pride among African Americans as well as illustrate the appropriateness of black demands for equality. The mission statement of the Ebony Museum of Negro Culture clearly reflected this point of view: 'The Museum, Gallery and Research Library will be dedicated to the preservation of the culture and history of Americans of African descent and Africans. Primarily, it shall emphasize the contributions of the Negro to American History, Life and Democracy' (Dickerson, 1988: 98).

These museums also saw themselves responding to a critical deficiency within the African American community. They did not control enough institutions which presented historical interpretations from an African American perspective. Consequently, the picture provided by other institutions frequently was not very positive or

uplifting. These early museums saw themselves as pioneers forging a new sense of pride and self-discovery within their communities.

Soon other cultural organizations joined these early institutions. The Museum of Afro-American History in Detroit (1965), the National Center of Afro-American Artists in Boston (1968), The Society for the Preservation of Weeksville and Bedford-Stuyvesant History (1968), The Museum of Afro-American History in Boston (1969), and the Anacostia Museum in Washington, DC (1967) all saw themselves as community-based and community-oriented museums. They focused on the African American residents in their immediate area and providing them with a better understanding of their history and culture. These museums did not always follow traditional paths to accomplish their aspirations. They did not see themselves as separate or removed from their constituents who often were not well-to-do or frequent museum visitors. Instead, they saw themselves as venues for local residents; places where they could hold activities which would enrich the lives of the participants.

They also saw themselves as agents of empowerment. They did not present passive exhibitions about African American history for their audiences. They sought to involve community members in the retelling and codifying of their own history. They wanted local residents to see themselves as important players in the historical events of their communities and the country. These institutions sought active engagement with residents of their cities who had been overlooked and neglected for many years by other historical and cultural institutions.

The Anacostia Museum offers an excellent example. Its origins emerged from efforts on the part of that community to create a museum to serve their specific needs. In their discussions with the Smithsonian community members provided guidelines for the characteristics of the museum. Among their expectations was that it should have exhibitions on African American Heritage and should have space for exhibitions produced by neighbourhood people. Anacostia residents wanted an active role in the museum, they did not want to be passive users of a facility which decided what was best for them.

To ensure their involvement, a Neighborhood Advisory Committee was created to help plan the new museum and its exhibitions. This committee held a series of open meetings with neighbourhood residents to learn more about their expectations and hopes. Through these encounters the committee and the director of the museum wished to ensure that community expectations played a critical role in decisions about what exhibitions and programmes to produce. When the museum opened it had a suggestion box for visitors to offer ideas for exhibitions the museum might create. A number of the ideas suggested became exhibitions produced by the museum (Marsh, 1968: 11–16).

Communicating directly with their constituents became a hallmark of these museums. They saw themselves in the middle of a two-way exchange. They wanted the history they presented to recognize and give support to the historical issues and remembrances which resonated in their local communities. This approach not only entailed well-researched and documented traditional scholarship, but also research within the community that amplified scholarly findings and made them more relevant for local visitors.

The Rhode Island Black Heritage Society used this method effectively after it opened in 1975. Their research process included direct involvement of the community in the collection and documentation of local objects. Oral histories were collected along with artefacts, photographs, and documents. Scholars then worked with community representatives in interpreting the information and in crafting an exhibition which included community perspectives. At times, their findings offered challenges to traditional interpretations of historical events particularly within the African American community (Austin, 1982: 32).

The method of approach employed by these museums proved quite successful and led to the establishment of additional organizations in other cities across the country. During the 1970s new museums appeared in Philadelphia, Los Angeles, Providence, Omaha, Dallas, and other locations. The growing number of these neighbourhood-focused museums led to discussions at a meeting of the Association for the Study of African American Life and History about the common concerns of these institutions. A series of gatherings over the next several years resulted in the formation of a national organization in 1978, the African American Museums Association (AAMA). This new body functioned as the agent which linked together the various museums across the country. In this capacity it has served as a lobbying, training, and networking entity for these museums. Through its national meetings and workshops the AAMA has provided support and information for member institutions to help them improve their operations and alert them to important potential funding sources (Austin, 1982: 30).

The museums belonging to the African American Museums Association had a tremendous impact upon their communities and upon the museum field. Other institutions observed the enthusiasm these museums generated among African Americans and other residents interested in seeing exhibitions on African American history. The success of African American museums in part encouraged other museums to think more seriously about creating exhibitions which focused upon or included material about the history of African Americans.

In an effort to explore this question seriously, the New York State

Arts Council and other groups sponsored a meeting to further investigate the changing role and responsibilities of museums. The Neighborhood Museum Seminar in November 1969 examined the place of museums in the community. The participants included museum representatives from across the country. They came because they recognized the lack of contact between museums and the communities which surrounded them. They hoped to discover methods of improving that relationship. Although several general principles emerged from the discussions, no absolute conclusions resulted. One point which clearly emerged was that large, urban museums could not simply ignore the growing dissatisfaction around them. They had to seek solutions which involved working with those communities rather than overlooking them. They needed to take positive steps in that direction or possibly face confrontations similar to those occurring in other educational and social institutions around the country (Hopkins, 1970: 11).

These concerns expressed at the Neighborhood Museum Seminar were prophetic. Frustrations among African Americans and others were increasing. While they believed it was important to have their own institutions, they also believed it was incumbent upon non-African American museums to include African American history in their presentations and programmes. The extent of their frustrations and concerns surfaced during the June, 1970 annual meeting of the Association of American Museums (AAM). At that gathering, activists disrupted the conference by questioning the relevancy of work done by those museums. They felt the activities of these museums often ignored a very large segment of their constituency and the issues of significance to them. The protesters demanded that museums of all types pay greater heed to the communities in which they existed and the challenges inherent to these areas.

For many museum professionals in attendance at the conference the requests seemed overwhelming. The activists wanted too much. As one attendee put it:

> They not only want to attend in huge numbers, and to attend free of course, and at hours when in the past the museums have been closed. They also want a different kind of experience from that which museum have traditionally supplied. They want changing exhibitions, dramatically new presentations ... They want many of the services which seemed more properly to belong to libraries or performing arts centers or even universities and community agencies. (Katzive, 1970: 18)

This description of the new demands the AAM members felt directed towards them, very much resembled the role played by African American museums for many years. The unspoken question was why

couldn't other museums duplicate at least some of the services and activities normally provided by most African American museums? More importantly, why couldn't these museums make greater efforts to include the accomplishments and contributions of African Americans in their exhibitions and programmes? The information was available as evidenced in the panoply of books published on the African American historical experience. There was no excuse for ignoring this research and the collaborative approach used in the work of the museums.

The concept of collaboration in particular was important. Well-meaning efforts to include African American history and perspectives had appeared earlier in large museums. In 1969 the Metropolitan Museum of Art opened an exhibition entitled 'Harlem on My Mind' which examined the 68-year history of that historic section of New York City. While well intentioned, the exhibition drew strong criticism in large part because no African Americans played key roles in the research or creation of the exhibition. As a result, many people argued, the show misinterpreted critical aspects of the culture and the history of that community. At the Neighborhood Museum Seminar this exhibit was cited as an example of the shortcomings of the very traditional approaches to research and presentation used by larger mainstream museums (Dennis, 1970: 17; Hoving 1968: 18).

At the Smithsonian Institution, in response to the push to acknowledge African American contributions, the National Portrait Gallery opened two exhibitions curated by an African American scholar, Letitia Woods-Brown, which looked at the rich local Black history and tradition of Washington DC. The next year, in 1973, the gallery sponsored another exhibition focusing on 'The Black Presence in the Revolutionary Era'. At the Museum of History and Technology (nor the National Museum of American History) efforts were made to include African Americans in newly created exhibitions. The 1975 exhibition 'We The People' addressed the issues of suffrage and the modern civil rights movement as part of its narrative. 'A Nation of Nations', which opened the following year included African Americans as well as other non-European groups among the communities represented in this story of the origins and the evolution of a multi-cultured nation (Ruffins, 1992: 583).

While these efforts represented steps in the right direction, they did not truly embrace the spirit and essence of the issues raised by disaffected African Americans. They wanted the larger Smithsonian museums as well as other museums around the country to move closer to the African American/neighbourhood museum model. This mode of operation revolved around working with the African American community and allowing their perspectives and input to help shape the themes and the conclusions of museum activities. While many

museums clearly heard and understood the issues, they had difficulty making the transition to this very different mode of operation.

The struggle lay with the matter of sharing authority. Museums did not easily embrace this idea. It removed them from the role of final arbiter and interpreter of ideas and collections. In its place the new methodology demanded the community play an equal role in crafting the point of view and the themes of exhibitions. It insisted that community members might have information and perspectives worth factoring into the creative process. This approach also argued that museums had to justify their choices in open discussions where their ideas might face challenges. They could not make decisions behind closed doors among like-minded people unable or unwilling to expand the types of ideas which they found acceptable for presentation in their museum.

The idea of a partnership with non-professionals demanded a new mindset. Museum staff normally surveyed their collections, determined what topics their holdings would allow them to explore, perhaps worked with a noted scholar in the field, developed a script and then presented the fruits of their labour to their visitors. Usually, these shows were of very high quality and very traditional. Rarely did they reflect much of the newest scholarship nor did they usually offer innovative or challenging perspectives. Most often their historical exhibitions presented interpretations which ignored the contributions of African Americans or relegated them to peripheral status within a larger context. Rarely were African Americans shown as significant figures or individuals of consequence.

A classic example were the historical re-creations of Colonial Williamsburg as observed by Zora Felton Martin, director of education at the Anacostia Neighborhood Museum, when she visited that site in 1974. Despite the historical evidence that nearly half the residents of that colonial city were African American, the re-created city she traversed had no interpretation of the slave experience. They had been expunged from the visible history of that city despite their verifiable significant role in the life of the city. She found this oversight both ahistorical and disturbing (Martin, 1984: 83–5). African Americans had similar reactions to historical presentations made at other institutions. The interpretations offered by many of these institutions often did not reflect historical reality.

Breaking out of their old framework and developing new approaches to creating exhibitions and programmes required a drastic change in the way traditional museums conducted business. It also meant taking risks and perhaps experiencing failures along the way. Despite the urging of leaders in the field like Joseph Noble, the president of the American Association of Museums, and William T. Alderson, the director of the American Association for State and Local History, museums were very

slow to venture into this very different relationship (Alderson, 1974: 9; Noble, 1975: 24–5).

One of the first museums to fully embrace a partnership approach in their exhibition programme was the Philadelphia Museum of Art. Through its Department of Urban Outreach it created in 1976, a series of collaborative exhibitions developed in consultation with five cultural groups. The exhibition 'Rites of Passage', focused on the ceremonies and circumstances which highlighted the passage from one stage of life to another. The museum worked with the African American, Chinese, Italian, Jewish and Puerto Rican communities in Philadelphia. Each of these groups participated directly in selecting artefacts, images, and themes for the exhibition. They also influenced the design and the installation of the exhibition space. The process and the exhibition were a resounding success which illustrated the very positive results which might accrue when true partnerships are formed (Bach, 1976: 36–42).

The exhortations from their leadership, the success of exhibitions like 'Rites of Passage', and continuing pressure from the African American community slowly began to bear fruit. The Smithsonian Institution followed a similar process to the one used by the Philadelphia Museum of Art in the development of its African Diaspora Festival in 1976. Under the guidance of Bernice Johnson Reagon, a civil rights activist and PhD from Howard University, this activity involved extensive fieldwork with artists, musicians, and craftspeople from across the USA and around the world. Consciously involving the artists in the planning and presentation of the festival resulted in a spectacular event which transfixingly illustrated the historical and cultural linkages between people of African descent in different parts of the world (Ruffins, 1992: 576–8).

The success of this endeavour lead to the hiring of Dr Reagon as a permanent staff member and the creation of the Program in Black American Culture (PBAC) at the Smithsonian in 1976. In the years that followed the PBAC produced several programmes which offered in-depth examinations of important aspects of African American life and culture. The success of Dr Reagon's programme not only highlighted the impact of community partnerships on creating solid African American historical presentations, but also pointed out the impact that hiring African American staff could have upon the quality and sensitivity of these undertakings.

While the commitment to hire African Americans as staff members at traditional museums gathered momentum somewhat slowly, efforts to work in partnership with community groups moved ahead more rapidly. During the course of the 1980s numerous museums turned to this approach in the creation of major exhibitions. The Brooklyn Historical Society early in that decade recruited a community advisory committee

to help it in the preparation of its new exhibitions. For its presentation 'Black Churches & Brooklyn', the society created an advisory committee and hired an African American guest curator who helped locate artefacts, performed research and co-wrote the script for the exhibition. According to the director of the society, David Kahn (1990: 9–10), this technique gave the exhibition a much different perspective and vibrancy that it would have had if the staff of the society had prepared it by themselves.

Similar results occurred at the Valentine Museum in Richmond, Virginia. Two exhibitions it created on the Richmond African American community 'Jim Crow: Racism and Reaction in the New South' (1989) and 'In Bondage and Freedom: Antebellum Black Life in Richmond' (1988) involved extensive collaboration with representatives of that community. In particular, the Jim Crow exhibit relied heavily upon the remembrances and material culture of Black residents to recapture the impact and tenor of Jim Crow laws and traditions in that city. The firm commitment of the director, Frank Jewell, to this development model both ensured the success of these exhibits and created long-term positive relationships with African American residents.

Other institutions enhanced the effectiveness of the partnership concept by adding African American staff. In Colonial Williamsburg, African Americans became part of the living history component of the site in order to tell the story of slaves who lived and worked in Williamsburg. At the National Museum of American History the addition of African American staff resulted in greater inclusion of the contributions of African American history in its general exhibitions such as 'After the Revolution' which looked at the late eighteenth-century history of the USA. These individuals also generated more exhibitions looking specifically at the history of African Americans such as 'Field to Factory: Afro-American Migration 1915–1940' (1987) or 'Go Forth and Serve: Black Land Grant Colleges Entering Their Second Century' (1990).

The very positive response to these exhibitions and the collegial relationship they generated between museums and their nearby constituents increasingly normalized the use of a partnership approach by museums. In a report from the American Association of Museums (1992: 16) one of its recommendations urged museums to 'Identify specific segments of the community that the museum would like to serve more fully, develop working relationships with them, and initiate programs to involve them in substantive ways'. It followed up this recommendation by setting the theme of its 1993 annual meeting as 'Partnerships: Museums and Communities'. The meeting was replete with sessions which offered strategies for establishing successful working relationships with local communities.

In many ways by the time of the 1993 AAM annual meeting, museums had come full circle. As they began to embrace the concept of partnerships with local communities they also began developing increasing numbers of exhibitions which focused on or included African American history. This was a recognition that the two concepts naturally linked together.

A growing sense of social responsibility reinforced this recognition. It was difficult for many of the larger museums located in urban settings to simply ignore the concerns expressed by their neighbours, many of whom were African American. It also made good business sense for these museums to respond positively to the urgings of local groups. Not only were they the neighbours of these museums, they were an important potential source of new visitors who could supplement or replace previous museum visitor pools. Demographic reports indicated that more and more museum visitors would be people of colour as the new century approached. They also were voters and constituents of elected officials whose decision to provide funding support for these museums often depended upon tangible evidence of the responsiveness of museums to local groups.

Pragmatism, demographics, and a sense of social responsibility have all helped bolster the case for including the history of African Americans in museum exhibitions and programmes. Also critical to this process were the efforts of African Americans. Their determination to preserve their history, to create institutions for its interpretation, and to insist their history had a rightful place in non-African American museums was instrumental in the shift made by mainstream museums. Both African Americans and museums benefited from the recognition by these institutions that residents of local communities had histories worth sharing. Museums became more representative and African American histories became more of an integral part of the history learned by visitors to these institutions.

References

Alderson, W.T. (1974) 'Answering the challenge' *Museum News*, November, 9, 63.

American Association of Museums (1992) *Excellence and Equity: Education and the Public Dimension of Museums, a Report from the American Association of Museums*. American Association of Museums, Washington.

Austin, J.F. (1982) 'Their face to the rising sun: trends in the development of black museums' *Museum News*, January/February, 29–32.

Bach, P. (1976) 'Rites of passage: a city celebrates its variety' *Museum News*, September/October, 36–42.

Blassingame, J. (1972) *The Slave Community*. Oxford University Press, New York.

Dennis, E. (1970) 'Seminar on neighborhood museums' *Museum News*, January, 13–19.

Dickerson, A.J. (1988) 'The history and institutional development of African American museums'. Unpublished MA thesis, The American University, Washington.

Franklin, J.H. (1956) *From Slavery to Freedom*. Knopf, New York.

Goggins, J. (1993) *Carter C. Woodson: A Life in Black History*. Louisiana State University Press, Baton Rouge.

Hopkins, K. (1970) 'Confrontation ... and community' *Museum News*, January, 1, 48.

Hoving, T.P.H. (1968) 'Branch out' *Museum News*, September, 15–20.

Kahn, D.M. (1990) 'City history museums as social instruments'. Unpublished paper from the conference 'Venues of Inquiry into the American City: The Place of Museums, Libraries, and Archives', sponsored by the Chicago Historical Society, the Common Agenda Project, and the Valentine Museum, Chicago.

Katzive, D. (1970) 'New York Annual Meeting: going to meet the issues' *Museum News*, September.

Marsh, C. (1968) 'A neighborhood museum that works' *Museum News*, October, 11-16.

Martin, Z. (1984) 'Colonial Williamsburg: a black perspective' in Nichols, S.K. (ed.) *Museum Education Anthology, 1973–1983: Perspectives on Informal Learning: A Decade of Roundtable Reports*. Museum Education Roundtable, Washington.

Nell, W.C. (1855) *The Colored Patriot of the American Revolution*. Wallcut, Boston.

Noble, J. (1975) 'Today's labor practices: affirmative action can work' *Museum News*, September/October, 24–5, 72.

Osofsky, G. (1966) *Harlem: The Making of a Ghetto*. Chicago.

Pennington, J.W.C. (1841) *Text Book of the Origin and History of Colored People*. [Publication details unavailable]

Ruffins, F.D. (1992) 'Mythos, memory, and history: African American preservation efforts, 1820–1990' in Karp, I. and Kreamer, C.M. (eds) *Museums and Communities: The Politics of Public Culture*. Smithsonian Institution Press, Washington.

Williams, G.W. (1822) *History of the Negro Race from 1619 to 1880*. Putnam's, New York.

8

Making Histories of African Caribbeans

Alissandra Cummins

In the introduction to his seminal book *The Black Jacobins* the eminent Trinidadian author, C.L.R. James (1980: v) wrote:

> I was tired of reading and hearing about Africans being persecuted and oppressed in Africa, in the Middle Passage, in the USA and all over the Caribbean. I made up my mind that I would write a book in which Africans and people of African descent instead of constantly being the object of other peoples' exploitation and ferocity, would themselves be taking action on a grand scale and shaping other people to their own needs.

For the last 450 years, Caribbean history has been, in effect a European history, and this has been reflected in museum displays. As a result, it has been of paramount importance that the historical subject-matter in many displays be reshaped, without which the conspiracy of silence could continue. The broader imperative behind this movement is one of discovery, revelation and reconciliation for Caribbean people living in a region, where independence has had the effect of changing the *status quo*.

Young Caribbean nations established from the 1960s onwards, whether consciously or not, have taken the decision to reclaim their African heritage and to revitalize a living culture, rather than regret a stagnated one. The formulation of both national and later regional cultural policy has been vital to this whole process of change. In the case of Caribbean museums, this has been a relatively recent phenomena. But in many cases, museums still continued to portray African art and material culture as if they were purely ethnographic relics of the past, rather than evidence of a sentient people and a living culture.

92

If power can be defined as the ability to interpret events and processes and to have them accepted and implemented, then the evidence suggests that the white élite in the Caribbean, with its external allies, have enjoyed a virtual monopoly of power for over 300 years. This social/racial minority which had dominance of productive resource ownership and economic decision-making, survived the reformist attacks of the mid-twentieth century, black-led democratic movement. The concentration of power and authority in their hands has been buttressed by the writings of historians.

> The evidence shows that from the time of this tiny island's first colonisation by the English in 1627, the works of these writers have represented critical elements in the hegemony of the metamorphosing ruling elite.

So wrote leading Caribbean historian Professor Hilary Beckles (1987: 131) in his introduction to an article examining the colonial historiography of Barbados and its implications for African Caribbean people. His observation, however, is equally applicable to virtually every other country within the region which witnessed similar developments with similar results.

By its very nature, this literature has been consistently hostile to the positive aspirations and interests of the demographic majority. Viewed from this perspective, the traditional historiography of the region constitutes part of the élite's intellectual ammunition deployed against the African Caribbean community. In the contemporary historian's view 'it has, therefore, to be resisted and defeated if the historically formed mythical images of Blacks are to be exploded and the record ... liberated from the ancient racist mentality of these white chroniclers' (Beckles, 1987: 131). Without exception, they alienated themselves from the possibility of revealing the cultural richness and philosophical complexity of the African dimension to Caribbean heritage.

Classical colonial historiography developed within the socio-economic framework of the Caribbean, following its wholesale adoption of slave-based labour. The colonies' political, legal, and ideological structures were designed largely as instruments of oppression over enslaved Africans, to ensure the greatest economic return. Slavery, though problematic to rationalize at the Christian level, was seen in the seventeenth century as a modernizing force, and the plantation, a civilizing institution for Africans who 'are as near beast as may be, setting their soul aside' (Ligon, 1657: 47).

Africans were described in ways which perpetuated stereotypical responses. Regarded as child-like, intellectually primitive and morally deficient, they were thought to be incapable of grasping conceptual

issues, and thus were considered unsuited to any but the most mechanical and repetitive tasks. The early historians' attempts to ignore the role of Africans in Caribbean history, though partly informed by tradition, ensured continued distortion and debasement. The Haitian Revolution in 1804 and the formation of a black anti-slavery Republic of Haiti only served to increase the fears of the élite plantocracy and hence the ardour of their attack on the reformist ideals espoused by those at home and in the metropole. Poyer's *History of Barbados* (1808), for example, characteristically outlines the fervent white nationalism which underpinned the social economic, and political structures of the colonial world. In an 1804 letter to Governor Seaforth, who had arrived in Barbados with the mandate to effect reform within the slave system, Poyer (1801: 162) expostulates the popularly accepted view among society that

> in every well-constituted society, a state of subordination necessarily arises from the nature of civil government. To maintain this fundamental principle, it becomes absolutely necessary to preserve the distinctions which naturally exist in the community. With us, two grand distinctions exist: first between the white inhabitants and free people of colour; and secondly, between whites and slaves. Nature has strongly defined these differences, not only in complexion, but in the mental, intellectual, and corporal facilities of these different species. We have acknowledged and adopted these natural distinctions.

In general, references to Africans in Caribbean history were incidental and replete with allegations of immorality and demonic tendencies. The historian's theory of social structure characterized the political and ideological context inhabited by the white colonists who were stern defenders of the faith. Within this environment, Poyer's attempt to use historical analysis to foster support for his negrophobic attacks on the social mobility of the free coloured populace received considerable support. The Africans described as 'an ignorant, super-stitious, vindictive race' (Poyer, 1808: 144) were, by the middle of the nineteenth century, free to earn their own living and make limited decisions on their own livelihood, despite the rabid opposition of the plantocracy.

According to these writers, however, Africans had been successfully stripped of their cultural identity and were now forced to create a new one. Thus the successful control and advancement of Africans in a 'free' society was conceived by many in terms of their degree of absorption of Christian theology and values. It was hoped this would reduce their indulgence of passions and other retarding vices, while introducing them to the 'civilized' lifestyles of the West.

Educational institutions established in the latter half of the nineteenth century were influenced by the philanthropic notion of emancipation through education, though only a vocational, Christian-oriented education was regarded as suitable. The early history of Caribbean museums is also replete with similar biases and attitudes. Museums, along with libraries, were created for the delectation of the public – but the privilege was only extended to a limited community, those with the time and the resources to utilize these facilities. Clearly this privilege did not extend to the African Caribbean population (Cummins, 1994: 194–8).

Even so, there were even more effective barriers to their participation in museum development – the membership structure of the organizations remained firmly in the hands of the European mercantile class determined on a course of imperialist and industrial expansion and transformation. Both the collections and the buildings which housed them, were unrelentingly Eurocentric in focus and, with the exception of the natural history specimens, aimed at attracting the interest of further investors in colonial expansion (Cummins, 1994: 196–8).

Museum officials appeared largely unaware of or, indifferent to, the black renaissance, in particular political awareness and socio-economic consolidation developing in the region at this time. Marcus Garvey and the emergence of the Pan-African movement within the Caribbean had fuelled a growing recognition of the disenfranchisement suffered by generations of African peoples. Part of the social and economic reforms demanded included redress for the suppression of African culture. Apparently oblivious, museums reinforced and glorified the importance and magnificence of Empire and later encouraged support for the Commonwealth.

Those African artefacts collected by the early Caribbean museums were by comparison, rather small and incidental to the focus of the institution. They were introduced, ignominiously, as the curios or remnants of other conquered tribes: the punitive expedition to the Ashante Kingdom (now South Ghana) in 1897 was a particular case in point. Divorced from their context or culture, such material was regarded by European soldiers, missionaries or explorers as little more than the spoils of war or the trophies of travel. Ironically, their almost negligent acquisition would later provide the precious resources needed to help tell the story of the Caribbean's other people. For more than a century, Caribbean museum development remained in the hands of private interest groups.

In the past, regional educational systems and museums have both served to illustrate the structural continuities and supportive ideologies within the tradition identified earlier. It is only within the last 20 years

that both European and African Caribbean groups have begun to question that stance, to analyse more objectively the traditional heterogenous white vision of historical experience and to attempt to present a more balanced view of Caribbean history. The reasons for this metamorphosis are many and varied.

Within the last 30 years, the phenomenal increase in histories written and published in the Caribbean evidence a major thrust to escape from the dominant Euro-centrism. With the development and expansion of the University of the West Indies (UWI), from its inception after the Second World War, but most particularly from the 1960s onwards, historians have been able to examine the Caribbean experience primarily from the perspective of African Caribbean peoples rather than the Europeans who came, conquered, and planted. Focusing instead on enslaved Africans, free coloureds, immigrants, peasants and workers rather than planters, pirates and priests, their efforts have brought the Caribbean to the forefront as a region whose unique history is worthy of study in its own right, rather than as an addendum to European history.

This direction has been part of a much greater historiographical trend towards 'peoples' history, which seeks to restore to the vast anonymous majority of human society, some degree of visibility in the historical landscape. As part of the post-colonial world, it has also attempted, with some degree of success, to redress the distortions created by historical studies which portrayed these societies as merely the creation of European colonists. The Caribbean peoples have moved to centre stage. Rather than focus on a single dominant culture, the Caribbean historians see the importance of examining the interaction of four great cultures – Amerindian, African, European and Asian. Rather than concentrating solely on the dispossession and the decimation of the Arawaks, and the enslavement and emasculation of the Africans, it has been possible to show instead that both groups participated actively in the creation of a new society.

The earliest application of this type of theoretical framework for museum development within the English-speaking Caribbean, came in 1961 with the development of the Jamaica Peoples Museum of Craft and Technology, established as part of the Institute of Jamaica's organizational expansion during the 1960s. Installed in the stables of Old King's House at Spanish Town, it became part of Prime Minister Michael Manley's socialist reform, as the Government sought to move beyond the confines of Kingston to establish among the local populace a pride and appreciation for traditional craft and culture.

The exhibits at the Jamaica Peoples Museum were innovative and virtually revolutionary for their time. Instead of relying on academic research and interpretation, the museum sought the advice of tradition-

bearers and acquired collections resonant of the rich variety of vernacular architecture, traditional arts and crafts, and cultural manifestations. The material was displayed in relevant contexts and continues to be interpreted by people from the community. Along with the development of other site and community museums, this national policy has had the effect of redefining the museum's role as cultural custodian, while at the same time encouraging the sense of pride and identity sought by government. Regrettably, this museum has fallen into considerable disrepair, but new initiatives by the Institute of Jamaica should improve its status in the near future.

Since the 1960s, new perspectives have been applied with increasing sophistication to the reformulation of Caribbean history and a substantial body of scholarly writing has been the result. This process has been stimulated by other significant factors. The establishment of the Caribbean Community (Caricom) in the early 1970s and the initiation of Carifesta, the major regional cultural festival offered a platform for the first regional assessment of the status of Caribbean museums. Historical archaeological investigation began to focus on life in the plantation yard, instead of in the plantation house, a change which afforded unique opportunities for reconstructing Afro-Caribbean cultural practices. Ironically, as the research gathered increased impetus, vulnerable Caribbean countries fell victim to a new colonialism – that of the foreign university which claimed access, and indeed custodial rights to the materials recovered from excavation. Whereas in their own countries, these institutions have come to realize, in theory at least, the ethical issues involved in returning research collections, particularly of human remains to their people, the same cannot be said for their recognition of the legitimacy of Caribbean claims to interpret their own history and to own their unique culture. The issue of repatriation, whether of recognized or unrecognized materials, remains relevant today. Once again, Caribbean peoples are experiencing a process of disinheritance just as acute, though with less bloodshed, and just as real.

The Institution of the Association of Caribbean Historians (ACH) under the impetus of the history department at the University of the West Indies, with its annual symposia on a variety of subjects and the publication of its essential *Journal of Caribbean History*, has created an invaluable climate for the formulation of new theories and understanding. This has benefited from the cross-fertilization of concepts and theses, as well as the sharing of knowledge gathered from all over the region. But what impact did these phenomena have outside the academic field?

Until the end of the 1970s, children in the secondary schools of the anglophone Caribbean sat the General Certificate of Education (GCE)

O-level examination in West Indian History. There is little doubt that the syllabuses and the examination papers used in this metropolitan-organized programme were conventional and Euro-centric in focus, and failed to take account of the new approaches and new research of the historians.

The establishment of the Caribbean Examinations Council (CXC) in the 1960s created the need for material change. The West Indian History Syllabus (Caribbean students first sat this paper in 1979) was explicitly designed to reflect new historiographical trends and to break away from the Euro-centred focus of the GCE syllabus. In addition, the CXC sought to emphasize research skills and the use of various sources to a far greater degree than the GCE programme. The initiation of the programme was a catalyst, from 1979, for the publication of new textbooks on Caribbean History, all published by British firms (some through their Caribbean subsidiaries).

How far these texts met the challenge offered by the CXC has been the subject of some debate. A critical assessment of these works in 1984 is illuminating. The degree of Euro-centrism and the extent to which the Caribbean peoples were presented as visible and active were open to question. The Amerindians were generally seen as passive victims being enslaved and dying off (cf. Watson, 1979: 22–7). As for the Africans, Watson's (1979: 83) view is quite explicit: 'What is perhaps most remarkable is how passive the vast numbers of slaves remained.' Greenwood and Hamber (1979: 93) agreed: 'In contrast to the Caribs, the Africans could be made servile – many accepted slavery as their lot.' Naturally these authors do not give the enslaved Africans any role in the events leading to emancipation and stress their total passivity after the end of slavery: 'the blacks knew of no other life than that of the plantation, and had no other ideas other than those instilled in them by their former owners' (Greenwood and Hamber, 1981: 121).

However all was not lost. Brereton (1984) observes that another author, Honychurch, 'makes a far greater effort to see the Africans as active participants in West Indian history'; for instance, his *The Caribbean People*, volume 2, has two chapters devoted almost entirely to Africans as autonomous beings and as rebels, and another on the slave trade which tries to depict the experience of the enslaved men and women themselves. And it is refreshing to read, Claypole and Robottom's (1980: 102) unequivocal declaration: 'At the centre of the history of the 18th century colonies is the life of the plantation slaves. What they endured there has been the most important influence on the development of free Caribbean societies of today.' Their chapter on this topic covers aspects of slave culture, family and social life, customs and beliefs, crafts and languages. It is encouraging to read that the African came to the Caribbean with 'languages, beliefs, skills and a place in

society ... a rich store of memories, stories and dances. In time he would use all these to piece together a life in his new American surroundings which owed much to his African heritage' (Claypole and Robottom, 1980: 93).

Nevertheless, Brereton notes that 'Everywhere in these texts, whatever the quality of treatment received by Amerindians, Africans, Asians, or post-slavery West Indians, Caribbean women are invisible, voiceless. Not one of the authors under review is a woman, and none of them is informed with even the most rudimentary feminist consciousness' (Brereton, 1984: 9). She also observed the rather hostile coverage of Caribbean black nationalist movements and their leaders, emerging primarily in the 1930s. Their contributions are either ignored or it is implied that the movements are something of a fad. For example, Greenwood and Hamber (1981: 127) remark that in the 1930s 'it became more fashionable to display one's blackness and African traditions'. The last ten years have seen some improvements with CXC commissioning more official textbooks and having them reviewed by Caribbean specialists. Once again the control of information can be identified as a powerful tool in ensuring cultural ownership.

How do these developments relate to regional museum development? Caribbean museums in existence before the 1980s were often guilty of the similar omissions, antagonism and ambivalence towards interpretations of African Caribbean history and culture in their permanent exhibits. The museums also needed to 'improve their awareness of their roots, traditions, and their understanding of the environment and use that information to evaluate the present and plan for the future' (Rivera and Soto Soria, 1982: 7). Again and again the authors emphasized the role of the museums in 'stimulating a greater appreciation for the past and a deeper awareness of national roots and thus, a greater sense of identity, pride and social conscience' (Rivera and Soto Soria, 1982: 15).

In 1978, the eminent Barbadian poet and writer, Edward Kamau Brathwaite responded to the Government's invitation to conduct a survey of indigenous cultural industries and to prepare proposals for a national development plan for culture in Barbados. Part of this process of critical review was the Government's initiative in assessing the status of the Barbados Museum. In appointing the Museum Development Plan Committee, the Ministry's letter expressed concern that:

the Barbados Museum is not really representative of the various aspects of Barbadian life ... The Minister is therefore committed to the development of a national museum policy aimed at changing the character of the Museum in order to make it truly representative of

the history, culture and development of Barbadian society ... as an institution in the service of national development. (Barbados Museum and Historical Society 1982: 1–2)

The process of redefining Barbados's cultural history was planned in the light of the museum's resources and deficiencies. It was recognized that in order to proceed with this metamorphosis, every aspect of the museum including the staffing, collections, the buildings and the available research would have to be revised. Deficiencies in the collection were described as telling the visitor 'a great deal about Barbadian Merchants and planters, their lifestyle and their adoption of European material culture [but] it says little or nothing about slaves, plantation labourers, peasant farmers and fishermen; African cultural survivals and folk culture ...' (Barbados Museum and Historical Society, 1982: 6).

The results of that process of reclaiming aspects of Barbados's history has already been the subject of detailed analysis elsewhere (Cannizzo, 1987). Essentially, however, the story-line was produced to encompass a sequence of themes similar to those espoused by the CXC in their development of the history curricula. The curatorial staff then faced the challenge of locating the objects and images with which to tell this story. This process had far-reaching implications for it meant that the museum must go to the people, those with the knowledge, skills and artefacts. For the first time, the people were part of the process and not simply the subject. Oral histories, photography and replication by local craftspeople were all necessary to the fulfilment of the plan.

Textual markers were designed to challenge the viewer and to excite curiosity to know more, while encouraging an understanding that history is an evolutionary process which requires more than just one source to tell the complete story. The language was designed to effect interpretation and not simply to project authorization. Folk cultural practices were placed alongside conventional Western developments, without any attempt to subsume the former as simply the unknowing efforts of an ignorant tribe. Each is shown to be worthy of respectful acknowledgement.

The imagery used required rigorous assessment, for while the museum held a large collection of Caribbean paintings and prints, many could not be considered for exhibition without extensive explanation to avoid misinterpretation. In many cases, photographs and artistic re-creations were given preference. This enabled the museum to illustrate earlier history in such a way as to make the greatest impact, without the European biases inherent in many of the museum's collections, and to maintain a balance in presenting Barbados as a multicultural society. As Cannizzo (1987: 26) observed: 'Throughout the museum, black culture is shown as worthy of serious museological investigation and display.'

Recent developments in Caribbean museums have taken a different direction and focus. In St Lucia, the Archaeological and Historical Society, long the custodians of the museum idea, took the innovative step of going to the people. A touring exhibit was developed to travel to 11 different communities around the island between July and November 1993 (Blasse, 1994: 1). The exhibition was generally well received and a visitor survey was conducted using questionnaires, supplemented by personal interviews. The use of interviews was found to be necessary due to 'the high rate of illiteracy in the country', a surprise to the organizers who remain proud of the educational system of that country.

The survey, which concentrated on exploring themes the participants might wish to see in a museum, also examined correlations with place of residence and age of the respondents to see how these factors might affect their choice of themes. The end result clearly revealed that overall the most popular themes suggested by all ages were Amerindians (81%), followed by slavery and the sugar industry (75%), African influences (75%), artwork (73%), and finally national heroes (71%). Not surprisingly the youngest age groups, 10–20 and 20–30, are heavily influenced by the changes in education outlined earlier and are eager to establish a connection with their African heritage.

For St Lucians between 40 and 50 years of age and those over 50 the results are reversed with little interest expressed in slavery or African heritage. For those forced to ask why, the answer lies largely with their upbringing – when convention made slavery a dirty subject and history gave Africa an ignominious place. Instead, their preference was for the nostalgic, the recognizable and non-threatening themes – the games and toys of their youth, and the French and English battles made familiar in the schoolroom.

In Belize, the Department of Museums was set up in 1990 with the intention of establishing a network of national museums, concentrating on specific themes relevant to a particular section of that large country. The immediate objective however, was to begin work on the development of the National Museum in Belmopan which will 'attempt to portray the life and history of Belizeans through time' (Branche, 1991: 2).

Prior to 1989 the word 'museum' had certain connotations in Belize. For the ex-British colony, the fascination with the glories of the Mayan culture took precedence over every other cultural manifestation and the word Maya became synonymous with museum, as though this were the only form of cultural expression in that country. Indeed before Independence, museum planning was focused on a national museum of Maya archaeology. But things changed with Independence and the focus shifted to 'the fostering of a consciousness of being Belizean, the

National Museum took on a wider focus inclusive [of] all Belizeans past and present' (Branche, 1992: 2).

The collections inherited from the Department of Archaeology, were overwhelmingly Mayan in origin (with a small natural history collection thrown in) and the museum staff soon recognized the need to develop and expand the focus of the national collection. An extraordinary process called the collection retrieval system was introduced in 1991, and the museum staff began to acquire historic, artistic and ethnographic artefacts relevant to all aspects of Belizean existence. How was this done? A circular to all government agencies asked them to identify all old, unused objects in their possession and this netted some of the first acquisitions.

An annual travelling exhibition programme reaped the largest harvest. By going out into the outlying communities, introducing themselves and the museum's mission and making important, individual contacts, the Department had introduced itself and had personalized the process of collection. By inviting the people to contribute their precious and personal collections, the Department had hit upon a successful formula of making this history 'theirs' instead of the usual 'ours'. Belize now has a hospitable climate for the development of a series of community museums. For example, Melda's Historical Museum emerged out of a family's desire to preserve the legacy of Garifuna heritage (Garifuna are the descendants of Carib Indians who interbred with African runaway slaves), its exhibits are based on the recollections of community elders and the reconstruction of a traditional settlement.

A similar initiative of developing annual travelling exhibits accompanied by small catalogues, undertaken by the Department of Archives in the Bahamas, had served to establish links with the other island communities. A donation from a major corporate donor enabled the Government to refurbish Vendue House, originally the Bahamian indoor slave market, for the purpose of museum development. The initial concept prepared in 1989 was very clear:

> This Museum will trace the roots and origins of the experience of slavery in the Bahamas, within the Caribbean context, the historical evolution of that institution from the 17th century ... Beyond slavery, the Museum will highlight the events of significance of the post-emancipation period till 1918, showing how the Afro-Bahamian people, always free in spirit, built on their African and European heritages to lay a solid foundation for the emergence of a truly free modern Bahamas. (Aarons *et al.*, 1989: 1)

Similar methodologies to those used in Belize and Barbados were employed in development of the Pompey Museum at Vendue House. Rigorous academic research was combined with the wealth of oral

histories garnered during regular trips to the Family Islands. At the same time, the curatorial team worked on developing relationships and establishing trust, which enabled them to acquire, borrow or reproduce illustrations and artefacts relevant to their stated goals.

By the same token, this process of research and collection also highlighted the importance of community interaction in the museum development process. The staff have reported that their visits served as a regenerating force for these remote communities, by reminding them of the importance of their cultural practices. In turn this acted as a catalyst and inspired the development of small community 'museums'. The exhibits focus largely on traditional Bahamian domestic practices, surrounding a reconstructed peasant farmer's trash-covered hut.

In the Cayman Islands, a somewhat different approach was employed. The Government purchased a major historical private collection of Caymanian domestic and craft artefacts. An invitation to the public to assist the museum in 'filling the gaps' in both its information and its collections, via the media, garnered immediate popular support among an eager community. A radio programme and regular news items kept public interest high. Once again the museum has sought to reconstruct the domestic everyday lives of a fledgling community. Fishing, turtling, wattle and daub architecture, basket-weaving and traditional Caymanian family life have been illustrated with black and white photographs and other family documents. No attempt has been made to reconstruct the European-oriented history which had once consumed so much attention.

In conclusion, Caribbean museums are reconsidering their role as custodians of cultural property. They have come to recognize that the people have their own interpretation of history and that their perspectives and traditions should determine the legitimacy of acquisition. Caribbean people have a valid claim on their own history and can determine for themselves whether an item should be in the museum and whether it should continue to be displayed; and how it should be interpreted for future generations.

References

Aarons, G.A., Outten, K. and Turner, G. (1989) 'Designs and displays for the Emancipation Museum at Vendue House'. Unpublished report of the Department of Archives, Nassau.

Barbados Museum and Historical Society (1982) *Final Report of the Museum Development Plan Committee*, Barbados Museum and Historical Society, Bridgetown.

Beckles, H. (1987) 'Black people in the colonial historiography of Barbados' in *Emancipation II: Aspects of the Post Slavery Experience in Barbados*, National Cultural Foundation and University of the West Indies, Bridgetown, 131–43).

Blasse, T. (1994) *Museum Survey Analysis Report: 1993–94*. St Lucia Archaeological Society, Castries.

Branche, W. (1991) 'Letter from the Acting Director Department of Museums' *Newseum* 1, December 2.

Branche, W. (1992) Untitled article *Newseum* 3, April 2.

Brereton, B. (1984) 'Caribbean history in the schools: a critical assessment of recent writing for secondary schools in the Anglophone Caribbean. Paper presented at the 16th Annual Conference of the Caribbean Historians, University of the West Indies, Cave Hill, Barbados.

Cannizzo, J. (1987) 'How sweet it is: cultural politics in Barbados' *Muse* 4, 22–7.

Claypole, N. and Robottom, J. (1980) *Caribbean Story: Book 1, Foundations*. Longman, London.

Claypole, N. and Robottom, J. (1981) *Caribbean Story: Book 2, The Inheritors*. Longman, London.

Cummins, A. (1994) 'The Caribbeanization of the West Indies: the museum's role in the development of national identity' in Kaplan, F. (ed.) *Museums and the Making of 'Ourselves'*, Leicester University Press, Leicester, 192–221.

Greenwood, R. and Hamber, S. (1979) *Caribbean Certificate History: Book 1, Arawaks to Africans*. Macmillan, London.

Greenwood, R. and Hamber, S. (1981) *Caribbean Certificate History: Book 3, Development and Decolonisation*. Macmillan, London.

James, C.I.R. (1980) *The Black Jacobins: Toussaint L'Ouverture and the San Domingo Revolution*. Allison and Busby, London, originally published 1938. (Third issue of the journal, p.v.)

Ligon, R. (1657) *A True and Exact History of the Island of Barbados*. [Publisher unknown] London.

Mason, T. (1993) 'Touring exhibition evaluation report. Unpublished report to the St Lucia Archaeological and Historical Society, Castries.

Poyer, J. (1801) 'John Poyer's letter to Lord Seaforth', *The Journal of the Barbados Museum and Historical Society* 19, 150–65.

Poyer, J. (1808) 'History of Barbados ... [Publisher unknown] London.

Rivera, R. and Soto Soria, A. (1982) 'Report of the mission to Costa Rica, the Dominican Republic and the OAS English-speaking member states in the Caribbean area. Unpublished report of the Organisation of the American States.

Watson, J. (1979) *The West Indian Heritage: A History of the West Indies*. John Murray, London.

9

Cleaning Up the Coal-Face and Doing Out the Kitchen: The Interpretation of Work and Workers in Wales

Kath Davies

In her paper on Welsh women's history, Deidre Beddoe (1981: 32) commented, 'if a creature from outer space landed in Wales, obtained a National Library of Wales reader's ticket and conscientiously worked through Welsh history, she would be really perplexed as to how the Welsh procreated. They were all men, even the Daughters of Rebecca were men in drag!' The same galactic historian could also be forgiven for thinking that Wales was a nation at leisure. Having visited several industrial museums, she would be impressed by the fact that heavy work was carried out by proud steam engines and air compressors, splendid in their shiny isolation and self-motivation. The impressions gained by this rather unusual tourist, would of course be hopelessly inaccurate in the fields of both work and women. Yet this interpretation might serve to draw attention to past and present shortcomings in documentary and material representations of Welsh history.

Contemporary publicity material produced by the Welsh Industrial and Maritime Museum at Cardiff, neatly encapsulates the 'shiny machine' syndrome. 'Marvel at the age of machines when everything was big,' it urges, 'machines that powered an empire, driven by King Coal'. Potential visitors are informed that, 'These fascinating exhibits give an insight into the way industry, coal, road, rail and sea combined to make Cardiff one of the world's foremost ports, and formed the basis for the rich and varied heritage we enjoy today' (WIMM, 1994). Clichéd cries of 'what about the workers?' immediately spring to mind, as does a feeling of disbelief at the fact that Wales's largest industrial museum maintains a policy of interpretation which results in the depopulation of history. The problematic nature of the displays at this museum is currently being addressed, but for the purpose of this study, the 'Hall of Power' will be examined in its present condition, as an example of a presentation which depicts work without workers.

The Welsh Industrial and Maritime Museum (WIMM) reflects the collection policies which prevailed during the 1970s and early 1980s. Throughout this period, which may be described as the heyday of industrial archaeology, objects were collected as 'totemic symbols' which were, as Colin Sorensen (1989: 71) explains, 'expected to perform unaided the immense task of explanation and evocation'. Machines such as those exhibited at WIMM and Swansea Maritime and Industrial Museum were regarded almost as *objets d'art* – beautiful and noble in their power. Representation of the people who worked, designed, maintained or benefited from them are disregarded. It is almost as if human presence would complicate and detract from the majesty of machinery. Awe rather than empathy is inspired by the 'Hall of Power' approach.

Of course, curators seeking to interpret the world of work, must defer to the artefacts in their collections. As Rob Shorland Ball (1989) comments, 'We are concerned with objects not history itself.' However, the degree of deference assumed and the very nature of museum collections raise important questions regarding the nature of interpretation and the formulation of collection polices. J. Geraint Jenkins, formerly curator of WIMM, has repeatedly pointed out that large machines will remain unrepresentative until they are supplemented by smaller associated artefacts, photographs and graphic panels which take account of the tremendous human contribution to industry (Jenkins, 1992: 54).

Although many curators remain hostage to 'shiny machine' collection policies, opportunities still exist to repopulate industrial history. Again, Geraint Jenkins (1992: 53) has made valuable suggestions as to how technological labels may be rewritten to include workers and emphasize that machines are only components of the world of work. Sadly, some museums in Wales have been slow to respond either to these recommendations or to changes in the perceptions of how interpretation of machines may be integrated with the role of industrial workers. The permanent exhibition at the Welsh Industrial and Maritime Museum remains, for the time being, a sanitized Xanadu for technologists and engineers, although several temporary exhibitions have been mounted which have made positive contributions to the interpretation of the world of work. Swansea Maritime and Industrial Museum and WIMM have introduced two-dimensional figures dressed in working clothes and placed them next to freshly painted compressor engines, but this minor concession to human contribution is as yet not complemented by a positive reinterpretation of the role of the machines themselves.

To overemphasize the shortcomings of these particular museums would, however, give a misleading impression of the depiction of work

in Welsh museums as a whole. Several curators have adopted imaginative approaches which have succeeded in presenting balanced interpretations where shiny machines do not take precedence over labour. For example, Amgueddfa Lechi (the Welsh Slate Museum) at Llanberis has an eerie *Marie Celeste* quality about it which leads the visitor to half expect the next shift of quarrymen to begin work in the dark, slate-dust covered workshop. Here the majority of machines (many of which still work) are left grubby and oily. The workers' presence manifests itself through arrays of dirty donkey-jackets and original collections of beer-mats in the canteen. A number of ex-quarrymen can still be seen working with slate and although their much reduced activity represents the decline of the industry, the men are ready to communicate their experiences to visitors (Figure 9.1). Interpretive panels, which are kept separate from the work areas,

Figure 9.1 A slateworker demonstrates his skill at the Welsh Slate Museum, Llanberis (National Museums and Galleries of Wales)

explore the processes and by-products of slate quarrying. Strikes and accidents are discussed, as are the cultural activities of the quarrymen. In this context, the world of work is presented as a whole and machinery becomes a means to an end rather than an end in itself.

Museums such as the Welsh Slate Museum undoubtedly have an advantage in that they interpret a particular industry *in situ*. Machines, shiny or otherwise, are not removed from their context, and curators are not obliged to spend vast amounts on fibreglass reconstructions of a slate face for example. However, in preserving the site itself, interpreters of the work carried out at the site can face a whole range of different problems. At the Big Pit Mining Museum in Blaenafon, visitors are taken down a coal-mine and given a tour of the more accessible areas of the pit, preserved as it was in 1980, when the last coal was cut. Ex-miners act as guides and talk about their experiences as working colliers. The experience of visiting Big Pit is a profitable one as it gives the visitor an impression of certain aspects of the coal industry. People can at least see what a real pit looks like and are free to ask the communicative guides questions regarding their former employment. However, due to health and safety regulations, many significant changes have had to be made in order that visitors have access to the mine. The cage which lowers the tourists to the pit bottom would have travelled at 14 ft per second when full of colliers. Visitors, however travel at 6 ft per second. Although visible, none of the coal-cutting machinery is in operation and therefore no impression is given of the noise and dirt involved in mining. Only the most accessible areas of the mine may be visited, thus the visitor will be unable to see what it was like to work in cramped and dangerous conditions. Needless to say, the rats and timber wasps have now been eliminated and visitors will not have to share their lunch boxes or sit in utter darkness to avoid being stung. Although effective, Big Pit can therefore only present an impressionistic view of what it was like to work underground. The mine has, however, retained a certain integrity in the honesty of its presentation. The pit has been tidied but not sanitized and neither machines nor men are presented as heroic. Guides are allowed to present their own histories, and their restraint and understatement gives a truer interpretation than conventional graphic panels. As one ex-miner remarked during a recent visit, 'It was dirty and dangerous, but at least it was work'.

In contrast to the Big Pit approach, Rhondda Heritage Park, another mining 'museum' offers visitors an 'experience' called A Shift in Time. This claims to be a representation of what underground work really was like. 'Just like a working miner you ride down in the cage to the pit bottom where the hardship and joys, sights, sounds and smells of Lewis Merthyr Colliery at work may be experienced' (Rhondda Heritage Park,

1994). Having completed the tour, visitors are invited to detonate their own 'explosion' and feel 'the effects resounding around you'. Miners who worked at the Lewis Merthyr colliery do not entirely agree with these claims of authenticity. One in particular who still works at the site as a guide feels especially frustrated by the lack of interpretation of the coal-face itself which was of course, central to the work of the colliers. Having been involved in the construction of the simulated pit bottom, this ex-miner was in a position to advise designers on how a more genuine atmosphere of work could be achieved. His recommendations for loud but intermittent drilling noises, representations of a narrow coal seam which would have been difficult to work and irregular roof height in working areas were ignored. Other suggestions regarding what the pit bottom should actually look like were also disregarded despite the fact that none of the recommendations breached health and safety regulations (England, 1995). The result is a re-created workplace which fails to interpret working conditions. Indeed, by presenting A Shift in Time as a genuine experience and allowing the visitor to detonate an explosion (which in a real mine was obviously an extremely hazardous task) Rhondda Heritage Park may be seen to be trivializing the work of the miner.

Such misrepresentations are in part overcome by the use of ex-miners as guides. As in Big Pit, their first hand relation of experiences at Lewis Merthyr is extremely effective. Even here however, an attempt was made to repackage the world of work for the heritage consumer. Blackened faces and perfect four-part harmonies of *Cwm Rhondda* have as yet been avoided, but scripts bursting with simulated collier *bonhomie* were provided to the guides along with coaching in third-person(!) interpretation. 'We even had a man down from the Tower of London to teach us how to be miners' remarked one guide in disbelief. The ex-miners of Lewis Merthyr, with the blessing of their new director, have discarded these unnecessary lessons, but this experience should be drawn upon by curators seeking to interpret labour. Lack of consultation and the failure to listen to first-hand advice where available can result in the alienation of the very people whose working lives we are seeking to represent. Museums should also be aware of the dangers of selling a 'real experience'. Big Pit for example refrains from describing what it has to offer in 'day in the life of a miner' terms simply because there is an understanding (coupled by legal regulations) that a true experience of this nature is simply too dangerous and arduous. The only way in which visitors could genuinely experience a day's work at the coal-face would be to spend eight hours underground at one of the few mines still working in Wales. In the case of Rhondda Heritage Park, perhaps the shiny machines should retain precedence, if the alternative interpretation of work comprises ersatz explosions.

The debate regarding the presentation of work in museums is of course far broader than the miners versus machines discussion presented above. Traditional heavy labour and its interpretation has perhaps assumed prominence because of the size of industrial collections amassed during the 1970s and the subsequent development of industrial museums and 'heritage' sites. However, the range of work carried out within any community (rural or industrial) is vast, and curators will need to take into account many different spheres of work. Alongside the 'heroic' miner or quarryworker, they would have been (to name just a few), farmhands, sailors, saddlers, blacksmiths, shepherds, dairy maids and, of course, women who worked at home. No single museum is likely to be able to interpret all these areas of employment, but consideration should be given to the variety of industries which make up a local economic community.

The depopulation of history also manifests itself in the interpretation of the above spheres of work. For example, the ubiquitous country dairy exhibition may often feature pristine butter churns, cheese presses and a whole array of butter working ephemera but have no corresponding graphic information or photographs to illustrate how these tools were used or who may have used them. Again, the objects take precedence over their operators. This is also often the case in museums which set out to interpret agricultural history. Row upon row of gaily painted root pulpers, ploughs and chaff cutters are deemed sufficient to interpret farming in Wales – a sort of 'Barn of Power' approach which again tells us little of the people who actually worked the land.

Of the museums that seek to interpret rural life, many are guilty of presenting a romantic folksy idyll. A muted sunlit saddler's shop, for example, may evoke a nostalgia (which is all too often imagined) but scant attention is paid to the role of that particular craftsperson. In Wales the isolation of rural communities meant that those communities had to be, to a large degree, self-sufficient. Consequently the role of saddler, blacksmith, weaver or carpenter was central to the local economy. They were important people within their societies not simply unintentional demonstrators of rustic crafts for our historical titillation. Of course an in-depth political analysis of the role of workers in society is extremely difficult in a traditional museum context, but perhaps more effort should be made to contextualize labour, particularly in rural micro-economics where roles are more clearly defined.

All the spheres of work discussed above may be broadly described as conventional within a museum context. Heavy industry, agriculture and crafts are familiar aspects of social history curatorship and although methods of interpretation may be debated there is no question as to whether these subjects should be explored. However, if one of the roles of a curator is to collect for the future, more consideration should be

given to apparently more mundane occupations which have taken precedence over traditional industries. In Wales, following the decline of coal-mining, more people are now employed in the Driver and Vehicle Licensing Agency offices at Swansea than in the whole of the Welsh coalfield. Similarly, the self-sufficiency of rural communities has given way to large out-of-town supermarket complexes. The dairy maid has been superseded by the checkout girl. The tourist industry has become a major employer in Wales, and a range of service jobs developed in its wake. As yet however, few museums in Wales have reviewed their collection policies in order that these changes may be reflected through material culture. A shop bar-code reader or a typist's swivel chair may not be as aesthetically pleasing as a butter churn or a milking stool, but they are nevertheless modern tools of the trade and should be collected accordingly. A re-evaluation of collection policies on a Wales-wide basis, will not of course be an immediate process. Until such a process has taken place, however, there are several ways in which curators can begin to reinterpret the world of work by using collections already extant in Welsh museums. A good place to start would be in the kitchen.

Numerous social history museums in Wales boast a traditional Welsh kitchen complete with dressers, fireplaces, ovens, tin baths and lines groaning with washing. But like the shiny beam engine, the centre of the household appears to run itself. In at least two Welsh museums, the Welsh cakes on display have spirited themselves from the griddle to the table, and the tin bath has mysteriously emptied itself of dirty water. The much admired industrious Welsh Mam seems permanently to stand on an unseen front doorstep idling away the hours with her next-door neighbour. These kitchens are presented as havens of quiet domestic bliss. They are reminiscent of the *How Green Was My Valley* interpretation of Welsh history, when the primary character of the novel recalls, 'Indeed, if happiness has a smell, I know it well, for our kitchen has always had it faintly, but in those days it was all over the house' (Llewellyn, 1988: 9). A truer interpretation of the kitchen would draw attention to the fact that the women, particularly the miners' wives, often worked longer hours than male labourers and were also subject to dangerous working conditions. As one historian of the coalfield has pointed out, 'The miners worked seven hours themselves and worked their women seventeen' (Watkins, 1947). The artefacts which can serve as a focus for a wider and more sensitive interpretation of the history of work are numerous. For example, many social history museums have a tin bath on display as a central part of the kitchen scene. While it is fitting that this commonplace object should be awarded pride of place, the depth of historical exploration goes little further than 'Didn't granny used to have one of those?' How many times a day granny filled it, and how she filled it are questions which are

generally left unaddressed. The simple addition of graphic panels and photographs could draw attention to the centrality of the role of the tin bath in the working life of the coalfield wife. It could be pointed out that in a household of three or four miners the women of the house would be constantly fetching, boiling and carrying water. The effect of such work on women's health could also be explored. For example, a midwife working in the Rhondda Valley in the 1920s estimated that most miscarriages and premature births were caused by carrying tubs of water to and from the bath (Evans and Jones, 1994: 6). Explanations of this kind would radically broaden the perception of the significance of this particular object. Granny may have had a tin bath, but would she have regarded it with nostalgic longing?

Washing dollies and mangles are other commonplace museum objects which could provide a starting-point for the reinterpretation of work. The connotations of these objects are obvious if we consider the constant struggle of the coalfield women against the dust and dirt of the colliery. However, apart from the more direct associations with domestic labour (more water carrying) objects related to laundry provide an important starting-point to understanding the very perception of work among women in industrial society (Figure 9.2). The traditional concept of the division of labour along the lines of 'her for indoors, him for out' is both epitomized and challenged by these objects. On becoming a miner's wife most women gave up formal outside employment in order to run the home. Oral testimony shows that many wives regarded this as an end to formally recognized labour. Despite their 'withdrawal' to the home, women often sought to supplement the family income by taking in washing, but yet they did not regard this as 'real' work. 'No, never worked no more' stated one miner's wife describing her life after marriage. 'I worked with the family and took washing in ... The lady across the road ... I used to do her washing ... then another person I used to wash for down the road, I went on a Sunday night to fetch the basket of washing ...' (Gittins, 1986). In fact, this woman obviously worked extremely hard, and her mangle or washing dolly was an important tool in generating extra income despite the fact that her 'work' was not officially recognized as such. Unfortunately, the lack of official recognition is perpetuated by many curators today who fail to draw out this important sub-text in their interpretation of laundry-related artefacts.

More sensitive graphic interpretation is not the only method available to improve representations of domestic labour. Home and hearth (whether industrial or rural) can be brought to life with a little curatorial imagination. In a small local history museum at Puivert in the Pyrenees, for example, simple devices were used which transformed the country kitchen on display into a hive of activity. The hearth

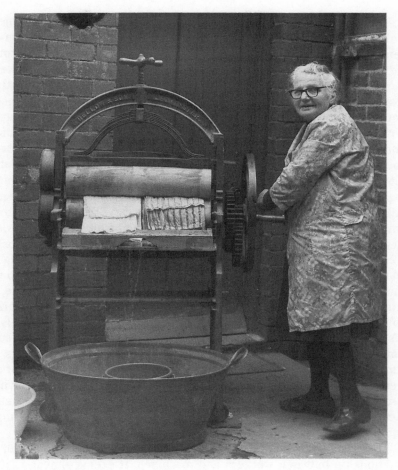

Figure 9.2 Working the mangle, Mrs Griffiths of Abbey Cwm Hir
(Radnorshire Museums)

ephemera on view was generally similar to that on display in
Abergavenny, Kidwelly or Llandudno for example, yet it was brought
to life by a simple soundtrack which played intermittently. Visitors
could hear busy steps across a wooden floor, the clanking of saucepans
and pans, an egg being whisked, a boiling pot, washing up being done
and the occasional sound of clucking hens in the background. The
presence of the housewife was made evident not only through the tape,
but also by a ghost-like Perspex outline of a woman. Graphic panels
displayed photographs of the kitchen *in situ* and of the woman who had
worked in it. Descriptions of a typical working day could also be read.
Thus visitors were given an insight into how a kitchen functioned and
what role was assumed by the objects used by the housewife.

The nature of the exhibitions at Puivert demonstrates that objects, work and workers are not mutually exclusive. With imagination and sensitive interpretation, artefacts can be contextualized and the role of workers and their use of the objects on display emphasized. However, the interpretation of labour should not merely comprise functional explanations or demonstrations of how objects, be they fan engines or flat irons, were used. Work has many socio-political by-products and is not simply a process of performing a particular task. Employment in both rural and industrial contexts gives rise to a complex network of social relationships which do not exclusively culminate in labour movements. As noted above, the Welsh Slate Museum at Llanberis explored the social and cultural life of the quarrymen. Their 'collective' outlook stemming from their employment gave rise to football teams and choirs for example. Similarly at Pontypridd Cultural and Historical Centre, an attempt has been made to interpret the activity of working communities in the area as a whole. Physical processes of work such as chain-making or mining are explained alongside the social activities of those particular industrial communities. Eisteddfods, brass bands, the annual miners' fortnight, Sunday school trips, rugby and boxing are all considered as an integral part of a community at work. Oral history testimony used in the exhibition demonstrates how workroles sometimes became incorporated into a social context. Many colliers and surface workers were so closely identified with their machines that they were actually named after them. One engineman on a steam winder became generally known as 'Little Puff', 'Dai Electrics' operated an electric winder, and 'Up and Down' worked on underground pumping equipment (Keen, 1991: 48).

Localized nomenclature of this nature shows the closeness of the relationship between workers and machines. It seems almost as if the two are interchangeable. The nicknames also illustrate the fact that there need not be a dichotomy between objects and their users. Curators who perceive their 'shiny' collections, rural or industrial, as problematic instruments of interpretation could perhaps turn to 'Dai Electrics' for inspiration. It should be remembered that objects are 'pegs on which to hang a story' (Jenkins, 1992: 54) and the nature of that story will often depend upon the imagination of the teller. Indeed, many curators are now approaching the interpretation of work from a more holistic stance. Positive efforts have been made to repopulate the 'Halls of Power', and to take into account many different types of work and associated social cultural by-products of industry. The process of re-evaluation should however be a continuous one. The work of curators in interpreting work itself has in effect only just begun.

References

Beddoe, D. (1981) 'Towards a Welsh women's history' *Llafur*, 32–8.

England, I. (1995) Interview at Rhondda Heritage Park, 25 April.

Evans, N. and Jones, D. (1994) 'A blessing for the miner's wife: the campaign for pithead baths in the South Wales Coalfield, 1908–1950' *Llafur*, 5–28.

Gittins, D. (1986) Collection of oral history interviews conducted in the South Wales valleys.

Jenkins, J.G. (1992) *Getting Yesterday Right*. University of Wales, Cardiff.

Keen, R. (1991) *Coalface*. National Museum of Wales, Cardiff.

Llewellyn, R. (1988) *How Green Was My Valley*. Hodder and Stoughton, London, (5th edn).

Rhondda Heritage Park (1994) Publicity leaflet.

Shorland Ball, R. (1989) Unpublished conference paper delivered at the seminar 'Is history nice? The danger of the deferential museum', Science Museum, London, 6 November.

Sorensen, C. (1989) 'Theme parks and time machines' in Vergo, P. (ed.) *The New Museology*, Reaktion, London, 60–73.

Watkins, H. (1947) *An Unusual Student* quoted in Egan, D. (1987) *Coal Society: A History of the South Wales Mining Valleys 1840–1980*, Gomer, Llandysul, 83.

Welsh Industrial and Maritime Museum (WIMM) (1994) Publicity leaflet.

10
Hard Men, Hard Facts and Heavy Metal: Making Histories of Technology

Lawrence Fitzgerald

Partial collections, partial truths

That technology is important to society is self-evident; it suffuses our lives to the point of transparency. Museums as 'legitimising institutions' (Kavanagh, 1989: 36) validate that importance. Yet, museums and collections classified as 'technology' generally encompass only certain types of technologies: computers but not staplers, water pumps but not toilet rolls, vacuum cleaners not sponge floor mops, cars not pushchairs. There is a clear disposition to collect large, complex, metallic, male manufactured or used technologies. Museum staff have been generally successful in overcoming the practical difficulties involved in acquiring these types of technologies and installing them within museums. Considerably less thought, time and money has been spent trying to interpret objects within an historical context or to question what counts as technology.

Porter has suggested that by using restricted and arbitrary definitions of technology and work, women have been, and are, excluded in traditional exhibitions about technology and industry (Porter, 1991): and not just women are left out of the picture. Staff responsible for interpretation usually choose to present histories from the viewpoint of bosses rather than workers and of producers rather than customers and users. Too often collections of technology are displayed as art objects or, as in the traditional 'power hall' of working machines, as art mobiles in ways that strip them of their wider personal, social and cultural meanings. My focus in this chapter is post-1800 technologies of the First World, as these pose particular interpretative challenges and offer unique opportunities for museum staff – not least because of their sheer number and diversity.

116

What sort of histories have been made?

Technology, like science, is a set of human activities and physical objects, as well as a form of human knowledge, but it would be wrong to assume that they are the same thing. As Lewis Wolpert has highlighted, 'the aim of science is to produce ideas, that of technology to produce artefacts' (James, 1992: 40). Unlike scientific knowledge, technological knowledge is much more intimately bound up with its activities and artefacts. For this reason, it has always been easier for museums to represent and interpret technology than science. It is the nature of that interpretation that often gives rise for concern.

Academic historians of technology and science appear to be the most vehement critics of museum exhibitions concerned with technology. Why? Possibly because the attitudes and beliefs about technology that are frequently promulgated in these displays have been long since abandoned by them. Historians have shifted their concerns and approaches while many museum staff are welded to a belief that the 'white heat' of a technological Utopia and the responsibility to meet what they consider to be the intellectual needs of technology enthusiasts, rather than the majority of their visitors.

Although rarely, if ever, explicitly expressed, three common-sense theoretical assumptions permeate many displays concerned with modern technology. These are the belief that technology is politically neutral, that somehow it exists outside society and that present technology is the best or, even, the only possible form of technology. 'Technology is a medium of power ... The person who possesses special knowledge and competence with technology has always had a valuable asset' which has afforded them 'a measure of power not only over matter but over people' (Cockburn, 1985: 6). This much is generally accepted, and indeed celebrated in many museums. More contentious seems to be the suggestion that modern technological artefacts embody political and ideological agendas. We can all easily accept that a Volkswagen Beetle or Hiroshima-type atom bomb are political objects but surely not things such as printing-presses, bicycles or machine tools. Yet, if we fail to recognize the political nature of technology, we effectively concur with the belief that it is in some way outside society; an exogenous force of unknown origin.

Usually implicit within this assumption of the 'otherness' of technology are ideas that: technology, in itself, is not good or bad, only people are; modern technology is inevitable and therefore nobody's 'fault'; and the choice between rival technologies or techniques is made primarily or, even, purely on technical grounds. These theoretical assumptions have been generally rejected by historians and sociologists of technology and a new approach, usually called the social construction

of technology (SCOT or social constructivism), has crystallized which incorporates this critique. SCOT's theoretical framework has been informed by studies in the sociology of scientific knowledge and developing feminist perspectives on the history of technology. These new studies could be used to produce more inclusive, relevant and critical history exhibitions about technology and people.

In addition to questionable theories, three main features have characterized history exhibitions in technology museums, uncritical celebration, idolization of 'great' engineers and scientists, and the ritual recitation of 'technical facts'. If belief in modern technology were a religion then its places of worship would be science and technology museums. In order to suggest how history exhibitions about modern technology might be better, we need to appreciate the deficiencies of traditional displays and how and why they have arisen.

Rivet-counting

The stereotypical 'internalist' interpretative approach found in technology museums has been described by J.J. Corn (1989) and others. Ettema's 'formalist perspective' is object-centred and 'usually seeks to explain the development of the physical forms of the object' (Ettema, 1987: 63). Hudson suggests the typical symptoms of Newcomen's disease are 'an inability to see any connections whatever between a machine and the people who buy it, use it and make it' and to act as if 'technology exists in a cultural and economic vacuum' (Hudson, 1987: 51). The internalist style is essentially antiquarian, a presentation of the 'internal history of a class of objects' (Corn, 1989: 239) designed to appeal to male, machine enthusiasts, commonly referred to as 'rivet-counters'.

The continued presence of this style of interpretation in older institutions such as the Deutches Museum, the Science Museum and the Museum of the History of Science, Oxford, may be partly explained by the age of the, almost literally, permanent displays. They simply reflect the outdated attitudes of historians of the time in adopting an art museum's object-centred approach (Hindle, 1972) rather than a people-centred ethnographic model (Kavanagh, 1990). But the style persists, particularly in the interpretation of transport collections. One suggested reason is that curators in these museums often have a science or engineering background which predisposes them to a belief in an objective historical reality and an unease with 'subjective issues' (Swade, 1991). Their technical bent, acquired through personality and experience, may encourage them to focus on hard data and 'facts', rather than people, in interpretation; thus excluding messy unquantifiable social/cultural interactions and suggesting the primacy of the

seemingly controllable (technology) over the indeterminable (people and society).

This is obviously not the complete story as object-centred interpretation is also common in most art galleries and art museums. A better explanation might be that this style of interpretation is perceived as safe and uncontroversial. Most curators responsible for collections of modern technology are men. The internalist style exhibition appears to be designed to appeal to male enthusiasts. By implicitly validating 'physical power and competitiveness, qualities that traditionally reflect more the society of man than woman', these exhibitions 'tend to exclude and mystify women visitors' (Corn, 1989: 241). This is borne out by the recent front-end evaluation of ideas proposed for an exhibition on the development of civil aviation. In a quantitative survey, women respondents showed statistically significant preferences, compared to men, for socially orientated themes such as 'how airlines affect the environment' over internalist topics like 'the technical development of aircraft engines' (Fitzgerald and Webb, 1994).

Internalist histories, however, have their benefits, producing a great deal of technical knowledge about how things work (Divall, 1994). This information has been used and generated by museums to operate machinery as an aid to interpretation. Technology is about skills as well as knowledge and artefacts: working exhibits provide an opportunity to demonstrate and preserve these skills.

Let's celebrate

If internalist styles of exhibition tell partial truths by omission, then the worst celebratory style exhibitions are guilty of propaganda. All museums celebrate their collections to some extent by displaying them and 'bestow an imprimatur on certain subjects simply be dealing with them' (Cappelletti, 1989: 63). In some museums, the interpretation is so uncritical it undermines their educational function. Basalla suggests, 'at times technology museums seem to have adopted the General Electric slogan, "Progress is our most important product"' (Basalla, 1974: 108). The Swiss Transport Museum is not alone in adding Utopianism to its product range. 'The objects', proclaims the director, 'are in a sense monuments of technology created to serve man, developed to improve living conditions and intended to establish relations between people' (Waldis, 1986: 75).

The celebratory exhibition style is characterized by lines of immaculate, over-restored technology, juxtaposed in chronological order to suggest progress (Morton, 1988). In the culturally sanctified space of the museum, a mythical engineering heaven is created where machines never fail and are always well designed and beneficial.

Sometimes the style is textually explicit: 'technology is progress' asserts the introductory gallery at Snibston Discovery Park near Leicester. More often large, powerful machines, whose significance may be out of proportion to their size, are transformed into technological icons. However, it is not merely their size but the way these objects are displayed that is used to convey cultural supremacy and adoration. If the large missiles in the National Air and Space Museum in Washington DC were hung by their tail fins pointing at the ground very different messages would be communicated (Batzli, 1990).

Uncritical celebration is not restricted to inanimate objects. It is conferred on particular people as well. Engineering classics are the result of the 'creative minds of individuals' (Evans, 1986). This belief, once common among academic historians of technology, is increasingly only unearthed and celebrated in museums. Typically, individual 'great men' are credited as solely responsible for giving birth to a technological child which is then let loose on society. In this way, technological innovation is treated as one person's struggle against society, thereby separating technology from its wider social and cultural base. Under capitalism, this emphasis is not accidental. Rubenstein argues that the traditional North American museum promotes the view that 'business people are the movers and shapers of society and that the workers are no more than interchangeable cogs ... which is why business spends so much money trying to sell it' (Rubenstein, 1990: 39).

Burying the past

In 1995, the Smithsonian Institution substantially revised the planned *Enola Gay* exhibition about the dropping of the atomic bomb on Japan. The reported reason was fierce opposition from US veterans groups (Raymond, 1995). Another exhibition at the Smithsonian dealing with the impact of science and its technologies on US society, which according to one account 'is so balanced to the point of being innocuous', has been criticized by the scientific community for overemphasizing the negative aspects of science and technology (Kleiner, 1995: 42). It appears that attempts to address the negative aspects, weaknesses, compromises and controversial nature of technologies by some museum staff are being undermined.

Yet museum audiences would welcome a more critical approach to technological history as shown by recent surveys (MacDonald, 1993; Fitzgerald and Webb, 1994). Two of the most powerful exhibits in the State Museum of Technology and Work in Mannheim are the wreckage of a crashed car in which the owner was killed and a Second World War military transport vehicle displayed in front of a large photograph of the

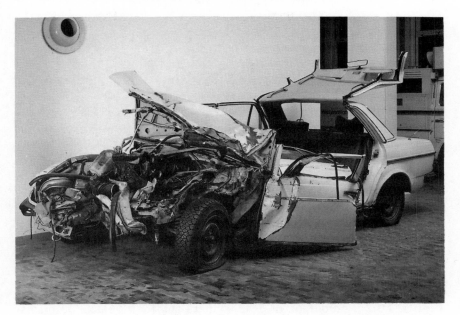

Figure 10.1 Wrecked car on display at the Museum of Technology and
Work, Mannheim (Landsmuseum für Technik und Arbeit
in Mannheim)

same vehicle containing dead soldiers (Figures 10.1 and 10.2). Postman
argues that people 'learn by contrast and comparison not by redundancy
and confirmation'. For First World countries totally committed to the
idea that 'technology is divine, there could not be a more mis-timed
vision of the future' (Postman, 1990: 56, 57). Mis-timed or not, some
science and technology museums have embodied uncritical celebration
in their mission statements (Carnes, 1986).

It's common sense

So why are so many curators of modern technology hooked on the
internalist and celebratory approaches to interpretation? Well, they
certainly have advantages. A huge number of low-cost, internalist and
celebratory style books on various technologies, particularly transport
and military technology, are produced every year. For resource-
constrained museums, these sources, for photographs as well as text,
are cheap, easily available, perceived as uncontroversial and validated
by quantity. For many it is just 'common sense'. In the post-Chernobyl
era, technological progressivism is generally in retreat but, even so, still
pervades popular media including television and film. Ideas of cultural

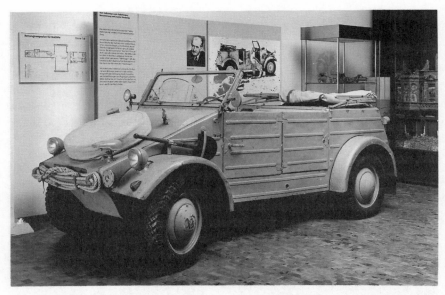

Figure 10.2 Photograph of dead soldiers and their vehicle on display
at the Museum of Technology and Work, Mannheim
(Landsmuseum für Technik und Arbeit in Mannheim)

and economic superiority are ingrained in First World societies, but
during the Cold War these ideas were deliberately intensified and
supported by governments who used modern technology, particularly
military and space technology, as symbols of their supremacy. Many
industrial and technology museums sprang up in this period, often run
by volunteer, non-historian enthusiasts. It is hardly surprising this
propaganda found its way into exhibitions. As Coxall has said of
exhibition text, and this surely applies to other media of communication
in exhibitions, 'if writers are articulating perspectives that have hitherto
been regarded as common-sense concepts, they may be implying
meanings of which they are unaware' (Coxall, 1991: 91). Although
internalist exhibitions are on the decline, the celebratory style was, and
still is, the 'common-sense' approach to interpretation for many
museum staff.

The celebratory style is encouraged by other factors: a museum's
need to attract visitors and its sources of funding. Museums exist for
the public benefit and are often judged, rightly or wrongly, on their
attendance figures. Many museums are reliant on income from visitors,
particularly those that charge admission. These financial and organiza-
tional pressures can direct museums into uncritical celebration of their
collections.

Guédon suggests that there are also pressures on museums from

both private and public funding bodies to present a partial view of science and technology (Guédon, 1986); to meet a social/political agenda or when they perceive there is an economic benefit. Corporate sponsorship of an exhibition may result in the apparent endorsement and promotion of particular products or viewpoints which compromise a museum's educational standing. A recent visitor survey of an exhibition at the Science Museum, London sponsored by Sainsburys found that 'quite a number of visitors ... suggested that commercial and political interests often interfered with scientific objectivity in exhibitions' (MacDonald, 1993: 40). Museums and visitor centres funded by single corporations such as the Sellafield visitor centre and the Volkswagen museum are noted for producing celebratory, partial histories of technology (Channel 4 TV, 1993). It maybe that management and staff in technology and industrial museums have also been too willing to collude with the wishes of potential sponsors or invite corporate sponsorship from organizations too closely associated with the subject-matter of the exhibition. After all, an arts sponsor would not expect to have a say in a new hang of an art gallery or the direction of a play, so why are sponsors allowed to influence the content of exhibitions about technology?

What sort of histories could be made?

The response in recent years has been for museums of science and technology to produce what Corn has described as social and cultural historical style exhibitions (Corn, 1989). This style is informed by academic social history and characterized by a concern with how people use modern technology and its impact on their lives. It has been used successfully by a wide variety of museums including, for example: in Germany at the Rüsselsheim Museum and the Museum of Technology and Work, Mannheim; in the USA in the exhibition on First World War aerial warfare at the National Air and Space Museum, Washington; in Britain at the Museum of Science and Industry in Manchester, the Imperial War Museum, London and the National Museum of Photography, Film and Television, Bradford; and in Sweden by the National Museum of Work, Norrköping. Through their interpretation of modern technology, these museums and others are beginning to demonstrate that 'every museum is in its own way, a social history museum' (Hudson, 1987: 47). Kavanagh (1993: 22) suggests that in many ways collections are defined and categorized by how they are interpreted, but by adopting a social historical style these museums seem to question these divisions.

The strengths of the social historical approach are that it can give us some insight into the influence of modern technology on society and

certain groups, such as workers (Rubenstein, 1990), and also helps to draw attention to the multiplicity of social groups with an interest in technology (Divall, 1994). This approach encourages museum staff to collect other forms of evidence along with objects to help interpret them, in particular oral history and it may attract new audiences, including more women, to science and technology museums (Fitzgerald and Webb, 1994). It may also provide a way into so-called 'black box' technologies, such as computers, as demonstrated by the success of the social historical style 'Information Age' gallery at the National Museum of American History in Washington.

Using the social historical approach by no means ensures an analytical and critical exhibition. 'Social historians tend to look from the perspective of the user, science and technology curators from that of the maker or supplier' (King, 1993: 49). At the National Railway Museum, York, 'The Great Railway Show' exhibition devotes a large section to the travelling habits of the British royal family yet ignores strikes and rail crashes. The 'Battle of Britain' exhibition at the Royal Air Force Museum, attempts to place its best known British and German aircraft within the political and social context of the Second World War. It merely succeeds in propagating myths and crude stereotypes, from the tableau at the start of the exhibition depicting a romanticized English middle-class family in their rural idyll, to the blitzed, but chirpy, London washerwoman near the end. The exhibition also serves to illustrate that internalist, celebratory and social historical styles of exhibition are not mutually exclusive but are often found in the same exhibition. The social historical approach of the Battle of Britain main story boards is overtly celebratory, yet individual object labels are as dry as dust, full of technical facts and feature little social context.

Despite its general advantages over the object-centred internalist style of interpretation, even the best social historical style exhibitions often treat modern technologies as if they were separate from society and as props in a story about society rather than an integral part of it. The approach suggests that already formed technologies simply impact on people's lives, attitudes that social construction of technology theories (SCOT) reject. Ettema (1987: 82) proposes that a synthesis of a people-centred (social historical) approach and an object-centred (internalist) approach is needed: 'rather than simply representing a concept with an object and relying on the viewer to read some understanding, artefacts should actually be part of the concept'. Ettema's solution is to acknowledge the social function of objects as symbols. But for modern technology this approach may marginalize physical function and how, and in whose interests, both social and physical functions are shaped.

A more complete integration could be achieved using a SCOT

interpretative approach which emphasizes the embeddedness of technology in society and the social groups or 'actors' influencing technological developments. Visitors could be encouraged to appreciate how a technology's form and function, (both physically and symbolically) are socially, culturally, politically and economically shaped to meet the needs of particular groups in society and, just as importantly, emphasize whose interests and needs are ignored. Unlike the social historical style, in order to appreciate why a particular technological solution was chosen it is also necessary to appreciate what things do as well as how they work.

Adopting the SCOT interpretative style could lead to less celebratory and more critical and analytical exhibitions. Museum audiences 'belong to different communities and to more than one community at the same time. When they enter museums they do not leave their culture and identities in the coatroom' (Karp and Lavine, 1993: 79). Individual modern technologies mean very different things to different groups of people in society. This 'interpretative flexibility' is often revealed by examining the perceived failings and failures of technology as well as the benefits. A passenger aeroplane will have a very different meaning for someone who lives close to the flight path of a busy airport compared to an airport worker. In addition, if technologies are 'interpretively flexible' in this way and potentially 'multi-directional' then they can be different (Bijker and Pinch 1987: 46). This is an empowering message for museum visitors compared to the usual message, purveyed through traditional approaches, that a particular technology or its current form is in some way inevitable.

How are these histories to be made?

Theory is all very well, but what would exhibitions informed by SCOT ideas look like? It would be quite easy to produce boring and inaccessible exhibitions. SCOT theories are not by themselves a recipe for exhibition success, we still need to know our target audiences and employ a range of proven interpretative techniques.

In 1993, a temporary exhibition which employed a SCOT approach to interpret some items of domestic and everyday technology was opened at the Museum of Science and Industry in Manchester. One exhibit, drawing on Bijker and Pinch's analysis (1987) of the early development of the bicycle, used a combination of real bicycles, cut out figures and period quotes (recordings as well as text) to convey how the development of the bicycle was in part determined by the competing needs of young female and male cyclists and bicycle manufacturers. Two other exhibits in this exhibition emphasized the 'interpretative flexibility' of modern technology. On a display panel, a series of

cartoons depicted different uses for a hairdryer, ranging from dusting dried flowers to setting glue. Visitors were encouraged to make their own suggestions on an adjacent board. A walk-through kitchen room set had four interactive elements which illustrated how some technologies are not designed to be used by people with certain disabilities. Thus emphasizing that the apparent success or failure of a technology depends very much upon your perspective (witness the 1995 protests in Britain by disability groups about inaccessible public transport).

One limitation of the SCOT approach to interpreting technology in museums is the relative lack of research material to draw on for exhibitions. As SCOT approaches to the history of technology are intrinsically object-orientated as well as people-orientated, this predicament could provide a research focus for museums with collections of modern technology, using SCOT as a model for object studies.

In advocating a SCOT interpretative approach, I am not trying to erect new intellectual barriers between exhibition-makers and their audiences. Curators have both subject and methodological expertise, but as SCOT theories stress, technology can mean different things to different groups in society. Historical meaning and knowledge does not solely lie with curators or the groups in society to which they typically belong. A curator's prime role is not therefore simply 'to disseminate historical knowledge to a lay public' (Fleming, 1993: 1), but to act as enablers/facilitators as well as providers (Merriman, 1991: 155; Walsh, 1992: 160), thereby recognizing the interpretative flexibility of their technology collections and empowering their audiences. Front-end and formative evaluation are recommended means of involving audiences in the formation of exhibitions. More directly, the staff of the Open Museum, part of Glasgow Museums, take the museums' collections out into the community and encourage direct audience involvement in the production of exhibitions.

In what other ways can we improve communication in history exhibitions about technology? O'Neill comments that, today, for most people, cultural information is provided 'televisually rather than written' (O'Neill, 1992: 36). Due to their background and training, many curators communicate easily through text and reluctantly and inexpertly through other media. Sound in particular is neglected in exhibitions, but it is crucial in determining the mood, atmosphere and the messages communicated. Museums of science and technology under-utilize sound except as a by-product of operating machines and yet it can be so important in providing a personal perspective, through oral history, and in bringing to life static pieces of machinery. The solution is not the sole responsibility of curators. It also lies with exhibition designers who tend to be visually biased, both in disposition

and training, and so usually treat sound as the icing on the exhibition cake.

The salvation of exhibition-making does not simply lie in new interpretative technology. Quin (1994: 2) writing about science museums, but equally applicable to other museums, neatly presents the reason why. 'As multi-media AV and interactive software become increasingly available at school and home, flashy exhibits alone can't and shouldn't be expected to, hold the interest of 21st century gizmo freaks. Human contact looks set to become the distinguishing attraction of the future science museum.' With the apparent decline in the sense of community in many cities, the great increase in museum-visiting in the past 20 years could, in part, be attributed to people's need to share experiences and be with other people in a safe environment. The most successful new museums have been those that have encouraged and provided for social interaction: 'heritage' sites such as Beamish, those with working exhibits operated by demonstrators like the Museum of Science and Industry in Manchester and museums with science centres. Melanie Quin (1994: 2) proposes the way forward is to 'design spaces for social interaction, galleries peopled with guides' and to provide 'live demonstrations and varied workshop activities'. She also stresses the importance of taking 'the action beyond the museum walls'.

'Hands on History' opened at the National Museum of American History in Washington in late 1992 and has been tremendously popular and successful with both children and adults. Not only can visitors experience using technologies such as a cotton-gin or find out what a hip-bath is, they can discover something about the lives of real people who used these technologies and their effect on people. Providing this sort of 'socially interactive' history is not cheap but is well worth the investment; this 150-square metre facility requires three or four part-time staff and two full-time staff for the three hours it is open each day. Other museums are establishing more personal and effective communication with their visitors by training actors to interpret individual objects and exhibitions through drama, as at the Science Museum, London, and the London Transport Museum, or by training demonstrators of working machinery to convey more than just technical facts, like at Beamish museum. With the decline of traditional industries in many First World countries, employing ex-workers as interpreters, as at the Big Pit museum, Blaenafon, Wales, has also become a practical and effective means of conveying personal experience.

Another way to improve history exhibitions about technology and establish good practice, is to ensure that they are critically reviewed and debated. Academic peer review is an accepted form of evaluating and raising the standards of exhibitions, provided other means of evaluation are also employed (Kulik and Sims, 1989). Unfortunately, too

many reviews read like advertising features. What criticism there is focuses on form rather than content or, as with much art gallery review, is designed to affirm the reviewer's membership of an exclusive and élitist section of society (Kavanagh, 1991: 187) rather than trying to promote a deeper awareness and understanding of exhibitions. The museum community is relatively small and there is an unwillingness to appear unsupportive of colleagues or upset potential employers. Basalla identifies the adoption by museums of industrial management structures instead of academic ones as an important factor in stifling debate. Criticism is simply seen as bad for business (Basalla, 1974: 105). There are no easy solutions to this problem, but professional associations and societies could play a role in raising standards by producing review guidelines for contributors to their publications.

Exhibitions about modern technology ought to be exciting and of interest to a wide range of audiences. After all, modern technology affects our lives more self-evidently than many other traditional exhibition subjects, such as impressionist paintings or Greek statuary, and it has the advantage that the makers and users are often still around to help us to bring the subject to life. Perhaps the seeming ubiquitousness and familiarity of modern technology has encouraged museum staff to use display techniques reminiscent of the discount store, stacking it high and selling it short of historical context. A more cogent explanation for the dreariness of many exhibitions about technology is the failure of exhibition-makers to appreciate the interests and needs of their different audiences and to develop effective means of communication. In this chapter I have suggested a number of ways forward. A recent British telecommunications company TV advert suggests that 'It's good to talk'. Timely advice for many museum exhibition-makers – particularly, if in future it is with their audiences and peers and not just to themselves.

References

Basalla, G. (1974) 'Museums and technological Utopianism' *Curator* 29(3), 213–20.

Batzli, S.A. (1990) 'From heroes to Hiroshima: the National Air and Space Museum adjusts its point of view', *Technology and Culture* 31, 830–7.

Bijker, W.E. and Pinch, T.J. (1987) 'The social construction of facts and artefacts' in Bijker, W.E., Hughes, T.P. and Pinch, T.J. (eds) *The Social Construction of Technological Systems: New Directions in the Sociology and History of Technology*, MIT, Massachusetts, 17–50.

Cappelletti, M. (1989) 'Exhibiting controversy' *Museum News* 67(6), 62–6.

Carnes, A. (1986) 'Showplace or forum: choice point for museums' *Museum News*, 64(4), 29–35.

Channel 4 TV (1993) 'Heil Herbie' on *Without Walls* (Channel 4 TV programme) 24 July.

Cockburn, C. (1985) *Machines of Dominance: Women, Men and Technical Know-How*. Pluto Press, London.

Corn, J.J. (1989) 'Tools, technologies and contexts; interpreting the history of American technics' in Leon, W. and Rosenzweig, R. (eds) *History Museums in the United States*, University of Illinois, Urbana, 237–61.

Coxall, H. (1991) 'How language means: an alternative view of museum text', in Kavanagh, G. (ed.) *Museum Languages, Objects and Texts*, Leicester University Press, Leicester, 85–97.

Divall, C. (1994) 'Theories and things: using the history of technology in museums' in Fitzgerald, L. and Porter, G. (eds) *Collecting and Interpreting Domestic Artefacts*, Science and Industry Curators Group and the Museum of Science and Industry in Manchester, Manchester, 3–12.

Ettema, M. (1987) 'History museums and the culture of materialism' in Platt, J. (ed.) *Past Meets Present: Essays about Historic Interpretation and Public Audiences*, Smithsonian Institution, Washington, 62–85.

Evans, F. (1986) 'History versus the rivet counters' *Times Higher Education Supplement*, 14 February.

Fitzgerald, L. and Webb, P. (1994) 'Vivant les différences: identifying audiences for a museum exhibition' *Public Understanding of Science*, 3, 277–90.

Fleming, D. (1993) 'Introduction' to Fleming, D., Pain, C. and Rhodes, J.C. (eds) *Social History in Museums: A Handbook for Professionals*, 1. HMSO, London.

Guédon, J.C. (1986) 'La Maison des Sciences et des Techniques, Montréal' *Museum* 38(2), 133–6 [in English].

Hindle, B. (1972) 'Museum treatment of industrialisation: history, problems, opportunities' *Curator* 15(3), 206–19.

Hudson, K. (1987) 'High technology and mass consumerism: interpreting the history of the modern period through museums' in Stratton, M. (ed.) *Interpreting the Industrial Past: papers from a Short Course held in February 1986*, Ironbridge Institute, Ironbridge, 47–54.

James, T. (1992) 'How to think unnaturally: book review of *The Unnatural Nature of Science* by Lewis Wolpert' *New Scientist*, 21 November, 40.

Karp, I. and Lavine, S. (1993) 'Communities and museums' *Museum News* 72 (3), 44–84.

Kavanagh, G. (1989) 'History in the museum and out of it' in Ambrose, T. (ed.) *Presenting Scotland's Story*, Scottish Museums Council, Edinburgh, 27–38.

Kavanagh, G. (1990) *History Curatorship*. Leicester University Press, Leicester.

Kavanagh, G. (1991) 'Mangles, muck and myths: rural history museums in Britain' *Rural History* 2(2), 187–203.

Kavanagh, G. (1993) 'History museums in Britain: a brief survey of trends and ideas' in Fleming, D., Paine, C. and Rhodes, J. (eds) *Social History in Museums: A Handbook for Professionals*, HMSO, London, 13–24.

King, A. (1993) 'Science and technology: unnatural science and inhuman history', in Fleming, D., Paine, C. and Rhodes, J.C. (eds) *Social History in Museums: A Handbook for Professionals*, HMSO, London, 48–51.

Kleiner, K. (1995) 'Science in American Life' *New Scientist*, 8 April, 42.

Kulik, G. and Sims, J. (1989) 'Clarion call for criticism' *Museum News* 67(6), 52–6.

MacDonald, S. (1993) *Museum Visiting: A Science Exhibition Case Study* (Sociology and Social Anthropology Working Papers. Keele University, Keele.

Merriman, N. (1991) *Beyond the Glass Case*. Leicester University Press, Leicester.

Morton, A. (1988) 'Tomorrow's yesterdays: science museums and the future', in Lumley, R. (ed.) *The Museum Time Machine*, Routledge, London, 102–27.

O'Neill, M. (1992) 'Pierro della Francesca and the Trainspotter', in Clarke, R. (ed.) *A Head of Steam: Industrial History in the Museum*, Scottish Museums Council, Edinburgh, 33–6.

Porter, G. (1991) 'Partial truths', in Kavanagh, G. (ed.) *Museum Languages, Objects and Texts*, Leicester University Press, Leicester, 103–17.

Postman, N. (1990) 'Museum as dialogue' *Museum News* 68(5), 55–8.

Quin, M. (1994) 'Fall editorial' *ECSITE Newsletter* 21, 2.

Raymond, C. (1995) 'Words from Washington', *ECSITE Newsletter* 22, 3.

Rubenstein, H.R. (1990) 'Welcoming workers' *Museum News* 68(6), 39–41.

Swade, D. (1991) 'Napoleon's waistcoat button: modern artefacts and museum culture' in *Museum Collecting Policies in Modern Science and Technology*, Science Museum, London, 19–23.

Waldis, A. (1986) 'The Swiss Transport Museum: 25 years of service to transport and communication' *Museum* 38(2), 75–8.

Walsh, K. (1992) *The Representation of the Past: Museums and Heritage in the Post-Modern World*. Routledge, London.

11
Making City Histories

David Fleming

Museums and urban history have, until relatively recently, not mixed at all well. There may be many things museums have failed to achieve in their various societies, but their failure to enlighten people about the nature of urban communities, historic or contemporary, has been of heroic proportions. Analysis of those communities has rarely been better than superficial, as curators world-wide, prisoners of their own cultural origins, have either simply shown little interest to start with, or have allowed themselves to be overwhelmed by the sheer scale of towns and cities, especially in the industrial and post-industrial eras.

A natural, albeit safe and conservative, preoccupation with object-based material culture, but at the expense of dangerous people-based historical themes, has fomented this narrow approach. In particular, it has tended to exclude all but a minority of townspeople from museum interpretation, producing exhibitions and programmes where the technology, design and aesthetics of largely unrepresentative objects has clear primacy over social history, and where there has been too little attention paid to the realities of urban culture. It has restricted curators in their thinking about how active museums could be, and how ambitious in their aims; it has encouraged curators to take refuge from change in society behind that which makes museums 'unique'.

The rise and rise of local, social and, ultimately, urban history has, though, begun to have a profound effect on museums, and one has a distinct feeling that city museums are finally about to come into their own.

Motivations

World-wide, progress remains fitful, but is quickening, with museums in the USA in the vanguard (Chester, 1995; Kahn, 1995; Lubar, 1995;

MacDonald, 1993; Scranton, 1995; Wallace, 1993). Meanwhile in the UK, if the momentum of the past few years is maintained, we shall soon have city museums in abundance. Or, at least, we shall see in abundance museums in cities which are, at last, attempting to address urban issues in a structured and positive, rather than anecdotal and reactive, fashion.

There is probably more to this increased emphasis on the urban experience in British museums than a simple response by curators to the undoubted shift in the academic writing of history. On the one hand, this shift has been wrought in part by a democratization of formal education, a lengthy process which has most certainly impacted upon the curatorial profession, leading to a quite dramatic attitudinal change towards the function of museums and their responsibility to the public at large. No longer are educational opportunities restricted to a social élite, whose exposure to and interest in marginalized groups is at best limited, and at worst absent altogether: and no longer are museums governed solely by such people. Change is being driven from within, by people who are better equipped to respond to new societal needs, to recognize what museums can aspire to be.

On the other hand, there are the cumulative demands of a system of local government which is dominated by socialist politicians. Local authorities, as they scrutinize their efficiency and their effectiveness in response to central government's unrelenting hostility, are requiring more of their museums than formerly: change is being demanded from without. These demands are part ideological, part economic, driven by perceived social and educational needs, and by cultural competitiveness between cities looking to diversify their post-industrial role and towards European tourist currencies. That these twin demands are not always reconcilable is worth noting: as museums have entered the tourism market-place, is there really much economic mileage in city museums which insist on addressing the true horrors of much of urban life? Conversely, how can so-called 'neutral ground' museums – ones wherein beautiful assemblages of objects are left to speak for themselves, and largely to tourist audiences – enfranchise the urban masses? We must, in any event, never forget that city museums are invariably public bodies, funded with public moneys: they are part of the political system, they are not independent, and because of this they will have to respond to society's demands, as manifested through political agendas, like it or not.

Elsewhere in the world the motivating factors in the creation of new, improved city museums are perhaps more diverse. In some cases, especially in capital cities or similar, the question of national or regional identity is a recognizable element (Blokh, 1994; Hermansson, 1995; James, 1993; Labi, 1993; Silier, 1993). Sometimes, especially in former Eastern Bloc countries after the demise of communist regimes, political

change has led to a renewed scrutiny of city histories (Bartmann, 1995; Boroneant, 1993; Buzinkay, 1995; Cepic, 1993; Dementieva, 1993; Koltomova, 1995; Kolveshi, 1993; Meller, 1995; Poroszlai, 1993; Rihter, 1995). Multi-culturism and a perceived role in helping knit together different ethnic or religious groupings are recurrent factors which illustrates the growing global acceptance that city museums should involve themselves in social issues, and should address themes which have been under-represented (Anderson and Reeves, 1993; Bryman, 1993; Buzinkay, 1995; Collins, 1995; Dufresne, 1995; Frostick, 1993; Galla, 1995; James, 1993; Labi, 1993; Lacey, 1995; van Lakerveld, 1993; Maguire, 1993; Montpetit, 1993; Parkhill, 1993; Silier, 1995; van Veldhuizen, 1993).

The limitations of material culture

Museums which were once merely *in* cities are increasingly adopting the role of being *of* cities, and entering into dialogue *with* cities. In so doing they are encountering a vast new range of problems, issues, challenges and opportunities. Moreover, there is debate about the role city museums should play within their urban society. Nobody seems seriously to question the need for museums to address broader audiences, to allow into the church those once so effectively discouraged, and even the most conservative among us now accepts that museums which deal with urban society must attempt to do so by including in the story those who traditionally have been excluded – the poor, women, children, minorities. This attitude remains tempered, though, by the restraints placed upon us by the use of material culture as the main medium through which we communicate our messages. This gives us problems for two reasons: first, museum collections are not representative of the history of a city in any but the narrowest areas. Secondly, it is impossible to assemble collections which are more than purely symbolic of modern urban society – it is too changeable, dynamic and complex. Those who recognize that museum object collections have their limitations as evidence accept that the collections can be augmented by archival records, photographs, film and memory, perhaps also by music and folklore and the topography, buildings and structures of the city itself. Some believe that drama and dance may also be part of the evidential mix, and, logically, of the museum user's experience.

Nevertheless, the overriding emphasis on the collecting and display of objects has a long pedigree, and it continues to dominate the thinking of many curators. It tends to be those who have raised object worship almost to the point of fetishism, those curators who, though they would assuredly deny it, see themselves as priests, who refuse to accept that

the role of the city museum might go far beyond that of collecting and recording, displaying and publishing, and enter into a more active role within city society. A preoccupation with objects leads inevitably to acceptance of a sedentary role for the city museum, because objects alone, in terms of their survival (accidental) and selection (passive or subjective, neither being a guarantee of any genuine representativeness), only allow us to go so far. One does not want to deny the potential power of objects or, indeed, their value as evidence but one must accept their limitations or their power becomes locked in. Some might argue that curators have been content *not* to release this power, secure in their own knowledge and monopoly of information. Big questions about making city histories in museums include what objects to collect, and what to do with them. Bigger questions still, though, are how far beyond the objects should we go, and how far beyond the museum? These are intensely challenging questions because museums, by their nature, tend to look backwards not sideways, let alone forwards, but if they are not faced up to, then the real potential of city museums will never be realized.

City histories

Cities world-wide come in many shapes, sizes and ages. Some large cities, such as St Petersburg or Chicago, are relatively new; others, like Beijing or London, have great antiquity. The same is true of smaller cities. City histories are big histories. In cities, everything that could happen, happens; everything that could have happened, has. If city histories were mere biographies, then their scale would defeat description. As it is, city histories in museums are more than biographies, they are complex systems of communication, as cities are complex processes; remember, cities such as Tokyo, São Paulo or New York have populations greater than those of many nations. By the year 2000, Mexico City will have a population greater than that of Scandinavia, and that is based on only the official estimate of a population, 40 per cent at least of which lives in squatter settlements.

Despite the complexity of cities, and the endless range of cultural factors which differentiates each from the others, there are common themes, such as housing or work, gender or age, the role of neighbourhood or social stratification, which can provide structure to analysis. Other than population density the most obvious of these is chronology. All cities have origins as urban settlements, whether lost in the mists of time, or identifiable with a known event. Athens was a large city 2,500 years ago, while Montreal celebrated only its three-hundred-and-fiftieth anniversary in 1992. Middlesbrough in the UK is younger still, Brasilia (current population over 1.5 million) was virgin rain forest

just 50 years ago. No two city histories are the same, but all cities have histories. One of the initial challenges to the city museum is to decide how to approach what might be a very long history indeed.

Consider a scheme for a new city history museum which is currently underway in Istanbul. This scheme has to confront just about every difficulty conceivable: it is a city so ancient it was captured by the Emperor Darius in 6 BC; it is a city so populous that no one knows exactly how many people live there – as always, it depends where one stops counting – but there are well over 10 million souls living cheek by jowl in and around the core of the old city. Even in the seventeenth century, over one million people lived there.

In coping with the history of such a very ancient city, in museum terms, it may be tempting to cite the absence of material survivals as a reason to avoid tackling the early years. In the museum itself, why do we not simply point people in the direction of the surviving architecture or towards the urban topography in general, and concentrate the museum's efforts on more recent times, from which material survives in relative abundance? I will return to this below. The trouble is that as we near the present day, it becomes more and more difficult to relate any coherent story because we have such a superabundance of material evidence: what do we choose to include? What properly represents an urban society of over 10 million people? So, if we avoid antiquity because we have so little, and yet we struggle to come to terms with the present day because we have too much, we tend to drift in the direction so familiar in many museums which uncompromisingly venerate material evidence as 'what museums are about' – the object-rich zone of the nineteenth, perhaps the eighteenth, and certainly the early twentieth centuries. Except we are landed straight back with the problem of the unrepresentative nature of collections, a story which has limited historic sweep, and a museum out of touch with contemporary issues.

These problems arise only if we adhere too slavishly to the value of material evidence. If our city museum starts from a desire to tackle the history, rather than from a desire to display or interpret whatever material evidence we have to hand, everything becomes clearer, at least in principle. The history itself is no less complex, but at least we are not strait-jacketed by collections which can never be more than indicative: we can deal with the whole story, we can use whatever sources are available as evidence, we can employ whatever interpretative devices we like – in Istanbul's Archaeological Museum, amid one of the world's richest collections of Graeco-Roman antiquities, possibly the single most inspirational exhibit is a modern model of the Trojan Horse.

In a city such as Istanbul, there are numerous physical remains of remote periods – Haghia Sofia, the Basilica Cistern, the Theodosian

Walls or more recent, Topkapi Sarayi, the covered Bazaar, the Suleymaniye. There are museums, such as the Archaeological Museum, the Military Museum, the Ataturk Museum, the Mosaic Museum, and many others. There are stretches of water – the Golden Horn, the Bosphorus, the Sea of Marmara – which have witnessed world famous events, real and mythological. There is old Stamboul itself. The visitor to Istanbul is surrounded by history. Many argue that any city is already its own museum, and there is truth in this. Surely, though, a major role for the new museum of Istanbul is to help make sense of the rest. Here we begin to touch on part of the essence of the role of the city museum, and the 'making' of city histories in museums – the synthesis of material and non-material evidence, the city museum as gateway to the city's history, as a focal point.

Long and complex city histories are most concisely related in books. Indeed, a history is a written work. A museum is, self-evidently, not a book. Beyond its role in research and collection management, in all its senses, a museum is essentially a place people visit for educational and social purposes. Because of this, more people will encounter a city history in a museum than will read a book on the same subject; it is likely to be their first encounter with the city's history in any structured sense. It should not, though, be their only one. It matters little what forms of exhibition the city museum presents. It is probably a good idea to have some form of basic 'permanent' display which explores the city's history in some detail, depending upon how much space there is, though the judicious curator will mix the media, the pace, the degree of interactivity, the use of humour, the atmosphere in order to bring the story to life. Different curators, given the same evidence to work with, will produce different histories. We are people, we are different from each other, we have our prejudices. In itself this is not difficult to achieve, providing there is a basic commitment to integrity, openness, and to allowing a place to those so often excluded from the story in the past. Naturally, programmes of activities, lectures, demonstrations, living history, drama and so on, will be used to augment displays, and exhibition programmes will ensure a variety of subject-matter, continually refreshed. Ideally, there will be publications on offer too. This is all very basic stuff.

However, the city history must break out of the museum itself, which should be regarded as just the beginning of an adventure, not the whole story. No museum in any city in the world – let alone one the size of Istanbul – can encapsulate the city's experience completely. So, the museum's role, beyond providing an initial contact point, is to signpost other activities. Such activities will revolve around visiting or making use of other sites, facilities and institutions in the city. These include historic buildings, secular and religious; different 'quarters' of the city;

road systems, bridges and waterways; factories; parks and gardens – the list is very long. In many cities there is a system of guided walks into which the city museum should be keyed. Then there are other museums, or similar. Amsterdam has its city museum, the Amsterdam Historisch Museum, but it has many others, each of which has its part in giving access to the city's history. Among these are the Kromhout Shipyard, Rembrandt's House, Anne Frank's House, Museum Amstelkring, the Royal Palace, the Jewish Historical Museum, the University Museum, the Museum of the Resistance, the Rijksmuseum. These museums conjure up different aspects of the city, including the story of its religious, artistic and maritime development. There is the Madame Tussaud Scenerama, which takes visitors into the Dutch Golden Age, quite clearly whetting their appetite for more – they are even urged to visit the Rijksmuseum in order to find out more about Rembrandt and Vermeer, both of whom have starring roles at Tussaud's.

There is still a museum tendency to sneer at the likes of Tussaud's; nothing could be more foolish, or arrogant. These places are not a threat, they are an opportunity. Museums should work in concert with the profit-making heritage sector, rather than wish it would go away – it won't, and nor should it, because today's visitor to the London Dungeon is tomorrow's to the Museum of London; that's up to the museum. Then there are the archive centres, libraries and study centres, learned societies, colleges and universities, all of which will, in their own ways, have city history on offer. The city museum should act as their gateway. Examples of this kind of 'catalytic' or holistic approach to a city's history, a sort of 'urban ecomuseum' if you like, can be found in a number of places in varying degrees of sophistication. The Montreal History Centre is an example of the genre, although it holds only tiny collections of its own and purists may question whether it is a city museum at all (Collins, 1995). It seems very likely that, as city museums grow in number and as they continue to look for interpretative approaches beyond the presentation of unrepresentative collections, this pattern of activity will become more common.

There is another very big issue here. City museums which break out of the confines of the museum itself in such a fashion, are not really breaking with tradition, more stretching it a little. Objects are not dismissed or relegated, they are merely being set in a wider context, partially to produce a fuller, longer history, and partially to fill some of the thematic vacuums which object collections cannot. Where the extrovert city museum starts to look more revolutionary is when it adopts a proactive role in contemporary societal issues, when it begins to act as an agent of social change.

The museum as an agent of social change

This proactive role is becoming more clearly understood and articulated by British social history curators, but it is a role still barely conceived of by others, mainly because of the enduring image of the museum as a concern only of the educated, better off sectors of society. To some people, including museum insiders, it is unthinkable that city museums attempt to involve themselves in big urban issues, and they ought instead to concentrate on working effectively with material culture. They should not put people before objects, and they should not attempt to address subjects in museums which cannot be illustrated with objects. It is unlikely, though, that too many city museums in Britain will accept such limitations, with their resonances of maintaining a tradition of restricted access and of a failure to respond to massive social change.

The British urban environment is in a spiral of decline. Poverty, unemployment, crime, chronic ill-health and racial tensions are features of towns and cities all over the country, and urban riots are an increasingly common phenomenon. It is not likely that this situation will improve in the foreseeable future, and things are likely to continue to deteriorate. Urban poverty, of course, is not new. It has always been deeply engrained, and yet museums, concentrating as they have on material culture, have managed to ignore it almost totally.

Beyond facing up to the neglect of the poor throughout history, the city museum should, like other sectors of society, confront the contemporary world head on. This has been recognized, if not yet always acted upon, fairly universally and examples of city museums playing an active role in society can be cited from all over the world.

By 'active role' I refer to the museum accepting the need to adopt an attitude of open access, participation and co-operation, to integrate its more traditional functions, such as interpreting material culture, with new ones. An example of such an attitude is the 'Museums in the Life of a City' initiative in Philadelphia, USA (Hamilton-Sperr, 1992), which set out to enhance 'the appreciation of cultural diversity and to reduce prejudice and racism', and to build museum/community partnerships. The Philadelphia initiative recognized that relationships between museums and others are an essential prerequisite for progress – museums can achieve little alone, but in partnership they can effect change. The initiative also accepted shared decision-making and a basic commitment to education. The kind of issues addressed by the initiative included crime, drugs, homelessness, children at risk, unemployment, racism. The partners of the museums involved included a housing association, a performing arts centre, a Cambodian Association, the Salvation Army, a zoo. The activities brought about through the

initiative ranged from setting up an urban nature centre, to science workshops, to creating internships at inner-city 'camps', to oral history projects to music, crafts, story-telling, films and dance, all on behalf of ordinary Philadelphia people.

Other lessons learned through the initiative were that it takes real commitment and *time* in order to build something which will last, which will make an impact, and that such partnerships are not always easy to set up or handle. Our work in Newcastle upon Tyne has much in common with the Philadelphia initiative. We too have had partnership projects, no two the same, no two with the same objectives, and with a variety of organizations. An example is a homelessness project involving a community-based adult education organization (On With Learning), parents of children at a nursery school in a part of the city suffering from severe social and economic problems (Ashfield Parents Enterprise) and homeless people or people with experience of homelessness. For this we managed to raise special funding, and our joint ambition has been to increase awareness in the city of homelessness and the plight of homeless people. Another project was the Alternative Motor Show, wherein young people from Newcastle's deprived West End put on a series of dance performances, for the first time in their lives, on the subject of car crime, an almost endemic problem in north-east England. Our major partner in this project was Dance City, a National Dance Agency, whose approach to working with disadvantaged communities closely resembles that of Tyne and Wear Museums, and with which we continue to work on joint projects.

Cities are full of such potential partners, all of which have their own agendas, and the keys to success for museums in forging partnerships are flexibility and imagination. These organizations are unlikely to approach the museum, and we have to be proactive or nothing will happen. Indeed, we may not be talking about 'organizations' at all, but loose, perhaps barely recognizable groups of people with something in common. Partnerships bring new, innovative ways of thinking for all concerned, they involve agencies which can pool experience and resources, and their output can greatly exceed that of the partners working in isolation.

Our belief here in Tyne and Wear is that we should go much further than 'involving' people in our museums and giving people a platform to express their concerns; we must work, with all our city partners, to ensure that museums and the inhabitants of our million-strong conurbation are involved in a series of dialogues and joint initiatives. The museum, in other words, has to extend beyond facilitating, which is an ostensibly attractive, but ultimately limited, function. Museums should make use of their perceived 'cultural authority' which, while readily misunderstood, can be a source of great encouragement to

ordinary people, providing relationships are built on a mutual trust rather than on cultural control. So committed are we to this belief that, as I write, we are preparing a major long-term initiative which will build upon, and bring renewed impetus to our partnerships, and produce a framework for our own programmes into which will be keyed the agendas of other agencies – museums, art organizations and venues, historic sites, sports and leisure providers, and venues, industry, commerce, educational institutions and agencies, training institutions and agencies, charities, the voluntary sector, welfare bodies, community associations and forums, and many others. Our initiative will not threaten nor divert the agendas of others, but it will be a flexible blueprint for joint activities, as well as a clear manifesto for the museum service. It will create an urban network which crosses disciplines constantly and which, therefore, offers a host of opportunities for access.

Those who make city histories in museums ought to ensure that their underlying philosophy is one which insists that people have a right to expect museums to be proactive, and involved in contemporary urban issues, so that effecting social change becomes *the* central aim. There are those who think the city museum should not or cannot fulfil such a role, and there are many who believe it must.

Acknowledgements

Many people have contributed (often unwittingly) to the thoughts expressed in this chapter – through their writings and lectures and through conversations. I should particularly like to acknowledge Janet Archer, Gina Barron, Ann Bukantas, Tim Chester, Stuart Davies, Liz Frostick, Cathy Ross, Alex Saint, Helen White, Penny Wilkinson and Alisdair Wilson.

References

Anderson, M. and Reeves, A. (1993) 'From tranquillity to provocation? Australian museums and urban communities' in Johnson, N. (ed.) *Reflecting Cities*, Museum of London, London, 109–15.

Bartmann, D. (1995) 'The Berlin City Museum and its extension building with the Jewish Museum'. Paper presented at the Second International Symposium on City Museums, Barcelona.

Blokh, A. (1994) 'The Leventis Municipal Museum in Nicosia' *Museum International*, 183, 51–3.

Boroneant, V. (1993) 'Bucharest Museum: some general considerations' in Johnson, N. (ed.) *Reflecting Cities*, Museum of London, London, 137–42.

Bryman, D. (1993) 'Making a living, making a life', in Johnson, N. (ed.) *Reflecting Cities*, Museum of London, London, 86–96.

Buzinkay, G. (1995) 'Museums in Hungary: special privileges versus the community' *Museum International*, 187, 35-9.

Cepic, T. (1993) 'A city museum in a new state', in Johnson, N. (ed.) *Reflecting Cities*, Museum of London, London, 143-4.

Chester, T.J. (1995) 'Exhibiting conflict, spirituality, and self identity: appropriate uses of interactive technology in an urban museum'. Paper presented at the Workshop on City and Social History Museums, Istanbul.

Collins, A.M. (1995) 'The city is the museum!' *Museum International* 187, 30-4.

Dementieva, N. (1993) 'The city museum in the changing political climate', in Johnson, N. (ed.) *Reflecting Cities*, Museum of London, London, 130-1.

Dufresne, S. (1995) 'The challenges facing urban museums: linking the past and present. Our experience at Pointe-a-Callière'. Paper presented at the Second International Symposium on City Museums, Barcelona.

Frostick, E. (1993) 'City history museums are only as good as their curators: discuss', in Johnson, N. (ed.) *Reflecting Cities*, Museum of London, London, 165-9.

Galla, A. (1995) 'Urban museology: an ideology for reconciliation' *Museum International* 187, 40-5.

Hamilton-Sperr, P. (1992) *Museums in the Life of a City*. Philadelphia Initiative for Cultural Pluralism, Philadelphia.

Hermansson, N. (1995) 'Nordic capital city museums and their cooperation'. Paper presented at the Second International Symposium on City Museums, Barcelona.

James, V. (1993) 'City Museums in Nigeria' in Johnson, N. (ed.) *Reflecting Cities*, Museum of London, London, 76-80.

Kahn, D.M. (1995) 'New collecting patterns at American city history museums: the case of the Brooklyn Historical Society'. Paper presented at the Second International Symposium on City Museums, Barcelona.

Koltomova, N. (1995) 'Spatial organization of the architectural ensemble of St Peter and St Paul Fortress: Conception of Regeneration and Reuse of Historical Heritage'. Paper presented at the Workshop on City and Social History Museums, Istanbul.

Kolveshi, Z. (1993) 'Some thoughts on political and cultural aspects of permanent exhibitions at the museum of the city of Zagreb' in Johnson, N. (ed.) *Reflecting Cities*, Museum of London, London, 132-6.

Labi, K.A. (1993) 'Modernisation, cultural change and city museums: an Accra perspective' in Johnson, N. (ed.) *Reflecting Cities*, Museum of London, London, 116-23.

Lacey, B. (1995) 'The Tower Museum'. Paper presented at the Second International Symposium on City Museums, Barcelona.

Lubar, S. (1995) 'The story of an exhibit on cultural pluralism'. Paper presented at the Workshop on City and Social Museums, Istanbul.

MacDonald, R.R. (1993) 'The urban Clio', in Johnson, N. (ed.) *Reflecting Cities*, Museum of London, London, 156-64.

Maguire, W. (1993) 'Reflecting a divided city: the case of Belfast' in *Reflecting Cities*, Museum of London, London, 81-5.

Meller, B. (1995) 'History, ideology and politics in the Historical Museum of Warsaw' *Museum International* 187, 22–7.

Montpetit, R. (1993) 'City museums: showing past places in mirrors of the present' in Johnson, N. (ed.) *Reflecting Cities*, Museum of London, London, 105–8.

Parkhill, T. (1995) 'A civic museum in a civil war'. Paper presented at the Second International Symposium on City Museums, Barcelona.

Poroszlai, I., 1993, 'Political Change: Szazhalombatta – Hungary' in Johnson, N. (ed.) *Reflecting Cities*, Museum of London, London, 124–6.

Rihter, A. (1995) 'Celje, the town of history in Slovenia'. Paper presented at the Second International Symposium on City Museums, Barcelona.

Scranton, P. (1995) 'Interpretative issues in city and social history museums: a visitor's perspective'. Paper presented at the Workshop on City and Social History Museums, Istanbul.

Silier, O. (1993) 'The history foundation and the social history museum'. Paper presented at the First Symposium on Social History Museums, Istanbul.

Silier, O. (1995) 'The Istanbul Museum Project becomes tangible'. Paper presented at the Workshop on City and Social History Museums, Istanbul.

van Lakerveld, C. (1993) 'Whose museum? The Amsterdam Historical Museum and the multicultural city' in Johnson, N. (ed.) *Reflecting Cities*, Museum of London, London, 101–4.

van Veldhuizen, A. (1993) 'Museum education in a multicultural city' in Johnson, N. (ed.) *Reflecting Cities*, Museum of London, London, 97–100.

Wallace, M. (1993) 'Razor ribbons, history museums, and civic salvation: a key-note address' in *Reflecting Cities*, Museum of London, London, 8–25.

12

Travellers' Boots, Body-Moulding, Rubber Fetish Clothes: Making Histories of Sub-Cultures

Amy de la Haye

Clobbered, ex-army, travellers boots, body-moulding, rubber fetish clothes and shredded psychobilly jeans are not items usually associated with the Victoria and Albert Museum, yet sub-cultural clothing now forms a significant part of the Textiles and Dress Collection. Since 1993, some 200 outfits from various sub-cultures have been acquired and these were displayed in the 'Streetstyle: From Sidewalk to Catwalk' exhibition, which ran from November 1994 to February 1995. This explored and presented two themes: authentic sub-cultural clothing from the 1940s to the present day and the high fashions which they have inspired stylistically, reversing the well-known 'trickle-down' theory. This chapter is concerned with the first. It initially sets out to explore the nature of sub-cultures and the role of style as a means of expression within them. Then, using the 'Streetstyle' exhibition as a case study, it discusses the possibilities and constraints of making histories of sub-cultures within museums, with specific reference to clothing.

A sub-culture is a distinctive group whose *moraes* are often at variance with those of the dominant culture. Sub-cultures function on many complex levels and this chapter can only attempt to address a few of these issues. Youth has always dominated sub-cultures and members are usually working class, as opposed to middle class (the latter are often referred to as counter-cultures, but here the term sub-culture is used to embrace both). For some young people membership is brief, forming a rite of passage, while others move through a series of sub-cultures and for some, commitment to one sub-culture is life-long. In many ways, membership is liberating, offering certain freedoms, in terms of lifestyle, sexuality, politics and personal appearance. Yet, sub-cultures also define their own boundaries and in doing so provide a sense of belonging, independent of the family.

Amy de la Haye

Post-war sub-cultures emerged partly as a result of increased levels of youth affluence. Between 1951 and 1964 Britain experienced a more rapid improvement in living standards than at any other time this century. The main beneficiaries of this were working adolescents, among whom incomes rose most dramatically. In his 1959 survey, *The Teenage Consumer*, Mark Abrams calculated that, in real terms, the discretionary income of this newly identified market sector had risen by 100 per cent since 1938. In America, sub-cultural style emerged some ten years earlier, with a small group of relatively affluent Caribbean American and Hispanic youths who adopted flamboyant zoot suits, asserting their black identity and flagrantly flouting wartime clothes and style restrictions. This fledgling economic base created unprecedented new markets and patterns of consumption. Alongside the dominant culture of youth, emerged sub-cultures with their own music, agendas and distinctive styles of clothing and adornment.

Music has always fuelled sub-cultures and together they have asserted themselves most notably in America, the Caribbean and in Britain. Stylistically, musicians and singers have often represented the ultimate to their sub-cultural fans, who have copied them avidly. However, as always, there are exceptions: for the Casual, the focus is not music but the football stadium, and for the Skater, skateboarding is the driving force. While music and sub-cultural developments are international, they are inextricably entwined with British culture. The reasons for this are clearly complex, but undoubtedly due in part to the existence of class structures and post-war art school education.

Among sub-cultures, it is style which first and foremost signifies allegiances, to kindred members and to the world at large. 'Streetstyle' is a term loosely used to describe the clothing and body adornments adopted by sub-cultures. A New Age Traveller called Fraggle (an assumed name) is a member of the Donga Tribe, who are based in the Forest of Dean and campaign to preserve the countryside, states, 'We dress brightly because we are really positive and optimistic – our lives aren't boring or bland. We use our clothes to relate to each other; you can look at someone and see you are part of the same family'.[1]

Within the stylistic boundaries of sub-cultures, there is much emphasis upon personal expression and clothes are often home-made or customized to individualize off-the-peg garments. It is predominantly small specialist retailers, tailors, markets and mail-order catalogues that serve the demand for sub-cultural clothing. Many designers are self-taught and start by making clothes for themselves and their friends (in contrast to mainstream fashion designers who are often formally college-trained). They have insight into the demands and tastes of a particular group and reflect, create and develop its style. Production is small scale and designs change frequently to ensure exclusivity. These

144

are supplemented with items from specific, large-scale manufacturers whose product is deemed 'authentic', such as Levi jeans, Doctor Martens footwear and, more recently, Joe Bloggs casual clothing.

In addition to creating and embracing their own material culture, sub-cultures also appropriate objects and styles from the dominant culture. It was the élite Savile Row vogue for Edwardian revival style tailoring which formed the stylistic basis and name of Britain's first sub-culture, which emerged in South London during the early 1950s. The New Edwardian style was subverted and transformed by the group that subsequently became known as the Teds. They exaggerated and parodied the original style and combined it with elements from American zoot suits (notably the extra long jacket) and western cowboy styles (the bootlace tie and the half-moon pocket detailing with stitched arrowheads). This eclectic approach, drawing upon the styles of other sub-cultures, united by their rebellious defiance, has become a sustaining feature of Streetstyle.

It is widely thought that sub-cultures actively dismiss seasonal changes in high fashion, but to some, top international designer clothing forms a core of their style. What is significant is that the appropriation is different to that of the fashion market. As stated earlier, it was the New Edwardian vogue which provided the catalyst for Teddy boy style. In more recent years, Louis Vuitton and Gucci accessories have represented the ultimate to B-boys and Casuals have gone to great lengths to obtain Burberry and Ralph Lauren clothes. Likewise, many contemporary Ragga girls are inspired by Chanel's use of black quilted fabric, leather entwined chain and interlinked 'C' trademark, and the style of Jungle fans is based around blatantly labelled top international fashion labels (notably Moschino and Armani). While in all instances the original designer-labelled item is infinitely desirable, fakes are most often the reality, yet somehow retain some of the cachet of the original. There are also examples of sub-cultures which reflect fashion changes within their own distinctive style. Teddy girls, for example, wore long, narrow, pencil-skirts in the 1950s but by the early 1970s, their velvet trimmed drapes were frequently teamed with mini-skirts. Indeed many groups with a complete anti-fashion stance, have an awareness of the prevailing modes in order to oppose them, while others are undoubtedly oblivious.

Sub-cultural clothing is thus highly complex, with few standard rules and much emphasis on individual interpretation. It is also resonant with socio-anthropological meaning. In his influential book *Sub-Culture: The Meaning of Style*, Hebdige (1979: 130–1) emphasizes that the significance of sub-cultural style lies within its own environment and that:

We should not attempt to lift them too far from the contexts in which they are produced and worn. If we are to think in formal terms at all, sub-cultural styles are more usefully regarded as mutations and extensions of existing codes rather than the 'pure' expression of creative drives, and above all they should be seen as meaningful mutations.

As curators, with a central concern for objects, their interpretation and presentation within museums, we embarked on constructing a history of sub-cultural clothing with some trepidation.

Clearly, it would have been impossible to convey the youthful angst and energies which charge sub-cultures within a museum gallery. Contextual settings could never have captured the spirit of a crowded, smoke-filled night club with loud music, a coffee bar, a pub with a band playing or a forest camp, and we therefore chose to avoid this approach. The very few supporting 'props' were motorbikes in the Rocker and Mod sections and a customized surfboard. Thus, the displays in the exhibition were almost exclusively devoted to clothing. This allowed the visitor to focus in detail upon this specific, and largely unexplored, area of the material culture of sub-cultures.

From the outset, it was apparent that it was going to be much harder to find original, American, western-style clothing from the 1940s than a Dior New Look cocktail dress of the same date, although the latter was produced in infinitely smaller quantities.

It was equally difficult to discover certain more recent items, such as a Northern Soul suit from the mid-1970s and a pair of Bjorn Borg Diadora training shoes, worn by Casuals in the 1980s. (Both were eventually sourced after fashion editor Marion Hume put out a call for help on the fashion page of the *Independent* newspaper, which part-sponsored the exhibition). The material culture of sub-cultures is often ephemeral or is passionately retained for sentimental reasons. In the case of clothing, it is often still worn by purists devoted to the original styles, who refuse to part with these cherished items, even temporarily. In all periods, it would have been easier to obtain high fashion; the routes are established and the sources largely Establishment – fashion houses, designers and their clients, museums, specialist dealers and private collections. To attempt to acquire and present a history of sub-cultural clothing was a totally different matter!

In 1992, the Victoria and Albert Museum had virtually no streetstyle clothing. After considerable debate about the proposed 'Streetstyle' project and its relationship to the existing holdings of dress and accessories, we actively set out to acquire a new collection to form the basis of the exhibition. The decision to collect in this field was a radical departure for the V&A. However, we felt that it did fall within the Textiles and Dress Section's policy to acquire contemporary dress,

which has always focused upon design that leads. Traditionally, this was the most luxurious *haute couture* and top levels of ready-to-wear clothing, and the collection was unashamedly élitist in this respect. Sub-cultural clothing also falls within the V&A's remit to acquire the 'cutting-edge'. As the national collection of the decorative arts, the museum acknowledges the wide cultural significance of streetstyle and its inextricable links to Britain.

Early on in the project, we made the ambitious decision to represent the major developments in streetstyle from the 1940s to the present day. The focus was upon Britain, although some crucial developments in Caribbean and American sub-cultures were pinpointed as critical elements. With inevitable financial and spatial limitations, this meant that only a few examples of the stylistic diversity within each sub-culture could be represented. The exhibition was arranged chronologically and groups were sited according to the date of their emergence. Some 50 sub-cultures were included, in addition to areas which were not strictly sub-cultural, but were pertinent, such as the Caribbean style and the gay and lesbian style sections. We sought to show early examples of each sub-cultural group, revival styles and examples of male and female dress.

Though we had a broad overview, we lacked the detailed knowledge of the, often subtle, cultural and stylistic nuances of each sub-culture. To obtain accurate contextual information about the individual sub-cultures and identify people who still owned clothing, we invited the support of a number of, what became known as specialist advisers. These were people with wide-ranging backgrounds and experiences, who usually were, or had been, linked with particular sub-cultures. Contact was made by attending the relevant pubs, clubs or events, by contacting specialist magazines and shops, and through word of mouth. The uniting force of the advisers was their generous commitment to the accurate representation of the sub-cultures to which they had insight and access, within the context of the museum.

The aim was to acquire clothing put together and worn by 'real people'. We didn't set out to achieve that which was 'typical' or 'definitive', as clearly there is no such thing. In many instances, the specialist adviser identified the clothes that we subsequently acquired or introduced us into a network of people, among whom we eventually found someone who had kept their clothing and were prepared to let us use it. Ideally, we sought to obtain a complete outfit from one person who acknowledged their allegiance to a particular sub-culture. In addition to obtaining 'authentic' clothing, we had the additional advantage of obtaining oral evidence from the wearer, sometimes supplemented by snapshots of them wearing the actual items.

Mandy Jarman was represented in the skinhead section, which was

co-ordinated by Shaun Cole. Mandy provided her two-piece green/gold Tonik suit, checked shirt with button down collar, mackerel tights and flat-heeled, crepe-soled, lace-up shoes, which she wore during the early 1990s as a purist revival style. The suit was made from original 1970s Tonik cloth which was made-up by MMM tailoring in Walsall for £250. Mandy stated

'I had it originally tailor made, as you can't buy these three-quarter length style suits off-the-peg. They were worn by original style skinhead girls in the late 1960s and early 1970s. They were worn mainly for best, for evening wear, dance halls – not a working-class outfit for daily use.'[2]

This was one of the few instances that someone involved in researching or providing clothes identified themselves in terms of their class position.

After many attempts to trace 1950s Teddy boys and girls, who were prepared to part with rare original clothing, even as a loan, we put out an appeal on the BBC Television's *Clothes Show*. The response was positive and we made contact with Pat Essam (née Goodman), who provided a black barathea, drape, jacket with silk velvet trim. On the label which accompanied her jacket, she wrote: 'I felt the bees knees in this jacket. I saved for it and really loved it and that's why I kept it for forty years. It still fits me and I still love it.'[3] The jacket was made-to-measure in 1954 by Weavers to Wearer, a Northampton-based tailors, and cost £10. She wore it with red tartan trousers and leather sandals (which laced up the leg), during the day and with a black pencil skirt and winkle-picker stiletto-heeled shoes for evening. A snapshot of her wearing the jacket was also displayed.

It was not always possible to source the clothes direct from the wearer, partly as a result of financial restrictions, which, for example, prevented travel to America or the Caribbean. We did our best to overcome this, by approaching people who had been involved with various sub-cultures, who no longer had their clothes but were prepared to re-create outfits they had worn. Individual items were then obtained from specialist clothing dealers, period and new clothing shops. In addition to acquiring items for the Dress Collection, we identified loans from people who could not bear to part with their cherished clothing for more than the three-month duration of the exhibition.

In four instances, after searching long and hard, we decided as a last resort to have replicas made of key ensembles: the male and female zoot suits, a hipster suit and the male Caribbean style suit. The zoot suits were based on the influential 1943 film *Stormy Weather* starring Cab Calloway and Lena Horne. Chris Sullivan designed the male suit, which was made up by Chris Ruocco Tailors. Chris spearheaded the

purist zoot suit revival in the early 1980s with his band Blue Rondo a la Terk, and has done much research into the original styles of dress. Cherry Parker, who was also involved in this scene, researched, designed and made the female outfit. Chris Sullivan and Chris Ruocco also provided the male hipster suit. The male Caribbean style suit was made by Derek Lilliard, who owns a tailoring shop in Covent Garden. This suit was a replica of those made in the Caribbean and worn in Britain in the late 1940s and early 1950s. Derek sought meticulous advice from his family and their Caribbean fabric supplier contacts.

We felt that it was important to involve visitors in thinking about how the clothing was obtained. Where we had particular difficulty obtaining an original, we clearly stated this on the label and stressed that the outfit displayed was a modern replica. We also hoped that by doing this, original items might come forward and were rewarded with a Rude boy outfit two weeks into the exhibition. This came, complete with underpants, from Gaz Mayall, manager of many 1960s Ska bands, and consisted of an original 1960s suit combined with items from the late 1970s when it was worn.

Each outfit had a 'clothes specific' label, which detailed the sub-culture, date and place it was worn and by whom, with specific information about the clothing fabric, makers, etc. All participants were invited to make a personal statement about their outfit and this formed the main body of text, usually in the form of a direct quotation. These were then drafted and sent to each 'wearer' for amendments and approval. Where possible snapshots of the wearer, in the same or similar styles to those shown in the exhibition, were also added and served to put 'flesh and blood' into the clothes.

Contextual information panels devoted to the history of each sub-culture were checked with the specialist advisors who had, in most cases, already provided or confirmed key facts. Photographs were also selected in conjunction with them and functioned to reveal stance, attitude, hair and cosmetic styles. They also served to show further variations on the clothing styles shown. Photographs were blown up as backdrops and were also used on the panels.

The mode of display and, crucially, the choice of mannequin was something we investigated and discussed at length. Clearly, standard, usually white, European, 'supermodel'-size, high fashion mannequins were completely inappropriate. We were not presenting imposed ideals of beauty and the mannequins had to be the right size for the clothes to show them as they were originally worn. For example John G. Byrne's 1971 skinhead jeans had to be the right length, just above the boot tops, and the B-boys baggy trousers had to drag on the ground. After much thought and consultation, we chose fibreglass 'flatbacks' produced by Universal Display Limited. These are torsos supported by specially

commissioned adjustable leg poles which facilitate variations in height. A distressed paint finish was chosen which resembled rusty metal. Abstract metal head designs were conceived by Sharon Beard, the exhibition designer. These provided the necessary proportion and could take hats and sunglasses where required, but avoided any suggestion of race or gender. A few days before the exhibition opened, contributors were invited to approve or adjust their mannequin, before the press and public were admitted.

Exhibitions of clothing are always popular – everyone can relate to the subject-matter and everyone's opinions have validity. This show was particularly people-orientated and appealed to a wide cross-section of the public. There was extensive national media coverage of the exhibition as well as an internally organized marketing campaign. This included eye-catching fluorescent posters, designed by Colin Corbett, and displayed throughout the London Underground, and widespread distribution of flyers. News also spread via the many hundreds of people living the length and breadth of Britain, with whom we had made contact during the course of our research. In its 12-week run some 109,000 visitors came to see 'Streetstyle'. In addition to the very real need of getting heads through the doors, the exhibition visibly succeeded in widening the V&A's visitor profile. The key roles played by the specialist advisers were central to 'getting it right' for a knowledgeable, discerning and critical audience.

Comments slips were available and many were received, often offering clothing, many positive and some critical – mainly about the use of replicas. Some people were disappointed that the clothes shown did not reinforce their own memories, but the plurality of sub-cultural styles and emphasis upon personal interpretations, meant that this was inevitable. However, it is important to acknowledge that museums, whatever their field, are dependent upon showing that which survives, which may not be representative. As far as sub-cultural clothing is concerned, it is possible that the individuals who have kept their clothing, in complete outfits and sometimes for as long as 40 years, were purists and exceptional in this respect.

We were aware that, to fully appreciate the impact of these clothes, it would have been ideal to make a comparison with mainstream fashion of the time, but space restrictions prevented this. Instead, visitors were encouraged to visit the Dress Collection and consider the relationship between fashion and streetstyle. Supporting educational activities, based around the exhibition, non-Western dress and fashion in the Dress Collection served to reinforce this point.

As stated, from the outset the notion of presenting sub-cultural clothing within a museum and 'Establishment' context was daunting. Sub-cultures exist in defiant rejection of the prevailing hegemony. Over

the years, they have been feared, condemned, dismissed, satirized and, more recently, awarded scholarly status. To place the clothes, static and separated from their wearer, within a national museum, primarily devoted to decorative arts, was to legitimize them and in doing so, possibly drain them of their potency. This was a risk we were prepared to take in the interests of a clothes based analysis and the formation of a unique collection.[4]

By staging this exhibition, it has been suggested in the media that the V&A had signalled the end of streetstyle. It is sad that many commentators should only associate museums with 'historical' objects and not recognize that they also actively face the hard, ongoing, challenge of collecting the here and now. Sub-cultures do survive, as the die-hard original, and young purist, Teddy boy members of The Edwardian Drape Society (TEDS) and the 59 Club for rockers testify, as do the host of more recent groups such as New Age Travellers, Ragga and Bhangra Muffins. All have a cohesive identity which is signified by – among other things – their clothing.

Notes

1 Interview with Fraggle by Sarah Callard, 1994.
2 Interview with Mandy Jarman by Shaun Cole, 1994.
3 Interview with Pat Essam by Amy de la Haye, 1994.
4 The acquisition of clothing was co-ordinated by Amy de la Haye and Cathie Dingwall, Textiles and Dress Collection, V&A.

Reference

Hebdige, D. (1979) *Sub-culture: The Meaning of Style*. Routledge, London.

13
Making Histories of Wars

Simon Jones

The depiction of war through museums exhibitions is most likely to be found in regimental museums. These museums often have a limited appeal outside of the individual regiment; partly accounted for by the fact that the British Army is small, professional and somewhat separated from the rest of society. Yet both in historical and contemporary terms, the whole population is affected by war, whether through the impact of international trade, some sense of nationhood or through the bitter experience of bereavement.

These museums, however, were not formed to present war, but for the specific purpose of instilling and fostering in the regiment the *esprit de corps* which enables it to fight more effectively. The depiction of the past in regimental museums is required, therefore, to serve a powerful purpose. Yet, there is much more that could be derived from them. The artefacts in their collections are invested with tremendous symbolism. Uniforms, colours, trophies and weapons, placed in displays which hitherto have appeared to the outsider as mute and irrelevant, are vivid signifiers of those codes and activities which have informed soldiers' lives continuously for several hundred years and which still function in this respect today.

Trophies, tradition and training

The display of war trophies has a long tradition. Military conquest has usually been motivated by material gain and victory was signified and celebrated by displays of weapons and armour taken from defeated enemies. The Romans piled these into triumphal mounds. Trophies were hung from lopped trees to which prisoners were chained; the whole being commemorated in stone statuary. Temples were built as memorials and became repositories for trophies or relics. The forum

constructed by the Emperor Augustus in Rome contained Imperial standards that had been lost to the Parthians in 53 BC and were recovered by Augustus in 20 BC (Borg, 1991).

In more recent times, it was those corps of the British Army with a technical function that tended to be the first to form museums, their collections being based on the models and exhibits used at their training establishments. Thus, in 1778, the Royal Artillery formed a Repository at the Royal Arsenal, Woolwich, which attracted arms and armour as well as many captured items of ordnance (Kaestlin, 1963). The Royal Engineers can trace their current museum to a model-room formed when their school was created in 1812, in which they later also placed trophies and curios taken from around the world. A key impetus in the creation of a proper museum by the Engineers was the bequest of relics from the estate of General Gordon, especially the richly embroidered mandarin uniforms presented to him by the Chinese Emperor in 1865. Killed in Sudan by the army of the Mahdi in 1885, Gordon was held to be an ideal of Victorian Christian morality and heroism, and artefacts associated with him were revered almost as the relics of a saint (see Chapter 18). This introduced a particularly Victorian theme, which became prominent in regimental museums – the presentation of the lives of great soldiers in such a way as to reflect glory upon the regiment and to provide heroes to be imitated. Indeed, the importance of the hero to the regiment was made clear when the Royal Engineers insisted that Gordon's artefacts should be displayed at the School of Military Engineering at Chatham, rather than at the Royal United Services Institute Museum in Whitehall:

> It would be greatly to the advantage of the Corps and the Service at large if a proper building existed at the S.M.E. for the reception of relics and objects illustrative of the lives of great soldiers, etc.; for to place such articles in the R.U.S.I. Museum, or elsewhere in London, however much they may be cherished there for their intrinsic interest, is to surrender their great value both for educational purposes and for fostering a proper *esprit-de-corps*. (Gale, 1894 [unpaginated])

Thus, the purpose of the relics in the museum was closely to associate Gordon and his reputation with the Corps.

Most other regimental museums were established in the 1920s, when units turned material gathered in officers' and sergeants' messes into more formal museum-like historical presentations. When the King's Liverpool Regiment proposed establishing a museum in 1928, the prototype cited was the Salle d'honneur of the French Foreign Legion at Sidi-Bel-Abbes:

Its walls are covered with battle flags, captured in many lands, and the arms of many countries, souvenirs of a dozen campaignes [*sic*]. Photographs of heroes, sketches, medals, etc. fill the spaces between the weapons. This hall is treated with the greatest respect ... Here the recruit learns his first lesson in Esprit-de-Corps. (Kingsman, 1928: 62)

Again the purpose of the museum was clearly associated with the benefit of the regiment, in this instance the enhancement of the self-image of the soldier.

Yet today, in general terms, the purposes of the regimental museum are to educate, promote *esprit de corps* and provide memorials (Amlôt, 1995). If we wonder that regiments present their histories in a somewhat partisan manner, we have only to consider the peculiarly complex and dangerous task governments have allotted them – the killing of enemies on the battlefield. This generally involves the application and direction of violence, in the form of firepower, as part of a controlled and disciplined plan. In this respect – the retention of corporate discipline in the face of danger – warfare is arguably not an activity for which humans are naturally equipped. Every part of the soldier's training must contribute, either directly or indirectly, towards the most efficient performance of this act. This is the principle which underlies the mystery of armies. It informs so many of their arcane and obscure habits and traditions, their directness of expression, their obsessions with drilling, obedience and uniformity, their clothes, equipment and, not least, their self-image.

The challenge facing the curator of regimental collections today is to locate meanings for them which render them relevant to broad audiences. In the case of curators with a military background, the role of the regimental collection is perhaps so obvious that it does not need stating. Yet civilian curators shy away from military collections, perhaps reluctant to bestow legitimacy on them. Yet there are ways ahead. There is a need to explain the regiment to the outside world and to show more prominently the links between its social organization and its work in battle. Without this, the regiments will continue to be seen by many as outside society, out of step with modern realities.

Using the artefacts

Most obviously clarified by this principle are the physical tools of battle, especially weapons and uniforms, but also other trappings of military life such as colours, ceremony, music, drilling and discipline. Weapons, especially in museums of arms and armour, have been treated as pieces of decorative art or technology and abstracted into discrete typological developments. The regimental museum is potentially well placed to

avoid this 'decorative' approach and could offer a more honest appraisal of weaponry. It could show how the weapons which the soldier uses, or has had used against him, dictate his social organization, his dress and his life and death on the battlefield. The effects of weapons can also be seen in artefacts damaged by bullets or shell-fire, which regimental museums will invariably have. The wounds inflicted by and upon the soldier, the whole point of the weapons, are rarely admitted to by museums, a point made by John Keegan (1993: 90):

> I constantly recall the look of disgust that passed over the face of a highly distinguished curator of one of the greatest collections of arms and armour in the world when I casually remarked to him that a common type of debris removed from the flesh of wounded men by surgeons in the gunpowder age was broken bone and teeth from neighbours in the ranks. He had simply never considered what was the effect of the weapons about which he knew so much as artefacts on the bodies of the soldiers who used them.

Weapons have been a key influence in the way that battles are fought. Most of those in the hands of soldiers before the mid-nineteenth century were effective only when used as part of a massed volley. An infantry battalion had to be manoeuvred and deployed as a single entity, like a battleship, and if several 'broadsides' could be inflicted upon the enemy a battle might be virtually won. This did not call for individual initiative in the ranks, rather for the simultaneous execution of a series of prearranged choreographed movements (Black, 1994). To do this in conditions of extreme danger required that the individual be subsumed into the organization as a whole. During the nineteenth century, however, percussion ignition, rifled barrels and improved powder increased the effectiveness of the soldier's weapon. This rendered close order tactics a liability as the dense masses of troops became too easy a target. Devastating fire could be better produced by smaller numbers of men well spaced and concealed.

Uniforms were influenced by weaponry, most especially in the adoption of camouflage once smokeless powder was introduced in the 1870s. Uniforms and badges are often a major constituent of military collections. Those made for ceremonial use are more likely to survive than those worn for work or active service. But, nations and their armies have never fought battles merely for the purpose of wearing distinctive uniforms and insignia. However, museums can make many useful points about uniforms. The development of uniform reflects that of the regiment as a formal institution, and specifically the (literal) importance of uniformity of thought and deed by its members. Military dress has consciously or unconsciously incorporated elements of the

clothing of warriors from other cultures, inferring that the soldier might somehow also acquire their fighting prowess. This has included various types of fur head-dress, frogging braid copied from Magyar horsemen and possibly the resemblance of the Tarleton helmet, conceived in North America in the 1780s, to the dressed hair of the Mahican. The adoption of warrior features on uniforms mirrors the channelling of barbarous behaviour into a disciplined assemblage.

That such features were merged into a standardized uniform reminds us that the discipline of successful European armies required the subordination of the individual to the mass. This is perhaps more typical of an industrial than a warrior society (Keegan, 1993). Uniform signifies the separateness of the soldier from society. In addition, it denotes distinction within the army and each regiment has adopted its own features, often against official regulations. The invention of the Scottish Highland kilt in the early eighteenth century was initially a symbol of a Scottish identity when under threat from Britain. When the British banned Highland dress following the 1745 rebellion, they nevertheless permitted its wear by the regiments of Highland soldiers under their own command. It symbolized the way that the army could subsume elements of other societies into their own system of allegiance (Trevor-Roper, 1983).

Function and symbol

A recurrent theme is the shift from the functional to the symbolic, sometimes in a comparatively short space of time. The scarlet uniforms of the age of gunpowder were appropriate when commanders had to recognize their own men on battlefields masked by dense black smoke. Within a few decades, the bright but obsolete service uniforms of the 1880s were being absorbed into the spectacle of an apparently timeless ceremonial. The rituals surrounding drill and colours have a very special significance to the regiment which may be almost impenetrable to the outsider. Ceremonies strengthen the corporate unity of the regiment by investing it with traditions which become time-honoured. The ceremonies associated with drilling and colours were originally tools to fight battles. Rigid parade ground drilling was the means by which armies manoeuvred compact blocks of soldiery to bring their massed musketry to bear upon an enemy. This was achieved only during the later seventeenth century when cadenced marching began to be practised on specially levelled grounds.

Regiments carried large flags, or colours, bearing national and regimental devices in the centre of their line identifying the point at which the men should rally if attacking or attacked. These were regularly 'trooped' so that soldiers could recognize their own

regimental device. Activities that had to be performed on the battlefield were reduced to a series of individual movements or drills which were then practised repeatedly. In this respect, close-order drill outlived its tactical value, but became ingrained within the ritual of regimental life. It became the method by which young recruits were taught the need to obey orders and perform hard physical work as part of a team, despite conditions of extreme danger, tiredness and confusion (Amlôt, 1995). Recruits were encouraged to subordinate their own identities to that of their regiment; they began to feel less regard for their own safety and more for that of their comrades and their colours. Today, long after colours are required for cohesion on the battlefield, they are still accorded a quasi-religious reverence. Thus they are consecrated when new, and are revered and handled formally at all times. When replaced, they are laid up in churches or some other suitable formal location.

Regimental museums often have significant ethnographic collections. As trophies these have been used to emphasize the power and success of the regiment and to symbolize the defeat of the enemy. They have been displayed in ways which give no clue to their original use, showing only that their owners had been rendered ineffective. As such, they exemplify the Darwinist use of ethnographic material which curators are now at such pains to avoid. An awareness of this legacy might enable the material to be displayed instead as products of complex cultures and appreciated as such.

Can regimental museums be social history museums?

With the influx of civilian curators into regimental museums, what may be termed a social history approach has increasingly been taken. This has been used as a means of making the collections relevant to a wider audience (Wilkinson and Hughes, 1991; Wood, 1986, 1988). The notion of the people's museum has become well established in mainstream practices with a concomitant responsibility to reach out to and involve members of the community. This is especially aimed at those, often the majority, who have not traditionally visited the museum.

A social history approach to military collections and displays has possibilities; especially pertinent is the depiction of war as personal experience. Voluntary enlistment and enforced conscription are significant features of relatively recent warfare. By the late nineteenth century, most European states had introduced compulsory military service. On the outbreak of war in 1914, thousands of men from all walks of life joined up; conscription followed in 1916. The literate middle classes left a considerable literature of recollections of the First World War (claimed sometimes not to represent the majority). Further, war in the twentieth century has more than ever affected the mass of

the population through war-work for women, food rationing and the bombing of civilians in factories and cities. The experience of war was felt directly at a personal level by all classes, whereas at other times it had remained the province of the military caste alone. The experience of the ordinary soldier has come to be regarded, in some cases, as more meaningful than histories which examined wars only from the perspective of commanders or the decisiveness of a battle. The approach is manifested in accounts which have given central prominence to personal recollection through the use of oral history (Keegan, 1978).

It is no coincidence that a museum which has pioneered the collection of the oral history of war was created during the First World War. The Imperial War Museum, founded in 1917, was described by its first director, Sir Martin Conway, as 'a record and a memorial' with

> a direct appeal to the millions of individuals who have taken part in the war or in war-work of any kind ... when they visit the museum in years to come, they should be able by its aid to revive the memory of their work for the war, and, pointing to some exhibit, to say 'This thing I did'. (quoted in Kavanagh, 1994: 130)

Because its aim is to represent the nation in arms, the Imperial War Museum deals with both home and war front experiences. Yet both the regimental museums and the Imperial War Museum were borne out of the sustaining ideology of war. They function as much as memorials as museums and for this reason tend not to question the rightness of the struggles that they are commemorating.

The practices of community involvement developed by social history museums can be used in regimental museums and, through this, common ground can be created for a wider range of visitors. One area researched by the Royal Engineers Museum has been family life. The demands of military life and discipline extend also to a soldier's family, and their welfare is an integral part of regimental life. Yet this had not formed part of the traditional content of the museum and few objects had been collected relating to it. An exhibit, created at the museum in 1988, depicts the sitting-room of the Medway home of a Sapper family during the Second World War (from which the Sapper himself is conspicuously absent) and it is popular among local people. 'Sapper Family Lives' was an oral history project run at the museum to document the experience of life in Germany through the eyes of Army wives. Wives of both officers and men talked of the difficulties of maintaining family life while married to servicemen, as well as the shared pleasures and camaraderie. Amusing and personal artefacts gave the distinctive flavour of life in Germany; Sapper families became more

involved and interested in the museum and a lasting record of family life was formed. An exhibition based on material like this could do something to broaden the appeal of the museum and to overcome its male-orientated image.

The links to the local community can also be used to explore common ground. Often the popularity of local Volunteer forces in the eighteenth and nineteenth centuries was an index of the prosperity and assumed status of local inhabitants. Colley (1994: 296) has highlighted the link between trade and the willingness to join local defence regiments during the Napoleonic Wars, pointing out that those with more of a stake in society were more likely to serve: 'War patriotism, it seems clear, was more likely to flourish where towns and trade did'. Enlistment in volunteer regiments also enabled merchants and traders to serve without being posted away from the locality and so continue to run and protect their business. In the Volunteer movement which arose in the late 1850s it is apparent, especially in major urban centres like Liverpool, that the new trading 'aristocracy' were claiming their place in the local armed forces to augment their economic and political power. In all cases, these links became most strong and were keenly felt during the First World War when both Territorial and New Army battalions suffered heavily.

Another theme which can arouse local feelings is the aftermath of war and remembrance. This can include artefacts relating to bereavement, memorials and the phenomenon of remembrance. It can also depict the welfare of soldiers and their families after war or military service. The experience of mourning and remembrance may have relevance for all bereaved families within the very recent past in, for example, Northern Ireland.

Medals are rewards to individuals which often become their memorials in regimental museums. However, they convey little about the events which they commemorate, the gallant act or the campaign. The number of medals offered and contained within collections means that their display is a major task, yet it is nevertheless a prime function of regimental museums and reaches to the heart of the role of the museum as the shrine of regimental tradition. As memorials, they can achieve some poignancy when displayed with biographical details of the recipient and a photograph. Medals are of course part of the mechanism of maintaining *esprit de corps* and it is noteworthy that they were rarely used to reward individual bravery before the nineteenth century. Instead 'honours' were given to the regiment as a whole, to be displayed on the colours. A universal reward for individual bravery, the Victoria Cross, was not instituted until 1855. By this time improvements in weaponry were rendering close-order tactics obsolete and giving the soldier more individual firepower and thus slightly more importance in the outcome of a battle.

Problems with the social history approach: violence and causation

We have examined how the regimental museum has been part of the process by which the soldier is trained to overcome a human disinclination towards violence. However, curators may be hoping to turn visitors away from violence as a means of solving international disputes and may justify the depiction of war's cruelty and futility as a means of persuading the public to reject it. In spite of such efforts, there are those who remain attracted to war and violence, often the young or immature – probably because it appears to offer a rite of passage. It is possible to pander to that darker side of human nature; the military museum needs to be wary that it is not promoting the very thing that it is trying to avoid.

The examination of the reasons for conflicts has traditionally remained outside the remit of a regimental museum. A social history approach may also omit causation if war is looked at in terms of personal experience only. If curators are not careful, they may leave unanswered the vital question 'why did this war happen?'. Spring (1993: 12) has pointed to the most significant difficulty of all war museums: 'Weapons cannot on their own be used to explain the complexities of and the reasons for conflict'. The causes of wars might be depicted in museums through the everyday commodities which were the benefits of military power and warfare, such as tea or cotton. The British Army was a key factor in Britain's industrial success for it enabled her to control the people and land who were seen as overseas sources of raw materials and markets for her manufactured goods. The army backed up chartered companies and individual traders. Most of Britain's military activity during the last century was devoted in some way to the expansion and defence of the trading realms which became the British Empire. There are already museums devoted to the material results of these military campaigns and perhaps it is equally important for them to acknowledge the role warfare played in their history.

Many of the ideas and concerns expressed here have been incorporated into proposals for the redisplay of the King's Regiment museum collection by National Museums and Galleries on Merseyside. These proposals have been subjected to market research conducted by the Susie Fisher Group through two focus groups, one of parents of children under 16 years of age and one of single people in their late teens and twenties. This revealed ambivalence towards the army and towards the notion of a regimental museum as a medium for presenting a 'true' view of the past.

The approach of placing battle at the centre of the soldiers' experience and way of life, and the issues surrounding this, were

received favourably. Fisher's report (1995: 23) stated: 'The effect of a weapon on the human body is sombre and compelling ... How is one soldier able to kill another? How does he feel at the time and afterwards?' The significance of drill and colours were not appreciated but when shown models of battle dioramas they wanted to be able to find out more about them. Most of all they were drawn to, yet alarmed by, the effect of army life and training on recruits and the way that it changed them: 'They approve and disapprove at the same time'. Young people were questioning about the reasons for wars, yet cynical that a regimental museum was the forum in which they might be answered. A particular obstacle was a lack of prior knowledge in which to contextualize historical events, one group member stated: 'Empire, history. It hales back to the past too much'. They did not immediately respond to the idea of depicting family life because they did not expect to be told the truth. Fisher comments: 'It would be very interesting if the inside story were to be revealed. But no-one believes the army would allow a museum to reveal it.' They expressed resentment at the way that the army treated women, one of the younger respondents stating: 'You never meet an army wife. She's behind walls. They have identical houses. A number not a person'.

The groups responded in very personal terms to the issues raised by the museum (Fisher, 1995: 27–40). The parents assessed the gallery principally on its ability to keep their children occupied. They found in the army, moreover, an archetype for the instilling of discipline and respect which they felt young people lacked. Yet there was ambivalence about this: 'I can't bear them telling me what to do. I've got my own mind. Get up, eat now, run for so many miles. The whole military set up is alien to me' stated one parent. The idea of remembrance and showing the aftermath of war appealed to both groups, with comments such as: 'Each man who died should be named' and 'You don't want to glorify death'. It was only in this context that links to the locality were appreciated, all found poignant a reference from a Liverpool typewriter firm for an employee later killed on the Somme. Bereavement, said the report, was 'the most intense contact point between civilian and army life'. The parents especially wished the effect to be 'solemnity, respect and a sense of value in the easy come, easy go, younger generation'. There was feeling for those left: 'You want to know what parents and families had to do, when the wages stopped'.

Conclusion

Regimental museums have represented war in museums to educate, promote *esprit de corps* and provide memorials within their closed regimental communities. Increasingly, there is a need to offer the

military collection to the general public, whose initial reactions can be ambivalent. One way forward seems to be to demystify the social organization of the regiment, especially in the contexts of battle and recounting of the experiences of the individual soldier and his family.

References

Amlôt, Colonel M.A. (1995) Personal communication.

Black, J. (1994) *European Warfare 1660–1815*, UCL Press, London.

Borg, A. (1991) *War Memorials from Antiquity to the Present*, Leo Cooper, London.

Colley, L. (1994) *Britons Forging the Nation 1707–1837*. Pimlico, London.

Fisher, S. (1995) *How Do NMGM Visitors Feel about the Proposed New Gallery for the King's Regiment? Qualitative Research*. The Susie Fisher Group, London.

Gale, W.A. (1894) *Report of the Gordon Relics Committee*. Royal Engineers Institute, Chatham.

Kaestlin, J.P. (1963) *Catalogue of the Museum of Artillery in the Rotunda at Woolwich*, Pt I. HMSO, London.

Kavanagh, G. (1994) *Museums and the First World War: A Social History*. Leicester University Press, London.

Keegan, J. (1978) *The Face of Battle*. Penguin Books, London.

Keegan, J. (1993) *A History of Warfare*. Hutchinson, London.

Kingsman (1928) *The Kingsman: The Journal of the King's Regiment (Liverpool)* 1(2), 62–3.

Spring, C. (1993) *African Arms and Armour*. British Museum Press, London.

Trevor-Roper, H. (1983) 'The invention of tradition: the highland tradition of Scotland' in Hobsbawn, E. and Ranger, T. (eds) *The Invention of Tradition*, 15–41. Cambridge University Press, Cambridge.

Wilkinson, S., and Hughes, I. (1991) 'Soldiering on' *Museums Journal*, November, 23–8.

Wood, S. (1986) ' "Too serious a business to be left to military men": a personal view of the military museum's role today' *Museum* 149, 20–6.

Wood, S. (1988) 'Obfuscation, irritation or obliteration? The interpretation of military collections in British museums in the 1980s' *Social History Curators' Group Newsletter* 15, 4–6.

14
Making Histories of Sexuality

Mark Liddiard

Introduction

This chapter seeks to explore what can only be described as something of an anathema – the treatment of sexuality by museums. Sexuality is a topic which has come to pervade almost every cultural media in contemporary society – newspapers, magazines, TV, films, adverts – and yet it has been almost ubiquitously ignored by museums. This is particularly intriguing when one considers that the history of sexuality has simultaneously become an area attracting widespread interest and, in many respects, museums are an obvious forum for examining the issue. This chapter therefore seeks to examine two issues central to the treatment of sexuality by museums. First, how can one account for the general exclusion of sexuality from museum displays? As part of this discussion, I suggest that there are a number of potential reasons for this exclusion which exert varying degrees of influence. However, understanding more about the nature of museum decision-making is the key to considering both the current lack of exhibitions on the topic of sexuality, and also to contemplating the future of sexuality in museums. This represents the second main issue that I want to focus upon – namely, is the topic of sexuality one which museums are likely to become more amenable to in the foreseeable future?

In discussing these issues, I draw upon empirical data collected as part of my doctoral research into the production and reception of museum exhibitions on another sensitive topic – warfare (see Liddiard, forthcoming). This data includes some 49 semi-structured interviews with a wide variety of museum decision-makers about the processes by which exhibitions are put together, as well as 200 structured interviews with museum visitors about their reception and interpretation of these exhibitions.

Current museum presentations of sexuality

On an immediate level, it is extremely difficult to make general observations about the ways in which museums present sexuality, given that they are heterogeneous. Nevertheless, it is intriguing that in spite of the wide variety of museum forms, with their highly diverse collecting and exhibiting policies, the theme of sexuality is almost uniformly ignored in museum displays and exhibitions. Indeed, there is good evidence to suggest that many museums actively seek to censor any explicit allusion to the topic. For example, the manner in which the British Museum has traditionally excluded their extensive collection of thousands of erotic and sexological books from public access, never mind display, has been well documented (see Fryer, 1966: Kearney, 1981), as have similar exclusions in other museums (see Kendrick, 1987). In a sense, however, this exclusion is intriguing given that sexuality has come to pervade our culture so thoroughly in almost every other media. Simultaneously, recent years have also seen the history of sexuality develop as an area of public interest and fascination, best signified perhaps by the BBC TV series *A Secret World of Sex* (see Humphries, 1988) and the 'safe sex' TV commercial involving 'Mr Brewer' recounting tales of sexual liaisons in the 1920s with his reusable condom 'Geronimo'. Yet despite the way in which sexuality has saturated so much of our contemporary culture, it is intriguing that it should remain such a neglected topic in the museum world.

Clearly, there are a number of potential reasons for why museums have been traditionally hesitant to mount exhibitions on sexuality. In sheer practical terms, one issue may be that of historical resources. In light of the traditionally veiled nature of much sexual behaviour, the extensive historical material which forms the basis for many museum exhibitions may be largely lacking in the context of sexuality:

> The generations brought up earlier this century, and in fact right up to the early 1950s, did not discuss sex in public. There were very few studies of their sexual behaviour by medical researchers and sociologists. The Victorian legacy was one of public inhibition and silence'. (Humphries, 1988: 9)

Subsequently, it may be that the dearth of historical resources on the theme of sexuality represents a very considerable obstacle to mounting a well-informed exhibition on the topic. After all, the historian and the museum 'investigates or reconstructs not the past, but the residues of the past which have survived into the present' (Stedman Jones, 1976: 296).

Understanding museums and their representation of topics such as

sexuality lies in comprehending the way in which they have traditionally focused on these 'residues' of the past. Relics or objects represent the focus of many museums, because they are frequently the only remains from previous historical periods. It may be for this reason that exhibitions on sexuality are highly unusual – because the subterranean nature of the topic may mean that it is lacking in the kinds of resources which many museums, and certainly more traditional museums, perceive as essential to mounting historically valid displays. In the words of Morton (1988: 131) 'if there are no objects available, it becomes very difficult to mount a museum display', a problem which necessarily arises from the object-centred approach adopted by many museums. Indeed, Porter (1988: 109–10) uses this fact to help account for the élitist and generally selective images that museums often portray. Namely, museums are invariably constrained in what they can display by what objects survive and it is clear that significantly fewer relics survive from less prosperous households. In the same way, given the apparent dearth of historical material relating to sexuality, it may be little wonder that museum presentations have struggled to deal with the topic.

However, it would clearly be erroneous to attach too much importance to this issue in accounting for the widespread absence of exhibitions on sexuality. I have already alluded to the large collection of material on the topic held by the British Museum, while the Bibliotheque Nationale in Paris and many university libraries have erotica collections of some sort (see Kearney, 1982). Yet this has not generally resulted in an exhibition on the theme of sexuality. Moreover, in the current technological climate, museums are not necessarily obliged to produce an object-centred exhibition anyway. Instead, they can adopt a variety of alternative media, such as reconstructions, videos and photos to address a topic, without necessarily having recourse to objects and relics. Indeed, the use of oral history is now becoming widespread in many museums and would be an obvious means of collecting the kinds of data necessary to mount such an exhibition. In fact, this was the technique predominantly used by the BBC series *A Secret World of Sex* (see Humphries, 1988). Of course, this technique also has its limitations – by implication, it can only be profitably used for collecting data on sexual behaviour from the turn of the century. Museums wishing to examine sexuality in the period before 1900 must rely on more traditional historical material. Yet the field of sexuality is perhaps not as barren of historical resources as it may initially appear. The use of love letters, for example, is a particularly important resource. Indeed, love letters were recently used, to quite poignant effect, in the Imperial War Museum's exhibition 'Forces Sweethearts' and have long been used by historians. Similarly, various artworks –

whether defined as erotica or pornography – can also give some interesting information on sexuality and sexual behaviour (see Curtis, 1990; Faust, 1980). Indeed, even hard-core pornography can be a valuable historical resource: 'Since practically all hard-core pornography is written by men for men to read, its subject-matter provides a fairly reliable index of the predominant themes in male sexual fantasy at any given period' (Fryer, 1966: 97).

Furthermore, it is easy to forget the work of sexologists such as Havelock Ellis, Krafft-Ebing, van de Velde, Kinsey, and Masters and Johnson to name a few, all of which provide an important source of data on sexual behaviour, at least since the turn of the century (see Brecher, 1969), while the Mass Observation Archive contains a wealth of material on sex, particularly between the late 1930s and the early 1950s. Certainly, there have been a range of historical studies which have focused upon the issue of sexuality in a wide variety of historical contexts – Gillis (1979) on the sexual relations of servants in the nineteenth century; Engel (1979) on Victorian prostitution; Blaikie (1987) on illegitimacy in the nineteenth century; Costello (1985) on love and sex between 1939 and 1945, and Farraday (1985) on lesbianism between 1914 and 1939. Similarly, there have also been a number of books addressing the history of sexuality in more general terms (see Gilbert and Roche, 1987; Mort, 1987; Parrinder, 1980). In short, despite the traditionally veiled nature of sexual behaviour, museums are not in fact faced with as dramatic a shortage of historical resources as it may initially appear. If this is the case, how might one account for the widespread exclusion of sexuality from museum exhibitions?

Probably the most important influence on the production of museum exhibitions and the inclusion or exclusion of particular topics is the museum staff, in particular, what Belcher (1991) calls 'the communicators' and 'the interpreters'. The interpreters essentially interpret the material for the potential exhibition, while the communicators consider the most effective way of communicating the message of the exhibition to the visiting public. These museum staff make many of the crucial decisions about particular exhibitions and displays. In the words of Belcher (1991: 77).

It may well be this group, who, by virtue of their expert knowledge, decide on the topics for exhibitions and how the collections will be interpreted. Almost certainly it will be for them also to decide what the specific objectives of exhibits will be and by what means they can be attained ... although exhibitions are designed for a purpose, they nevertheless remain a plastic art form, and as such they can be fashioned by their creators to impart their own personalities and knowledge.

In many respects, this holds the key to understanding the way in which certain topics are incorporated into museum exhibitions. Namely, most museums employ a diverse range of staff, who each have particular roles in the museum and ultimately decide which topics will be addressed in exhibitions and precisely how these topics will be dealt with. The problem is understanding more about the decisions they reach and the rationale behind these decisions.

What is largely uncontentious is that much museum decision-making is often highly pragmatic. A number of different museum staff are usually involved in the development of any specific exhibition and eliciting just why they made the decisions they did is difficult when one considers that so much is the result of personal compromise and agreement. The fact that involved individuals such as designers, curators, educationalists, marketing managers and even historical consultants are all bringing diverse and even contradictory perspectives to the development of exhibitions is interesting, not least because it illustrates the importance of the negotiation process in putting exhibitions together. In simple terms, museum exhibitions are almost always the result of considerable negotiation. However, it is interesting that while different museum staff may adhere to very different perspectives, there nevertheless seems to be almost an implicit agreement that issues relating to sexuality will not be covered. I would suggest that this may in fact relate to the professional culture of museum staff.

This notion of a museum professional culture is clearly interesting in the context of sexuality, not least because it may help to explain why other topics which were similarly excluded from museum displays, such as women and ethnic minorities, are now increasingly being included. On an obvious level, this can be explained by reference to specific staff personalities. Some museum staff are particularly amenable to displays of this kind and are highly progressive in their approach to constructing exhibitions, while other museum staff are quite the opposite. The issue, of course, is why some individuals are so much more open to presentations of such issues than others? Certainly, the manner in which museum staff have been trained does play an important part in influencing their subsequent decisions. In light of the fact that much professional training in the museum field has readily adopted new developments from the discipline of history, regarding women's history for example, the manner in which staff have been professionally trained has clearly played an important role in the increasing inclusion of alternative perspectives in museum displays. However, because so few museum staff are professionally trained, particularly in national museums, this can only be part of the story. Of course, some staff, such as curators, may have entered the profession directly from the

discipline of history anyway, where such approaches are now firmly established. Many others, however, have come to consider and adopt these ideas and perspectives through alternative means.

Of particular importance is the growing body of literature written by and for the museum professional. Many of these books and journals have been written from a progressive perspective and have been read widely throughout the museum world. The result has been somewhat profound as the museum profession as a whole and particular museum staff have begun to adopt these ideas. Of course, many of these notions have been vehemently opposed by a number of museum staff, but what is clear is that the professional culture of many museums has experienced something of a shift, with a subsequent impact upon the manner in which many museum exhibitions are constructed and the kinds of topics which are included. Indeed, the informal workplace culture of museums has also played a significant part in disseminating these ideas to a wider audience of museum staff.

In light of these developments, and the evidence which suggests that museums are increasingly mounting exhibitions on topics such as women and ethnic minorities, which just a few years ago would have been deemed almost unthinkable in many museums, can we expect to see the issue of sexuality begin to pervade, however peripherally, the work of museums?

The future for museum presentations of sexuality?

Of course, it would be folly to predict in any concrete manner the future for museum presentations of sexuality. Ultimately, the topic is laden with potential problems. Museums considering an exhibition on the theme of sexuality would have to consider a number of salient issues, such as ensuring that the public were not offended, resolving any potential legal problems and, of course, securing support from the higher levels of the museum hierarchy. Nevertheless, these difficulties are far from intractable and many museums have certainly overcome similar problems to mount successful exhibitions on other sensitive themes. Indeed, I would suggest that it is increasingly likely that museums will come to consider the issue of sexuality in their work for two main reasons. First, the professional culture of museums and museum staff has experienced and is continuing to experience something of a shift towards topics which would once have been considered inappropriate for museums to display. This is linked to the second main point, namely, the increasing influence of commercial considerations on the production of museum exhibitions has a number of very important implications for the topic of sexuality.

Evidently, the decisions reached by museum staff about the manner

in which they produce exhibitions and particularly the kinds of topics that the exhibition will address are not straightforward. Far from it. Instead, many exhibitions are the result of a complex interplay of factors. For example, we have already seen that the resultant exhibition is usually the consequence of widespread negotiation and compromise between various museum staff, each with their own personal and professional agendas. Certainly, the perspectives taken by museum staff are partially linked to their personal upbringing. This is indicated by the following quote, which suggests that the relative exclusion of women from many museum accounts of the past has

> arisen not because women or any other part of the museums' audience has been actively written out of the displays, but because the issues were simply not considered when the displays were created. In common with all elements of museum work, military museums are largely run by white, middle class, able-bodied men. How does one group, even with the best of intentions, cater for another group whose perspective it does not share and whose needs and interests are unfamiliar? (Wilkinson and Hughes, 1991: 27)

Yet, as I have already outlined, the rationale behind many of the decisions reached by museum staff may have far more to do with their professional development, which in turn is linked to the professional culture of the museum within which they are working. This is important because museum staff are obviously constrained in terms of what they can and cannot exhibit by the professional culture of the museum. As one of my respondents – a head of department in a national museum – said

> because the people who are doing displays are always constrained by their personal upbringing and their academic upbringing, the institution's way of doing things and the need to tow a relative line when they are not the people who are actually in direct control of the museum and the need to ensure that they can do what they want without getting on everyone's backs, and also the need to look to their peers for approval, quite necessarily constrains what they feel is appropriate to display.

Clearly, therefore, the professional culture of the museum is an important determinant of what is included in displays. Moreover, if the professional culture of many museums is experiencing a dramatic shift towards topics which traditionally were not seen to be appropriate for museums to display – such as women's history – then it seems possible that issues of sexuality will begin to be dealt with by museums in the near future. (Although one must also recognize that there are important differences between topics such as women's history and sexuality,

which may mean that such comparison is problematic). Yet even if one accepts this scenario, it is important to remember that the professional culture of museums is only one of a number of constraints on the topics and themes which may or may not be covered by museums. For example, the production of many museum exhibitions is often more dependent on the decisions made by previous curators and decision-makers than on anything that current museum staff may desire:

> Objects will be acquired because they relate to existing collections. Thus the history of the institution and the decisions made over collection policies by former curators will deeply influence what is possible in the present and the future. This often results in a display of objects that is out of joint with current values. (Hooper-Greenhill, 1988: 228)

In a sense, therefore, even if there is staff agreement that the museum should be dealing with topics such as sexuality, implementing this to the point of actually mounting an exhibition may be far from straightforward. Nevertheless, I would suggest that a number of changes to the museum world in general are such that they make the appearance of museum displays on sexuality in the near future not simply a possibility, but a probability. Of particular importance is the issue of commercialism.

The issue of commercialism has had a dramatic and profound impact upon the development of museum displays, not least because it is an issue which has – rightly or wrongly – come to pervade almost every aspect of museum work. While the importance of commercial factors has now thoroughly permeated the entire museum field, it nevertheless differentially affects the various museum sectors. The national museums, for instance, have generally managed to stay fairly aloof from more fundamental moves towards commercialism. The traditional research focus embodied by many national museums, such as the Imperial War Museum, has meant that they have been able to justify their existence almost regardless of any commercial rationale. Local museums, on the other hand, have been far more susceptible to commercial pressures. With the widespread reduction in local authority spending, local museums have found their very existence being fundamentally challenged from commercial perspectives. When local authorities are finding themselves having to make dramatic spending cuts, so local museums are frequently the prime candidate. This appears to have had a profound impact upon the manner in which exhibitions in local museums are initiated and developed. Commercial considerations, both in terms of the revenue generated and, equally importantly, the number of visitors attracted, are increasingly playing a part in the development of local exhibitions and in the kinds of issues which are being developed into exhibitions.

If local museums are generally more commercially minded than the national sector, then the operation of the independent sector rests almost entirely upon commercial rationale. This is, after all, their *raison d'être* – the sole objective, or at least the primary objective, of the independent sector is to make money. Entrepreneurs moved into the heritage market in the 1980s and they clearly played a very large part in the heritage boom of this period, essentially because there was an increasing realization that there was a very substantial market for this product (see Hewison, 1987; Wright, 1985). While the 1990s is not proving to be such a kind period for the independent museum or heritage centre, as visitor figures have frequently dropped resulting in sometimes dramatic reductions in revenue, the independent sector has nevertheless firmly established itself in the UK. The enormous importance that this sector has attached to commercial considerations has heavily influenced virtually every aspect of their work and increasingly that of other museum sectors.

In light of the fact that museums have been drawn heavily into the commercial arena, the preferences of visitors and potential visitors have also begun to take precedence, certainly more so than ever before (see Terrell, 1991). Recent years have undoubtedly seen more attention being paid towards the needs and preferences of the visitor and an increase in the number and range of visitor surveys. This development has a potentially significant impact upon exhibition policies, as museums increasingly adopt their exhibitions to what they believe visitors want to see, which in turn has dramatically influenced the kinds of topics which museums now seek to address. Let me illustrate this point by referring again to the manner in which museums are increasingly displaying exhibitions in which women are no longer the peripheral group that they once were. I have just suggested that many of the decisions taken by museums are increasingly informed by commercial considerations. It may be that the increasing inclusion of displays relating to women has very close links to this development. Women, as half of the population, represent a huge potential market for museums and one which they largely under-utilize. In 1991, for instance, just 26 per cent of the visitors to the Imperial War Museum were women. Linked to this, women have become increasingly vocal in their demands to be included in historical displays, while the fact that many museum staff are also women has added to this pressure. In short, museums are experiencing pressure from a number of directions to develop more balanced and progressive displays which include women. However, these pressures have long existed, to a degree at least, and yet many museums have still been hesitant to include such displays.

In part, this shift has resulted from the gradual replacement of older, more traditional, staff with younger staff that are more in tune with

recent ideas about the interpretation of history. But this is only part of the reason for these changes. Instead, and this is an important point, these various pressures are evidently compatible with the commercial rationale increasingly being adopted by museums as they attempt to expand their visitor base and their income. In other words, there is a sense in which topics such as women's history, which have long been neglected by museums, are now beginning to receive substantial coverage at least in part because of their commercial potential. Indeed, the increasing influence of commercialism can be viewed in conjunction with the general process, closely linked to post-modernism, by which

> more traditional forms of high cultural consumption (such as museums, galleries) become revamped to cater for wider audiences through trading-in the canonical, auratic art and educative-formative pretensions for an emphasis upon the spectacular, the popular, the pleasurable and the immediately accessible. (Featherstone, 1991: 96–7)

While these developments raise highly disturbing questions about the future of museum displays on topics which may not be highly popular and commercially viable, the implications for sexuality are clear.

There is no doubt that sex as a topic has enormous commercial potential. This can be witnessed both in the manner in which sex is manipulated by mainstream media to sell their products and also in terms of pornography. From this point alone – that sexuality has very considerable commercial potential – it seems quite possible that museum displays on sexuality will find favour in the near future. This point can be illustrated by the development of a brothel museum in the Australian outback, with the full support of the local MP and tourist board. As May (1993: 18) notes 'The museum idea started off as a bit of a joke, she admits, but she soon came to realise its commercial potential'. Indeed, highly successful displays such as the recent 'Forces Sweethearts' exhibition at the Imperial War Museum, consisting of a variety of displays from graphic love letters to pornographic magazines issued to troops, may actually herald the arrival of sexuality as a valid and appropriate topic for museum coverage.

Of course, whether or not more museums mount exhibitions relating to sexuality and the history of sexuality remains to be seen. To an extent of course, this may be dependent on a broadening of attitudes towards sexuality in Britain, although of course one could also speculate that with the growing educative role of museums in the context of the school curriculum, and the increasing attention being devoted to sex education in schools, museums may be identified as a possible medium through which some of these issues could be fruitfully addressed. Whatever the actuality, it is nevertheless imperative that museums at

least begin to consider the importance of sexuality as a topic for exhibitions, because if they continue to ignore the issue, as they have traditionally done, then the implications are disturbing. The commercial potential of displays on the history of sexuality is hardly a source of contention. Subsequently it is possible, even probable, that it will begin to attract the attention of the sex industry, which is notoriously good at exploiting such commercial possibilities (see Hebditch and Anning, 1988; Skordaki, 1991). Indeed, this has already been the case in The Netherlands, with the establishment of a number of 'sex museums' run by the sex industry. In light of the void left by the traditional neglect of sexuality by museums, and the possibility that this may be exploited by the sex industry, it is imperative that museums begin to address the topic of sexuality and contest this ground, in what feminists such as Cole (1989) have described as a cultural offensive, as the feminist movement has sought to define sexuality and the representation of sexuality in their own terms.

Conclusion

In conclusion, it is clear that museums have traditionally excluded almost all reference to sexuality in their displays and exhibitions and there are a number of potential reasons for this exclusion, such as the traditional nature of the professional culture in museums and, to a lesser degree, a lack of historical resources on which to base exhibitions. However, it is possible to suggest that the near future is likely to witness a growing acceptance by museums that sexuality and the history of sexuality are valid topics for museum consideration and one can already identify moves in this direction. In part, this can be linked to the shifting nature of the professional culture in museums. However, of particular importance for encouraging the development of museum exhibitions on sexuality is the growing influence of commercialism. Of course, whether or not museums do make significant moves in this direction remains to be seen, but it is nevertheless imperative that museums at least begin to consider sexuality as a valid topic for display. It is certainly too important an issue to allow the sex industry to set the agenda.

References

Belcher, M. (1991) *Exhibitions in Museums*. Leicester University Press, Leicester.
Blaikie, A. (1987) 'Illegitimacy in nineteenth century North East Scotland', PhD thesis, University of London.
Brecher, E. (1969) *The Sex Researchers*. Andre Deutsch, London.

Cole, S.G. (1989) *Pornography and the Sex Crisis*. Amanita, Toronto.

Costello, J. (1985) *Love, Sex and War 1939–45*. Collins, London.

Curtis, A. (1990) *Erotic Antiques*. Lyle, Galashiels.

Engel, A. (1979) 'Immortal intentions: the University of Oxford and the problem of prostitution 1827–1914' *Victorian Studies* 23(1), 79–108.

Farraday, A. (1985) 'Social definitions of lesbians in Britain 1914–1939'. Unpublished DPhil thesis, University of Essex.

Faust, B. (1980) *Women, Sex and Pornography*. Penguin, Harmondsworth.

Featherstone, M. (1991) *Consumer Culture and Postmodernism*. Sage, London.

Fryer, P. (1966) *Private Case Public Scandal*. Secker and Warburg, London.

Gilbert, H. and Roche, C. (1987) *A Women's History of Sex*. Pandora, London.

Gillis, J. (1979) 'Servants, sexual relations and the risks of illegitimacy in London 1801–1900' *Feminist Studies*, Spring, 143–73.

Hebditch, D. and Anning, N. (1988) *Porn Gold: Inside the Pornography Business*. Faber and Faber, London.

Hewison, R. (1987) *The Heritage Industry: Britain in a Climate of Decline*. Methuen, London.

Hooper-Greenhill, E. (1988) 'Counting visitors or visitors who count?', in Lumley, R. (ed.) *The Museum Time-Machine: Putting Cultures on Display*, 213–32. Routledge, London.

Humphries, S. (1988) *A Secret World of Sex: Forbidden Fruit The British Experience 1900–1950*. Sidgwick and Jackson, London.

Kearney, P. (1981) *The Private Case: An Annotated Bibliography of the Private Case Erotica Collection in the British (Museum) Library*. Landesman, London.

Kearney, P. (1982) *A History of Erotic Literature*. Parragon, London.

Kendrick, W. (1987) *The Secret Museum: Pornography in Modern Culture*. Viking, New York.

Liddiard, M. (forthcoming) 'Images of war: museums, the state and ideology'. Unpublished Phd, thesis, London School of Economics.

May, P. (1993) 'Rooting for the dirty diggers', *New Statesman and Society*, 6 August.

Mort, F. (1987) *Dangerous Sexualities: MedicoMoral Politics in England since 1830*. Routledge and Kegan Paul, London.

Morton, A. (1988) 'Tomorrow's yesterdays: science museums and the future', in Lumley, R. (ed.) *The Museum Time-Machine: Putting Cultures on Display*, 128–44. Routledge, London.

Parrinder, E.G. (1980) *Sex in the World's Religions*. Sheldon Press, London.

Porter, G. (1988) 'Putting Your House in Order: Representations of Women and Domestic Life', in Lumley, R. (ed.) *The Museum Time-Machine: Putting Cultures on Display*, 102–27. Routledge, London.

Skordaki, E. (1991) 'The production of men's magazines: three case studies and a sociological analysis'. Unpublished PhD thesis, London School of Economics.

Stedman Jones, G. (1976) 'From historical sociology to theoretical history', *British Journal of Sociology* 27(3), 295–305.

Terrell, J. (1991), 'Disneyland and the future of museum anthropology', *American Anthropologist* 93(1), 149–53.

Wilkinson, S. and Hughes, I. (1991) 'Soldiering on', *Museums Journal*, November, 23–8.

Wright, P. (1985) *On Living in an Old Country*. Verso, London.

15
Making Culturally Diverse Histories

Nick Merriman and Nima Poovaya-Smith

One of the first surveys that examined attitudes towards museums held by typical non-visitors, such as members of ethnic minority groups, painted rather a depressing picture (Trevelyan, 1991). An earlier survey had shown that white people were 50 per cent more likely to visit museums than Asian people, and 100 per cent more likely to visit than people of African Caribbean background (Greater London Arts, 1989). The London Museums Service survey attempted to explain this by showing that museums were seen by these groups – and other non-visitors – as being intimidating and almost totally devoted to educated white culture, and therefore held little relevance for them (Trevelyan, 1991: 47).

This chapter briefly explores ways of opening up museums to hitherto disenfranchised audiences and examines some of the complex issues attendant upon this. It also looks at examples of museums where the representation of cultural diversity has been part of the agenda for a number of years now.[1] We concentrate here on communities usually grouped under the unsatisfactory heading of 'ethnic minorities'. This encompasses non-dominant groups classified by ethnic, religious and linguistic differences from 'mainstream' culture. Nevertheless the general thesis presented here can apply equally well to many other non-dominant groups whose histories have hitherto been largely ignored by museums. Our examination will principally restrict itself to the situation in Britain as other chapters in this volume have addressed the representation of First Nations, African Americans and African Caribbeans in the Caribbean.

The need to reflect cultural diversity is underpinned by considerations that are both economic and ethical. The educated, white middle class who mainly comprise museum staff and dominate museum visiting do not have a monopoly over the past or of the shaping and analysis of

176

the present. Museums – including many which call themselves 'independent' – receive public funding in order to preserve and exhibit material culture for the public benefit. This public is highly diverse and is increasingly demanding that museums in receipt of public funds reflect this diversity in their programmes. The National Curriculum in schools encourages the adoption of this perspective and teaching staff welcome initiatives espousing cultural diversity. The need for museums to become more accountable, particularly to local communities, has been further reinforced by the Audit Commission report, *The Road to Wigan Pier?* (1991: 6). This noted that 'in some local authorities too little attention had been paid to attracting the public to the museum'. The Commission strongly recommended that local authorities took into account the needs of different potential user groups when preparing strategic plans for their museums.

Previous research has demonstrated, unequivocally, that the vast majority of the population are interested in the past and the manner in which it affects the present, but that a smaller percentage express this interest by visiting museums (Merriman, 1991). The task, therefore, is not so much one of forcing reluctant members of the public into museums, as one of removing cultural and class barriers that deter otherwise interested people from visiting them. As Poovaya-Smith (1991) has shown, it is a task which is perfectly possible to achieve.

The recognition that the history and contemporary reality of minority communities are worthy of representation in museums has had a recent and somewhat faltering beginning in Britain, with the exception of Jewish history, which has a longer museum pedigree. The debate in Britain is still less developed than in North America, from which it primarily stems. In North America, the debate over representation derived its impetus mainly from the civil liberties movement of the 1960s (Crew and Sims, 1991) and is now relatively sophisticated, as the papers in this volume, and in Karp and Lavine (1991) and Karp *et al.* (1992) indicate.

Interestingly, and perhaps ironically, the material history of a number of the minority communities has been the focus of widespread academic study for some time. As a consequence of Britain's imperial past, the national museums of Britain have extensive holdings of artefacts from former colonies such as the Indo-Pakistan sub-continent. This research has managed to retain, until very recently, an Olympian aloofness from the actual communities who live in Britain. Radical developments about representation were actually pioneered away from the national museums, mainly in the regions, by museums in Leicester, Bradford and Birmingham, and in London in museums such as Hackney and the Museum of London.

The systematic study of contemporary minority cultures began as a

grassroots movement in the 1970s and 1980s. In the arts world, Naseem Khan's thoughtful *The Arts Britain Ignores* (1976) provided a powerful starting-point. Events such as the International Conference on Blacks in Britain in 1981 and publications such as Peter Fryer's *Staying Power* (1984) and Rozina Visram's *Ayahs, Lascars and Princes* (1987) further consolidated this area of research. These provided interested museum professionals with some synthetic evidence on which to base interpretive work.

Typically some of the initial developments came from outside the museum framework with the foundation of the Black Cultural Archives in Brixton in 1982 and the Greater London Council exhibition 'A History of the Black Presence in London' in 1986. Within the museum world, an innovative move was made in Leicestershire in 1982 with the creation of a full-time permanent post of Assistant Keeper of Indian Arts and Crafts, a title now changed to that of Cultural Development Officer. Bradford followed suit with the appointment of an Assistant Keeper of Ethnic Arts in 1985, a post which has since evolved into the Keeper of Arts with the term 'ethnic' deliberately deleted from the title. Kirklees appointed a Multicultural Curator in the same year, a post which has now been changed to Multicultural Officer, Museums and Arts.

The Leicester, Bradford and Kirklees posts uniquely combined curatorial responsibilities with outreach work, particularly among the non-visiting museum public. Thus, almost by accident, the question of accountability destined to become such an issue in the 1990s was addressed by these museums, in however minor a way, in the 1980s itself. The creation of these three posts, which have now been in place for approximately ten years, has allowed, in the cases of Leicester and Bradford particularly, the building up of a permanent collection, the setting up of an ambitious exhibitions programme and outreach initiatives with the local communities. Unfortunately, such established posts are the exception rather than the norm. Other recent developments, mostly short term, include the creation by Blackburn Museum Services of a post for an Asian Arts Development Officer in 1990. The Victoria and Albert Museum appointed a South Asian Arts Education Officer, funded by the Paul Hamlyn Foundation, to enable work to be carried out on the Indian collections, in 1991.

Temporary exhibitions such as Bradford's 'Double Vision' (1986), and 'Warm and Rich and Fearless: An Exhibition of Sikh Art' (1991), the Hayward Gallery's 'The Other Story' (1989), Leicester's 'Arts from the Muslim World' (1992), Dundee's 'The Miles tae Dundee' (Murray and Stockdale, 1990) and the Museum of London's 'The Peopling of London' (1993) contributed to the climate of changing perceptions and, among the minority communities, gradually increasing expectations. This impact has been reinforced by papers, publications and reports

such as Peter Fraser and Rozina Visram's report on the Geffrye Museum (1988), which demonstrated how the traditional furniture and decorative arts collections of this inner-city museum could be reinterpreted in ways that were relevant to local black and Asian communities. The work of local history museums responsive to their communities, for example in Haringey (Hasted, 1990) and Hackney, has perhaps been lower profile but significant in bringing about change.

Now an increasing number of museums are undertaking projects which attempt to reflect Britain's cultural diversity through time. However, many of these projects are of a temporary nature and rarely widely reported. So while there have been areas within Britain where valuable work has been carried out on issues of cultural representation, the lack of an overview and their piecemeal and fragmentary nature in relation to the whole, mean that these initiatives or continuing developments can be overlooked and their lessons lost. But arguably, almost all these initiatives have acted as instruments of change in either small or significant ways. Our aims here are to report on recent initiatives that can be considered as examples of good practice and to explore the potential for future approaches. What does emerge clearly, from all this, is that there is no single 'correct' approach. Instead, a diversity of approaches is appropriate both to the diversity of cultures involved and to the different local circumstances, resources, relationships and themes that are being explored.

The shift undertaken by museums from being driven by an internal agenda to a more receptive approach to audiences, both potential and actual, is a momentous one. Dickerson (1991) characterized it as a shift from espousing a single authoritarian view of the past to a multifaceted one. From the confident belief that the representation of white culture encompassed the entire history of a subject or region, issues of representation have come to the fore and the whole interpretive philosophy of museums is now being challenged. Interpretation, a process that was previously seen as straightforward, is now beset with doubts and questions. How does one define a community? Who speaks for it? How does one take account of diversity along lines of gender, age, religion and class within a community, for instance? How can communities become genuinely involved in museum processes, without compromising the latter's traditionally neutral and apolitical stance? Or should museums become less neutral? How should museums deal with issues such as racism? Finally, how can resources be identified to ensure that initiatives do not degenerate into the tokenistic?

There are no simple answers to these questions, but at their heart lies the realization that broader constituencies need wider, more lateral approaches. While methods of implementation and detail will necessarily differ between museums, there is a quantitative and qualitative

assessment that, we would argue, should be a fundamental starting-point for all museums planning a strategy to open up museums to a broader audience:

- Research that allows museums to establish the composition of the communities in their area in order to compare this with the profile of museum visitors.
- Complementary qualitative research on the interests, needs and perceptions of users and non-users of museum services to inform this strategy, and to evaluate the degree of success of any initiative, once it has been implemented.

The Museum of London, for example, used the simple statistic that 4 per cent of the museum's visitors were from minority communities, compared with 20 per cent in London's overall population, to formulate a major project. The exhibition, 'The Peopling of London' showed that cultural diversity was as old as the city itself and therefore sought to challenge the notion that immigration from overseas was a recent 'problem' (Merriman, 1996). In doing this, the exhibition presented the previously neglected histories of London's minority communities, in a way which would be relevant to the communities themselves. By intensive outreach, consultation and participation, the proportion of 'ethnic minority' visitors to the museum rose greatly over the exhibition period.

From this baseline of audience research, the museum must begin to forge partnerships of mutual trust with its constituent communities (Hooper-Greenhill, 1995). This has been done in widely differing ways in different local circumstances. Some museums establish formal liaison mechanisms with official representatives of local communities. Others prefer to work more informally by canvassing a wide range of opinions. Some museums view outreach and liaison (linked sometimes to collecting programmes and oral history recording) as an end in itself. Others wish to see a more publicly tangible product of a partnership, such as an exhibition.

Whatever the specific approach espoused by a museum, it is essential that the museum approach the partnership with a local community with a degree of humility and a willingness to listen and learn. If it truly wishes to work in partnership with local people and build a long-term relationship, the museum must be prepared to recognize that cultural authority is no longer the sole prerogative of museums, but will need to be shared more widely. It will be a time of questioning and even of dislocation for the museum, but ultimately an enriching one.

Some museums have responded to this challenge by appointing members of staff specifically to liaise with minority communities and

develop museum projects with them. As we have seen, occasionally these are permanent posts. More often, they are short-term contract posts attached to specific projects. For example, Merseyside Maritime Museum appointed an outreach worker to work with the black community in Liverpool on the development of the Transatlantic Slave Trade Gallery (Taubman, 1994). Frequently, these members of staff are from the minority communities themselves and therefore bring an insider's perspective to their work. Walsall Museum and Art Gallery appointed a Punjabi-speaking Sikh as Events Co-ordinator for the duration of the exhibition 'Warm and Rich and Fearless' on tour from Bradford (Selwood *et al.*, 1995).

These are all positive and welcome developments, but they are not the only answer. It is important that museums begin to reflect the cultural diversity of the British population right across their own staffing structure. This has to be done with sensitivity and without ghettoization. Ethnic minority museum staff should not only deal with minority community liaison, just as staff from the dominant culture should be able to work with minority communities.

It would also be short-sighted to assume that minority audiences will only be attracted to interpretations of minority culture and conversely that interpretations of cultural diversity are not of interest to members of the dominant culture. Bradford Art Galleries and Museums, for example, was informed by both groups very early on in its consultative exercise that there was a strong mutual interest. This in turn raises the question of whether the ideological stance taken in the approach to representation is one that stresses separation or integration of minority histories. Is the ideology one of the melting pot, or of cultural pluralism and diversity, or can we go beyond these concepts?

A good example of one approach is the museum devoted entirely to the representation of a particular community. In Britain, for example, there are at least three Jewish museums, and these provide the most unambiguous instance of this approach. The museums have necessarily developed in close consultation with the community; they are usually located in its midst, they mostly recruit staff from the community itself, and the community, through its board of representatives, can attempt to run the museum on its own terms. The museum is thus well placed to highlight the history and role of the community and can serve as a genuine focus for community pride and commemoration in a way that most mainstream museums cannot. The role of these museums in remembering the Second World War, for instance, has a deep and emotional resonance for the Jewish community that a non-Jewish museum could not replicate.

More generally, the community museum is frequently a response to lack of interest from the mainstream museum culture and can serve as a

critique of the dominant culture. Clifford (1991) provides a useful comparison between the display of First Nation culture in two mainstream museums and two community-run museums to highlight this very point. As a result, separate community-run museums are in an excellent position to depict the history and articulate the concerns of the communities they serve. Equally importantly, they can help break down resistance to museum visiting in general and introduce new audiences to the concept of museums. However, as Karp and Lavine (1991) show, community museums themselves are not free from controversy and there can be fierce disputes over representation.

Despite these manifest advantages, the separate community museum may not be the answer in every instance. At the purely practical level there is a limit to the number of separate museums that could exist across the country. It is unlikely that a museum for every community could be supported in large conurbations. At the conceptual level, it is important to balance out the advantages of close community participation against the drawback that such museums run the risk of separating out the experience of the particular community from the rest of society and in some cases perpetuating a marginal status. Bradford's consultative exercises, for example, revealed that the Asian communities of Bradford would have felt let down if they had been presented with a community museum as an alternative, without a mainstream presence. This could easily have been perceived as a downgrading of status, and consequently a combination of the two is seen as ideal. The Sikh community are currently exploring the possibilities of setting up just such a system, with their own community museum in Bradford as well as maintaining a presence in the main museum service.

The far more common approach towards a recognition of cultural pluralism is for existing museum services to organize temporary exhibitions and projects, usually linked to a particular community. For instance the Geffrye Museum organized an exhibition on 'Chinese Homes' in 1992, Sheffield has organized a number of exhibitions on its African Caribbean community, Southampton organized an exhibition on its black community (Belgrave, 1990), as has Liverpool. All have involved an extensive degree of 'outreach', ranging from close consultation to a touring mobile museum visiting community centres. All these initiatives have the advantage of recognizing and working with the cultural authority of the mainstream museum while incorporating the previously hidden histories of neglected communities into its narratives.

However, areas with no significant minority presence should not opt out of representing cultural diversity. Many museums do more than represent the history of their area, and we would argue that all museums wishing to make themselves relevant to contemporary society

should embrace the concept of a culturally diverse programme. The Museum of Modern Art in Oxford is an excellent example of a truly cosmopolitan arts venue. Its imaginative programme of contemporary art often includes art from India in exhibitions that are thoroughly researched and academically sound. Cultural diversity can also be an opportunity to move beyond the local and develop an international profile for the museum. Museum partnerships with the Asian populations of Bradford and Leicester, for example, have led to collaborations with the Governments of India, Pakistan and Bangladesh. Bradford has increasingly become a source of touring exhibitions on the arts and crafts of the Indo-Pakistan sub-continent. This enables other museums to buy in exhibitions they may not otherwise have had the resources to organize. Rotherham took Bradford's exhibitions, '101 Saris' and 'An Intelligent Rebellion: Women Artists of Pakistan'. The latter has enabled them to secure funding not only from their Regional Arts Board but also from the British Council for an artists' residency from Pakistan. Exhibitions on contemporary crafts and art such as the two exhibitions from Bradford, previously cited, and the photographic exhibition 'Kanu Gandhi's Mahatma', in Leicester (1995) have won financial and academic support from the countries concerned. They add breadth and depth to the way communities are represented and, in terms of contemporary critiques, are a revelation to members of the communities themselves about developments in their countries of origin.

This leads naturally on to a consideration of exhibitions on contemporary fine and decorative art produced by artists of minority descent. This is a crucial area of depiction, because quite often the works are a contemporary, often powerful commentary on minority experience in Britain today and in time become of great historical importance. A good example is the work produced in the 1980s by artists such as Sutapa Biswas, Tam Joseph, Keith Piper, and Lubiana Himid who encapsulated the contemporary spirit of anger by challenging a system that had persistently undervalued minority groups. Yet most of these artists would object to being too firmly identified as being part of a particular culture, let alone a particular community. Quite rightly, they feel this diminishes them and the dreaded phrase 'positive discrimination', which could quite effectively prevent these artists being taken seriously by the art establishments, hangs in the air.

While exhibitions focusing on the history and culture of particular communities can be valuable in redressing their previous neglect, treating communities in isolation can also run the risk of institutionalizing their marginalization as 'the Other'. Another approach has therefore sought to recognize the history and contribution of ethnic minority cultures *within* narratives of mainstream British history. Communities

183

are not separated out for different treatment but their crucial, and previously neglected, role in shaping Britain is brought to the fore. This approach has been espoused by Croydon Museum in developing its new premises (MacDonald, 1995) and to differing degrees in the permanent installations about the slave trade in Liverpool and Hull, in the plans for a Museum of the British Empire in Bristol (Griffiths, 1994) and in temporary exhibitions such as 'the Peopling of London' and 'The Miles tae Dundee'. Other museums, such as Bradford and Leicester, have incorporated previously neglected communities by involving them in contemporary programmes of collecting and exhibiting. The aim of all these initiatives has been to bring about a recasting of what constitutes British history, and a broadening of the category that the dominant culture refers to as 'we' (Dickerson, 1991). Here, the traditional authority of the mainstream museum, which is usually felt to inhibit participation from minority groups, can be transformed into a positive attribute by ensuring that history is presented in a more comprehensive and less polarized light.

Some museum-based projects have moved beyond the approach of solely highlighting the minority contributions to mainstream history. Using artists/curators from outside the museum framework, the projects have questioned the nature of the museum as an authoritative repository of collective memory, and reused museum objects in new contexts to highlight the multiplicity of interpretations that can be placed on cultural material. In the 'Mining the Museum' project at the Maryland Historical Society (Corrin, 1993) the artist Fred Wilson worked with existing museum collections to reveal the suppressed history of African Americans. In one display of fine silverware, for example, he introduced a pair of slave shackles from the collections (Wilson, 1995). In Susan Vogel's exhibition on African art, similar African collections were displayed in four different contexts to demonstrate how the setting of objects brings forth different meanings to the viewer (Vogel, 1991). The first setting was a diorama of an African village which attempted to show the material in an 'authentic' context, the second was in a curator's office arranged haphazardly as if there for study, the third was in a collector's gallery, and the fourth in a white modern art space. In Britain, a similar multiple-perspective approach has been followed by Peirson Jones (1992) in the ethnographic gallery at Birmingham Museum, where a selection of objects can be interpreted in four different ways via an interactive video disk.

The criticism that initiatives which stress the minority contribution to mainstream history subscribe to the ideology of the melting pot, where cultural differences are effaced to produce a uniform British citizenry, cannot really hold water. This North American phrase is

totally misapplied to the British experience. 'Melting pot' usually implies a surrender of one's identity to the forging of a synthetic culture. The process of highlighting the minority contribution to history described above is more one of setting the record straight, presenting a more accurate and less monolithic view of history. This is not a political strategy to promote assimilation and to silence dissent and difference (*con.* Cameron, 1992) since sight is not lost of the critical and oppositional elements of the minority cultures.

Some initiatives are now beginning to point the way forward. For example, the Institute of International Visual Arts[2] and Bradford Museums are now firmly of the view that their approach must be to present the myriad visible or invisible points of interaction, influence, conflict and mediation between various cultures, either in a historical or contemporary context. They feel this would mitigate against the dangers of distortion to which a separatist or monolithic Euro-centric approach is vulnerable. The proposed display of Bradford's new heritage, broadly adopts a similar approach. Bradford's starting-point is that the Asian presence in Britain has its history in the sub-continent, where the two cultures, British and Asian, were closely intertwined. The display, taken from the permanent collections, will be deliberately sited on the same floor as the permanent collections from the European section.

As we approach the twenty-first century, notions of what constitutes the 'Other' or 'One of Us' are beginning to blur. This is just as well. Elastic redefinitions of culture and heritage are the only way to proceed towards a future already fraught with unknowns.

Notes

1 Throughout the chapter the term 'museum' is used to refer to art galleries as well.
2 The Institute promotes the work of artists from a plurality of cultures and cultural backgrounds, across its four areas of activity – exhibitions, publications, research and education and training.

References

Audit Commission (1991) *The Road to Wigan Pier? Managing Local Authority Museums and Art Galleries*. HMSO, London.

Belgrave, R. (1990) 'Black people and museums: the Caribbean Heritage Project in Southampton' in Gathercole, P. and Lownthal, D. (eds) *The Politics of the Past*, 63–73. Routledge, London.

Cameron, D.F. (1992) 'A change of heart' *Museum Management and Curatorship* 11, 375–86.

Clifford, J. (1991) 'Four Northwest Coast museums: travel reflections' in Karp, I. and Lavine, S.D. (eds) *Exhibiting Cultures: The Poetics and Politics of Museum Display*, 212–54. Smithsonian Institution Press, Washington DC.

Corrin, L.G. (1993) 'Mining the museum: an installation confronting history' *Curator* 36(4), 302–13.

Crew, S.R. and Sims, J.E. (1991) 'Locating authenticity: fragments of a dialogue' in Karp, I. and Lavine, S.D. (eds) *Exhibiting Cultures. The Poetics and Politics of Museum Display*, 159–75. Smithsonian Institution Press, Washington.

Dickerson, A. (1991) 'Redressing the balance' *Museums Journal*, November, 21–3.

Fraser, P. and Visram, R. (1988) *Black Contribution to History*. CUES Community Division and Geffrye Museum, London.

Fryer, P. (1984) *Staying Power. The History of Black People in Britain*. Pluto Press, London.

Greater London Arts (1989) *Arts Survey of Greater London*. GLA, London.

Griffiths, G. (1994) 'Walking the tightrope. The development of the Empire and Commonwealth Museum, Bristol'. Paper presented at the 'Heritage in a Multicultural Society' conference, St Mary's College, Strawberry Hill, 18 March.

Hasted, R. (1990) 'Museums, racism and censorship' in Baker, F. and Thomas, J. (eds) *Writing the Past in the Present*, 152–62. St David's University College, Lampeter.

Hooper-Greenhill, E. (1995) 'Audiences – a curatorial dilemma' *Art in Museums*. New Research in Museum Studies 5, 143–63, Athlone Press, London.

Karp, I., Kreamer, C.M. and Lavine S.D. (eds) (1992) *Museums and Communities. The Politics of Public Culture*. Smithsonian Institution Press, Washington DC.

Karp, I. and Lavine, S.D. (eds) (1991) *Exhibiting Cultures. The Poetics and Politics of Museum Display*. Smithsonian Institution Press, Washington DC.

Khan, N. (1976) *The Arts Britain Ignores: The Arts of Ethnic Minorities in Britain*. Community Relations Council, London.

MacDonald, S. (1995) 'Changing our minds: planning a responsive museum service', in Hooper-Greenhill, E. (ed.) *Museum, Media, Message*, 165–76. Routledge, London.

Merriman, N. (1991) *Beyond The Glass Case: the Past, the Heritage and the Public in Britain*. Leicester University Press, Leicester.

Merriman, N. (1996) 'The Peopling of London Project' in Hooper-Greenhill, E. (ed.) *Cultural Diversity and Museums and Galleries in Britain*. Leicester University Press, Leicester.

Murray, J. and Stockdale, D. (1990) *The Miles Tae Dundee. Stories of a City and its People*. Dundee Art Galleries and Museums, Dundee.

Peirson Jones, J. (1992) 'The colonial legacy and the community: the Gallery 33 project' in Karp, I., Kreamer, C.M. and Lavine S.D. (eds) *Museums and Communities: The Politics of Public Culture*, 221–41. Smithsonian Institution Press, Washington DC.

Poovaya-Smith, N. (1991) 'Exhibitions and audiences: catering for a pluralistic public' in Kavanagh, G. (ed.) *Museum Languages: Objects and Texts*, 119–34. Leicester University Press, Leicester.

Selwood, S., Clive, S. and Irving, D. (1995) *An Enquiry into Young People and Art Galleries*. Art and Society, London.

Taubman, A. (1994) 'The development of the transatlantic slavery gallery', unpublished paper given at 'Heritage in a Multicultural Society' conference, St Mary's College, Strawberry Hill, 18 March.

Trevelyan, V. (ed.) (1991) *'Dingy Places with Different Kinds of Bits.' An Attitudes Survey of London Museums amongst Non-Visitors*. London Museums Service, London.

Visram, R. (1987) *Ayahs, Lascars and Princes. The Story of Indians in Britain 1700–1947*. Pluto Press, London.

Vogel, S. (1991) 'Always true to the object, in our fashion' in Karp, I. and Lavine, S.D. (eds) *Exhibiting Cultures. The Poetics and Politics of Museum Display*, 191–204. Smithsonian Institution Press, Washington, DC.

Wilson, F. (1995) 'Silent messages' *Museums Journal* 95(5), 27–9.

16
Making Histories of Religion

Mark O'Neill

I am not sure whether anyone, however scrupulous, who spends time and imaginative resources on these dark places, can, or indeed, ought to leave them personally intact. Yet the dark places are at the centre. Pass them by and there can be no serious discussion of human potential. George Steiner, *In Bluebeard's Castle*.

Even his (Casaubon's) religious faith wavered with his wavering trust in his own authorship, and the consolation of the Christian hope in immortality seemed to lean on the immortality of the still unwritten Key to all Mythologies. For my part, I am sorry for him. It is an uneasy lot at best, to be what we call highly taught and yet not to enjoy: to be present at this great spectacle of life and never to be liberated from a small hungry shivering self – never to be fully possessed by the glory we behold, never to have our consciousness rapturously transformed into the vividness of a thought, the ardour of a passion, the energy of an action, but always to be scholarly and uninspired, ambitious and timid, scrupulous and dim sighted. George Eliot, *Middlemarch*.

The most obvious and important thing to be said about making histories of religion in museums is that they don't do it very often. This is not to say that there are not millions of religious objects in museums, as most fine art, anthropology, archaeology, historical and general museums have a high percentage of objects which had a significant religious meaning to their original owners and creators. In the subject index to *Museums of the World* (Richter, 1995), between Railroads and Reptiles, are the headings Religious Art and Symbolism, and Religious History and Traditions. These do not direct the reader to the British Museum, the Louvre or the Smithsonian, which between them must have a high percentage of the world's most significant religious artefacts. Nor do they include the Museum of Mankind, the Musée de l'Homme, the

Victoria and Albert Museum or the Uffizi, Skansen or the Museum of Welsh Life, all of which have important and famous religious artefacts or buildings. The fact is that in general, for museums, religion scarcely exists as a category. The vast majority of religious objects are either aestheticized as art icons or treated by curators as evidence of the exotic beliefs of peoples remote in time, place and culture, or as local history objects like any others.

This absence of religious history is true even of most of those museums with religion in their title or who have collections they label as religious. Of the 800 or so museums listed under the directory's religious headings (out of a total of over 24,600), most make little or no attempt to communicate to visitors the complex range of feelings associated with these objects at the time of their creation, or to explore associated rituals, ethical systems and power structures. The main exceptions are buildings which have been converted into a museum from an earlier religious use, sometimes churches, but most often convents and monasteries, though here too architectural history can often dominate. Even in Britain's great cathedrals, from Westminster to Glasgow, many of the brochures do not describe the various rituals which went or go on in them, but instead go through the architectural 'naming of parts' and urge visitors to appreciate their beauty, referring only rarely to the belief systems which inspired them. Thus John Wesley's House and the Museum of Methodism are exceptions rather than the rule, linking an active place of worship with a living shrine to a religious founder where people come to see the 'relics' and a museum which surveys the history of that religion (Taylor, 1992: 22). Many museums of Judaism, usually sited in former synagogues, often achieve a balance (Burman, 1994: 34; Marin, 1994: 33–4). Attempts to create a similar facility interpreting the history of the Bar Convent in York and the role of the Institute of the Blessed Virgin Mary in teaching Catholic girls in the north of England, have failed due to lack of funds.

Few general museums include a section on religion – a rare exception, as in so many other areas, is the Museon, in The Hague, which is a multidisciplinary museum established with an explicit educational purpose. One of its displays includes 'Ritual objects, statuettes of gods, fetish dolls, amulets ... all tributes that believers render to their gods' (Museon, 1989: 47).

This significant absence reflects profound developments in museum history and in Western culture. The mass movement of people from the countryside to towns without enough churches, the widespread adoption of detachment and objectivity as the ideal of academic study, the spread of a belief in scientific and technological progress (with a consequent decline in belief in miracles), the separation of church and state and the growth of largely secular doctrines such as nationalism

and socialism, improvements in medicine and education, and the increase in personal liberty arising from a wide range of developments from universal suffrage to the invention of the contraceptive pill, all contributed to the process called secularization, a 'growing tendency in mankind to do without religion, or to try to do without religion' (Chadwick, 1991: 17). The most obvious result is a radical decline in regular attendance at religious worship and in formal membership of religious organizations from the late nineteenth century onwards.

Today, only 14.4 per cent of the British population claims active membership of a Christian church (Davie, 1994: 46), though between 60 and 70 per cent of people profess a nominal allegiance to a religion. The indices of religious commitment illuminate this picture somewhat. According to one survey in 1990, 71 per cent of British people (72 per cent of Europeans) believed in God, 64 per cent (61 per cent) believed in a soul and 44 per cent (44 per cent) believed in life after death. One-third of all children are baptized (Davie, 1994: 81). If one broadens the definition of religion to include 'healing, the paranormal, fortune telling, fate and destiny, life after death, ghosts, spiritual experiences, prayer and meditation, luck and superstition' as well as the more spiritual aspects of the ecological and green movement and alternative medicine, it is clear that secularization has not eradicated all evidence of belief in the sacred (Davie, 1994: 83). This 'New Age' set of beliefs, combined with practising and nominal Christianity and the significant ethnic minorities who have retained their distinct religious beliefs and practices present a much more complicated picture than the term secularization would imply. 'Belief without belonging' is relatively widespread in society (Davie, 1994: 93–116).

Even if secularization had created a completely 'post-religious' society, this would not explain the absence of religion from our museums: we also live in a post-agricultural and a post-industrial society, and there is no shortage of agricultural or industrial history in museums. Nor does the development of a modern economy inevitably undermine religion. The religious revival in America is one example, and an even more dynamic case is that of Taiwan. Despite the rapid social transformation that has accompanied phenomenal economic growth since 1949, traditional religious belief not only remains unabated, but continues to climb. One of the consequences of this is that a World Religions Museum is being established by the Ling-chiu Shan Wu-Sheng Monastery.

Modern museums emerged in the West, not in some way outside society, but as part of a complex of processes for which 'modernization' is a shorthand. At one level, the taxonomic project of nineteenth-century science lent an aura of rationality to the hoarding instinct, and religion and superstition were excluded or stuffed and mounted as part

of the past which progress was making unnecessary. However museums, and especially art galleries, were also seen as part of the bulwark against the new materialism. For nineteenth-century social critics like Arnold (1869), culture was what would replace religion in promoting 'sweetness and light' among the Philistines, the Barbarians and the Populace. Similarly, for Ruskin 'to see clearly is poetry, prophecy and religion', and 'the visual sense was paramount to unlocking the visible and invisible truths about God' (Koven, 1994: 25). The purpose of the first exhibitions organized to bring art to the working classes in Whitechapel was to enable them to 'see' in this sense.

In Arnold's view, when most people had abandoned the 'facts' of religion, culture would supply its 'poetry' (quoted in Steiner, 1971: 91). This prediction may be seen to have come true to some extent for those whose religion involves 'belief without belonging', though the culture which supplies the poetry is far more likely to be music and nature than experiences found in museums and art galleries (Argyle, 1992: 40–41). Though museums have consciously rejected this spiritual role, and would now see Ruskin's and Arnold's ideas as naïve and patronizing, an underlying belief that museums and art galleries are civilizing influences is still one of the fundamental assumptions upon which their public funding is justified.

This inheritance emerges, at least metaphorically, in the use of the language of religion – temple, pilgrimage, relic – to describe the role of museums in the lives of individuals and societies (for example, Duncan, 1991). Donald Horne bases his entire account of the changes in meaning of the museums and monuments of Europe on an ironic usage of the idea or metaphor of 'the tourist pilgrim' (1984: 9–25). From earliest childhood, museums can be enlisted to carry out social functions formerly the role of the church. 'The ceremonial agenda can be part of the pattern of growing up. Children are taken to a museum for instruction in life's mysteries as once they might have been taken to a cathedral to see the stories in its stone carvings, stained glass, frescos or mosaics (Horne, 1984: 12).

Much of the social veneration of the sacred has passed on to art, so that while curators and collectors having cast off religious meaning in any but a semantic sense, they and their institutions have benefited greatly the high status given these works. 'Tourism as faith can also be seen in the long queues outside the art museums' (Horne, 1984: 13). The ambiguous message of galleries and museums is thus that religion is a thing of the past, but that if there is anything sacred in society it is art. 'Tourism can become, in effect, a celebration of Christianity's fall from dominance' (Horne, 1984: 47).

The public triumph of reason over religion, has not been without a

cost however. The greatest oversight in museums is that the world of feeling embodied in religious buildings, artefacts and rituals has been in general excluded from displays, especially in art galleries. 'While most other museums are now more than glass cases of exhibits arranged for the benefit of the scholar, the art museums still maintain the holiness of paintings as authentic "relics", and their own sanctity as cathedrals' (Horne, 1984: 16). The greatest art galleries are replete with religious works, always shown as part of the great art history narrative, where the most important context for art is other works of art, rather than life, past or present. At its simplest, the flat controlled lighting of galleries transforms paintings into easily comparable units of art. No attempt is ever made to re-create the flickering candlelight of the medieval or Renaissance period, much less add relevant music which would help convey something more of the original 'presence' of the works. Whatever the personal passions of curators for the objects in their care, the displays are more often than not those of a Casaubon, 'scholarly and uninspired, ambitious and timid, scrupulous and dim sighted'. All of these elements – the assertion of secular triumph over religion, and the irony involved in the secular veneration of the work of art, while the religious meanings were rejected – were captured in 1791 in Quatremère de Quincy's complaint against the removal of art from churches to create the Louvre: 'Can one better proclaim the uselessness of works of art than by announcing in the assemblages made of them, the nullity of their purpose?' (quoted in Sherman, 1994: 128–9).

But the passing from religion to reason was not a simple transition, it also involved a struggle for control. One of the chief instruments in this was the encyclopaedic idea of the inventory, for inventory, as Barthes has pointed out, is not neutral, it asserts control. Portraying museums as places of rational, scientific order or as temples of high aesthetics has important practical consequences. It is an essential justification for the claims of ownership of many Western museums of the greatest treasures in their collections. If beliefs relating to objects were treated as real rather than being merely 'associated information' they could not be controlled – not only would the meaning of the objects be in dispute, but also their very ownership. This is the basis of the clash of values involved in many cases of claims for repatriation. What is evidence or a fine specimen for one group is a holy relic to another but, one suspects, equally sacred to both.

Acknowledging the objects as having a real religious meaning would also undermine the authority of the institution itself, and of the individual curator as expert. Religious meanings in the mind and heart of the believer are very different from those in the mind and heart of the scholar. Communication between them is not always easy. Rationality and scientific detachment justify the reduction of belief systems to safe

frames of reference and allusion, which the adept can use to decipher the objects in a manner as rich in meaning and feeling as solving crossword puzzles. If religious beliefs represented by museum objects were treated as being real however, collecting, storage and conservation as well as displays would be transformed, as many American museums are discovering in the aftermath of the Native American Graves Protection and Repatriation Act (Monroe and Echo-Hawk, 1991).

The shift in Europe from Christianity to Humanism and non-religious belief systems has not been stable however, and neither now provides a solid basis for validating the roles of museums in society. Most museums, in spite of the new crop of mission statements and restructurings, avoid the issue of what their role in society is. They cling to the desire, common to both scientific and aesthetic approaches, of trying to achieve acts of 'pure perception' (Berger, 1980: 16). This enables them to remain dedicated chiefly to the preservation of the institution and, with some expedient modifications, the continuation of existing practices, as being self-evidently worthwhile. Very few show any awareness of the damage done to Western civilization by the mass slaughter of 1916–17 and the Holocaust, outlined by George Steiner (1971: 51) in his 'inventory of the irreparable'.

We can, Steiner argues, no longer assume that the West is the locale of high civilization:

Western Culture worked on the assumption, often unexamined, that its own legacy, the repertoire of its identifying recognitions, was in fact the best that has been said and thought ... Lost also ... or at least decisively damaged, is the axiom of progress, the assumption, dynamic in its self-evidence, that the curve of western history was ascendant ... We no longer accept the projection, implicit in the classic model of beneficent capitalism, that progress will necessarily spread from privileged centres to all men. (56)

And finally, and perhaps most importantly perhaps for museums:

we can no longer put forward without extreme qualification ... that which correlates humanism – as an education programme, as an ideal referent – to humane social conduct ... Libraries, museums, theatres universities, research centres, in and through which the transmission of the humanities and of the sciences takes place, can prosper next to the concentration camps. (59–63)

If museums do not humanize, what are they for? How can museums, as preservers of the valued, contribute to the evaluation of the losses and gains involved in change without the conviction of progress? Is aesthetic hedonism sufficient justification for public funding? In what

way, in the words of the Museums Association definition, do museums contribute to 'the benefit of society'? Unless these questions are addressed the quest for 'pure perception' seems less like a way of transcending distraction from objectivity and aesthetic purity than a serious commitment to being blinkered. These most challenging of questions are avoided in most museums, and most intensely by the greatest and oldest.

But even if one side-steps Steiner's argument that the horrors of mass destruction and genocide are deeply bound up with the same qualities which led to the greatest achievements of European high culture, with Christianity and Humanism, and simply asks why our culture fails to prevent them, the role of museums as cultural institutions in society can no longer be taken for granted. Museums avoid the issue by trying to separate the great achievements from the dark places. But this also separates the collections from life and confers on them 'an archival pseudo-vitality' and 'the inertness of scholarly conservation' upon 'what was once felt life' (82–3).

The first general museum of world religions was founded in Germany in 1927, by the Professor of Theology at the University of Marburg, Rudolf Otto, author of *The Idea of the Holy* (1925). The Religionskundliche Sammlung (Collection for studying and teaching religions) began in 1912, and comprised objects he collected himself in his travels to investigate first the varieties of Christian experience, and then those of other religions. This was a major break with traditional practice in the study and teaching of religions, which relied on the Holy Scriptures only, as if they comprised the whole of religion. Writing at a time when philosophers such as William James and sociologists such as Emile Durkheim were interested in the emotional and social aspects of religious experience, Otto (1932: 254–5) was himself greatly moved by the sensual, believing that

> It would be a fertile and important task to represent the type, character and particularity of religion and religions, not by recounting their teachings or listing their religious litanies and terms, but by collecting and confronting their heads and portraits in order to perceive the spirit of religion and the spirit of individual religions and compare them. Thus one perceives the 'pax Christi' as reflected in the portraits of Christian saints and believers and one notes how, typically, their expression, mood and position of their muscles and bodies are different from those of the 'shanti' – the placidity of the perfect Indian saint or the peace of Nirvana in the features and the 'half-smile' of the Buddha and Bodhisattva figures of the Far East.

Significantly, Otto felt obliged, like most curators, to present the objects in a 'rational' and 'scientific' manner, with no attempt to evoke the

'feeling for the numinous' which was at the heart of his appreciation of his own and other faiths.

One of the main challenges for a museum of religions is how to divide up such a vast subject. Marburg uses a mixture of geographical and 'artificial terms, invented by scholars', which is in part dictated by the balance of the collection and the space available for display: Extinct Religions; Judaism, Christianity and Islam, seen as distinct but linked historically and in terms of belief; tribal religions, mostly West Africa and the South Seas; non-Buddhist religions in India, China and Japan; and Buddhism in south-east Asia, China Japan and Tibet. This also reflects a Euro-centric view, and recent relabelling and the guided tours try to suggest that the people who hold apparently 'exotic' beliefs are responding to the problems of human existence in ways similar to Europeans. Summarizing the aims of the museum, the current director writes

> In the Religionsckundliche Sammlung visitors are supposed to discover, in how many different ways human beings interpret their life and their death and try to master it, and they should learn to respect that other human beings have decided in favour of religious ways other than that they have chosen for themselves. (Kraatz, 1995)

The genesis of the St Mungo Museum of Religious Life and Art (Carnegie *et al.* 1995; O'Neill, 1994, 1995) was very different from that of Marburg, reflecting not a measured academic aim, but a mixture of opportunism and principle typical of Glasgow, a dynamic and politically energetic city with a much broader social agenda than that of a university. A half-finished visitor centre for the medieval cathedral was rescued by the city council on the understanding that it would become a museum. The principles which led to it becoming a museum of world religions were a commitment by Glasgow Museums to getting closer to life, abandoning academic or material culture categories, and a desire to create more socially inclusive displays. More explicitly than most museums, it addresses the issue of social role and its aim is stated clearly in the foyer: 'We hope the St Mungo Museum will encourage mutual respect and understanding among people of different faiths and of none.'

A similar motivation has prompted the establishment or development of other museum projects. The Musée des Religions in Nicolet, Quebec hosts temporary exhibitions in order to offer 'visitors' classes in religious pluralism' (Paradis, 1993: 7). Hull City Museum's 'Faith in the City' exhibition, provided an opportunity for research and collecting for what in time will be the religious section of the planned new local history displays (Tyler, 1994).

The stated purpose of the proposed World Religions Museum in Taiwan is 'Respect, Acceptance, Universal Compassion'. The founders believe that

> as people's understanding of the essence of various religions increases, they can perhaps apply those insights to daily life. We hope that with the establishment of the WRM, people of many religions can work together to promote world peace and the welfare of humanity. (World Religions Museum, 1994)

This differs from both Marburg and St Mungo's in its belief in the truth of religions – though it explicitly does not seek to make converts. Marburg attempts to describe beliefs, while St Mungo's takes its task to be to convey the emotional and social reality of those beliefs. All three, to differing degrees, blur the boundary between the sacred and the secular and seek, at the very least, not to exclude the possibility of visitors having spiritual experiences in response to the displays.

Museums of religion by definition are politically and socially engaged because they present a challenge to fundamentalism of all faiths. In Marburg, the gallery on Judaism, Christianity and Islam poses a potential challenge for Christian visitors.

> They on the one hand, shall learn that their Christian religion is not a religion of its own right: it is the daughter of the Jewish religion, in its origin a Jewish sect. And the Christian claim of 'completing' the Jewish message, again, in a similar way, is set out against the Christian message by Muslims. (Kraatz, 1995)

The fact that most of the visitors are from Protestant Germany, and most of the Christian exhibits are from Catholic and other traditions may also provoke difficult reactions, as may an image of the local synagogue burned down by the Nazis in the section on Judaism. In creating St Mungo's we felt as if we were breaking major taboos by showing a range of art from all over the world in one gallery. Salvador Dali's *Christ of St John of the Cross* is displayed in the same room as an Islamic prayer rug, a Kalabari Screen from Nigeria, and an Egyptian mummy mask. Very few visitors have found this uniquely heterogeneous mixture difficult to understand or to accept what they have in common – a religious aspiration to transcendent beauty.

However, the aim of creating a more inclusive display can also lead to the avoidance of controversy. In Hull's 'Faith in the City' the team decided not to show any images of religious practices of ethnic minorities which might reinforce prejudice in the majority community (for example, animals being slaughtered by a Halal butcher). This is

perhaps understandable in a first, temporary exhibition, but in a longer-term exhibition perceived negative as well as positive aspects cannot be avoided without censorship. The process of consultation does not relieve the curator from his/her responsibilities to the wider community to address issues of general concern.

St Mungo's is generally celebratory in tone, but we carefully chose a number of the negative effects of religion to highlight – its role in causing wars and persecution, in the oppression of women (especially the practice of clitoridotomy) and the destructiveness of some missionary work. Persecution, difficult to interpret with objects, is represented by the single greatest example, the Holocaust. Other controversial issues, such as arranged marriages, the Fatwah against Salman Rushdie, racism and sectarianism are raised through quotes from members of the relevant communities.

Representing religion in a society where it is a source of division and conflict is a difficult task. The Museum of Christianity in The Hague, which opened in 1979 brought together the Archiepiscopal Museum of Utrecht, the Episcopal Museum of Haarlem, and the Old-Catholic Museum. The Netherlands was able to undertake this museum, largely because it has left these divisions far behind it, though it is still a sensitive area. The museum was state funded on condition that it enabled 'all Christian communities in the Netherlands the opportunity of being presented. A part of the museum was to be particularly devoted to the Reformation and its religious communities' (Statemuseum Het Catherarijneconvent, 1981: 3). It was not to be an art museum, but a historical museum, portraying the history of Christianity in the Netherlands. The social division between Catholics and Protestants is shown, symbolically, in a divided house – a sitting-room, one half of which is Protestant and the other Catholic.

The Catholic-Protestant divide in Scotland was created with the migration of thousands of Catholic Irish to the largely Protestant Scotland in the nineteenth century. Still a factor in society, this division is addressed directly in St Mungo's Scottish Gallery. This has not been as controversial as the fact that the Protestant tradition itself is perceived by a substantial minority of visitors as being under-represented. Though much of this is due to the fact that the Protestant tradition (and Scottish Presbyterianism in particular) does not produce many objects, and very few indeed of any visual interest, the fact remains that for many visitors the gallery does not feel Scottish enough.

The blurring of the boundaries between the religious and the secular has perhaps most strikingly taken place in the Ulster Folk and Transport Museum, which displays reconstructed Protestant and Catholic churches, in which ceremonies are sometimes held – giving many visitors the first opportunity in their lives to enter a building of

the 'opposing' denomination. The conflict between the Christian communities in Northern Ireland has created a situation where the irreparable is unavoidable, and where the role of culture can be a matter of life and death. The result is that there is an official policy about the role of museums in society, and one which has been able to grow in response to external social changes (Buckley and Kenney, 1994). In the 1970s, the museum aimed to be an 'oasis of calm' outside the conflict, and to illustrate those aspects of people's culture, other than religion, which they shared. Since the mid-1980s, young people from both communities have been brought together for educational activities, through the Education for Mutual Understanding programme. The next logical step is a gallery interpreting the history of religion in Northern Ireland, and plans for this are well advanced.

Attempts by museums to make histories of religion reflect a wider attempt to redefine their role in society. One commentator saw St Mungo's as redressing a historic imbalance, in which the history of religions has been dominated by their texts, ignoring the fact that for the majority of history most people have not been literate, and the language of symbols and objects dominated (Arthur, 1994). This may also be true of most museums where, despite the apparent dominance of the visual, the actual model for displays is that of the book, whether coffee-table or monograph, and the experience of the imagined visitor closest to that of the reader – solitary, introverted, and silent. St Mungo's is a deliberate attempt to create a new visual language of objects in three dimensions, which aims to communicate the meaning of the objects as part of the 'felt life' of both the visitors and the members of the objects' cultures. A gallery on religious history in the Ulster Folk and Transport Museum would assert in a unique way the link between culture as preserved by museums and within life itself. These developments and others in what has been called the 'new museology' involve a rejection of taxonomic thinking and remote aestheticism, in favour of a view of society based on relatedness and change. They are struggling to engage with the realities of human life, the universal mysteries of birth and death, love and tragedy, individual freedom and belonging. This inevitably involves acknowledging that the 'dark places are at the centre' and not unfortunate but peripheral phenomena, an essential step if museums wish to contribute to the 'serious discussion of human potential'.

References

Argyle, M. (1992) *The Social Psychology of Everyday Life*. Routledge, London.
Arnold, M. (1869) (1969) *Culture and Anarchy*. Cambridge University Press, Cambridge.

Arthur, C. (1994) 'The art of exhibiting the sacred', *The Month*, July, 281–9.

Berger, P.L. (1980) *Invitation to Sociology*. Penguin, Harmondsworth.

Buckley, A. and Kenney, M., (1994) 'Cultural heritage in an oasis of calm: divided identities in a museum in Ulster' in Kockel, U. (ed.), *Culture, Tourism and Development, The Case of Ireland*. Liverpool University Press, Liverpool.

Burman, R. (1994) 'Window on a world', *Museums Journal*, February, 34.

Carnegie, E., Dunlop, H. and Lovelace, A. (1995) 'St Mungo's Museum of Religious Life and Art, a new development in Glasgow', *Journal of Museum Ethnography* 7, 63–78.

Chadwick, O. (1991) *The Secularization of the European Mind*. Cambridge University Press, Cambridge.

Davie, G. (1994) *Religion in Britain since 1945*. Blackwell, Oxford.

Duncan, C. (1991) 'Art museums and the ritual of citizenship' in Karp, I. and Lavine, S.D. (eds) *Exhibiting Cultures, The Poetics and Politics of Museum Display*, 88–103. The Smithsonian Institution, Washington.

Eliot, G. (1872) (1994 edn) *Middlemarch*. Penguin, London.

Horne, D. (1984) *The Great Museum: The Re-presentation of History*. Pluto, London.

Koven, S. (1994) 'The Whitechapel picture exhibitions and the politics of seeing' in Sherman D.J. and Rogoff, I. (eds), *Museum Culture*, 22–48. Routledge, London.

Kraatz, M. (1995) Personal communication.

Marin, J. (1994) 'Keeping the faith', *Museums Journal*, February, 33–4.

Monroe, D.L. and Echo-Hawk, W. (1991) 'Deft deliberations', *Museum News* July/August, 55–8.

Museon (1989) *Catalogue*. The Hague: Museon.

O'Neill, M. (1994) 'Serious earth' *Museums Journal*, February, 28–31.

O'Neill, M. (1995) 'Exploring the meaning of life: the St Mungo Museum of Religious Life and Art' *Museum* 1, 50–3.

Otto, R. (1925) *The Idea of the Holy, An Inquiry into the Non National Factor in the Idea of the Divine and its Relation to the Rational*, trans. by John W. Harvey. (First published 1917) Oxford University Press, Oxford.

Otto, R. (1932) *Das Gefuhl Des Uberweltlichen*, 254–5. Sensus Numinis, Munich. I am grateful to Dr Kraatz for this reference and to Ulrike Al Khamis for the translation.

Paradis, M. (1993) 'The Musée des Religions' *Muse*, Spring, 7–8.

Richter, E. (1995) *Museums of the World*. Saur, Munich.

Sherman, D.J. (1994) 'Quatremere/Benjamin/Marx: Art Museums, aura and commodity fetishism' in Sherman D.J. and Rogoff, I. (eds), *Museum Culture*. Routledge, London.

Statemuseum Het Catherijneconvent (1981) *Guidebook*. The Museum, Utrecht.

Steiner, G. (1971) *In Bluebeard's Castle*. Faber and Faber, London.

Taylor, A. (1992) *John Wesley's House and the Museum of Methodism, Wesley's Chapel Magazine* 4, Autumn.

Tyler, J. (1994) 'Where angels fear to tread' *Museums Journal*, February, 26–7.

World Religions Museum (1994) *The Way of the Heart*. World Religions Museum, Taiwan.

17
Making Histories from Archaeology

Janet Owen

'Histories from archaeology' interweave across all the other elements
and issues outlined in this book. Archaeology contributes to the making
of children's histories, family histories, rural histories and to the
histories of work and workers. The reasoning behind the inclusion of a
separate discussion 'making histories from archaeology' is more to do
with the *type* of history written from archaeological evidence, rather
than the subjects or topics studied. However, the histories being
written from archaeological evidence are changing, reflecting the shift
in emphasis of current archaeological and historical paradigms. The
intention of this chapter is to outline the developments currently taking
place in archaeological theory, and to discuss how these changes are
opening up new, exciting ways of interpreting archaeological material
culture in museums, with reference to museum displays. In doing so,
the chapter will discuss ways of making archaeological narratives more
meaningful and relevant to people today, and will suggest that the
traditional 'conceptual boundary' between the treatment of social
history and archaeological collections in museums should be reas-
sessed.

'Social history material' and 'archaeological material' have tradition-
ally been considered as separate entities in museums, yet both groups
consist of past material culture. Social history items are acquired by the
museum from individuals in the community who can also provide an
object with a particular, identifying meaning. The owners may well have
used the objects themselves, or be knowledgeable about how the
objects were used by other members of their family or by friends. A
relative wealth of documentary evidence and personal memories
provides a narrated context which is both relevant and meaningful to
our everyday experiences.

In comparison, archaeological items are acquired by museums from a

source that is removed, both chronologically and conceptually, from the past individual and society for which the items once held meaning. By its nature, archaeological material is found in the ground where it was deposited, intentionally or unintentionally, by an anonymous owner. It is often hundreds, if not thousands, of years old. The finder is obviously a direct source of information about the circumstances of an object's discovery, but can shed little light on the original purpose and past meaning(s) of that object. Traditionally, the narrated context of archaeological material culture is provided by a complex amalgamation of 'scientific' and theoretical observations about the material and its associated physical contexts. These processes are impersonal, and can only be understood by a small percentage of the population, the 'archaeologists', who impart the results of their research to the wider audience. Public interpretation of archaeological material tends to concentrate on describing the 'safe' aspects of past societies, facts which can be deducted from the evidence: technology, economy and lifestyles.

However, traditional approaches to archaeology in museums are rooted in the theoretical paradigms which were prevalent in archaeology during the 1960s and 1970s. As with any discipline, these paradigms are continuously changing and developing, and current paradigms advocate a more personal and social approach to archaeological interpretation, a more holistic approach to past material culture and an appreciation of the socio-historical nature of archaeology. Museums are increasingly exploring ways of working within these current paradigms and, in so doing, are seeking to make histories from archaeology which are more meaningful and relevant to today's museum visitor.

The changing theoretical landscape

Nick Merriman (1989) carried out a survey in 1985 of people's attitudes to the past and to museums, and the results of this survey clearly suggest that the vast majority of the UK public feel it is worth knowing about the past, but also that traditional museum activities do not attract a large percentage of that public. Non-visitors are perhaps less able, or less willing, to relate to the past as presented in museums, a past which Merriman suggests is a middle-class narrative reinforcing middle-class values, a technical, clinical and impersonal past for which visitors need to have the appropriate intellectual framework to understand the middle-class codes. The lower classes in particular therefore perhaps find nothing in museums which is relevant to their experiences, or their perceptions of the world around them. These findings suggest that if museums wish to encourage a wider interest in archaeology (which if

nothing else is a necessary prerequisite to museum archaeology's survival in the current political climate), they need to look closely at the nature of current narratives in museums, and experiment with making histories from alternative perspectives, perspectives to which both traditional 'non-visitors' and 'visitors' alike can relate. People relate most easily to the personal present, to the 'here and now', but they can also attempt to place themselves in other people's shoes, taking their own personal baggage of experiences with them. Therefore, those of us responsible for making histories in museums should seek not only to explain the archaeological material culture in our collections in relation to the people and societies who made them, but also in relation to the people and society of today.

Within the realm of archaeological and museological theory there are a number of developing arguments upon which museum archaeologists can draw to construct histories of the form suggested above.

'Contextual archaeology' places emphasis on using past material culture to try to understand the nature of the social context within which that material culture was made and used. Such an approach will undoubtedly involve inductive as well as deductive reasoning. Material culture is seen as a 'text' from which ideas about the structure of a past society can be inferred, each object having its own place in the coded structure of that society (Hodder, 1987a). An object does not have a purely functional existence, but also symbolizes aspects of the 'parent' society's ideological framework.

While investigating the relationship between a society's ideology and its manifestation in material culture, Hodder analysed the contemporary symbolic role of a bow-tie in the management strategy of a particular pet food company in the Cambridge area (1987a). As a starting point, Hodder stated that ideology is an integral part of the management process, and then went on to identify various aspects of material culture used by the company to reinforce their presiding ideology. Bow-ties were worn to identify different levels of lower and middle management (each level identified by a specific colour) during the period 1953–76. The bow-tie scheme provided a sense of neatness and order, and allowed management to be easily identified. However, the bow-ties were discontinued in 1976 in order to encourage a sense of superficial equality between all workers, and to encourage communication across management levels. Hodder argues that this change of approach was necessary to cope with the personnel changes effected by the adoption of computerized technology at the factory. All management levels now worked together on the high-technology production line, and a number of 'outsider' computer graduates were employed by the company. In order to avoid resentment of the 'outside highflyers' by the longer-serving workers at the factory the bow-tie as a visual symbol of status

was dropped, and other measures, including a no redundancy policy and retraining, were introduced to try to maintain the community atmosphere of the workforce.

Hodder, and others, argue therefore that the symbolic meaning(s) of an archaeological artefact in the past is also important to our understanding of past societies. The contextual archaeological approach suggests that an object's decoration, and Shanks and Tilley (1992) also argue its form, provide clues to its past, symbolic role and therefore to the ideological frameworks of past societies. We should attempt to ask questions of archaeological material culture, such as why seventh century BC perfume jars (aryballos) from Korinth are decorated with exquisite scenes of 'masculine endeavour and wild otherness' (Shanks, 1995: 171). What can the use and popularity of such decoration tell us about the society within which it had 'original meaning'?

The form of any event or process in the present and in the historical past, is shaped by the form of previous events and processes. Therefore archaeology should be considered as part of any analysis of long-term social structures, the idea of archaeology as long-term history (Hodder, 1987b). Hodder argues, for example, that the rise of capitalism in more recent times cannot be fully considered without looking at evidence for the form of social structures in prehistoric and early historic societies. Contextual archaeology provides the methodological means of analysing these early social structures.

We cannot detach our interpretations of events and processes in the past from the social context of our present. Therefore, one aspect of contextual archaeology is also to look at how the context of contemporary society influences any attempt to interpret the symbolic meaning of an object in the past (Hodder, 1987a). In *Re-Constructing Archaeology*, Shanks and Tilley (1992) explore this post-modernist archaeological theory in greater detail, and apply their thoughts directly to a number of contemporary 'archaeology' and 'social history' museum displays. They argue, very convincingly, that narratives in archaeology displays do not explain past realities, but discuss past material culture in the context of the present author's social and individual experiences. The past as represented in museums is not actually what happened in the past, it is not 'the truth' about the past, as this is a concept which is in reality unattainable, or perhaps non-existent. Rather it is a product of the present, and reflects the present preoccupations and beliefs of the author. In consequence, the author of museum narratives has a powerful role, and Shanks and Tilley argue that what museum display 'histories' really do is further reinforce or legitimize the dominant social and political norms of the present.

The Jorvik Viking Centre in York, for example, provides a didactic and authoritarian narrative of the past which celebrates the heroic work

of the archaeologist. Shanks and Tilley (1992) argue that Jorvik is an exercise in self-gratification on the part of archaeologists and is also a political statement justifying the role of the York Archaeological Trust in particular, and the archaeological discipline in general. The history narrated at Jorvik pays great attention to the labour of discovery on the part of the archaeologists, and the labour of reconstructing the past as accurately as possible.

Far from being a damning indictment of archaeological interpretation as a waste of time and public money, however, Shanks and Tilley argue that this philosophical awakening can and should be used positively by archaeology and museums to make archaeological collections, and the process of making histories from them, more accessible to a wider audience. 'The museum must allow the visitor to construct a past along with the archaeologist-curator: participation not as a means to a pre-given, pre-discovered end, but as an open process of constructing different pasts' (Shanks and Tilley, 1992: 98).

'Past material culture' is not stuck in the past, it is not dead and buried, but is an integral part of our present. Bender (1993) explores this dimension further in her work on the site of Stonehenge. She attempts to identify and consider the dynamic and living network of meanings which this prehistoric monument holds for contemporary and past societies. Stonehenge has meant, and does mean, different things to different people. Bender argues that rather than looking at Stonehenge as a chronological fossil from another age, we should be looking at it as the focus of a number of histories, linked by themes which cut through time: for example ritual, folklore, political identity, Establishment versus Anti-Establishment. Bender's work on Stonehenge has included the preparation of a touring exhibition about the site which encourages the viewer to consider alternative ways of thinking about the monument.

Putting theory into practice

I have identified the following three principles, based on the theoretical arguments summarized above, which could be used to guide any construction of histories from archaeology in museums.

Emphasis on the personal and social nature of material culture

Contextual archaeology has a lot to offer us in our quest for a more personalized history from archaeology. It focuses discussion on the people and society behind the objects as much as on the objects themselves – we look through the object to consider the past society and the individual beyond. The museum visitor could be asked to

consider the symbolic meaning of the form and decorative styles exhibited by artefacts in museum collections. Why did the maker decorate some items and leave others plain? Why are similar artefacts decorated in different styles? Why do we use decoration in our own society? The process and resulting interpretation of contextual analyses carried out on material could be explained to the visitor, and they could be asked to draw their own conclusions about the interpretation presented by the museum, based on the evidence before them. To introduce the visitor to the concept of contextual analysis, which otherwise might be alien to their way of thinking, the process could be applied first to a modern item with obvious symbolic meaning to people in contemporary society, a Coca-Cola bottle for example, before the narrative moves on to apply the method to archaeological material culture.

Linking past societies to contemporary societies

The idea that archaeology is a part of long-term history is a significant one for museums. Past material culture can be linked in displays to the present through a thematic consideration of long-term social structures. The 'Peopling of London' exhibition held at the Museum of London in 1994 focused on the long-term theme, the in-migration of people into the London area, and analysed it through material culture from the prehistoric period to the present day (Merriman, 1990). The visitor was invited to look at and consider human artefacts left by the people who first moved into the area now occupied by London *circa* 300,000 year ago, and was then led on a chronological journey through the succeeding prehistory and history of people moving into the London area. In the earlier sections the story was told around archaeological artefacts and sites, but as other forms of material evidence became available the archaeological material was interpreted alongside social history material, fine art objects, documentary records and contemporary oral sources. The linking of past material culture in this way to contemporary material culture, concepts and personal experiences may enhance the relevance of the past material culture to the museum visitor.

However, it must also be borne in mind that all societies are different, and unique, and that social differences are reflected in material culture. In our desire to provide meaning and relevance to archaeological material culture, we must be careful not to ignore the 'strangeness' of past societies. Every society has ideological concepts which other societies find difficult to relate to or understand. A wooden cross does not have the same meaning or significance to a non-Christian society as it has to a Christian society. Likewise, Stonehenge has a

different meaning or significance to a follower of a pagan faith than it has to a follower of the Christian faith.

It is this 'strangeness' of other societies which inspires our curiosity in the past, and our desire to 'imagine' what living in other societies or other times must have been like. Our celebration of past material culture should embrace these social differences, but through contemporary analogy find ways of helping the visitor to understand them.

Following the work of Barbara Bender on Stonehenge (Bender, 1993), museums should also consider focusing narratives on the networks of both contemporary and past meanings of specific archaeological sites or artefacts represented in their collections. After all, archaeological artefacts in museums are merely portable forms of Stonehenge – portable forms of past material culture. There are a number of well-documented historical meanings for prehistoric flint and stone axeheads, for example, and these meanings reflect the underlying ideological beliefs of historical societies. Such axeheads have been found built into the walls of buildings dated from *circa* 500 BC through to the post-medieval period, and historic evidence suggests that their purpose was to protect the building and its occupants from the threats of lightning and bewitching. Before scientists in the nineteenth century identified these axeheads as human artefacts from a distant past, communities in many parts of Britain explained their occurrence as 'thunderbolts' fallen from the sky during thunderstorms. In Cornwall, axeheads were deemed to have medicinal properties as a result of their supposed supernatural origin, and were boiled in water which was then drunk as a cure for certain diseases (Grinsell, 1976). Today, prehistoric axeheads are viewed as something to be scientifically analysed by archaeologists and as emotive symbols of our human predecessors.

The involvement of the visitor in the process of interpretation itself

Post-modernist theories have stripped the didactic power from archaeological interpretation. People responsible for making histories from archaeology in museums should in turn remove the authoritative tone from their narratives, and acknowledge within the narrative that their story is just one interpretation of the material evidence (Shanks and Tilley, 1992). Their story is not the truth, and alternative histories can be made from the same evidence, the form of which is determined by the preconceptions and experiences of the author. Museums should therefore identify the people behind the museum narratives, the authors, rather than hiding them behind the mask of academia, and should break down the powerful authoritarian nature of the narrative through the use of humour and irony (Shanks and Tilley, 1992). Pearce (1990: 164) comments on the successful attempt to introduce humour

into the 'Lost Kingdom' exhibition at Scunthorpe Museum and Art Gallery in 1988. The labelling of a strip of bronze from a grave at Manton as 'God knows – but we don't – Sixth Century' is just one example of the attempt to dispel the complete authority of the author, though the display was traditional in most other respects.

Authors should encourage the visitor to critique the narrative and examine the evidence for themselves, so that 'visitors' to an exhibition become 'participants' in the development of the history being made, bringing their own experiences to bear on the material culture remaining from the past. The use of drama and theatre in archaeological interpretations may be another way of encouraging museum visitors to challenge their own preconceptions about past material culture.[1] Museums might also consider incorporating historiographical analyses of the local archaeological communities, past and present, into their narratives, creating a social history of archaeology which considers how the social and individual perceptions of these communities influences the form of archaeological archives in museums today (Hudson, 1981: Morris, 1993).

Putting theory into practice: case studies

I now propose to apply the above model to an assessment of three case study museum displays: the 'prehistory' galleries at the Museum of London, Colchester Castle Museum and Stoke-on-Trent City Museum and Art Gallery. These prehistory galleries have all been redisplayed in the last three years, and therefore the creators have had access to the latest museological and archaeological theories. Prehistory galleries were selected for analysis partly because of this author's background, and also because all the issues under discussion in this chapter are seemingly most accentuated when working with material culture produced from societies for which no other evidence of lifestyles remains. All three galleries adopt the traditional definition of prehistory, and narrate a story of human life during the period *circa* 500,000 years BC until the coming of the Romans in AD 43 (Table 17.1). In doing so, they cover a huge time span and a complex picture of change, in a very limited display area.

Emphasis on the personal and social nature of material culture

The 'People Before London' Gallery at the Museum of London emphasizes the people behind the material culture on display throughout the narrative, both implicitly in the issues discussed and explicitly: 'We have chosen to humanise the past by focusing on specific

207

Table 17.1: The traditional archaeological periods *c.* 500,000 years
ago until the coming of the Romans in AD 43 (approximate
dates)

Palaeolithic Period	Old Stone Age	*c.*500,000 BC–*c.*8,000 BC
Mesolithic Period	Middle Stone Age	*c.*8,000 BC–*c.*4,000 BC
Neolithic Period	New Stone Age	*c.*4,000 BC–*c.*2,500 BC
Bronze Age Period		*c.*2,500 BC–*c.*500 BC
Iron Age Period		*c.*500 BC–AD 43

sites and the needs of individual people [in the past] ... ' The story
broaches the symbolic nature of certain material culture remains. The
finely made Neolithic and Bronze Age stone axes are displayed
emotively in spotlighted cases as status symbols of power, and used
as evidence to argue for a hierarchical society in the Bronze Age. The
story asks the visitor to think about why certain Bronze Age items
appear to have been thrown into the River Thames. Are they votive
offerings reflecting a particular social or religious practice in the past?
However, if time and space had allowed, it would have been interesting
to see further discussion of the symbolism of artefact decoration and
form.

The visitors to Colchester and Stoke are told, in the respective
orientation galleries, that archaeology is akin to digging up the rubbish
tips of the past. However, the prehistory galleries do not explicitly
remind the visitor that the objects they see in front of them were once
made, used and thrown away by people in the past. Apart from the
representation of people in the murals and illustrations, the displays do
not use the objects to delve into the psychology of past individuals or
the structuring codes of past societies.

The narrative at Colchester does identify and describe 'symbolic'
attributes of some of the items on display, the various decorative styles
on the Neolithic pottery for example or the role of certain Bronze Age
items as status symbols, but does not discuss or ask the visitor to think
about the deeper past social practices these attributes could symbolize.
The 'Dagenham Idol', a 'mysterious' wooden carving of a stylized
figurine dated to 2000 BC, is exhibited, but its potential spiritual or
religious significance or its significance as a piece of rare prehistoric art
are heavily underplayed.

The story of prehistory told at Stoke rarely mentions the symbolic
aspects of past material culture, with the text concentrating on
imparting information about the economic and technological attributes
of life in the past. The occasional references to symbolism are of a

superficial nature. For example 'At the centre of the mound, [King's Low barrow] two narrow wooden stakes had been driven 1 metre into the ground. They may have had some ritual significance'. The gradual elaboration of Bronze Age metalwork is discussed in the display, but is given only a technological explanation: 'two-piece moulds ... made possible the production of elaborate shapes with patterned surfaces or with sockets for hafting'. The text does not consider *why* people in the 'Bronze Age' started wanting to produce elaborate shapes and patterned surfaces.

Linking past societies to contemporary societies

All three case study galleries visited are primarily structured chronologically, and are clearly 'archaeology' galleries. However, all three narratives use thematic sub-titles rather than referring to traditional 'period' terms, such as Palaeolithic and Neolithic:

- 'The First Humans' and 'The First Farmers' (Archaeology Gallery, Stoke City Museum & Art Gallery)
- 'The First People' and 'Farming' (Archaeology Gallery, Colchester Castle Museum)
- 'People Like Us' and 'Out of Europe' (People Before London Gallery, Museum of London).

The emphasis is placed on concepts which we understand in the present: farming, people, the European Community.

The People Before London Gallery also explicitly identifies sub-themes which run through the display selected for their relevance and meaning to today's society: 'We have chosen to ... [give] greater prominence to green and gender issues and 'The need to conserve limited resources was as important in prehistory as it is today' ('Can You Believe What We Say?' Section; 'Technologies of Fire' Section; People Before London Gallery, Museum of London). The authors interpret past material culture in association with contemporary material culture, partly as a means to relate the former to the contemporary issues mentioned above, and partly as a means of providing a relevant and meaningful context for *individual* artefacts. Lower Palaeolithic flint bi-faces are displayed alongside a modern Swiss army knife, in an attempt to suggest their multi-purpose nature in prehistory. A Bronze Age hoard of scrap metal is displayed in association with a crushed aluminium can to suggest the 'timeless' concept of 'recycling' raw materials. As the display draws to a close, and the visitor moves forward in time to the Romano-British period, he/she is asked to dwell for a minute or two on the 'prehistoric inheritance' of

today's society. The narrative reminds us, both visually and textually, that our present landscapes, social structures and ideologies are rooted in prehistory, and points to language and customs as two areas of our society where this influence can clearly be perceived today.

Each graphic board at Colchester considers one specific theme of life in prehistory, though set within chronological boundaries: war, status symbols, pottery, the environment, the uses of scrap metal, etc. These themes were selected for their contemporary relevance to modern life,[2] but the narrative does not explicitly cross-reference them to our present experiences or lifestyles. A background soundtrack plays, quite deliberately, a mixture of familiar and less familiar sounds to evoke an atmosphere of both familiarity with the present and of 'strangeness'.[3]

The Archaeology Gallery at Stoke leads the visitor through a general narrative about the prehistory of the local area, and towards the end of the gallery introduces him/her to the cave sites of the Manifold Valley. Archaeological work at these sites has suggested that they have been used by people, for a variety of purposes, from prehistoric times through to the present. They provide a perfect case study for encouraging the visitor to think about prehistory as part of long-term history, and the author of the gallery narrative uses these sites to provide a contextual link between the present and the past.[4] However, the display as it currently stands fails to fulfil the potential of this case study to stimulate such conceptual links in the mind of the visitor.

The involvement of the visitor in the process of interpretation itself

The visitor is welcomed into the People Before London Gallery by the questions 'how accurate are they [the common images often used to portray prehistory]? and 'can you believe what we say?', and as he/she leaves is asked 'now what does prehistory mean to you?' An overall intention of the gallery is that the visitor thinks critically about his/her own perceptions of prehistory and the effect that this gallery has had on those perceptions.[5] In the introduction, the authors identify themselves by name, and state that the narrative of the exhibition is only one of a number of different narratives which could be developed from the same material culture remains. This move to strip élitist power from the narrative, is accentuated in parts of the display by the use of humour and irony. When discussing, for example, the role of stone and bronze axes as status symbols in prehistoric societies, the narrative suggests that ironically the prestige of such objects 'is assured by their display in cases such as this ... '. The authors were also keen to create a theatrical atmosphere in the gallery,[6] and emotive quotes introduce each section, aiming to break down any formal barrier of interpretation before the viewer goes on to consider the authors' story: 'Look. In a

small clearing at the river's edge is a sturdy log cabin ... ' (Splendid Isolation Section).

In certain sections of the story, the narrative actively encourages the visitor to think about the evidence before them: 'How are we to interpret the burial [the burial of an aurochs found at Harmondsworth]? Was it a ritual killing? Was the meat inedible? Were parts of the carcass taboo? Or simply too heavy to carry away?' (Broadening Horizons 3300–1200 BC Section).

In the 'technology sections' of the gallery, the visitor is encouraged to touch and think about samples of raw materials and replica artefacts, which illustrate points made in the text. The 'Find Out More Boxes' located at the end of each section in the gallery, provide the visitor with further information about the issues discussed in the display and recommend sources to consult if he/she wishes to follow up their interest in those issues. The guided tours given by the authors provide them with an opportunity to argue their case further, and give the visitor an opportunity to question the authors directly about their interpretation.

However, the rest of the narrative is primarily didactic, and the visitor must read the introductory board to be aware of the authors' intentions. The use of 'possibles' and 'maybes' in the text has consciously been kept to a minimum.[7] The complex nature of archaeological evidence is not discussed. In particular, there is no consideration of the bias in the archaeological record created by negative evidence. Earlier material, and evidence of certain material types, are less likely to survive to be recovered in the present. The resulting material culture text is therefore not an accurate reflection of all material culture existent in the past. For example, the narrative implies that status symbols, and the social practices behind them, 'appear' once society becomes more sedentary and hierarchical in the period 7000–3300 BC. The narrative does not mention that this apparent development may be as much a reflection on the survivability of material culture through time as a reflection of any real trend in past society.

The authors of the prehistory galleries at Colchester and Stoke remain anonymous hands, and the stories told are primarily didactic and humourless. At the beginning of both galleries is a section which introduces the visitor to the archaeological process, and to the idea that archaeology is for everyone. However, there is little attempt, in the prehistory galleries themselves, explicitly to draw the visitor into the overall process of interpretation. Information is given as fact, and complexities of the archaeological evidence are glossed over in the text. At Colchester, for example, the 'Celts' are described as a people with a single culture and language spreading across Central and Western

Europe during the period 500 BC–AD 50, a simplistic interpretation of the evidence which is strongly criticized in recent academic literature about the period.

The narrative at Stoke does occasionally break from its didactic description of the evidence to suggest that archaeologists are uncertain of how to interpret some evidence remaining from the past.

> 'Excavations [at Ossom's Cave] have recovered several flint and chert tools, as well as numerous animal bones. Most of these were reindeer which, it was thought, had been killed by hunters and butchered at the cave. However, this may not have been the case. Bones which have been butchered bear clear marking of this activity. No such marks have been positively identified on the Ossom's Cave reindeer bones ... The presence together in this cave of so many reindeer bones and visiting humans is a puzzle ... ' (Hunter-Gatherers Section, Archaeology Gallery, Stoke-on-Trent Museum)

An interactive area has also been incorporated into the gallery at Stoke, which encourages the visitor to have a go at reconstructing replica post-medieval ceramics from sherds, and to have a look at some typical boxes of archaeological bulk finds.[8] The activities on offer do not relate specifically to the narrative of prehistory being told around the visitor, and in my view do not sufficiently orientate the visitor in how to make use of the interactives on offer. For example, the boxes of bulk finds are labelled impersonally with their site code, context details and material type. In order to understand the material within the boxes, you have to be able to decipher the codes written on the box: how many visitors are likely to know which site the particular three letter code represents, and what the term 'cistercian ware' implies? Without knowing these basic pieces of information, it is unlikely a visitor's attention will be held for long on a box of sherds he/she knows nothing about.

Where next?

All of the galleries specifically reviewed in the preparation of this chapter, are experimenting, to varying degrees, with ways of making histories from archaeology which have their roots firmly implanted in current archaeological paradigms. In doing so, these histories are becoming more relevant and meaningful to the visitor, and the traditional boundaries between archaeological and social historical concepts are being eroded. However, a number of aspects in the model defined earlier still need to be explored by museums. Out of the three displays studied, only the People Before London Gallery at the Museum of London really grasps the post-modernist 'nettle' and attempts to

expose the contemporary face of archaeology. Those of us currently responsible for making histories from archaeology in museums have a lot of experimenting to do over the next few years if we are to succeed in making those histories more personal and relevant to the museum visitor. We must not be afraid to take risks and try out novel ideas of interpretation.

A major obstacle facing museums, in this respect, is undoubtedly the fact that most archaeological displays set up are of a permanent nature, and it becomes an even greater risk to spend large amounts of money on an exhibition format which turns out to be a disaster. Perhaps this is where temporary exhibitions could play more of a part, as comparatively less money is involved in their creation and the results are on show for a much shorter period of time than a permanent display. Experimenting with different approaches to archaeological interpretation in temporary displays could provide a means of testing certain methods and identifying successful and unsuccessful approaches. This knowledge could assist exhibition designers in their creation of new permanent galleries, and associated museum services.

We also need to evaluate archaeological interpretation at all stages in the creation process, whether the display be permanent or temporary, and publicize the results of these evaluations. In particular, we need to evaluate what people do find meaningful and relevant, which techniques succeed in personalizing archaeology in this way, and indeed if that is what the visitor wants from museum histories anyway. The Museum of London is carrying out an ongoing evaluation of the People Before London Gallery, which has produced interesting interim results. These results suggest that the visitor welcomes the idea of using museum displays to challenge his/her own perceptions of the past, but that the present exhibition design does not easily facilitate this form of intellectual debate at an individual level: 'The entrance is trying to equip visitors with some analytical tools, before showing them the story. This makes rational sense but perhaps not emotional sense' (Fisher, 1995: 14). The survey results also suggest that the techniques used to link past material culture with present material culture were understood and appreciated by the visitor.

We should be conducting experiments which emphasize the link between the past and present; which break down the barrier between social history and archaeology, and allow us to view the process of archaeology itself as a social construct; which involve the visitor in the process of interpretation of archaeological material culture. Hull City Museums and Doncaster Museum and Art Gallery are just two museums currently redesigning their archaeological displays, and experimenting in this way. Figure 17.1 suggests an experiment this author proposes to try at some point in the not too distant future.

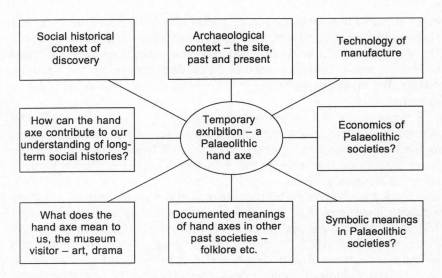

Figure 17.1 A proposal for making a history from archaeology in museums

Acknowledgements

I would like to thank all those who have helped me in the preparation of this chapter, particularly the curators who allowed me to interrogate them about their work: Jon Cotton, Barbara Wood, Christine Jones, Stephen Douglass, David Barker and Deborah Ford. Despite the critical comments made in the context of my arguments about some aspects of the displays, I thoroughly enjoyed my visits to all of them.

Notes

1　Thomas, J., Theoretical Archaeology Group Conference Paper 1993.
2　Douglass, S., interview May 1995; Jones, C., personal communication, interview March 1995.
3　Jones, C., interview March 1995.
4　Barker, D., interview May 1995.
5　Cotton, J. and Wood, B., interview February 1995.
6　Cotton, J. and Wood, B., interview February 1995.
7　Cotton, J. and Wood, B., interview February 1995.
8　Barker, D., interview May 1995.

References

Bender, B. (1993) 'Stonehenge-contested landscapes (medieval to present-day)' in Bender, B. (ed.) *Landscapes: Politics and Perspectives*. Berg, Providence, RI.

Fisher, S. (1995) 'How do visitors experience the New Prehistoric Gallery? Qualitative research', unpublished research commissioned by the Museum of London.

Grinsell, L.V. (1976) *Folklore of Prehistoric Societies in Britain*. David and Charles, Newton Abbot.

Hodder, I. (1987a) 'The contextual analysis of symbolic meanings' in Hodder, I. (ed.) *The Archaeology of Contextual Meanings*. Cambridge University Press, Cambridge.

Hodder, I. (1987b) 'The contribution of the long-term' in Hodder, I. *Archaeology as Long-term History*. Cambridge University Press, Cambridge.

Hudson, K. (1981) *A Social History of Archaeology*. Macmillan, London.

Merriman, N. (1989) 'The social basis of museum and heritage visiting' in Pearce, S. (ed.) *Museum Studies in Material Culture*. Leicester University Press, Leicester.

Merriman, N. (1990) 'Dealing with present issues in the long-term: 'The Peopling of London Project', in Southwell, E. (ed.) *Ready for the New Millennium-Futures for Museum Archaeology: The Museum Archaeologist*. Conference proceedings, Hull, 37–43.

Morris, M. (1993) 'Reaching the parts other histories can't reach? The role of oral evidence in the historiography and sociology of archaeology', unpublished paper presented at History of Archaeology Session at the Theoretical Archaeology Group Conference.

Pearce, S.M. (1990) *Archaeological Curatorship*. Leicester University Press, Leicester.

Shanks, M. (1995) 'Archaeology and the forms of history', in Hodder, I. (ed.) *Interpreting Archaeology: Finding Meaning in the Past*, 169–74. Routledge, London.

Shanks, M. and Tilley, C. (1992) *Re-Constructing Archaeology: Theory and Practice* (2nd edn). Routledge, London.

18
History and Folklore

James Rattue

Mention the word 'folklore' with reference to museums and the characteristic reaction is one of combined interest and consternation; interest, because the notion is unfamiliar, and consternation because its usefulness is not accepted. This is largely due to the traditional distance between the academic disciplines of history and folklore since the later nineteenth century, when historians rejected naïve folkloristic methods of analysis along with the excesses of 'Whig history' (Blaas, 1978; Phythian-Adams, 1975). This never seems to have been the case in (for instance) Scandinavian academic circles, and to a lesser extent Celtic ones. The Swedish university of Lund gave folklore as a degree subject in 1912, and the Department of Folklore at Helsinki was founded in 1888 (Anon., 1976: 174; Hartala, 1969: 89–111). The Irish Republic, too, has long had a Folklore Commission.

Museums absolutely reflected this situation. The Professorship of Ethnology at Stockholm, which had a prominent folklore element, was based in Nordiska Museet from 1918, and only moved into the university later. In more recent years the museum has published work by the folklorist Sven Ek, and in 1985 conducted a survey into the folklore of the construction industry (Rehnburg, 1976: 172–4; Ropeid, 1985; 163–6). 'Folklore' was the first of the classificatory divisions established at the National Folkemuseum of Denmark in 1879 (Rasmussen, 1966: 23). Among Celtic museums, the National Museum of Wales developed a Department of Oral Tradition and Dialect, and the Ulster Folk Museum one of Oral Narrative and Folklore; a quarter of the latter's publications for 1986–87 had generally folkloric themes. The Manx Museum is still involved with the collection of stories, music and dialect (Harrison, 1986; Ulster Folk and Transport Museum, 1988: 13).

In English museums, folklore has traditionally been isolated from the

mainstream. The use of the phrase 'folk museum', though, is of course quite familiar. It first appeared in the *Museums Journal* in an article written by Elijah Howarth in 1905. In his scheme for such a museum, he explicitly included the folklore element both to show how personal ornaments 'evolved' from charms and amulets and to explore the superstitions which gave rise to them (Howarth, 1905–06: 295–301). By our current understanding, Howarth's crude evolutionism was misconceived, but the important point is that he found folklore material quite acceptable. In the early years of the self-conscious 'museum community', before and during the First World War, English curators maintained a degree of interest in folklore. In 1915 and 1916, the use of recording equipment to gather folksongs was encouraged and, according to its proponents, the planned national 'folk museum' in London was to include displays on children's games and popular customs (Balfour 1911–12: 224; Butterfield 1915–16: 191; *Museums Journal* 15: 213; *Museums Journal* 16: 241).[1]

However, there was some terminological slippage between 'folklore' and what later came to be called exclusively 'folklife'. G.R. Carline treated the terms 'folklore specimens' and 'folklife objects' as interchangeable; and Butterfield, when reviewing a Sussex local history museum, applied the word 'folklore' to a charcoal-burner's turf-hut (Butterfield, 1914–15: 102; Carline, 1919–20: 93-4)! Gradually, it appears that the term 'folklore' was subsumed and forgotten within 'folklife', and the latter quickly gathered a rural stereotype about itself, largely defined by Celtic curators such as Iorwerth Peate of the Welsh Folk Museum and Dr Grant of The Highland Folk Museum, Kingussie. They and their disciples complained at the ghettoisation of 'folklife' (Peate, 1941: 45), but were largely responsible for it. The image became one of the dewy-eyed, romantic, reactionary contemplation of rural society, illustrated by collections of craft tools, ploughs and other 'bygones'; and if folklife was tarred with the rustic brush and seen as subordinate to 'proper' history, it is hardly surprising that folklore itself disappeared from view.

This rustic, quaint image is not the only problem for folklore in impinging on the awareness of museum workers. The condescension of the academic world is only just being broken down, and of course it is this world from which most museum historians eventually emerge. Keith Thomas produced his massive study of popular culture, *Religion and the Decline of Magic*, as long ago as 1971; Bob Bushaway had published *By Rite*, an examination of the social history of the agricultural calendar in rural communities, in 1982; and E.P. Thompson's collection of essays, *Customs in Common*, touching on many folkloric themes such as ritual fence-breaking, wife-selling and 'rough music', appeared in 1991. But in 1984 Tosh still saw fit to

criticize Paul Thompson's work on oral evidence on the grounds of its possible 'contamination' by other sources, a complete missing of the point so far as folklore is concerned (Tosh, 1984: 178).

But the work of these academics has largely investigated eras of the past which have been excluded from the concerns of the present generation of museum social historians, which seems suspicious of anything prior to the Tolpuddle Martyrs, or, preferably, before relevant photographs became available. Folklore cannot be relevant to the *modern* world, surely? There is a difficulty here, to be sure. The very definition of a thing as 'folklore' implies that we recognize it as untrue, and this demands a distance between investigator and subject, either a chronological distance or a social and cultural one. It is less easy to isolate the subconscious quirks of our own society while we are still inside it.

Less easy perhaps, but not impossible, and valuable work has been undertaken. In 1981, Douglass wrote that 'when you're a kid in a pit village you don't get Goldilocks and the Three Bears as a bedtime story. You get Churchill and the '26 Strike', and tales of the impossibly callous utterances of Lady Astor. McKelvie examined Bradford folklore in 1963, and Messenger the oral culture of the Ulster linen industry. In the early 1970s a PhD candidate in folklore at Indiana University isolated 101 folkloric themes from a day's television-viewing (Dorson, 1972: 41–2; Douglass, 1981: 61, 63; McKelvie, 1963; Messenger, 1975). In December 1994, BBC2 devoted part of its truly deranged celebration of 'Weird Night' to modern folklore issues, including a review of the year by the *Fortean Times* (the journal studying the odd), and a drama exploring contemporary legends, in which an eminent folklorist suffers the unhappy consequences of consuming a live octopus. Folklore is alive!

The last problem is a far more serious objection to the relevance of folklore to museums. In the 1930s, as the separation of folklife and folklore took hold 'a compelling interest developed in the material culture rather than the oral literature of the folk' (Dorson, 1968: 441). Hugh Cheape of the Royal Museums of Scotland suggests that folklore 'is rarely represented as such, because museums do not collect folklore, they collect objects'. We may argue that new historiography has expanded museums' concerns to the point at which objects are inadequate and oral testimony necessary too, but this is only partly true. Museums are subject to commercial pressures, and in order to cope must define their purposes more firmly. The stress on real objects is a useful method of distancing museums *politically* from other institutions with similar interests; and *intellectually* from a social-science driven historiography which some find threatening. So we find David Tucker and Kevin Moore (1994: 22) arguing that 'what is unique

about museums is material culture', and that curators should not engage in any activity 'unless such work focuses on the material culture in collections and of communities'. No room for folklore, you might think.

But what locks folklore in the rustic ghetto, and what separates it from and subordinates it to material culture, is the definition of the term itself. Two American academics, for instance, state that 'folklore deals with the traditional behaviour of a group', which can clearly mean anything at all (Dewhurst and McDowell, 1981: 114). If this conjures up any picture, it is of the 'ragged old paupers' relating stories, ballads and Celtic poems, such as J.F. Campbell found in the mid-Victorian Highlands (Thompson, 1990: 94). Arguably, the word 'tradition' should be avoided as though it carried anthrax. 'Oral' offers more scope. For instance, a recent article in *Folklore* on medieval erotic imagery turns for evidence to Durer's engravings, seventeenth-century pornography, Shakespeare and John Aubrey to build up the system of images late medieval people used to symbolize sexuality (Jones, 1991). These sources are not oral, but they are *oral-assumptive* – they assume current, spontaneous oral usages in the society round about. Folklore, then, is 'oral-assumptive symbolic behaviour': behaviour which, not necessarily oral itself, assumes a system or usages in the world of everyday speech and action, usages which are not direct (in the sense that 'this is a red apple' is direct) but representational, referring to things by talking about something else. When a young mother just ahead of me in a Chatham street shouts at her child 'Your mouth's as big as the Blackwall Tunnel', that's folklore; a peculiarly West Kentish piece, too.

This definition seems close to the actual practice of modern folklorists, and certainly liberates us from the customary stereotypes. Certain things begin to look like folklore which previously did not and these can, with the benefit of imagination, be linked to objects which are already in, or might soon find their way into, museum collections. Folklore is, after all, not bizarre but commonplace. It shows us society in its underwear. We can see in it the symbols a society used to express its deep desires, needs and anxieties, and to construct history which ignores these things is to develop a picture of the past which is incomplete. Charles Phythian-Adams (1975) sees in folklore the chance to investigate the deep fabric of past human beliefs, by working out symbolic systems and arranging them around a structuralist framework – to sketch out an entire mental landscape. Few museums could attempt anything so wildly ambitious, but that is no reason for ignoring folklore completely.

Just as a museum with a good relationship with its local or corporate community becomes the focus of historical investigation going on around it, so it is possible to inject folklore into that investigation. Oral

research is the most 'direct' method of doing this and there is a tradition of museums conducting oral surveys with folklore content: a good example is the survey of the parish of Oneilland East carried out by the Ulster Folk Museum during 1967–68 (Ulster Folk Museum, 1968: 30–1). But nothing systematic has been done. The aim in folklore research would perhaps be a more limited one than the full-scale examination of local oral culture, and might be simply to ensure that there is some input into the work in which a museum is engaged, or that other organizations such as historical societies have some commitment to it. Of course, this depends on the extent of such activity: almost every village in the Home Counties seems to have a historical society, yet in the catchment area of the Priest's House Museum in Wimborne, Dorset, only a couple of villages out of 30 have one. But the material is there. For example, Alec Gill's (n.d.: 49) work on the 'superstitions' of the Hull fishing community and the displays at the Fishing Heritage Centre in Grimsby were based on this type of research. There is room here for co-operation between museums and local groups, where they exist, the former providing the latter with help and, perhaps, facilities to present their work, in return for sharing the fruits of the research.

When a museum contemplates carrying out its own research, however, the matter is more complex. The Manx Museum's surveys were co-ordinated by museum staff, but largely conducted by volunteers, which ought to provide a model of how best to effect such an investigation (Harrison, 1986: 201). For all the emphasis Higgs puts on 'contact with local societies' in the oral work of the Museum of English Rural Life, there is still a taint of the colonial in his description of the museum staff descending on the village of Aldington to extract its history and traditions (Higgs, 1963: 35–6). It must always be remembered that oral history, particularly with reference to folklore, is to a degree affected simply by being recorded. Making people aware of the importance of their histories is to alter what relationship they may have with them. The relationship moves from the instinctive to the conscious – and, thereby, something is destroyed. Investigators are always *aware* and so are outside the spontaneous structure of what they are investigating. They destroy as they preserve. Hence the type of survey inflicted on Aldington ought not to be contemplated without a little humility. We defined folklore by referring to spontaneity, and once folkloric tradition is recited for the benefit of the investigator, museum-based or not, it is spontaneous no longer. Its links with the culture are severed: the living continuity is broken. Yet unless the collectors are aware of the folklore it will not be collected.

This is the difficulty with the purely democratic approach of sending out questionnaires, as a recent Folklore Society survey of contemporary food-lore discovered. Only 77 out of 1,000 forms were returned,

presumably because of the problems of recognizing modern folklore when it occurs (*Folklore Society News*, 14 January 1992: 1–2).[1] The only solution is one which favours museums. The Irish Folklore Commission pioneered the technique of creating a network of local informants who were aware of what folklore was, and simply kept their ears open for it (MacDonald, 1971: 415). This obviously ties in with the sort of volunteer penumbrae with which most museums are familiar. The task is for the museum to raise its Friends' awareness and to encourage them to be effective informants.

But what is to be done when the oral work has been conducted, or is inappropriate? So long as we retain the stereotypical image of what folklore is, material culture that links into oral culture will indeed be sparse. Chesterfield has its well-dressing screens,[2] Shaftesbury its Byzant,[3] but these are oddities. A less prejudiced definition opens up the horizons. Current material culture studies suggest that objects can express in symbolic form ideas and belief in the same way that oral culture can; indeed, in many cases, oral culture reinforces that symbolism. The relationship between objects and folklore is well borne out in Pearce's study of the material culture of the Inuit peoples, to whom objects are part of a complex structural code which embodies the community's beliefs and ways of living. The basic sexual division of labour is reflected both in objects and in obviously 'folkloric' acts such as communal dancing, mourning for sea mammals and the exploits of the goddess Sedna, and indeed it is artificial to make a distinction, as the oral and material reinforce one another (Pearce, 1989: 55–8). Robert Jameson's example of the Victorian dinner party is at once less picturesque and more powerful because it is closer to home. The elaborate ritual of the meal, including not only what the participants did, but what they did it *with* seems to symbolize the ideology of the Victorian upper classes (Jameson, 1987). It not only symbolizes it, but by objectifying it, by turning it into material reality, it makes that ideology capable of ritual repetition; it strengthens the system of language and imagery in which the ideology is expressed in other ways.

I quote these examples not because it will be easy, or even possible, often to mount exhibitions expressing these sorts of ritual systems. Few museums would have available material, and it would be difficult to express the ideas in accessible ways. The reason for quoting them is that they open our minds to the possibilities of objects. In the folkloric model, objects become deep, rich, powerful items bearing complex social messages, rather than, as they often become in local history museums, three-dimensional illustrations to the book on the wall; or, worse, mute clods whose light remains unlit. Folklore reveals people's relationships to the objects they use to express their lives in a way no other medium does.

A few instances will illustrate the point. The myth of the man in the rubber-works who punctures each tenth contraceptive, even told as a joke, expresses the unease people have with the idea of sex for pleasure which has no prospect of 'punishment'. The well-known tale of the poodle in the microwave can be interpreted as a defensive joke told to defuse people's lack of understanding of modern technology. Very many people who went through the Second World War insist that Lord Haw Haw once announced the fact that the Town Hall clock in Eastbourne was five minutes slow, to show that German Intelligence had penetrated to the core of British life. Not only do the monitors deny such a broadcast ever took place, but neither did the Eastbourne clock ever run slow – not long enough to be noticeable, anyway. Yet this offbeat fable throws light on the power and centrality of the wartime wireless. A more oblique example is the gold-plated carriage clock presented to my father for 25 years' service with his employers. It is the key material component of an annual ritual whose details embody the relationships of class and hierarchy which make the institution work: employees higher and lower in the hierarchy than my father received correspondingly different presents. There is no reason that this should be, and the procedure is not laid down. It is spontaneous, and symbolic: it is folklore.

To keep your ears and mind open for the possibilities of folklore is to be constantly surprised. You might be forgiven for thinking a military museum, such as the one I work in, unprofitable territory for folklore, but instead you trip over it endlessly. Regimental dress, for instance, commonly incorporates all sorts of idiosyncrasies which begin as informal, even accidental, usages and which have become enshrined in formal regulations. Several regiments include a flaming grenade in their insignia. Traditionally, the grenade of the Royal Artillery has seven flames, while that of the Royal Engineers (REs) has nine. The difference is ascribed – at least by the REs – to an incident in which a set of artillerymen fled from a pair of gun emplacements in the sight of the enemy, and had their places filled by plucky Sappers, to whose emblem a pair of extra flames was accordingly added. This incident is located variously during the Crimean War, the Boer War, or even the First World War, which was indeed when the number of flames was set down (previously numbers had varied, ten and eleven flames not being unknown). An RSM of about 40 years of age, visiting the Royal Engineers Museum not long ago, stated he had not only been told this story when a trainee, but was actually *taught* it on a Corps history course. It need hardly be said that the Artillery and the Engineers are traditional rivals.

The museum has a large collection of papers gathered by Alexander Barrie in the 1960s while researching his book on First World War

tunnelling, *War Underground*. One of the paths down which he became sidetracked was the story of guns and explosions from the Western Front being heard in southern England. Placing a newspaper advert in 1962, Barrie received claims that the sound of bombing at Messines Ridge had been heard in Croydon and even Norwich. A cutting from the *Daily Telegraph* in 1917 referring to gunfire heard in Beckenham showed that the stories certainly dated to the First World War itself. Other correspondents claimed to have heard the bombardment of Plymouth in the Second World War from a hundred miles away, and even the sound of the Sputnik satellite in 1958. However, Fred Fallick of the 2nd Royal Berkshires and Captain H.R. Kerr of 179 Tunnelling Company RE stated that they were both at Messines and were extremely doubtful of these tales (CHARE: 9007.1.100–112).

But the most detailed, and material example of this military museum folklore is the cult of General Gordon. Gordon's exemplary, devout lifestyle and unfortunate death in Khartoum in 1885 turned him into a martyr, a Christian hero and a stick with which to beat the Gladstone government that was held to have abandoned him to his fate. Lewis's of Birmingham even produced a medal referring to Gordon as 'the latest Christian Martyr' – there are examples in both Birmingham and the Royal Engineers Museums (Birmingham 1964N00411; GGC311, GGC312). Gordon was a Victorian saint; and there are many striking resonances with the cults of his medieval counterparts. Legends grew up around him: that he went into battle leading the Chinese Emperor's forces against the Tai-Ping rebels bearing nothing more than a small cane, for instance, and he was for some years believed to have survived the fall of Khartoum (Johnson, 1993). More realistically, his body was hoped to be still in existence somewhere. A supposed witness of his death reported: 'Some say Gordon was cut up in little pieces, but others relate that they embalmed his body and took it to the Mahdi. There were bodies cut up; but I am inclined to believe these were the bodies of the Consul and doctor, not Gordon's' (news cutting in CHARE: 8107.10.11).

As well as legends, there are relics, a high proportion of them distinctly dubious in good medieval fashion. The Royal Engineers Museum has four canes each said to be the one carried by Gordon in China (GGC8, GGC25, GGC280), while another was sold in 1966 and is now in Texas. In 1897, the Royal United Services Institute (RUSI) put on an exhibition of Gordon relics, and the presence of the 'yellow jacket' awarded by the Emperor was announced in the newspapers. Lady Head wrote in high dudgeon to the RUSI Director to declare 'it is only right that I tell you that Sir Robert Head and I possess Gordon's *real* Yellow Jacket', given to them by the hero himself (CHARE: 8107.10.11). The RUSI was eventually able to display three Yellow

Jackets; but it is now thought that the Heads' example was a 'salmon riding jacket'. The Royal Engineers Museum holds no fewer than *four* unique Yellow Jackets (GGC193, CHARE: 2001.77, 4801.32, 4801.36). The most bizarre set of relics associated with Gordon's death is contained in a box bearing the name of Sir Rudolph Slatin, the officer held prisoner by the Mahdi for several years (GGC316). These comprise 'Gordon's chit', 'One of Gordon's teeth', Gordon's last match, pencil and buttonhole, 'A piece of lace from Gordon's chemise' and 'A fly said to have walked on Gordon's nose'!

The arrival of Kitchener's army in the Sudan in 1898 to 'avenge' Gordon led to a further outbreak of relic-collecting. The Mahdi's tomb at Omdurman was ritualistically dismantled and Kitchener carted back the most spectacular parts to present to Queen Victoria. The Governor's garden at Khartoum was stripped of roses, pebbles were gathered from the ground, the medals and currency notes Gordon had issued during the siege were put into reliquaries. The spear supposed to have killed the hero found its way into Mr Middlebrook's odd 'cabinet of curiosities' at the Edinburgh Castle pub in the 1890s (de Peyer, 1980); and the Royal Engineers Museum holds a piece of the staircase where Gordon was killed, encased in a silver reliquary and topped with a cross (GGC3). Henry Wellcombe, who later purchased a number of relics, also visited Khartoum to gather pebbles.

All this is the sort of thing Erasmus would have found quite familiar: there are distinct shades of Virgin's milk and fragments of the True Cross. The Gordon cult, discovered in the most unpromising surroundings, shows how closely folklore can relate to material culture and how important it therefore is for museums to consider.

But museum displays using folklore material in any sort of systematic, integrated manner are very rare. A remarkable exception is the display on 'Sheffield in Tudor and Stuart Times' at Bishop's House, Sheffield. The exhibition was the responsibility of the then Keeper of Social History, David Bostwick, whose previous work had covered folkloric themes, notably the symbolic uses of the craft of the Sheffield plasterers, investigated in his doctoral thesis. Artefacts were gathered from Sheffield City's own museum collections, and from the independent Traditional Heritage Museum (items such as the Handsworth Sword-Dancing costumes); replicas were used when necessary. One particularly arresting part of the exhibition is called 'The Poor People's Corner and Parlour' – the snarling cat, the glitter-eyed rats, the hanging charms against witches and ill luck, create a strong sense of menace – the tangible strangeness of the world which was a constant reality for the people these displays are celebrating. Photographs of local medicinal wells where sicknesses and wounds were cured are also on show. The current Keeper, Kim Streets, describes the subject-

matter as 'the rituals of birth, marriage and death, religion, war, superstitions and traditions, work and production, hunting and social division' and adds rightly that the exhibition 'would not be complete without some mention of our belief systems.[4] The Old Grammar School at Hull also plans displays on popular beliefs and traditions.

There is a third approach to integrating folklore material into museums, though a difficult one. The reconstruction of folk-rituals has been popular in some quarters, such as the Museum of Welsh Life (National Museum of Wales, 1988: 3) and, although folk-dancing and its kith are likely to raise sneers, these forms can be valid in at least two ways.

The first is educative. The Nordiska Museet in Stockholm incorporates folklore in the *lekstugan*, the children's role-playing area where 'popular belief and the world of the imagination are included' (Nordiska Museet, 1992: 247). The play routine follows the cycle of the day; in the night section the children tell stories. By a mixture of objects, sound effects, figures and activities, they are encouraged not only to *do* what children of 1890 did, but to try to *believe* as they believed. Annike Tyrfelt of the Nordiska Museet suggests this has a dual rationale: not only does it teach children about old myths, but, by extension, it helps them 'to see through a lot of modern myths and become more critical of them'.[5]

The second has to do with communal identity. Folk customs which have survived into the modern era are now maintained largely to assert a (mostly specious) local independence in an age in which local identity of any kind is threatened by mass culture, and most other links of memory and tradition with the past have been cut. Museums are perhaps the last non-partisan public institutions which can re-establish those links and that identity: as such they have a role to play in maintaining public symbols of local identity, when they persist, helping to keep them alive, and documenting the changes in them as their meaning changes.

These three approaches offer different methods of getting folklore into museum activities. They are not too grandiose; all local museums could make use of some. The aim is limited, not a revolution in museum practice but a new sidelight upon the ways museums think about their collecting, display and communal relations. Yet I hope enough has been said to argue that it is a worthwhile aim.[6]

Notes

1 Brief anonymous untitled notes.
2 Derbyshire is noted for the custom of well-dressing, which dates back several centuries. Usually during Ascensiontide, wells and pumps in many

places are decorated with screens, commonly depicting religious themes, which are formed by pressing flower petals into wet clay. Several years ago Chesterfield Museum included some well-dressing screens in a display on local customs, and in July 1993 the Red House Museum, Christchurch, held an activity day during which children could help make a dressing-screen for the museum's own well.

3 The town museum at Shaftesbury holds the Byzant, an object which seems to have developed from a decorated staff and which, along with other items, was annually presented by Shaftesbury to the parish of Enmore Green to recognize its ownership over the water supply.

4 Personal communication.

5 Personal communication.

6 This chapter was adapted from a University of Leicester MA dissertation; thanks are due to all those who contributed towards that. Also my thanks to Kim Streets of Sheffield City Museums, and to Hugh Cheape and Annike Tyrfelt for permission to quote from correspondence.

References

Anon. (1976) 'Ethnology and folklore, University of Lund' *Ethnologia Scandinavia*, [Vol. no. not known] 174–5.

Balfour, H. (1911–12) 'A national folk museum' *Museums Journal* 11, 221–5.

Barrie, A. (1962) *War Underground*, Muller, London.

Blaas, P.B.M. (1978) *Continuity and Anachronism*. Nijhoff, The Hague.

Bushaway, R. (1982) *By Rite*. Junction Press, London.

Butterfield, W.J. (1914–15) 'A Sussex Village Museum' *Museums Journal* 14, 99–102.

Butterfield, W.J. (1915–16) 'Museums and Folk Art' *Museums Journal* 15, 186–92.

Carline, G.C. (1919–20) 'The arrangement of local and folklore specimens' *Museums Journal* 19, 92–5.

Cheape, Hugh (1995) Personal communication.

de Peyer, R. (1980) 'Curiosities of the Edinburgh Castle', *Camden History Newsletter*. [Vol. no. and paging not known]

Dewhurst, K. and McDowell, M. (1981) 'Popular culture and the European folk museum' in Schroeder, F.E.H. (ed.) *Twentieth Century Popular Culture in Museums and Libraries*. Bowling Green Popular University Press, Bowling Green, OH.

Dorson, R.M. (1968) *The British Folklorists: A History*. Routledge and Kegan Paul, London.

Dorson, R.M. (1972) *Folklore and Folklife*, University of Chicago Press, Chicago.

Douglass, D. (1981) 'Worms of the Earth' in Samuel, R. (ed.) *People's History and Socialist Theory*, 61–66. Routledge and Kegan Paul/History Workshop, London.

Gill, A. (n.d.) *Hessle Road*. Hutton Press, Hull.

Harrison, S. (1986) 'Voice of the people: the work of the Folk Life Survey', *Hundred Years of Heritage*, 190–205. Manx Museum and National Trust, Douglas, Isle of Man.

Hartala, J. (1969) *Finnish Folklore Research 1828–1918*. Societas Scientarum Fennica, Helsinki.

Higgs, J.W.Y. (1963) *Folklore Collection and Classification*. Museums Association, London.

Howarth, E. (1905–06) 'A Folk Museum' *Museums Journal* 5, 295–301.

Jameson, K. (1987) 'Purity and power at the Victorian dinner party' in Hodder, I. (ed.) *The Archaeology of Contextual Meanings*. Cambridge University Press, Cambridge.

Johnson, D.H. (1993) 'In search of Gordon's Head' *Times Literary Supplement*, 30 July.

Jones, M. (1991) 'Folklore motifs in late medieval art' *Folklore*, 101.

MacDonald, D.M. (1971) 'Collecting oral literature' in Dorson, R.M. (ed.) *Folklore and Folklife*, 407–30. University of Chicago Press, Chicago.

McKelvie, D. (1963) 'Oral tradition and belief in an industrial region' *Folklife* 1, 77–94.

Messenger, B. (1975) *Picking up the Linen Threads*. University of Texas Press, Austin, Texas.

National Museum of Wales (1988) Guide to the Welsh Folk Museum. St Fagans, Cardiff.

Nordiska Museet (1992) *Leka Fur Livet (Play for Life)*. Nordiska Museet, Stockholm.

Pearce, S.M. (1989) 'Objects in structures' in Pearce, S.M. (ed.) *Museum Studies in Material Culture*, 47–60. Leicester University Press, Leicester.

Peate, I.C. (1941) 'The place of folk culture within the museum' *Museums Journal*, 41.

Pythian-Adams, C.V. (1975) *Local History and Folklore, a New Framework*. Leicester University Press, Leicester.

Rasmussen, H. (1966) 'The origin and development of the Danish Folk Museum' in Rasmussen, H. (ed.) *Dansk Folkemuseum and Frilandsmuseet, History and Activities*, 7–36. Nationalmuseet, Copenhagen.

Rehnburg, M. (1976) 'Ethnology and folklore, University of Stockholm' *Ethnologica Scandinavia*, [Vol. no. not known] 172–4.

Ropeid, A. (1985) 'Culture and construction workers' *Ethnologica Scandinavia*, [Vol. no. not known] 163–6.

Thomas, K.V. (1971) *Religion and the Decline of Magic*. London [publisher not known].

Thompson, E.P. (1991) *Customs in Common*. Merlin Press, London.

Thompson, F. (1990) 'J.F. Campbell' *Folklore*, 100.

Tosh, J. (1984) *The Pursuit of History*. Longman, Harlow.

Tucker, D. and Moore, K. (1994) 'Back to basics' *Museums Journal* July.

Ulster Folk and Transport Museum (1968) *Yearbook 1967–8*, The Museum, Holywood.

Ulster Folk and Transport Museum (1988) *Yearbook 1986–7*, The Museum, Holywood.

19
Making the History Curriculum

John Reeve

Enacting a national history?

'Teach them that General Wolfe captured Quebec', were the sole instructions from Winston Churchill when R.A. Butler (Education Minister in the wartime government preparing the 1944 Education Act) asked him what should be taught in schools.

'We are quite different from the rest of Europe ... we alone have not been occupied or defeated for nearly one thousand years; they have, regularly'. Margaret Thatcher during the 1992 Election Campaign.

'We traduce Britain's glory if we teach a history which makes us seem like anyone else ... [This is a] cause for alarm to anyone who does not share the Archbishop of Canterbury's view that – Britain is "quite an ordinary little country"' – John Keegan, the military historian, responding to proposed revisions to the national history curriculum. (*Daily Telegraph*, 5 May 1994)

The Education Reform Act of 1988, for the first time, defined what should be taught to whom, when, at what level and for how long. In England and Wales, Key Stage 1 (for children aged 5–7), Key Stage 2 (7–11) and Key Stage 3 (11–14) were instituted, with assessment at each stage. Core subjects of English, maths and science are now taught and tested up to the age of 16, along with the foundation subjects of technology, history, geography, art, music, physical education, religious education and a modern language (after 11). All are prescribed with detailed curriculum and attainment targets.

Raymond Williams (1962: 172) observed that 'an educational curriculum ... expresses a compromise between an inherited selection of interests and the emphasis of new interests'. More recently, Stephen

228

Ball has viewed the national curriculum debates as a battleground between old humanists and industrial trainers, (Ball, 1990: 5). However, this is certainly not true of the debate about the history curriculum, which did not always split neatly along obvious political or academic fault lines.

There was consensus on the right that children should 'know the elements of our national past' (Professor Norman Stone of Oxford) and that 'history is national property ... national self image, sense of heritage and purpose' (the political historian, Jonathan Clark), but these concerns were very widely shared (Kearney, 1994: 49). Another issue was how Welsh, Scottish and Irish history should be included (see Kearney, 1989 for a pre-curriculum treatment). The fact that the debate became so heated and took up so many column inches of both the serious and tabloid press, reflects the continuing belief that a knowledge of national history is an essential part of a properly civilized person. At one point it was even proposed that history should be compulsory up to the age of 16. As the socialist historian, Raphael Samuel (Ruskin College, Oxford and editor of the *History Workshop Journals*) observed, 'we live in an expanding historical culture ... history as a mass activity ... has never had more followers than it does today, when the spectacle of the past excites the kind of attention which earlier epochs attached to the new' (*Times Literary Supplement*, 10 March 1995).

However, the debate on the history curriculum did raise issues about what 'national heritage' should be and also about standards in schools, 'the mastery of a body of knowledge' being a particular concern (see for example, Scruton *et al.*, 1985: 8–9). The right were on the attack against what they regard as insidious 'political correctness' in the educational profession. This was an attack on the 'isms': 'progressivism, comprehensivism, egalitarianism, multiculturalism, pluralism, relativism' (Ball, 1990: 11).

As is also the case in the USA, this is part of a much larger debate, with conservatives counter-attacking against post-modernist critiques of a traditional history with 'the absolute primacy of certified facts' (Lee, 1994: 43; cf. Bloom, 1995). In this light, the Cambridge constitutional historian, Sir Geoffrey Elton, opined 'we need more English history and not this non-existent history of ethnic entities and women' (Visram, 1994: 55). Despite a heated campaign in the press, and a spirited rearguard action by one right wing member of the committee reviewing the history curriculum in 1994, the right did not triumph.

Whose 'common cultural heritage'?

'Plainly the educational establishment aims to score another substantial victory. It sees Britain as a multi-racial society in which the teaching of

purely national history borders on impropriety' (*Daily Telegraph* Editorial, 5 May 1994).

'Our pupils will be part of a world where Britain ... will be just one among a number of major European states and where some of the most significant developments will be around the Pacific Rim. It is in no one's interest for their compulsory history to be so predominantly British' (Martin Roberts, historian and head teacher, *Times Educational Supplement* 24 June 1994).

The attack on multiculturalism within the curriculum has been vociferous since at least the Black Papers (Ball, 1990; Nixon, 1985). American conservatives have responded similarly to proposed new national standards for world history which included Asia and Africa, but also the usual European elements as well (including, but not foregrounding, Egypt, Greece, Rome, and the Renaissance). 'By deciding not to give any emphasis to western civilisation, they lost any organising principle', was one extreme Republican reaction (*Times Educational Supplement*, 2 December 1994).

The National Curriculum in England sought to create a good balance of local, national and world history. But in fact, just as the government had insisted, English history has been favoured particularly in the revised, slimmed down version of the curriculum published in 1995. English history dominates both Key Stage 2 (4/6 units) and Key Stage 3 (3/6 units), with only one unit of non-European options in both. Europe is awarded a unit in both Key Stage 2 (Ancient Greece) and Key Stage 3 (a turning point such as the Renaissance, or the French Revolution) and world history has one (the twentieth-century world at Key Stage 3). Yet, conservatives were still not satisfied: 'there have been many empires but none has had a greater world impact than the British, not even the Roman, not even the Chinese ... the Empire is what makes the history of Britain important, and it was not created by our tolerance or sense of fair play' William Rees-Mogg, former editor, *The Times*, 28 February 1994).

The popular press saw the non-European units as a ridiculous intrusion. A slimming down was unacceptable if it meant losing Guy Fawkes and national heroes: 'Nelson could soon be just history in schools. Pupils face lessons on Abyssinia' (*Daily Express*, 28 February 1994). They meant Assyria, one of the optional non-European units at Key Stage 2. Merriman (1991) makes the point that world history is seen as important only by higher status people and not by the working class. The popular press was therefore probably telling its readers what they wanted to hear.

Ancient Greece was reconfirmed in the 1995 curriculum revisions as

part of the 'entitlement' to a classical subject, one of the criteria laid down for the review. Nicholas Tate, now Chief Executive of the School Curriculum and Assessment Authority (SCAA), who chaired the history panel, has discussed this issue at some length since:

'for the past thousand years and more the study of Greek and Roman civilisations and their languages has been at the core of education. To toss this aside in one generation may not be wholly wise ... '. He is especially concerned that if the curriculum does not 'transmit a common cultural heritage' pupils will not 'pick it up elsewhere' (*Times Educational Supplement*, 2 December 1994).

Primary specialists have retorted: 'Why single out Ancient Greece? Might not Ancient China or Japan be more appropriate now?' (*Times Education Supplement*, 3 June 1994) and 'strong intellectual and cultural dimensions make the topic more suitable for older children' (Noble, 1994). However, older children are marching through English history so there simply is no room. As a result, Ancient China and early modern Japan are suggested options at Key Stage 3.

Museums and the National Curriculum

Not surprisingly, the radical changes in educational policy have had a major impact on museums and galleries. For museums, one especially significant feature of the history curriculum is its insistence on the use of a wide range of sources, often referred to as DAPOS (documents, artefacts, photographs, oral history and sites). Visits to museums and the use of museum-based education services have increased significantly, especially for national museums. The British Museum now has three times as many children visiting than before the curriculum was implemented, and similar trends are noted elsewhere.

The debates about the content and range of the history curriculum have had major implications for museums and the educational uses of their collections. Significantly, two museum education specialists, Gail Durbin, Head of Schools Services at the Victoria and Albert Museum, and the author, Head of Education at the British Museum, have played an active part in the formation and revision of the National Curriculum. Gail Durbin was on the history panel of the Schools Examination and Assessment Council; the author was on the panel revising the history curriculum in 1994.

When revisions in the history curriculum were being considered, views from a number of leading museum and heritage organizations were taken into account. For example, the education service of English Heritage, like that of the British Museum, was especially concerned

about the lack of prehistory, and the distorted nature of the 'Invaders and Settlers' unit at Key Stage 2. During the revision of the curriculum in 1994, it was admitted that Roman Britain was far more than the Romans in Britain, and so the unit was reformulated to include 'Celtic' Britons who were the bulk of the population.

Other pressure groups included the Joint Association of Classics Teachers (JACT): classics teachers were pleased about the inclusion of Greece at Key Stage 2, but disappointed at the revised optional nature of the Roman Empire unit at Key Stage 3. Representations were also made by the British Association for Local History, and black activists (Pankhamia, 1994). Academics concerned about the future of their subject have also made representations. For example, the British Association for Near Eastern Archaeology has an active schools committee concerned to resource and campaign for the Mesopotamian optional unit at Key Stage 2.

From the museum perspective, the pressure of the curriculum has resulted in innovative responses. A successful series of booklets has been published by English Heritage, including *A Teacher's Guide to Learning from Objects* (1990), edited by Gail Durbin, Sue Morris and Sue Wilkinson (all museum educators). Museum educators and teacher trainers now use it extensively in their work. Furthermore, with the reduced space for learning about museums in initial teacher training and the demise of many traditional arrangements for in-service training for teachers (INSET), museum educators are having to address methodologies and taxonomies more frequently in their work with teachers.

Museums offer excellent opportunities for cross-curricular work. For example, the Ancient Greece unit has been a great success in encouraging work involving myths, art, design, technology, helped particularly by resources such as the Channel 4 *Eureka* TV series for schools, produced in association with the British Museum. The new Hellenistic Gallery in the British Museum could be used particularly for the part of the revised Greek unit that looks at the wider Greek world. This stretched from the south of France to India and can be illustrated from collections held by a number of the British Museum's departments. Making such links is often left to the museum educator.

Decisions about which topics are now compulsory and which optional have affected the use of certain collections and educational access to them. Ancient Greece is now a compulsory topic, yet Ancient Egypt has remained an option, but a very popular one. The optional nature of other subjects at Key Stage 2 (including Benin, the Indus Valley and the Assyrians), their unfamiliarity and lack of teaching resources have dissuaded many schools from studying them through museum collections. This has not been without controversy.

The maverick right-wing teacher on the History Curriculum Review Panel, Chris McGovern, commented in his unofficial 'Minority Report': 'as desirable as it may be to teach non-European history, it should not be a legitimate area of state interference. What interest, for example, does the government have in the history of Benin?' (McGovern, 1994: 4). A Lewisham primary teacher responded to this: 'I am studying Benin this term because I have good artefacts close by in two museums and because it provides my Afro–Caribbean-descended children and my white children with an understanding of their collective history', and she particularly stressed slavery as a central issue (Jenny Barnett, letter to the *Times Educational Supplement*. 10 June 1994).

This controversy places on museums an increased responsibility to arouse and maintain interest in these subjects, and they have been able to do so by working in collaboration with other organizations. For example, for the Benin unit, Channel 4, The World Wide Fund for Nature and Pictorial Charts Educational Trust co-operated on producing educational resources, with the Museum of Mankind mounting a special exhibition, which included a 'self-help' handling collection. The Horniman Museum has also provided resources and teaching programmes for Benin.

The Key Stage 2 unit on 'Exploration and Encounters' (including Columbus, and also the conquest of the Aztecs) was another victim of slimming down in 1994: Aztecs became a non-European option. Hitherto, this had been an extremely popular topic. As a result of the earlier unit, the Museum of Mankind had been inundated with primary groups for 'The Day of the Dead' exhibition on Mexico. The new Mexico gallery (opened at the British Museum in November 1994) was conceived within very tight space constraints by a team including an educator, Penny Bateman, who has written an Aztecs Activity Book and substantial teachers' packs to accompany the gallery. The British Museum is determined to keep alive in the curriculum the Aztecs, and the different kinds of historical experience that they offer, despite sniffy comments from educators about this 'brutish and bloody uncivilised civilization' (Noble, 1994: 7) or *Today* newspaper asserting that 'Aztecs take over from Nelson in history class' (5 May 1994). The historian John Fines has observed that 'many teachers ... have used this unit to deal with the moral aspects of such issues as slavery' (*Times Educational Supplement*, 18 March 1994).

To all intents and purposes, multiculturalism has been left on the shelf in the history curriculum, but museums and galleries continue to play an active part in presenting and interpreting other cultures (Poovaya Smith, 1991; Reeve, 1994; Visram, 1994). A similar situation exists with gender studies, mentioned in the history curriculum but not fully integrated or prioritized. John Hamer, one of Her Majesty's

Inspectors of Schools, reported that 'although about half of the schools (in respect of Key Stage 3 history) were giving a satisfactory account of the ethnic and cultural dimensions of the societies studied, only rarely was there a sufficient amount on the role of women' (*Times Educational Supplement*, 17 September 1993. See also Bourdillon, 1994; Osler, 1995; Phillips, 1993; Porter, 1991; Reeve, 1994).

In the review of the National Curriculum in 1994, each subject panel included a special needs expert, and they also met together separately. On the history panel Judy Sebba, of the Cambridge Institute of Education, was a particularly energetic participant, and by promoting the needs and concerns of special needs teachers, was also helping to keep the wider needs of mixed ability and object-based teaching to the fore in discussion. The resulting 1995 revision of the National Curriculum states firmly that 'the revised national curriculum provides teachers with much greater flexibility to respond to the needs of pupils with identified special educational needs', (DfE, 1995: v). Access for children with special needs is itemized in detail among the common requirements for the history curriculum.

The American disability expert, Renée Wells, observed that 'Museums are empowering places in the sense that visitors can express themselves in a very individual way. Unlike a classroom, there is no "right", or "correct" response. Some people with learning difficulties feel liberated by the museum environment' (quoted in Pearson and Aloysius, 1994: 69). This was borne out by work at the British Museum, in particular a project on the Greeks. Participants in the project were struck by the way that 'children developed a degree of understanding of the ancient world and an awareness of what a museum is'. Pearson and Aloysius (1994: 54) believe strongly that 'Some children with severe learning difficulties may respond to topics more powerfully and emotionally than mainstream pupils, who may not be concentrating so markedly on the visual impact of a museum project'.

Anglo-Saxon attitudes

If we look at the Anglo-Saxon element of the compulsory 'Invaders and Settlers' unit for Key Stage 2, it is possible to assess the degree to which the National Curriculum has changed the agenda for museums. In particular, it has identified a specific target audience for a compulsory topic, in relation to age range, ability and expectations, thus enabling the focusing of both resources and in-service training for teachers.

Before the National Curriculum, a decreasing number of A–level students worked on the Anglo-Saxons as background to an option on the Norman Conquest; secondary schools used the Sutton Hoo ship burial

(the finds from which are on display in the British Museum) as part of the Schools Council History Project, 'What is history?' unit; and primary schools tackled the Anglo-Saxons, along with Vikings, very often as a 'How they used to live' type of topic.

Following a dozen television series for schools on historical topics linked to museums (for example on Egypt, Vikings, Ancient Olympic Games), the producer Tom Stanier made a series on the Anglo-Saxons, first broadcast in 1992. Rowena Loverance of the British Museum Education Service acted as consultant and wrote the accompanying book. Series like this, available on cassette and increasingly well supported by publications and other resources, in-service teacher training provided by museum education departments, and often substantial teachers' packs, had been operating as part of an unofficial national curriculum for primary schools in the 1980s.

In 1991 preparations were under way at the British Museum for an exhibition on the Anglo-Saxons, 'The Making of England', a specialist exhibition with a scholarly catalogue (Webster, 1991), designed as a tribute to the outgoing director, Sir David Wilson. In the planning process for the exhibition, the Education Service made it clear that, as a result of the National Curriculum, primary children were now the main schools audience for this topic, and although the design and conception of the exhibition made few compromises in their direction, a number of important experiments were possible using the exhibition. Notable among these were a schools opera project with the Royal Opera House Education Department and the development, with the company Research Machines, of the museum's first multi-media programme, which was on trial in a prototype form in the exhibition. Both benefited enormously from a specific brief and age range for this topic.

The focus for the opera was the Anglo-Saxon epic *Beowulf*, the singed manuscript of which was in the exhibition. Because the Sutton Hoo ship burial was discovered in Suffolk, it was decided to work with a mixture of primary and secondary Suffolk schools. A team of composer, producer, designer, choreographer and musicians from the Royal Opera House worked with children and teachers. Members of the British Museum Education Service, including two postgraduate interns (who were also assisting on the regular Monday handling sessions for schools during the run of the exhibition), provided sessions at the museum and visited schools during the project.

The remarkably successful results of this project, including performances to packed audiences at the Snape Maltings of an absorbing 50-minute piece, show the importance of a lively, cross-curricular approach to history topics. Moreover, this was shown to be successful not just at Key Stage 2. The secondary pupils (working on drama, technology, art and music) derived as much benefit as the

younger children. It also showed that schools could still respond to creative initiatives, despite curriculum restraints.

In 1994, a further operatic collaboration, this time on Egypt, who two London primary schools, was filmed for the Channel 4 schools television series *Eureka*. The series documented the development of the opera and the ways in which the museum and its collections was used as a source of information and inspiration. Museum experts and collections were shown being cross-examined in a very focused way, by groups of children looking for the evidence they needed: how the Egyptians danced, what they wore for particular occasions, motifs that could be adapted for posters, costume, or stage design; myths or histories that could form the basis of the story. Both opera projects need now to be published in a flexible form for wider dissemination.

Multi-media, especially the integrated use of CD-ROM and video, has emerged as one of the most exciting possibilities for future methods of museum and gallery communication. Further, it may provide creative solutions to problems particularly exacerbated by the National Curriculum (Reeve, 1994: 81). Museums, large and small, cannot accommodate all the school groups that now need to use specific collections, especially of small objects (such as Anglo-Saxon jewellery, coins, Tudor miniatures). Even those schools that can visit now need far more flexible forms of information to enable the teacher, and often the pupil, to determine how they might focus their preparation and how the visit itself might be structured.

The production of multi-media does, however, require the availability of substantial resources, notably in the form of commercial sponsorship or through co-production. It also requires precious staff time over many months of concentrated work to develop the programme. In the case of the Anglo-Saxons exhibition, multi-media production was part of an overall commitment of Rowena Loverance's time to work on the schools television series, input to exhibition planning, collaboration on the opera project and development of the exhibition guide, teaching resources and accompanying events programme. In these and many other ways, the National Curriculum has made museum education departments prioritize more ruthlessly and reconsider how best to deliver their services.

After feedback from the public, children and teachers, during the Anglo-Saxon exhibition, and on subsequent in-service teacher training sessions, the resulting CD-ROM was published and has subsequently also been adopted by the National Council for Educational Technology for distribution free to 1,000 schools. The programme is accompanied by the existing Activity Book (published by British Museum Press), the BBC 'Fact-Finders' book, and a detailed manual giving precise information on how the programme can be used across the curriculum at different Key Stages and ability levels.

Even when the early medieval galleries are redisplayed possibly in the late 1990s, it is unlikely that much more space will be made available, nor probably will much more contextual information be provided. The multi-media package will thus continue to be a critical form of distance learning for teachers and children. It can be used with local museum collections and regional sites, as much as with a visit to the British Museum.

The history curriculum has in turn helped force a viable museum curriculum that is object-based. The CD-ROM project on the Anglo-Saxons is about processes of production and interpretation, with objects posed as problems to be questioned and elucidated and not (as in so many publications even for the National Curriculum) mere decoration for the text.

Agenda and strait-jacket?

The National Curriculum has given museums and galleries a much more specific agenda for work with schools, potentially enabling the streamlining of resources, in-service teacher training and other services. It has helped museum educators to play a much more credible and more focused role as public advocates in the planning process for exhibitions and galleries through knowing who their school audience will be and their specific needs.

However, a curriculum is also a restraint and there is a danger of changing the relationship between mainstream education and museums and galleries, subsuming them into the practices of schools, rather than maintaining them as 'another kind of learning experience'. Conversely, museums and galleries have the opportunity now to exert far more influence over school practice.

Another consequence of the curriculum is that exhibitions or galleries that do not relate closely to the National Curriculum are unlikely to attract school interest. The British Museum has already found this at the Museum of Mankind with the exhibition, 'Paradise' which was about Papua New Guinea. Unlike most pre-curriculum exhibitions, this did not attract a large number of schools, in contrast to 'Day of the Dead' which was related more closely to the curriculum.

After years of promoting the value of museum and gallery education to teachers, teachers in training and educational policy-makers at all levels, museum and gallery education staff are now being asked to deliver on an unprecedented scale across the whole curriculum and at all Key Stages. This is in addition to all the other roles that museum and gallery educators now try to fulfil. There have been no extra resources available from central government for museum education and in some instances resources have been withdrawn. Some 80 per cent of all

museums and galleries do not have any educators. Resourcing the curriculum in museums therefore remains a central issue. Providing for the new kinds of lifelong learning that we hope the school and museum experience will encourage becomes a major goal for the future.

References

Anderson, J. (1994) *Times Educational Supplement*, 3 June.

Ball, S. (1990) *Politics and Policy Making in Education*. Routledge, London.

Barnett, J. (1994) *Times Educational Supplement*, 10 June.

Bloom, H. (1995) *The Western Canon: The Books and Schools of the Ages*. Macmillan, London.

Bourdillon, H. (ed.) (1994) *Teaching History*. Open University and Routledge, London.

DfE (1995) *National Curriculum*. HMSO, London.

Durbin, G., Morris, S. and Wilkinson, S. (eds) (1990) *A Teacher's Guide to Learning from Objects*. English Heritage, London.

Editorial (1994) *Daily Telegraph*, 5 May.

Fines, J. (1994) *Times Educational Supplement*, 18 March.

Hamer, J. (1993) *Times Educational Supplement*, 17 September.

Haydn, J. (1994) 'Skeletons' *The Historian* 44, 21–2.

Kearney, H. (1994) 'Four nations or one?' in Bourdillon, H. (ed.) *Teaching History*. Open University and Routledge, London.

Kearney, H. (1989) *The British Isles. A History of Four Nations*. Cambridge University Press, Cambridge.

Keegan, J. (1994) *Daily Telegraph*, 5 May.

Lee, P. (1994) 'Historical knowledge and the National Curriculum' in Bourdillon, H. (ed.) *Teaching History*. Open University and Routledge, London.

McGovern, C. (1994) *A Minority Report*. Campaign for Real Education, York.

Merriman, N. (1991) *Beyond the Glass Case: The Past, The Heritage and the Public*. Leicester University Press, Leicester.

Nixon, J. (1985) *Guide to Multicultural Education*. Blackwell, Oxford.

Noble, P. (1994) 'Post-Dearing History' *Primary History*, June, 6–8.

Osler, A. (1995) 'Does the National Curriculum bring us any closer to a gender balanced history?' *Teaching History* 79, April, 21–5.

Pankhamia, J. (1994) *Liberating the National History Curriculum*. Falmer Press, Brighton.

Pearson, A., and Aloysius, C. (1994) *Museums and Children with Learning Difficulties. The Big Foot*. British Museum Press, London.

Phillips, R. (1993) 'Change and continuity' *Teaching History*, January, 9–12.

Poovaya Smith, N. (1991) 'Exhibitions and Audiences: catering for a pluralistic public' in Kavanagh, G. (ed.) *Museum Languages: Objects and Texts*, 119–34. Leicester University Press, Leicester.

Porter, G. (1991) 'Partial truths' in Kavanagh, G. (ed.) *Museum Languages: Objects and Texts*, 101–18. Leicester University .Press, Leicester.

Rees-Mogg, W. (1994) *The Times*, 28 February.

Reeve, J. (1994) 'Museums and Galleries' in Prentice, R. (ed.) *Teaching Art and Design*. Cassell, London.

Roberts, M. (1994) *Times Educational Supplement*, 24 June.

Samuel, R. (1995) *Times Literary Supplement*, 10 March.

Scruton, R. (ed.) (1985) *Education and Indoctrination*. Education Research Centre, Harrow.

Visram, R. (1994) 'Black perspectives on British history' in Bourdillon, H. (ed.) *Teaching History*. Open University and Routledge, London.

Webster, L. (ed.) (1991) *The Making of England*. British Museum Press, London.

Williams, R. (1962) *The Long Revolution*. Penguin, Harmondsworth.

20

Shadows and Sacred Geography: First Nations History-Making from an Alberta Perspective

Michael Ross and Reg Crowshoe

The sense of smell stirs memories. A sweet grass smudge awakens mine. Its fragrant smoke evokes experiences foreign to my own upbringing as a non-Native, but closely related to my thinking about museums. Time spent with members of the Peigan Nation has deepened my understanding of the meanings of objects in museum collections and of how important they can be for cultural growth and renewal.

Smudge is used like a gavel. It gets your attention.

> Virtually every holy artifact was incensed with sweet grass. The incensing usually was done at a smudge altar ... Several small pieces were broken from the braid and placed on hot coals ... Prayers accompanied every smudge. It was believed that a person would not lie if he used the incense ... Almost every ceremony began with prayer and the burning of sweet grass (Hellson and Gadd, 1974: 9).

This chapter explores some of the background, motivations and challenges of Alberta First Nations history-making within a context of understanding. I raise many questions along the way and conclude with a model suggesting the dynamics involved. In preparing this chapter, I consulted with keepers of the largest Alberta First Nations collections and listened to one particularly well-informed and authoritative First Nations person with whom I have a relationship of trust and respect. Abstract meanings and understandings tie First Nations together, cultural practices make each one distinct. Native beliefs have parallels with Western concepts. A challenge for this chapter, and for this subject, is to see the world through another's eyes.

Two main 'voices' will be heard throughout. I am of a mixed English/Scottish/Irish ancestry, common to many third and fourth generation

Canadians. Reg Crowshoe is a member of the Piikani (Peigan) Nation, one of three Blackfoot-speaking Canadian peoples who have lived in this territory for hundreds of years.

From our traditional world view, history, heritage is abstract. And authority was given to us by Creator to exist. So, you have to take an abstract existence and put it together with a physical existence which makes entities, which are Niitsitapi. So, when you look at heritage you're looking at history that's a part of that abstract component you need for survival. Basically for me to be maintained as an entity I need that heritage and history. (Crowshoe)

Cultures in context

About 150,000 people of aboriginal origins currently live in Alberta, perhaps 6 per cent of the current population in a Canadian province over twice the size of the UK. Plains peoples have occupied this area for 12,000 years (Wilson, 1986). A person claiming a First Nations identity might live on one of over 90 Alberta reserves as a status Indian, live off-reserve as a non-status Indian, be a woman or her child who has reclaimed rights previously forfeited through marriage to a non-Native man, or not be an 'Indian' at all but a Métis of mixed Native and white ancestry. Alberta First Nations speak languages and dialects belonging to three linguistic families. They are not a single culture, hardly newcomers and definitely not a 'vanishing race'.

European settlement began in sixteenth century Atlantic Canada (Whitehead, 1991) and reached Alberta 4,000 kilometres away in the eighteenth century. Bison herds upon which many Alberta First Nations depended for survival were reduced to near extinction by 1880 (Nelson, 1973). Smallpox, measles and scarlet fever epidemics struck repeatedly during the 1800s claiming, for instance, almost half the Blackfoot-speaking peoples (Dempsey, 1986). White settlers flooded west following completion of the trans-continental Canadian Pacific Railway. Apprehensive officials bent on assimilation used the Indian Act (federal legislation first consolidated in 1876) to surpress the Sun Dance and discouraged other ceremonial practices integral to the cultural life of Alberta First Nations (Baker, 1993; Dempsey, 1980).

A Sun Dance is a complex of ceremonies usually held over several days in mid-summer. Authority for putting up a Piikani Sun Dance comes through the Natoas bundle. A Sun Dance can be compared to a community meeting: participants follow an agenda according to shared beliefs and traditional practices. The Sun Dance provides the physical venue and objects for leaders to make decisions about the future directions of the tribe. Versions of the Sun Dance are still widespread

among Northern Plains peoples and may date back to the early 1800s (Baker, 1993; Dempsey, 1986; Ewers, 1958).

Treaties confining First Nations to reserves were signed in Alberta between 1876 and 1899 (Dempsey, 1979), though not all land claims have yet been settled: and 'confining' is the word. A First Nations person once needed a pass to leave their reserve (Jennings, 1975) and until the 1960s could not vote in federal or Alberta elections. From 1882 onwards, children were removed from their families and placed in 'civilizing' white-run industrial and religious residential schools. Sometimes 'infective' (e.g. tubercular) children lived and studied together in punishing conditions, usually forbidden to use their own languages (Stocken, 1976). The last of these schools closed in the 1960s, but the 'cultural void' they created is still felt by First Nations (Figure 20.1).

Modern reserve life is fraught with social problems related to health, education and unemployment, characteristic of marginalized populations elsewhere. Many reserves appear under-developed by Western standards. Less apparent on the outside are the internal struggles on reserves which divide members into those who want to maintain traditional beliefs during the process of development and those who feel traditional ways cannot be accommodated during the transformation into, what they argue, is an unavoidably Westernized future. Most non-

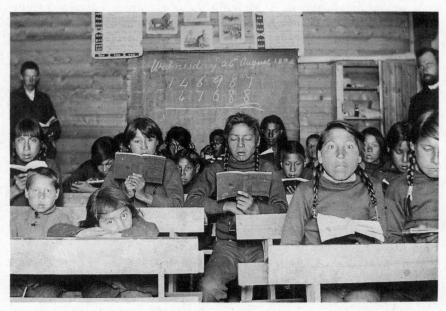

Figure 20.1 Children at North Camp School (Anglican Church Missionary Society), Blackfoot Reserve, near Gleichen, Alberta, 1892 (Glenbow Archives, Calgary NA 1934-1)

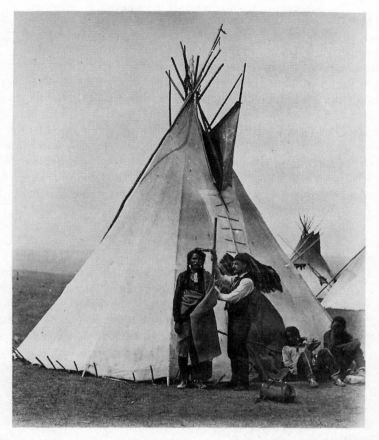

Figure 20.2 Ethnologist measuring and photographing an 'Indian', Macleod District, southern Alberta, 1910s (Provincial Archives of Alberta, 'a' collection, A.20, 746)

Native Canadians' actual experience of a reserve is the time it takes them to drive through one on the highway.

Ideals and romantic images of 'Indianness' and 'the Noble Savage' remain as fascinating (if not more so) for Europeans and Asians as they are for North Americans (Figure 20.2). Yet, as Fulford (1992: 33) comments, such fantasies can be devastating for Native peoples 'who grow up with mass culture in the same way other North Americans do, automatically absorbing its imagery'. This media-driven hybrid of typically Plains cultures proto-types and Hollywood hype is a kind of 'virtual reality'. Doxtator and Francis offer us additional insights: 'Images of Indians ... persist not because of their fallacy or accuracy but because they function as a readily understood symbolic language in the predominant culture' (Doxtator, 1988: 26); '[T]he stereotype did not

disappear so much as change content ... Feeling an absence of the sacred in modern life, many non-Natives look to Indian culture for values they find lacking in their own' (Francis, 1992: 58).

The commercial reality for Alberta heritage attractions is that they must attract a primarily non-Native audience to be financially viable and this audience seeks an exotic experience. Some visitors to sites such as the Head-Smashed-In Buffalo Jump Interpretive Centre (a World Heritage Site near Fort Macleod), may be apprehensive of their first ever encounter with a North American Native person. Some come with sincere expectations of meeting interpretive guides decked out in breach clouts, buckskins and feathers and 'Native workers at Head-Smashed-In get a lot of satisfaction from destroying some of these myths' (Figure 20.3).

Objects and collections

First Nations collections held by Alberta museums are massive, diverse and span time from prehistory to the present day. The Provincial Museum in Edmonton has about 14,000 ethnographic items including perhaps the largest Blackfoot collection in Canada. Glenbow Museum in Calgary has an estimated 20,000 items related to North Western

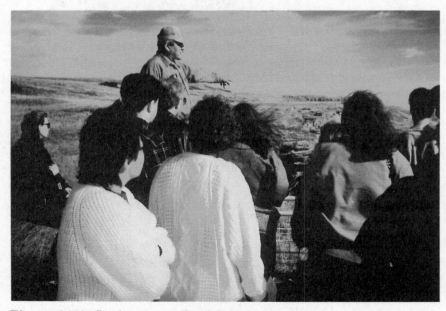

Figure 20.3 Students tour Head-Smashed-In Buffalo Jump Interpretive Centre with guide Leo Pard (Piikani) (Museums and Collections Services, University of Alberta)

Plains peoples representing Cree, Saulteaux, Blackfoot, Sioux, and others. The Whyte Museum of the Canadian Rockies in Banff holds fewer items, primarily Stoney and some Kutenai, but has a large photographic archive relating to First Nations peoples. Glenbow and the Provincial Archives also have extensive public collections of photographs.

Photographs are significant here. Advancements in photographic technology and its growth as a popular phenomenon coincided, around the turn of the century, with an initial period of non-Native settlement and tourism into southern Alberta. At the time, Native peoples, weathering the storms of colonization, were not busily 'kodaking' (Silversides, 1994). Yet the often anonymous subjects of these early photographs are the ancestors of present-day First Nations people. The collections represent personal and emotional memories for them and through them a First Nations viewer may come face to face with past relatives for the first time. Archival photographs constitute for some Native people their earliest, possibly only, 'family albums'.

First Nations collections may have fundamentally different meanings for Native and non-Native museum visitors. For example, Forts Macleod, Whoop-Up and Calgary have small collections directly related to one of Anglo-Canada's 'great romances' – the March West in 1874. This was when the just formed North West Mounted Police came to stop Americans illicitly trading whisky with vulnerable First Nations (Francis, 1992). For white people, the Mounties became comforting icons of peace and security. Yet for the First Nations of southern Alberta, the decade which followed their arrival brought territorial invasion, mass starvation, relegation to reserves and social disruption. How is this history to be related and balanced and by whom?

When I went to residential school all the Native kids were in the dorms and the non-Native were in their own quarters ... there was always that division ... We made friends but I always had to ask permission ... to play, and if I got caught without permission then I was punished ... The teachers were white, the farm instructors were white. But they came with a lot of rules and regulations ... And then when I went to the museum in Fort Macleod, the first time I saw it, the same concept of that division came in because ... it was the FORT ... it represented the Mounted Police ... the military. (Crowshoe)

Stories, songs, dances and ceremonial 'rights', powerful ways of perpetuating memories and meanings in cultures with oral traditions. An object's 'power' exists separately from it and is possessed by the person who owns the rights to it. Some First Nations objects have associated rights with obligations and the transfer of these rights to subsequent

owners can sometimes be costly. The Provincial Museum, Glenbow and Head-Smashed-In have ceremonial rights for some First Nations materials in their collections (for example, designs painted on tipis).

Elders and ceremonialists advise some museums on how to manage and handle their collections of First Nations material. Collections might be categorized differently by elders than by Western-trained curators; by specific links to individuals and families instead of by culture group, for example (Churchill, 1987). However, it is not enough that a museum adviser be a Native person or an elder. Museums have also to be aware of the transferred rights held by members of their Native advisory councils and should be asking the question 'do they carry themselves in the right way?' There is a need for museums to understand, from a traditional perspective, the complexity and power of First Nations collections.

Of particular concern are 'Sacred' items. These are stored separately from other materials, not only for reasons of security (items are valuable in the international art trade) and to control access, but also out of respect, so that someone working in the collections will not encounter them unintentionally. Both the Provincial Museum and Glenbow report observing menstrual taboos and other handling protocols. Native and non-Native staff members may be given ceremonial authorization and protection to work with certain materials. Unprotected handling can cause bodily harm, a belief now shared by some non-Native museum workers. Glenbow keeps medicine bundles in a quiet place and a staff member smudges them daily, as is done traditionally. The respect given to another world view broadens the meaning of standards in the museum care of ethnographic collections and is essential for their documentation.

Behind-the-scenes care of First Nations collections and the ongoing collaborations between museum staff and First Nations representatives tell us much about how these objects are regarded by non-Western peoples. Exhibitions incorporating First Nations collections could be enlivened by revealing publicly some of the special arrangements necessitated by them. In this way, museum visitors might be given a greater sense of the collection's potency in the modern world.

Considerable First Nations material is held in overseas collections, a point brought home by the 1988 Glenbow exhibition 'The Spirit Sings: Artistic Traditions of Canada's First Peoples' (Harrison, 1987). Overseas holdings are orphans: they raise many difficult questions. What is the location, nature and extent of these collections? What moral and legal rights do First Nations have to these materials? Do their originators have any claims on how these materials are handled and presented? Are rights' holders still living? Some Alberta First Nations objects should not be publicly displayed, even graphically. It is likely

that First Nations and keepers of foreign collections will need to negotiate these concerns in the future. The 'information superhighway' may necessitate this happening sooner rather than later.

Various approaches are now being taken to the loan of materials to Native peoples who are especially keen to use ceremonial objects. The museum must appraise the ceremonial rights of the borrower to use the item and be assured that the item will be cared for during the period of the loan. The museum concerned may want community-wide access assured and must be clear on how and when the material will be returned, or indeed if it will. Sensitive negotiations are required to avoid causing strains in museum/Native relationships, which might be counter-productive to future collaborations. Museum professionals decide legitimate requests for loans based on advice from elders, in consideration of past experience and in accordance with the physical stability and relative values of the object. Such decisions are difficult: it has been known for 'loans' to be decamped with and situations have arisen where museum directors have agreed to loans that curatorial staff, trained in the Western object preservation paradigm, have been reluctant to facilitate. The loan and use of material exposes the basic dichotomy of view about the care of this material in museums. For a curator, handling an object jeopardizes its condition; for First Nations, disuse may pose the greater threat.

> *The museum is saying co-management ... Western disciplines, methods of preservation, education, conservation we all agree with. But they also bring with that their practices ... They say take your old system, we don't understand it ... but use this system ... Well, why not take your system apart and bring your theories and we'll bring our practices to the table. At least that way we've got mutual partnership for co-management. (Crowshoe)*

Through use, 'activated' material has its abstract component coupled to its physical presence. In a sense, it has been awakened. Glenbow Museum will not take certain loaned 'activated' material back into collection storage because of the conservation treatment required of it (to prevent infestation, for example). Respect for life naturally precludes procedures such as quick-freezing and fumigating that might endanger it. McMaster describes how First Nations objects in museums are put into a state of suspended organicity, 'debugged, de-contaminated, deferred, democratized, and detached' (McMaster, 1993: 25). Another museum takes loaned material back into their collection, subject to possibly invasive conservation treatment. How 'activated' objects are handled depends, ultimately, on how the rights' holder interprets their responsibilities *to care* for that material.

Bundles are especially potent. Loaning them can be like loading fuel rods into a nuclear reactor. Medicine bundles are collections of objects wrapped together. Unlike personal amulets small enough to be worn around the neck, bundles are large enough to be cradled in one's arms. Each originated when a person received a vision meant to be shared with the whole community (Dempsey, 1986). Bundles are opened at certain times in ceremonials. People honour vows by dancing with objects in the bundle, prayers are offered, food is shared, gifts are distributed, faces are painted, and the bundle, renewed, is re-wrapped.

The prototypes of some bundles are hundreds of years old and their current manifestations have been in flux for generations. 'Power' is held in sacred bundles, not by individuals. A bundle might be compared to a museum: it is an inspired assemblage of meaningful objects held together and presented for community benefit and education, and ritually cared for by its owners.

The bundles give you that abstract authority to exist ... Historically, when we put bundles together people brought material objects to come together in a physical bundle. Each item has a song, had a protocol, had an origin story, authority, what have you. Had an abstract component ... That abstract bundle's got the wisdom, education, spirituality ... Those are your rules for decisions to help your community survive. And if you're looking at Native people and museums working together then they've got to be a community amongst themselves and not a community apart from each other. (Crowshoe)

Bundles are as contentious as human remains and raise similarly profound and charged questions concerning their presence in non-Native museum collections (Good, 1990). Can they be preserved as templates for future generations? Are there implicit fiduciary responsibilities? Do they belong there at all? Some materials would not have survived the 'cultural void' without sanctuary in museum collections. Bundles exemplify the complex challenges of First Nations history-making in Alberta museums.

Now we're looking back at bundles and saying we need bundles as a basis of self-government. In turn the bundles are becoming active again and the museum people are caught smack in the middle of this Indian controversy. It's an Indian issue and should be dealt with by Indian people. (Crowshoe)

Alberta museums usually purchased or were given their First Nations material by individuals and families (possibly as the founder's

endowment) or as purchases made from other collections. And, budgets permitting, they continue to acquire historical and contemporary material. Earlier, objects entered Alberta museum collections during economic hard times, as a result of legal prohibition and official discouragement of cultural practices, and when ageing owners of ceremonial items and society accoutrements, such as rattles, had no one left to claim them. Ownership and the circumstances around material entering the collection may be unclear or interpreted differently by parties operating from different world views. Was the material intended only as a loan? Was it the intention of the donor to transfer ceremonial rights with the material? Did cash payment or gifts given at the time signal a sale or a traditional offering for temporary use? Documentation may not adequately answer these questions. It may be non-existent.

When I was young I saw some old timers bring some stuff to the museum with the intention to leave it there until someone who knows what to do with it comes along ... To leave it there for safe keeping ... for future generations ... Future generations that know what they're doing should make this material active again ... Future generations can interpret transferred rights and authority differently depending on what is most needed for survival. Culture changes but practices can stay the same for hundreds of years. (Crowshoe)

The 'cultural void' created by the residential school period is being addressed by Alberta First Nations looking to museums for help in renewing cultural practices. First Nations want to repatriate what they feel belongs to them and want a say in how collections originating with them are owned, stored, handled, displayed and interpreted (Assembly of First Nations/Canadian Museums Association, 1992). The 'Canadian way' is through discussion, compared to the United States where issues between museums and Native peoples may be resolved by legislation (Penny, 1992). Discussion indeed!

'The Spirit Sings', the corporate-sponsored exhibition organized by Glenbow Museum in conjunction with the 1988 Winter Olympics in Calgary, was, as Byrne describes it, a lightning rod for decades of discontent in relations between First Nations peoples and the Canadian museums community (Byrne, 1993). This exhibition was criticized as a 'White man's show about Indians', seized upon by the Lubicon Lake (Cree) First Nation as a means to pressurize still-unsettled land claims issues, and was shunned by potential lenders and other exhibition venues (Harrison, 1988; Byrne, 1993). It generated dialogue between the Assembly of First Nations (AFN) and the Canadian Museums Association (CMA), and set off several years of regional conferences

and working groups, culminating with the 1992 'Task force report on museums and First Peoples' (AFN/CMA, 1992). This coincided with reflections upon the 1992 Christopher Columbus Quincentenary, put succinctly in Simpson's article title 'Celebration, commemoration, or condemnation?' (Simpson, 1992; McMaster and Martin, 1992).

First Nations history-making in Alberta museums has not been the same since the task force report articulated an all-embracing commitment to principles aimed at establishing partnerships between museums and First Nations. Their report made specific recommendations for action in areas of interpretation, access, repatriation, training and implementation (AFN/CMA, 1992). Its actual impact is now being assessed by the CMA. My contacts tell me it is unthinkable now for a museum to 'go it alone' in developing a Native-themed exhibition or major programme; that greater trust has developed between First Nations and non-Native museum managers (as reported by non-Natives); that various advisory liaisons have been established; that several training efforts have been tried or are underway; and, that non-Native workers feel more comfortable around Native people. However, different world views and straitened world economies will dog First Nations history-making in Alberta for some time.

Case studies briefly considered

A glance at several initiatives linking Alberta museums and First Nations shows this area of history-making as an evolving, generative activity working to perpetuate culture rather than preserve it frozen in time according to someone's interpretation of what it was.

An exhibit

In 1988, the Provincial Museum in Edmonton opened 'Northwind Dreaming: Fort Chipewyan 1788–1988', a 3,000 square foot temporary exhibit curated by Patricia McCormack commemorating the bicentennial of this northern community which is mostly Cree, Chipewyan and Métis. Her approach was influenced by a 20-year involvement there and by her ongoing interests in contemporary and 'ordinary' material culture. McCormack is particularly interested in the dynamics of cultural maintenance and modification – how 'Indians' can be 'modernized people driving trucks and talking on cell phones but remain distinctively Native'.

Several aspects of 'Northwind Dreaming' stand out. The exhibit presented culture as a dynamic contemporary creative force with deep historical roots. Exhibition development was community influenced and not always curator imposed. Further, research time spent there

respected that community's pace of life (McCormack, 1989).[1] The exhibit opened in Edmonton, but an 'executive summary' of it, suitable for installation in venues that could not meet museum standards, subsequently toured over a four-year period to Fort Chipewyan and elsewhere. The exhibit panels and photographs were ultimately donated to the Fort Chipewyan Bicentennial Museum. The community was able to see exhibited materials on loan from other collections in Canada, the USA and the Scottish Orkney Islands, where links dated from fur-trading days were re-established (McCormack, 1989). The exhibit catalysed a process of concerted community history-thinking and built that community's capacity for future history-making.

A loan

Peigans and the Provincial Museum in Edmonton were involved in an unusual project which was 20 years in the making resulting, in 1990, with the reconstitution of a Natoas bundle, vital to the Sun Dance. Rights' holders worked with items from fragmented bundles already in the museum's collection, items which had previous blessings from past owners. This shortened a process that would have taken many ceremonies and more money than anyone had. As it was, the process was very controversial, involved great risks and had to be checked with others every step of the way.

Does this loan present a model for likewise 'cloning' or transferring 'power' from other objects in museum collections? An object could be loaned out, somehow reproduced, then either the original or the new version could be returned to the museum collection. Win, win? Maybe.

From the beginning when I brought the elders together they said I should get the Natoas back from the museum. That topic was discussed and discussed and finally the museum proposed 'Well, why don't we make a new one?' ... These were all old parts we pulled out of the museum, put them together and made the Natoas. Then we had the Sun Dance and made them active ... that abstract authority coming back alive to make that Natoas an entity. So in a sense you made a new Natoas, you never cloned the last one. Cloning is playing God ... if you add, delete or change anything in it ... you're saying you're better than Creator ... So, in essence there's two now ... The Natoas in the museum made it possible for us to put it together. (Crowshoe)

Is there potential for doing this with other bundles?

If you'll understand it from our perspective there's potential, but not to keep looking at it from one direction and saying 'Yeah, we can keep

cloning them', and we're on the other side saying 'We keep taking the old stuff and making new stuff'. The Natoas was a good practice. We knew where we stood from a traditional perspective. The museum people knew where they stood from their Western discipline ... But did anybody understand the other person? (Crowshoe)

A 'museum'

The authors were involved in the development of a concept and feasibility study for a Native-owned and operated cultural centre on the Peigan Reserve called 'Keep Our Circle Strong' (Penumbra Associates, 1991). A 'museum' is at the heart of this project, aimed at economic and cultural renewal for a culturally rich but resource-poor reserve faced with high unemployment. The centre would be located on good roads in a scenic area. Rock discusses this area as part of a 'tourist space' in which Native heritage development has the greatest potential for cultural and economic revitalization, but with dangers of uncontrolled cultural commercialization (Rock, 1992).

The study estimated that the centre could attract between 150,000 to 500,000 annual visitors, would cost about $C20 million to fully build and $C3 million annually to operate, but had a chance to be self-supporting and generate considerable economic benefits to the reserve and region. A dream perhaps, but it caught the attention of provincial and federal governments eager for good works which coupled First Nations issues with cultural tourism, economic development and Native self-sufficiency. An *ad hoc* committee and elders guided the concept of the Peigan Nation Chief and Council supported it.

The proposed centre would be a keeping place for materials repatriated from other collections, but not all would be kept according to Western museum standards. Some of the collection would be used. Portions of the space would be public and others private. Pow wows, a seasonal tipi camp, horses and, possibly, bison would animate the site. The centre would build confidence through contemporary cultural self-knowledge and practice. It is considered the most advanced concept of several and the one that most directly links a museum-like development to an effective, comprehensive, community-empowering programme. 'Self-confidence is induced by the consciousness of one's existence as a cultural being, heir to a long genealogy of other cultural beings, and thus a subject to one's own life (instead of being an object among a controlled crowd in a more or less welfare state) ... ' (de Varine, 1992).

'Ma'kin ehma' was the Blackfoot term Reg Crowshoe used in discussions with elders to most closely approximate the non-Native concept of museum. It means death lodge. Death lodges are burial places, traditionally avoided, whose contents are never used again.

'Most Canadian Plains groups at contact preferred above-ground disposal of the dead, and early White accounts include many descriptions of scaffold and other "burials"' (Wilson, 1993: 65). Bodies with accompanying clothing and personal effects were placed on scaffolds, in trees, rock cairns and crevices, and in sealed tipis – death lodges – visible, vulnerable and violated by people who did not understand or respect their sanctity (Wilson, 1993). Burials were a source of 'curios' and human remains. Government surveyors and North West Mounted Police took part in this collecting. But a death lodge was clearly not what was envisioned by 'Keep Our Circle Strong'.

Our museum is a place where we'd take inactive material. If I have an active bundle and it wears out, I replace it with another bundle. But the inactive stuff I take to a place that's sacred geography. Not a death lodge. Sacred geography to keep it going. But if someone dies and they want to take their bundles with them, then you leave it with the body and you leave it with him and he takes it into the Spirit World ... So, again, a museum's got to spend time and money on understanding our principles and then we can say a museum could be sacred geography. (Crowshoe)

Circumstances have slowed development of 'Keep Our Circle Strong'. It is ahead of society's capability to accommodate it easily, but past the time of government's capacity to finance it single-handedly. It may appeal to private investors 'less inclined to dictate direction or set the agenda'. First Nation politics and personal relationships, especially evident in close-knit groups, can (paradoxically) fragment community support and frustrate co-operative outcomes. Moreover, planning in non-Western cultures is not always a strictly linear, cause-and-effect process.

A cost-intensive development operated according to principles and practices derived from traditional ways is not yet trusted by Canadians who hold power. Highly evolved financial and administrative (not to mention political) skills are required to manage projects of this magnitude and complexity. Sentencing circles, just now being tried for Native offenders in the justice system, have application for establishing culturally appropriate First Nations museum management models. Museums, themselves a cultural artefact, are an institutional invention of the colonizing culture. That they may not be ideal for a First Nations 'museum' should not surprise us.

253

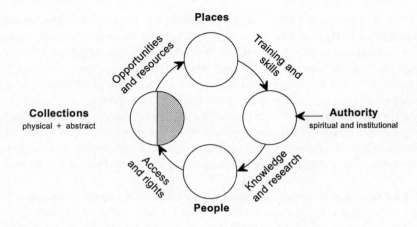

Figure 20.4 Dynamics of First Nations history-making

Conclusions

First Nations history-making involves the positive interplay of various forces and circumstances. Figure 20.4 draws four principal factors together and shows how the absence of any one affects them all. Access to collections without ceremonial rights or cultural knowledge, for example, incapacitates both the First Nations community and the keeper (often a museum). A First Nations project without control of its finances may never get off the ground. A First Nations facility operated as a tourism destination would fail to maintain viable levels of visitation if it lacked either industry standard amenities or staff trained to deliver consistently good quality visitor services.

First Nations history-making in Alberta is motivated by resurgent needs to recover, renew and thereby perpetuate distinct cultures within the powerful North American milieu. Museums are a potentially rich medium for exactly this kind of cultural growth. For history-making in museums, First Nations need a place in others' museums, need places of their own, and need a place at the management table.

Acknowledgements

This work was partly based on and considerably informed by a series of tape recorded interviews Michael Ross had with people involved with First Nations collections and their interpretation. The responsibility for interpreting their views here is wholly his. Thank you to the following: Dr William J. Byrne (Assistant Deputy Minister, Alberta Community

Development, Cultural Facilities and Historical Resources Division); Dr Gerald Conaty (Senior Curator of Ethnology, Glenbow Museum); Bernadette Lynch (Education Officer, Whyte Museum of the Canadian Rockies); Dr Patricia A. McCormack (Assistant Professor, School of Native Studies, University of Alberta); Richard Shockley (Director, Fort Whoop-Up Interpretive Centre); Dr Phil Stepney (Director, Provincial Museum of Alberta); and Chris Williams (Facility Manager, Remington-Alberta Carriage Centre).

Michael Ross gratefully acknowledges financial assistance provided by the Alberta Museums Association through their Special Projects Grants Program supported by the Alberta Government.

Note

1 Time spent by a museum in a First Nations community can be a significant investment of financial and human resources, which in Alberta is exacerbated by the often long distances separating museums from First Nations. Working visits to museums by First Nations members often involves the payment of the traditionally respected honoraria, but this is now problematic for 'down-sized' museum budgets.

References

Assembly of First Nations/Canadian Museums Association (AFN/CMA) (1992) *Turning the Page: Forging New Partnerships Between Museums and First Peoples*. Assembly of First Nations/Canadian Museums Association, Ottawa.

Baker, W.M. (ed.) (1993) *Pioneer Policing in Southern Alberta: Deane of the Mounties 1888–1914*. Historical Society of Alberta, Calgary.

Byrne, W.J. (1993) 'Collections, traditions, and a path to the future' *Alberta Museums Review* 19(1), 21–6, 48.

Churchill, E. (1987) 'The Blackfoot Elders Project: linking people and objects in museum research' *Native Studies Review* 3(2) 71–85.

de Varine, H. (1992) 'Cultural action – a concept and its ambiguities' in *Papers in Museology 1*, 176–9. Almovist and Wiksell International, Stockholm.

Dempsey, H.A. (1979) *Indian Tribes of Alberta*. Glenbow Museum, Calgary.

Dempsey, H.A. (1980) *Red Cow, Warrior Chief*. Western Producer Prairie Book, Saskatoon.

Dempsey, H.A. (1986) 'The Blackfoot Indians', in Morrison, R.B. and Wilson, C.R. (eds) *Native Peoples: The Canadian Experience*, 404–35. McClelland and Stewart, Toronto.

Doxtator, D. (1988) 'The home of Indian culture and other stories in the museum' *Muse* 6(3), 26–8.

Ewers, J.C. (1958) *The Blackfeet: Raiders on the North Western Plains*. University of Oklahoma Press, Norman and London.

Francis, D. (1992) *The Imaginary Indian: The Image of the Indian in Canadian Culture*. Arsenal Pulp Press, Vancouver.

Fulford, R. (1992) 'Let's bury the noble savage' *Rotunda* 25(2), 30–5.

Good, D. (1990) 'Sacred bundles: history wrapped-up in culture' *History News* 45(4), 13–14, 27.

Harrison, J. (1987) *The Spirit Sings: Artistic Traditions of Canada's First Peoples. A Catalogue of the Exhibition.* Glenbow-Alberta Institute/McClelland and Stewart, Calgary.

Harrison, J. (1988) 'The Spirit Sings The Last Song?' *International Journal of Museum Management and Curatorship* 7(4), 353–63.

Hellson, J.C. and Gadd, M. (1974) *Ethnobotany of the Blackfoot Indians, Canadian Ethnology Service Paper No. 19.* National Museums of Canada, Ottawa.

Jennings, J. (1975) 'Policemen and poachers: Indian relations on the ranching frontier' in Rasporich, A.W. and Klassen, H. (eds) *Frontier Calgary 1875–1914,* 87–99. University of Calgary/McClelland and Stewart West, Calgary.

McCormack, P.A. (1989) 'Working with the community: a dialectical approach to exhibit development', *Alberta Museums Review* 14(2), 4–8.

McMaster, G. (1993) 'Object (to) sanctity: the politics of the object' *Muse* 11(3), 24–5.

McMaster, G. and Martin, L.-A. (eds) (1992) *Indigena: Contemporary Native Perspectives.* Douglas and McIntyre/Canadian Museum of Civilization, Vancouver.

Nelson, J.G. (1973) *The Last Refuge.* Harvest House, Montreal.

Penny, D.W. (1992) 'Reflections on the task force' *Museum Anthropology* 16(2), 9–11.

Penumbra Associates (1991) 'Keep our circle strong: Medicine Lodge Centre, Cultural Renewal and Research Program', unpublished proposal for the Peigan Nation Chief and Council, Edmonton.

Rock, R.L. (1992) 'Native tourism: endangered spaces?' *Prairie Forum* 17(2), 295–311.

Silversides, B.V. (1994) *The Face Pullers: Photographing Native Canadians 1871–1939.* Fifth House, Saskatoon.

Simpson, M. (1992) 'Celebration, commemoration or condemnation?' *Museums Journal* 92(3), 28–31.

Stocken, H.W.G. (1976) *Among the Blackfoot and Sarcee.* Glenbow Museum, Calgary.

Whitehead, R.H. (1991) *The Old Man Told Us: Excerpts from Micmac History 1500–1950.* Nimbus, Halifax.

Wilson, C.R. (1986) 'The Plains: a regional overview', in Morrison, R.B., and Wilson, C.R. (eds) *Native Peoples: The Canadian Experience,* 353–8. McClelland and Stewart, Toronto.

Wilson, M.C. (1993) 'Bones of contention: treatment by whites of native burials on the Canadian Plains', in Reeves, B.O.K. and Kennedy, M. (eds) *Kunaitupii Coming Together on Native Sacred Sites: Their Sacredness, Conservation and Interpretation,* 65–85. Archaeological Society of Alberta, Edmonton.

21
Making Children's Histories

Brian W. Shepherd

Museum work, as any thoughtful curator becomes increasingly aware through a career involving collection, interpretation and presentation, involves the creative act of assisting in the 'making' of meaning. In a history museum, this making of meaning would appear to stand at an extreme from the positivist view of social science which seeks an objective inquiry into social phenomena. Historians always find difficulty in addressing topics using rigorously scientific approaches and those who attempt to do so find it increasingly difficult to embrace broad issues, as even the narrowest of fields of investigation have scope for the non-scientific 'hunch' in the selection of evidence, its weighting and, arguably, its bias. Subjectivity, it seems, permeates even the most 'scientific' of approaches to history. The sheer impossibility of harnessing a body of material culture to be truly representative of the varieties of childhood experience makes a nonsense of any pretence that a museum addressing children's experience can be truly comprehensive, definitive or unbiased. What is it then, that a museum attempting to make children's histories can offer?

The chapters comprising this volume share the common theme of 'making histories', and as such also share, in many cases, similar theoretical problems and possibilities. This chapter will proceed from the specific to the more general, while acknowledging the overriding importance of understanding the cultural theory underlying any representation made.

The Edith Cowan University Museum of Childhood in Perth, Western Australia, is fortunate to have within its collections a number of significant family collections. These comprise 'childhood' items well provenanced to families on whom the museum holds a deal of information. Among these are those pertaining to the Riley family, the Boyd family and the Collard family.

The Revd C.O. Riley migrated to Western Australia in the early 1890s as an Anglican Bishop at a time when Western Australia (one third of the Australian continent) was a part of the Archbishopric administered from South Australia. He was shortly joined by his wife and growing family and resided in the Bishop's House (now a much treasured heritage building) on the banks of the Swan River close to the city centre in a select residential area occupied by prominent citizens of the then colony. The Riley children, six in all, were born between 1887 and 1897. The eldest, Catherine Pauline, was responsible for the donation to the museum of some 150 items from the children's toybox, together with a number of photographs of the children. These are mostly studio photographs, although there are some of the children in their domestic environment – with the family horse in the garden of Bishop's House, with their governess (the boys attended Bishop Hale's school as they grew older, while the girls were educated at home) and playing with their toys and the family dog in the extensive grounds.

At present, this collection is displayed within an area devoted to childhood playthings. A major display panel features a large studio portrait of the children, with supporting photographs drawn from those mentioned above, together with a photograph of Catherine Pauline taken in 1987 on her hundredth birthday when the museum held a birthday party for her. In this photograph, she holds the same doll she is shown holding at the age of eight in the studio portrait, a poured wax doll which is displayed in original costume among the range of toys in child height cabinets and pull-out display-storage drawers beneath. Another recent photograph shows Bishop's House today following restoration in the 1980s. A brief text draws attention to the children's privileged background, the British (and Empire) connotations of the playthings and the gender role conditioning suggested by the arrangement of toys into 'boys' toys' and 'girls' toys'. This latter theme provides the basis for separating the toys displayed in three cabinets – one for boys' toys, one for girls' toys and one for those shared by both. Evidence for this division was provided by Catherine Pauline through interviews conducted in 1984 and 1985.

The Boyd collection, also in the same 'theme' area of the museum's display, comprises playthings from an only child, William Boyd, born in Maryborough, a country town in the state of Victoria in 1947. Growing up in the post-war prosperity of Australia in the 1950s when an increased birth rate combined with the culturally diversifying impact of large-scale migration from Europe, Bill may be regarded as representative, if not entirely typical, of the 'baby boomer' generation. He is representative in that his childhood years span those of the baby boomers and the range of some 400 childhood-related items are those common to fairly average-income Australian households of the time. He

was, however, not 'typical' to the extent that his was a rural childhood at a time when Australia was increasingly becoming an urbanized society. He was an only child at a time when the average family numbered almost three children and his family was impoverished due to his father's problem with alcohol which led to an unstable record of unskilled employment. Bill's mother, who had been raised in an upper middle-class family, devoted herself to Bill, possibly as something of a solace in a far from perfect marriage. She stitched, knitted and crocheted, cooked, kept house and hoarded – hoarded everything.

When she died in 1993, the Museum of Childhood was fortunate to have the opportunity to acquire a well-provenanced and comprehensive record of Bill's childhood, revealed through the items he had used and been familiar with in his past. These include a comprehensive range of his clothing, ranging from his christening gown to knitted and crocheted baby layettes, his toddler's clothes and some clothes from when he was a small boy. Included too are elaborate pram and cot covers, blankets and carrying shawls. Bill's toys are as masculine as they are extensive. Most numerous are his toy guns ranging from a home-made rifle to a repeater revolver. Soldiers also abound, but here is it interesting to note the change of emphasis from those of the Riley children, which reflect the British Empire, to the presence of American Indians and Canadian Mounties. This American influence is particularly reinforced by an Indian costume made by Bill's mother from two hessian Colonial Sugar Refineries' sugar bags, with a head-dress fashioned from dyed chicken feathers collected in the family fowl pen. The museum also acquired items such as his tricycle, potty chair, toy cupboard, pram, many photographs, school items, a quantity of original containers of household products commonly used in the 1950s, as well as some household items and appliances such as a butter churn and a wringer.

The challenge of harnessing this somewhat unique collection for meaningful interpretation via display is currently stretching the ingenuity of the small staff of the Museum of Childhood. A modest start has been made through the presentation of a range of his playthings with explanatory labels identifying some of the individual items, but with major emphasis being placed on thematic aspects. Hence reference is made again to the gender role conditioning evident in the toys, to the American influence including a heavy emphasis on toys relating to the indigenous peoples of America, to the absence of toys relating to Australia's own indigenous peoples, and to the influence of British traditions which in this case is most strikingly obvious in the Union Jack and Australian flags Bill waved at the Queen on her post-coronation tour of Australia in 1954. The display, however, relies on the presentation of the playthings rather than on text as its medium of communication and is well supported by photographs of Bill – in a

primary school class group, playing in his Indian outfit and seated on the verandah of the family home. The juxtaposition of 'Bill's Toys' and those of the Riley family, with those of Fred Collard and in close proximity to other dated and provenanced items, is intended to provoke visitors' awareness of factors affecting the changing nature of toys over time and through circumstance, as well as to promote their appreciation of common threads.

Fred Collard was born in 1928 in a Nyungar family, the name given to a large group of Aboriginal people who occupied the South-West of Australia prior to white settlement. Fred's father, as was common among Aboriginal men at the time, worked at a variety of manual tasks on properties in the South-West and the family led an itinerant life, sometimes living in the various towns servicing the agricultural and pastoral industries of the region and sometimes on rural properties. Partly from cultural tradition, partly because of their itinerant lifestyle and partly because of their socio-economic position, the Collard children had few possessions. In fact when Fred showed an interest in the Museum of Childhood he had no material objects of his childhood which he could offer for display to complement the other two collections previously discussed. Neither could he produce any photographs of himself or his family. However, Fred confirmed what discussion with other Aboriginal people had reported to the museum, namely that several improvised toys were extremely commonly used by children of his generation. Fred soon improvised again some of these toys which now comprise a small display in this same area of the museum – toys which are in marked contrast with those of the Riley and Boyd displays.

Included is a treacle tin semi-trailer with wire axle and pulling handle. This item is simply a treacle tin filled with sand which could be dragged along sand tracks in the bush. Sometimes up to three tins would be hooked together and often would be played with by several children in a 'follow-the-leader' fashion all mimicking the sound of a semi-trailer truck. Another item, known as Kidigu Kidigu is made from an old wheel (such as a pram wheel) with a piece of fencing wire forming a handle and named after the sound made by a Model T Ford car. The user would run along small tracks in the bush (the highway) pushing the wheel in front while making the sound of the engine and pretending he was a vehicle. Fred also supplied a child-size didgeridoo. This famous aboriginal instrument was, according to Fred, typical of those usually given to boys. Adults would teach them how to play it around the camp-fire at night. They would later go off into the bush to practise until proficient. As they improved they would learn how to mimic animals and birds. The toys thus reflect both traditional and transitional aspects of an Aboriginal family's life of the time, as well as

imaginative play not dependent on commercially manufactured toys more commonly available in white society.

These three displays offer various possibilities for the making of meaning – and indeed, taken in isolation, they constrain the making of meaning to some extent. They span a period from the 1890s to the 1950s, one to which adult visitors can relate, often through association with their parents' or even grandparents' generations. For children, especially young children, all three belong to the never-never land of 'the olden days' and are not immediately discernible as coming from different periods. The displays pertain more to boys than to girls and are thus vulnerable to a charge of being 'gender biased'. (This charge the museum would strongly resist because the Riley display is positioned within the area devoted to 'playthings', at the point of transition from an area devoted to girls' toys to that devoted to boys' toys, while both the Boyd and Collard displays are positioned within the latter area.) The three displays span a wide range of socio-economic backgrounds: Riley clearly signifying a privileged family, Boyd an 'ordinary' Aussie boyhood and Collard something of a deprived background in relation to the dominant Australian culture.

None of these displays expressly claims to be 'typical' of an Australian childhood, though the statements above clearly indicate that curatorial intent has been to encourage visitors to 'make' meaning which would transcend the particular and to think about the varieties of childhood experience suggested by them.

This brings us to a consideration of who is making meaning through these displays. Quite obviously the museum has a major role here as the objects themselves, together with their mode of display, are selected by the institution. However, visitors of all ages bring to them their own cultural baggage in the shape of expectations, childhood memories, ideas about what children are like, what children ought to be and what is appropriate to include in the presentation of children's toys (Hooper-Greenhill, 1991). Expectations of a museum of childhood are, it seems, extremely important in the minds of visitors. A questionnaire administered by the author to 25 adult visitors at the Bethnal Green Museum of Childhood in London in 1994 failed to elicit one response suggesting that the displays in that museum concentrate on children's toys at the expense of other important aspects of children's lives. It would seem that, in the minds of most, a museum of childhood could be synonymous with a toy museum – this in spite of the fact that the upper gallery of that museum is increasingly being devoted to the history of childhood. An almost leading question asking visitors whether they had expected displays to reflect more of children's domestic, work or educational life generally drew a response to the effect that such themes would be better dealt with in another museum and that the

emphasis on toys was entirely appropriate. An exhibition dealing with childhood in the Powerhouse Museum in Sydney is titled 'Childhood – A World Apart' and similarly concentrates on playthings with a modest inclusion of nursery furniture, christening robes and some children's clothing. This also seems to reflect, this time with curatorial intent, an expectation that childhood is removed from the daily round of living and exists in an almost dream-like realm where the perception of the child (and hence of childhood) is fanciful, imaginative and ideal (Middleton and Edwards, 1990).

It would seem that adult visitors have clear ideas as to what is appropriate to display in a museum of childhood and even clearer ideas as to what is appropriate in the context of playthings. It is, after all, the adults of the community who both manufacture and/or select the playthings which children possess today, and the same was true in the past. The very concept of childhood is one constructed by adults rather than by the children who are obliged to inhabit the physical, intellectual and emotional space fashioned for them by custodial adults. Adults, it might be argued, have largely appropriated childhood for themselves (Shepherd, 1994). After all, unlike most social phenomena represented in museums, childhood is an experience through which all adults have themselves passed giving them an 'inside' view of what it is, or was, like. Whether adults in fact retain sufficient memory or feeling of what it was like thus making them reliable authorities is, however, debatable. Adults readily find in displays of childhood such as those discussed, a confirmation of what they already know. The familiar icons associated with the concept such as dolls, teddy bears, toys, games, nursery items and christening gowns are the things most easily identified as belonging especially to the early years of life, things which are generally only carried into adult life as items of nostalgia for a period of life now passed (Samuel and Thompson, 1990).

A dilemma for a museum of childhood is to decide whether to satisfy the expectations of visitors, and hence to run the risk of feeding this latent nostalgia by perpetrating something of a myth of a universal childhood composed mostly of playthings, nurseries and christening, or whether to confront the visitor with something quite different thus forcing a rethink of the concept. If a museum of childhood does not collect and display quantities of the commonly accepted 'childhood' items and use them to make childhood histories, it will certainly run the risk of so alienating its potential clientele as to jeopardize its very existence. Further, these very items would seem to belong more properly in a museum of childhood than elsewhere. However, to do no more than to reinforce entrenched stereotypes is to abrogate the serious curatorial responsibilities of interpreting collections so as to pursue the cultural and educational mission of the museum.

One way out of this dilemma is to harness what is increasingly understood to be the nature of the experience of museum visiting: namely that it is in the nature of a dialogue between the visitor and the museum presentation. Borrowing from educational theory, it may be suggested that a meaningful encounter will be experienced when the 'area of mismatch' between visitor expectation and museum presentation is within the grasp of the visitor. In learning theory, the 'area of mismatch' refers to the gap between what the learning brings to a learning situation as prior knowledge and what the learning programme offers. Where there is congruency between the two, there is no opportunity for new learning, but where the gap is too great the learner is not able to make the necessary intellectual leap to achieve the programme's objective (Ausubel, 1968). Adapting this to the museum situation, one may equate the visitor's 'cultural baggage' and expectations to their prior learning and the museum representation to the learning programme. Where the museum fails to present a sufficiently recognizable framework, the visitor will not be able to grasp the meanings which are intended. However, displays which simply reinforce existing understandings held by visitors offer no challenge or stimulation. They fail to introduce the 'other'.

What, then, can be said in this of the three family presentations outlined above? First, they all contain easily recognizable symbols of childhood. Even allowing for the complication of assembling displays for an audience of greatly different ages and social backgrounds it is extremely unlikely that the basic theme addressed would be misinterpreted. True, 'Fred's toys' are likely to appear somewhat strange to many viewers, but their juxtaposition with the two other displays will highlight both their similarity of theme and their contrast in content. Indeed, at a relatively simple level their presentation is a means of considering the 'other', of suggesting that the stereotyping of toys does not fit all cases. In the Riley collection, the sharp division between girls' toys and boys' toys separated by a third case containing toys and games shared by both genders is in itself a means of prompting consideration of changing gender roles over time. There is a danger here that by simply presenting toys in this way the museum may continue to reinforce entrenched stereotypes. Labels (including some specially written for children) which overtly question the contemporary relevance of such categorization are here designed to encourage even young visitors to think critically of the effects of prescribing toys along gender lines.

As has already been mentioned, the toys reflect different periods, socio-economic and ethnic backgrounds. Again, here the juxtapositioning of the displays in close proximity one to the other offers the potential for the visitor to examine differences within the same

restricted theme. For example, although British conditioning is strongly evident in both the Boyd and Riley collections, the Rileys were immigrants who migrated to a colony, whereas Bill Boyd was Australian-born in an era well after Federation. The Riley toys include lead soldiers reflecting the diversity of the British Empire. Bill's toys include a Royal Visit flag he waved at Queen Elizabeth on her post-coronation tour of Australia in 1954. They also include another strong element missing from the Riley collection, a reflection of the growing influence of the USA and Canada on Australian life (the home-made Indian outfit, plastic Canadian Mounties and souvenirs from popular American heroes such as Davy Crockett and the Lone Ranger). The influence of the 'Cowboy and Indian' reflection of American relations with indigenous people is interesting to note in contrast with the toys of Fred Collard, himself an indigenous Australian. Fred's toys are simple reflections of important mechanical items in European society: the Model-T Ford and the semi-trailer, although the child-sized training didgeridoo reflects the transition of indigenous cultural values. Bill's toys contain none which reflect white Australia's evolving relationship with its own indigenous people.

There are, not surprisingly, many other and more subtle points of contrast which can be teased out of these displays by those with the time, inclination and suitable background to discern them. These would include the notion of 'Sunday Toys', so labelled in the Riley collection and notably absent in the others and the ways in which the toys reflect the state of technology of the societies from which they sprang. This can be seen both in what the toys represent and the substances from which they were made. For example, a tin toy mechanical submarine in the Riley collection contrasts with the plastic cars of the Boyd collection – plastic being a relatively new commodity in the 1950s. The predominance of guns in Bill's toys contrasts strongly with the other two where they are absent. The heavily educational emphasis in many of the Riley toys is absent in the other two, reflecting possibly both a change in the values of eras and also in the differences in socio-economic background.

It would be a rare visitor indeed who, even with the aid of a museum guide, considers all these issues as he or she gazes into three quite small displays. However, all are possible and the displays make available a variety of readings according to the level of interest, application, intent and background of the visitor. The museum has 'made' something of the history of these children through presentation of their playthings and has made it possible for visitors to connect easily with a commonly understood theme. The visitors, for their part, have been encouraged to 'make' something of the history for themselves through the presentation of material culture and its juxtaposition in three

complementary displays. In so far as the visitors 'make' their own histories from the clues offered through the objects and the limited interpretive texts, attempt has been made to avoid both didactic and overly detailed exploration on the one hand and haphazard arrangement of heterogeneous bits and pieces on the other. The intention has been to allow visitors to 'read' the displays at their own level providing hopefully stimulus, challenge and interest to all. In this style of presentation, the museum attempts to offer a satisfying experience to visitors of all ages.

Up to this point, this chapter has dealt with a tiny canvas and has not addressed the enormous scope of what might be possible in attempting to make histories of children in museums. However, in defence of the approach taken, the artefacts of children found in museums, although possibly representative of a large group, are generally provenanced to particular experience. While major themes relating to the broad history of childhood may certainly be addressed in museums it will often be the artefact which relates to the particular circumstance which will arrest attention. Thus, for example, the Apprentice House at Styal, Cheshire in the UK which attempts to examine the living conditions of orphan cotton-workers during the Industrial Revolution, does this by presenting the particular example of one such living environment. As such, it is a springboard into the examination of a widespread social phenomenon affecting children at the time.

Similarly, the new history galleries at Bethnal Green address themes of infant and children's clothing over time, but do so by the presentation of individual artefacts reflecting particular times and circumstances. Here, however, the particular is rarely linked to the broader experience of a specific individual as items are used more to trace changing practices over time. Hence the children's history being made at Bethnal Green is one which is thematically based, rather than one concentrating on the history of individual children. One is encouraged, for example, to consider changes in infant care through displays thematically based which feature artefacts presented chronologically, with explanatory text which relates them to a broader social context. Feeding devices arrest attention through their variety, design and decorative features and include a variety of bottles, pap boats and bubby pots. It is quite possible to consider the impact of a growing awareness of germ theory through examining these closely and reading accompanying labels, but it is the artefacts which retain centre stage, rather than the theme of improving standards of health care. Similarly infant clothing, including some arresting early items and exquisite examples of needlework, also allow one to consider changing attitudes to practices such as swaddling and the reasons for changes, but in a rather tentative manner.

This gallery also considers infant care through the presentation of

nursery equipment such as high chairs, bassinets, cradles and perambulators. Such displays are extremely useful reference points for the study of the aspects of children's history with which they deal and together they convey valuable contextual background of the lives of infants from the social groups they represent. They do not, however, attempt to synthesize the parts into the life experience of particular infants in time, place, class, gender or ethnic group (Jordanova, 1990). This is not to imply that such an approach is not valid, but rather to point out that the form of children's history being made here contrasts strongly with that suggested by the family collections discussed earlier.

An important children's collection belongs to the National Trust in Sydney, Australia. Formerly located in the National Trust property Juniper Hall in Paddington, it was known as the Australian Museum of Childhood. The collection displayed a splendid array of children's artefacts, illustrations for children's books (including original Ida Rintoul Outhwaite watercolours, May Gibbs illustrations and Ginger Meggs comic illustrations). In contrast to the Edith Cowan University Collection, the emphasis here was clearly derived from a decorative arts tradition and objects were selected for their Australian content, manufacture and provenance. The collection grew out of the James Hardie collection of children's books and board games, and these remained an important nucleus of the growing collection.

Relocated, in 1993, to the Merchant's House in the famed tourist trap of The Rocks, close to Circular Quay and below the pylons of the Harbour Bridge, in its new incarnation the Australian Museum of Childhood children's collection was to be used largely in an educational context as a part of the interpretation of this 1870s town house. Thus a re-created kitchen and scullery provided a base for learning about food preparation of the time while above stairs the parlour was to provide a focus to considering the social life of the household. In other rooms the childhood collection would be presented in a series of changing displays. Unfortunately, changing administration and curatorial staff have to date not allowed the museum to reach its proposed potential and it is difficult to assess the merits of the concept. Promotional material advertising programmes, such as 'Eat your way through history', encouraging school groups to utilize the resources of the kitchen to participate 'hands on' in giving a realistic understanding of the eating habits of children (and adults) in the nineteenth century, add an important dimension not currently available at Bethnal Green.

The opportunities provided by a building such as the Merchant's House to experience a total domestic environment in which children grew up in another time and place is an important way of 'making' children's history. It would seem, however, that a problem not thoroughly resolved here is the rather mixed message it presents to

the casual visitor who is somewhat confused by a building which is partly presented as a historic house and partly as gallery space for a connoisseur's collections of childhood artefacts. It would seem also that it is essential that any institution attempting to make children's histories should be clear in its intentions. This is not to deny the validity, and indeed the desirability of encouraging visitors to 'make' of its offerings what they will, but rather to suggest that the parameters in which this can occur must be clearly understood. The Merchant's House as a visitor venue does not as yet make it clear whether the house is to be approached as a venue to be explored from a child's perspective or not.

Returning to the Edith Cowan Museum of Childhood with this thought in mind, the curatorial intent is to present via displays and public programmes some of the fruits of its collection, documentation, conservation and research into Australian childhood experience. It attempts to do this for visitors of all ages. While in part styling itself as a children's museum, it embraces childhood as a concept largely appropriated by adults and so seeks to address adults equally with children via its presentations. In a conscious effort to transcend the limitations of being pigeon-holed as a 'toy and baby' museum, the major themes highlighted in its galleries are infancy and child-raising practice, playthings, home life and school life, while a number of minor themes are either woven into these or occupy niches of their own. These include 'Growing up on a Group Settlement' (the Group Settlement Scheme was an important co-operative scheme between the British and Australian Government to resettle British families after the First World War), 'An Orphanage Childhood' (the story of a girl in the Salvation Army Girls' Home 1918–1922) and 'Growing up in War Time'.

In order to integrate groups of visitors of all ages, and to encourage family groups to share experiences across age groups, the museum includes many interactive experiences in all its theme areas. These 'hands on' components are a part of its displays, rather than something apart. For example, 'dress ups' are available associated with displays of children's costume; a baby-sized doll may be dressed in reproductions of a Victorian baby's layette of clothing attached to the relevant display; games may be played on reproductions close to the display of originals; visitors can participate in children's 'jobs' in the home display centring on 'helping around the home'; and children can participate in lessons in a reconstructed bush school of the 1920s using genuine equipment of the period.

Thought has been given to the semiotics of the whole, as well as the parts. Thus a conscious effort has been made to counterbalance a somewhat middle-class bias in the displays relating to infancy and playthings by a more working-class emphasis in the 'home' and 'school'

displays. The latter two themes contain heavy, though not exclusive, emphasis on the decade of the 1920s, where the schoolroom is a reconstruction of a rural one-teacher school of the 1920s and the 'home' area seeks to enable visiting school groups to make a natural progression from 'home' to 'school' within a consistent time period.

The display 'Growing up on a Group Settlement', which is located in close proximity to the 'home' display, can also be effectively related to this theme as many of the items displayed and activities organized around this display are typical of the lives of children living on the Group Settlements. The limited resources available to these settlers and their struggle for survival clearly identifies them as working class. These circumstances called forth the need to improvise and the museum features much home-made furniture and household effects frequently made, for example, from kerosene packing cases and tins. Inevitably, this contrasts strongly with the many fine dolls, toys, infant gowns and nursery furniture which are 'treasures' of the Museum of Childhood. Having said that, there are items in both the 'playthings' and 'infancy' areas which are also from humble backgrounds and a significant number are improvised. However, there is a conscious effort to balance the representation of class through the whole, where it has proved more difficult to do this in the parts. The same is true of other themes such as ethnic diversity and family background. The orphanage childhood display, for example, is a strong signifier pointing to the fallacy of assuming that children always grow up in a nuclear family with two nurturing parents. Similarly, a pin ball game on the theme of 'family therapy' is included to indicate that psychological disturbance in children is a significant phenomenon.

It is, as was stated at the outset of this chapter, clearly impossible to make children's histories in a museum in such a way as to present a definitive and balanced survey of childhood experience over time. Inevitably any theme, issue or biography singled out for examination will be at the expense of those neglected. By choosing, for example, to emphasize home and school life of the 1920s the museum is open to the charge of bias in favour of this decade at the expense of others. A more restricted mission and collections policy would overcome this to some extent, but even within a narrower focus the same dilemmas will arise. A consciousness of the issues involved does, however, inform curatorial intent and allow for common sense to take on board an awareness of how one is 'making' history through selections made and through the manner of presentation. Any representation of childhood in a museum can, at best, be little more than a window into a portion of that world of experience (Jenkins, 1989). Because all artefacts are particular examples of their type and because all have their particular histories, it follows that museums are able to provide meaningful glimpses into

particular lives, thus extending whatever generalized concept of childhood they may already possess. Through the particular, visitors may all experience the 'other' thus at once connecting with familiar symbols, but through them experiencing something new. The challenge for the museum lies in judiciously harnessing its collection and its information to unlock the varieties of children's experience in captivating, intellectually respectable and balanced ways which assists diverse clientele to join in the making of meaning.

References

Ausubel, D.P. (1968) *Educational Psychology: A Cognitive View*. Holt, Rinehart and Winston, New York.

Hooper-Greenhill, E. (1991) 'A new communication model for museums' in Kavanagh, G. (ed.) *Museum Languages: Objects and Texts*, Leicester University Press, Leicester, 47–62.

Jenkins, J.G. (1989) 'The collection of material objects and their interpretation' in Pearce, S. (ed.) *Museum Studies in Material Culture*, Leicester University Press, Leicester, 119–24.

Jordanova, L. (1990) 'Objects of knowledge: a historical perspective on museums' in Vergo, P. *The New Museology*, Reaktion, London, 21–40.

Middleton, D. and Edwards, D. (eds) (1990) *Collective Remembering*. Sage, London.

Samuel, R. and Thompson, P. (eds) (1990) *The Myths We Live By*. Routledge, London.

Shepherd, B.W. (1994) 'Childhood's pattern: appropriation by generation'. In S. Pearce, (ed.) *Four Museums and the Appropriation of Culture: New Research in Museum Studies*. Athlone, London.

Index